W9-BWG-437

SIR JOSHUA REYNOLDS

SIR JOSHUA REYNOLDS

THE SUBJECT PICTURES

MARTIN POSTLE

University of Delaware

CAMBRIDGE
UNIVERSITY PRESS

Published by the Press Syndicate of the University of Cambridge
The Pitt Building, Trumpington Street, Cambridge, CB2 1RP
40 West 20th Street, New York, NY 10011-4211, USA
10 Stamford Road, Oakleigh, Melbourne 3166, Australia

© Cambridge University Press 1995

First published 1995

Printed in Great Britain at the University Press, Cambridge

A catalogue record for this book is available from the British Library

Library of Congress cataloguing in publication data

Postle, Martin
Sir Joshua Reynolds: the subject pictures / Martin Postle.
 p. cm.
Includes bibliographical references and index.
ISBN 0 521 42066 0 (hardback)
1. Reynolds, Joshua, Sir, 1723–1792 – Criticism and interpretation. 2. Reynolds,
Joshua, Sir, 1723–1792 – Themes, motives. 3. Reynolds, Joshua, Sir, 1723–1792 –
Catalogs. 4. History in art – Catalogs. 5. Gods, Roman, in art – Catalogs. 6. Art,
British. 7. Art, Modern – 17th–18th centuries – Great Britain. I. Title.
ND497.R4P66 1994
759.2 – dc20 93-28687 CIP

ISBN 0 521 42066 0 hardback

ND
497
.R4
P66
1995

In memory of Tim

Contents

Plates

Colour plates

Preface

The masterpiece, once completed, does not stop: it continues in motion, downhill. (Julian Barnes, *A History of the World in* $10\frac{1}{2}$ *Chapters*)

Works of art are not static. With the passage of time they change physically, and the attitudes of those who view them also change. As Julian Barnes has observed of Géricault's *Raft of the Medusa* (Louvre, Paris), the painting – due to the artist's flawed technique – is deteriorating. Yet, paradoxically its power as an icon steadily increases, as successive generations reinvent it according to their own preoccupations and prejudices. For better or worse Géricault's *Raft* is now famous. Many of the paintings discussed in my book have, like *The Raft*, deteriorated due to Reynolds's own technical shortcomings – although their physical decline has not been compensated by lasting fame. Yet, during Reynolds's lifetime, and in the forty years or so after his death, pictures such as *Ugolino and his Children in the Dungeon* and *The Infant Hercules Strangling the Serpents* were the most widely discussed British pictures of their time. Not everyone admired them, but few ignored them.

Towards the end of Reynolds's life, on 30 August 1789, the following notice appeared in the London press:

It is with extreme concern we announce that the infirmity which lately attacked Sir Joshua has been attended with such severe consequences that the sight of one eye is gone for ever! The fellow organ may possibly assume hereafter an energy beyond what it at present possesses: but Sir Joshua relinquishes from this moment all the inferior branches of the art, and will dedicate his remaining powers to historical and fancy subjects.

By now Sir Joshua Reynolds's eyesight was rapidly failing. Portraiture, the art form upon which he had based his professional career and material success, was no longer a viable option. Instead, he chose to concentrate his energies upon those works he had always painted for pleasure and instruction, rather than financial gain – his history paintings and fancy pictures. Today, Reynolds's reputation rests on his tripartite achievement as a portraitist, a writer of art theory, and his presidency of the Royal Academy of Arts. The subject paintings, by way of contrast, have been regarded as pictorial marginalia. As a portraitist Reynolds was a consummate professional. He could complete the face of a portrait in four

one-hour sittings, clothing and accessories being painted by assistants or specialist 'drapery' painters. Subject paintings, on the other hand, often occupied him for months, or even years, as he tested out materials, theories on colour, as well as precepts which he advocated in his *Discourses on Art*. Seen in terms of his own attachment to them, and their seminal role in shaping and defining the burgeoning British School of art, the subject paintings lay at the heart of Reynolds's practice, not on the periphery.

After Reynolds's death in 1792, as his contribution to the formation of the British School was assessed, the subject pictures were used as tokens of his respect for high art by those who defended him as a national institution, and examples of his limitations as a painter by those who attacked his pretensions. Today, as attempts are made to gain a deeper insight into the major transitions in British culture during the late eighteenth and early nineteenth centuries, an evaluation of the role played by Reynolds's subject pictures in the formation of national artistic taste will, I hope, serve as a useful catalyst for further discussion.

This book is based upon my doctoral thesis, submitted to the University of London in 1989. The aim of the thesis was to produce an original piece of research based upon a study of Reynolds's subject pictures. The text has been considerably revised since then, although the intention has not changed. None the less, as I have become increasingly aware, there remains considerable scope for expanding many of the areas touched upon in the text, especially with regard to the overall function of history painting in Britain and its role in defining and locating social and political – as well as artistic – hierarchies during the period 1770 to 1830.

My first debt in preparing this book is to William Vaughan, who supervised my thesis at Birkbeck College, University of London, and who has since continued to provide guidance and support. I also wish to thank the examiners of my thesis, David Bindman and David Mannings, for their helpful comments and suggestions both on specific points in the text, and on the structure of general arguments. In addition, I am grateful to Brian Allen who not only read and commented on my manuscript, but who has given tremendous help and support in so many areas of my research over the last few years. Among those scholars who have offered advice and assistance I am especially grateful to David Alexander, Nicholas Alfrey, Ilaria Bignamini, Elizabeth Einberg, John Ingamells, Mary Joseph, Alastair Laing, Christopher Lloyd, Sir Oliver Millar, Evelyn Newby, Nicholas Penny, Michael Rosenthal, Andrew Sanders, Desmond Shawe-Taylor, and Richard Spencer. I also wish to express my special gratitude to Robin Simon and to the late Emeritus Professor Alastair Smart, with whom I

studied, and who first encouraged me to pursue my interest in British eighteenth-century art.

Much of my research would not have been possible without the kind cooperation of the staff of the Paul Mellon Centre for Studies in British Art. For their unfailing support I would like to thank Philippa Brown, Juliet Collings-Wells, Kasha Jenkinson, Claire Lloyd-Jacob, Arabella Sim, Douglas Smith, Fenella Taylor, and Antonia Yates. I am also grateful to Nick Savage and Helen Valentine of the Royal Academy of Arts; John Sunderland, and the staff of the Witt Library; and Sheila O'Connell, Kim Sloan, Hilary Williams, and the staff of the Department of Prints and Drawings, British Museum. I would also like to thank Margie Christian of Christie's, and Richard Charlton-Jones and David Moore-Gwynn of Sotheby's for their assistance with photographic enquiries. Visits to private collections, and public art galleries were assisted by a grant from the University of London Central Research Fund. The colour reproductions in the book were made possible owing to a generous grant from the University of Delaware.

Many private individuals have contributed towards my research, by granting access to their picture collections, and by responding to my enquiries. I am grateful to Lady Theresa Agnew, Mr John Barratt, Lady Anne Bentinck, Lord Carnarvon, Lady Juliet de Chair, Mr Michael Copland-Griffiths, Miss Jeanne Courtauld, Lord Daventry, Dr John Edgcumbe, Lord Egremont, Mr Henry Engleheart, Lord Feversham, Lord Halifax, Lord Harrowby, Lord Lambton, the late Lord Moyne, Sir Arundel Neave, Mr Ian Noble, Lord Normanton, the Duke of Northumberland, Lord Romsey, Robert and Jane Rosenblum, Lady Mary Roxburghe, Lord Shelburne, Mr John St A. Warde, Dr Richard Wendorf, and Lord Zetland.

I would like to thank Hilary Gaskin, Jenny Potts, Ann Rex, Rose Shawe-Taylor, and everyone at Cambridge University Press.

Finally, I owe an abiding debt of gratitude to my family for their encouragement over the years, and most especially to my wife Martine. The book is dedicated to the memory of my brother-in-law, and good friend, Tim Salter, who was tragically killed on 28 April 1993.

Martin Postle, December 1993
University of Delaware

Acknowledgements

By permission of the Albright-Knox Art Gallery, Buffalo, New York colour plate 5; By Courtesy of David Alexander Esq. 53; By permission of the Ashmolean Museum, Oxford 71; Reproduced by Courtesy of the Trustees of the British Museum 23, 27, 30, 54, 61, 67, 68, 75; By kind permission of the Earl of Carnarvon 24; By kind permission of Lady Juliet de Chair colour plate 13; Reproduced by Courtesy of the Art Museum, Cincinnati 21; By permission of the Corporation of London 56; reproduced by kind permission of Miss Jeanne Courtauld 78 (photograph from the Courtauld Institute of Art, London); By permission of the Detroit Institute of Arts colour plate 16; By permission of English Heritage colour plates 6, 8, 9 and (black and white) 1 and 12; Reproduced by Courtesy of the Faringdon Collection Trustees, Buscot 22, 37; By Courtesy of the Executors of the tenth Earl Fitzwilliam 81; Reproduced by permission of the Syndics of the Fitzwilliam Museum, Cambridge 52; By kind permission of the Earl of Halifax 25; Reproduced by kind permission of the Earl of Harewood 8; By Gracious Permission of Her Majesty the Queen 72, 77; By permission of The Hermitage, St Petersburg colour plate 15, and black and white 76; Reproduced by kind permission of Lord Hillingdon 19; By permission of the Huntington Art Gallery, San Marino 17; Reproduced by permission of the Los Angeles County Museum of Art, William Randolph Hearst Collection colour plate 2; Reproduced by kind permission of Lord Lambton 55; By permission of Merseyside County Council (Lady Lever Art Gallery, Port Sunlight) 2; Reproduced by permission of the National Gallery of Ireland, Dublin, 59; Reproduced by Courtesy of the Trustees of the National Gallery, London 18, 62; Reproduced by permission of the National Gallery of Victoria, Melbourne, Australia 60; By permission of the National Trust colour plates 1, 4, and black and white 82 and 83; By kind permission of the Master and Fellows of New College, Oxford, 70; Reproduced by kind permission of the Duke of Northumberland 9; photographs from the Paul Mellon Centre for Studies in British Art 3, 4, 5, 6, 7, 10, 13, 15, 20, 26, 31, 33, 34, 39, 40, 41, 42, 44, 45, 47, 48, 49, 50, 51, 58, 59, 63, 64, 65, 66, 74, 79; Photograph supplied by Thomas Photos, Oxford, reproduced by kind permission of the Master and Fellows of New College, Oxford 69; By kind permission of Lord Normanton colour plate 12; Reproduced by permission of Jane and Robert Rosenblum colour

plate 14; By permission of the Royal Academy of Arts, London 3, 11; By Courtesy of Lord Sackville colour plate 7, 10 and black and white, 46; Reproduced by Courtesy of the Earl of Shelburne 13, 32; Sotheby's colour plate 11; By permission of the Trustees of the Tate Gallery 14, 36, 73, 80; Reproduced by permission of the Trustees of the Wallace Collection, London 28, 29, 35; By Courtesy of the Earl of Warwick 38; Beinecke Rare Book and Manuscript Library, Yale University, 84.

1 Several types of ambiguity: historical portraiture and history painting

'The English', observed Louis-Sebastien Mercier on a visit to London in the early 1780s, 'excell in portraits, and nothing surpasses the portraits of *Regnols*, which the principal examples are full-length, life-size, and on a par with history painting' (Shawe-Taylor, 1990, p. 21). Portraiture could, and often did, aspire to the level of high art in eighteenth-century England. And by his death in February 1792 the portraiture of Sir Joshua Reynolds ('Regnols') was claimed by admirers as a form of history painting in its own right (Shawe-Taylor, 1990, p. 29). This book is devoted principally to Reynolds's subject paintings. But since the borderline between history painting and portraiture was uncertain during Reynolds's lifetime, and because Reynolds was himself responsible to a large extent for this situation, the historical portrait requires our initial attention.

In 1932 Edgar Wind examined the differences between the portraiture of Reynolds and Gainsborough within the context of eighteenth-century philosophical enquiry (see Wind, 1986, pp. 1–52). He allied Gainsborough's instinctive approach to the scepticism of David Hume, while Reynolds's more measured and self-consciously intellectual stance was linked to 'moralists' including Samuel Johnson and James Beattie. Wind contrasted the art of Reynolds and Gainsborough through examples drawn from portraits of children, young girls, men of learning, military and professional men, actors and women (in that order) and concluded that 'the fundamental divergence of Reynolds and Gainsborough was over the legitimacy of heightened, metaphorical, and dramatic expression' (Wind, 1986, p. 34). According to Wind, Reynolds himself felt that Gainsborough 'lacked the imagination which enables the painter to rise above his particular subject and awaken in the spectator the memory of an Idea' (Wind, 1986, p. 17).

Reynolds's mode of portraiture relied on association – or 'the memory of an Idea'. Frequently he conveyed a heroicized image where the 'idea' not only transcended but superseded the individual's identity. But to what extent, and in what ways, did Reynolds's historical portraits encroach on territory which had previously been the province of history painting? In this first chapter I will argue that Reynolds's methods raised among his contemporaries a series of ambiguities which not only elided distinctions

1

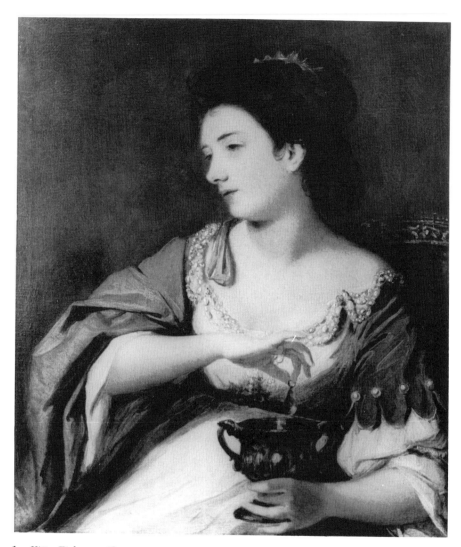

1 *Kitty Fisher as Cleopatra*.
 Oil on canvas, 76·2 × 63·5 cm. 1759. The Iveagh Bequest, Kenwood
 (English Heritage).

between the established genres, but undermined the development of history painting in England in the late eighteenth century.

When Reynolds's *œuvre* was catalogued by Algernon Graves and William Vine Cronin, at the turn of the century, they divided it into two categories, 'Portraits' and 'Historical, mythological and fancy subjects'. Pictures of identifiable sitters were considered as portraits, while works with historical or literary titles were classed as subject paintings.[1] Such division is helpful in a catalogue but in the critical evaluation of Reynolds's paintings it only serves to confine debate. Of Reynolds's portrait of *Kitty Fisher as Cleopatra* (plate 1) Nicholas Penny has stated: 'without the evidence of the prints which are given the title used here ["Miss Kitty Fisher in the character of Cleopatra"], it may be doubted whether Reynolds's painting would have been recognised as a likeness of Kitty Fisher, or indeed considered as a portrait at all' (Penny, 1986, p. 195). Similarly, of *Elizabeth Gunning, Duchess of Hamilton and Argyll* (plate 2), which was exhibited with the Society of Artists in 1760, it has been observed that 'in the crowded context of the public exhibition, it certainly would have caught the eyes as a history painting, a work of Art, and not as the portrait of a contemporary'(Balkan, 1972, p. 91).[2] Both statements beg a number of important questions: first, who would have recognized these pictures as subject paintings rather than as portraits; secondly, to what extent does a sitter's anonymity diminish the portrait element in a picture; and third, how did Reynolds's contemporaries variously perceive and define the category of history painting? We can begin by looking more closely at the portraits of Kitty Fisher and Elizabeth Gunning, Duchess of Hamilton and Argyll, cited above.

At the time Reynolds painted her portrait, Kitty Fisher was a notorious courtesan. To satisfy the public's curiosity pamphlets were printed which concentrated, at times in graphic detail, on her amorous pursuits. Her face appeared in print-shop windows, including Edward Fisher's mezzotint after Reynolds's own painting.[3] Reynolds's image therefore relied for its full impact on the public's ability to identify Kitty Fisher and to make the link between her own extravagant behaviour and that of Queen Cleopatra. And yet the picture itself was not exhibited in public during the artist's life-time.[4] Who therefore, apart from the artist and a number of self-professed 'cognoscenti', conceived of the painting primarily as anything other than a portrait of Kitty Fisher – albeit in exotic mode?[5] Similarly, Elizabeth Gunning (1733–90), later Duchess of Hamilton and Argyll, was widely regarded as among the most beautiful women in England (see Bleackley, 1907, pp. 96–7 and *passim*). She and her sister, Maria, had been a *cause*

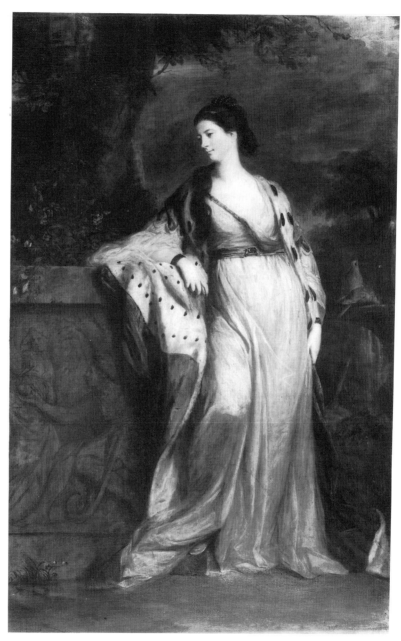

2 *Elizabeth Gunning, Duchess of Hamilton and Argyll.*
Oil on canvas, 238·5 × 147·5 cm. Exhibited at the Society of Artists,
1760, as 'A lady; whole length'. Lady Lever Art Gallery, Port Sunlight
(Merseyside County Council).

célèbre for almost a decade. Horace Walpole had reported to Sir Horace Mann in 1752: 'There are mobs at their doors to see them get into their chairs; and people go early to get places at the theatre when it is known they will be there.'[6]

In Reynolds's painting Elizabeth Gunning leans in a flimsy chemise against a plinth depicting the Judgement of Paris, while a pair of doves – Venus's emblem – drink water from a fountain. The majority of viewers would be left in no doubt that the intention was to make a comparison between the subject and the goddess Venus. As Shawe-Taylor has observed, Reynolds's portrait – 'almost a treatise on Female Beauty' – was only one of a series of contemporary images of Elizabeth Gunning, in which this kind of comparison was made.[7] Although Reynolds continually downgraded the importance of likeness in portraiture, any allusion he made rested ultimately on the recognition of the sitter by his audience. John Opie was speaking on behalf of generations of artists when he stated acidly to the assembled Royal Academicians some years later:

So habituated are the people of this country to the sight of portraiture only, that they can scarcely as yet consider painting in any other light ... one's ear is pained, one's very soul is sick with hearing crowd after crowd, sweeping round, and, instead of discussing the merits of the different works on view (so as to conception, composition, and execution) all reiterating the same dull and tasteless question, *Who is that?* and *Is it like?*' (in Wornum, 1848, p. 284)

Ironically, the quest for a more discriminating audience had been one of the principal reasons why artists, including Reynolds, stopped exhibiting at the Society of Arts after 1761 – where 'the company was far from being select, or suited to the wishes of the exhibitors' (Edwards, 1808, p. xxv).[8]

In painting *Kitty Fisher* and *Elizabeth Gunning* Reynolds aspired to more than portraiture. The 'elevation' of the image did not, however, lie in the obfuscation of the sitter's identity, but in a dextrous manipulation of the various conditioning factors inherent in portrait production as well as an understanding of the subtle, and often ambiguous, interplay between portraiture and subject painting. There were, in the late eighteenth century, a variety of different, and at times incompatible, criteria on which individuals evaluated works as history paintings. The labelling of works as portraiture or history were often based on personal and arbitrary judgements which Reynolds ably exploited – through his art and his art criticism.

The marked divergence of opinion concerning the relative status of Reynolds's work within the hierarchy of genres emerges strongly

in newspaper criticism during the 1770s. Here opinion oscillated between the strictures of a 'purist' debate engaged in by artists and connoisseurs, and a 'popular' viewpoint, shaped by the ephemeral ritual of the masquerade and fuelled by gossip and hearsay. None the less there was, across the board, a tacit understanding of the rules which governed the established genres of history painting, portraiture, landscape, and still-life. The need to acknowledge such divisions was spelt out by 'A Virtuoso' in *The Public Advertiser* of 4 May 1774:

Although it requires some Skill and Practice in judging of Pictures to disentangle the Branches into which they are divided, so as to have a distinct view of each part separately, yet we are indispensably obliged to do something of this, if we mean to go still further than the mere Decision of the Eye, and to add that Attic Seasoning to our Judgement which is derived from Reason and an improved Taste.

How one distinguished between the 'Branches' clearly depended on the vested interests of the individual, as disfavour could be made manifest through the a variety of cavils. In 1773 Reynolds exhibited *Ugolino and his Children in the Dungeon* (colour plate 10) at the Royal Academy. To all intents and purposes it is a history painting, and yet it was criticized in the following manner by 'Florentinus' in the *Morning Chronicle*: 'Sir, I should be glad to know upon what ground you call your picture of Count Ugolino an historical piece? According to history, Count Ugolino had but two sons and two nephews; you ought therefore to have set it down in the catalogue, as a fabulous piece, since you have deviated from history.'[9] In 1777 Reynolds showed a group portrait of the *The Bedford Children* (plate 3) at the Royal Academy. *The London Chronicle* (29 April – 1 May), observed that the picture 'is said to allude to St. George Killing the Dragon', and that it was 'founded entirely upon legendary history'. The self-styled 'Dilettante', writing in *The Morning Post* (1 May 1777), disagreed:

Sir Joshua, too, must deal out his spinach and eggs in what he calls history. You were pleased to comment ironically, on his St. George, 'What a saint! how engaged! and what a dragon!' Yet the head of the little boy behind, so far as it may be considered as a portrait, is very fine, as well as Miss Warren, but that a delicate young lady should be so passionate, and at such a scene, is certainly below criticism.[10]

Unlike *Ugolino*, *The Bedford Children* was clearly intended to be satirical. It could, however, count as history painting to some because it illustrated a Christian legend. Similarly *A Fortune-teller* (colour plate 1), also exhibited by Reynolds in 1777, was described in the following terms by 'Gaudenzio'

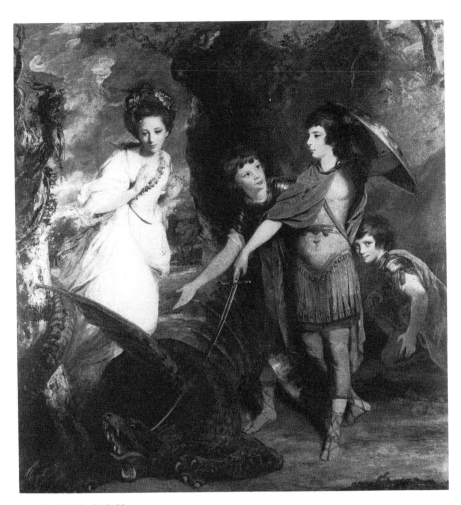

3 *The Bedford Children.*
 Oil on canvas, 207 × 192·5 cm. Exhibited at the Royal Academy, 1777, as
 'Portrait of a nobleman with his brothers and a young lady'. Formerly Earl of
 Jersey (destroyed).

in *The St. James's Chronicle* of 17–19 April 1777: 'A Gipsey is telling a young Girl, sitting on her Lover's Knees, her Fortune, and seems to be saying to her that she will soon be married to him, at which she laughs, and is pleased, without well knowing what it means. So I understand the historical part of this Picture.'[11] Gaudenzio's mode of criticism clearly exasperated more high-minded commentators such as the correspondent of *The London Chronicle*, who regarded the painting merely as a specimen of genre painting:

A Fortune Teller is said by some to be an historical piece, but with what propriety I cannot conceive. An historical piece I always understood to be a representation of some particular feat in ancient or modern, real or fabulous, sacred or profane history. But this is a representation of no such fact, and therefore cannot be called an historical piece any more than a picture of Jonas shuffling the cards would be. (*The London Chronicle*, 29 April – 1 May 1777)

Mrs Hester Thrale, who knew Reynolds personally, also objected to the picture as a subject painting – although her reasoning was more idiosyncratic: 'The Fortune Teller painted by Sir Joshua Reynolds', she affirmed, 'is a Portrait. I once saw the Woman who sate [*sic*] for it' (in Balderston, 1942, vol. I, p. 42).

The emergence of the subject painting within Reynolds's *œuvre* occurred during the 1760s, the decade during which British artists first began to exhibit their paintings in public. During this period Reynolds was clearly weighing up the manner in which he wished portraiture to reflect his own aspirations as an artist. In this respect 1767 was a watershed. This year he declined, for the first time since 1761, to send any pictures to the exhibition of the Incorporated Society of Artists. His absence was noted:

> I LOOK about; my optics strain,
> I look for Reynolds in the room in vain,
> REYNOLDS with great ideas now inspir'd
> Hath from the common crowd awhile retir'd.[12]

The sentiment contained in these verses, with their reference to 'great ideas', is confirmed by a letter written at the time by Edmund Burke to Reynolds's protégé, James Barry, who was currently pursuing his studies in Rome: 'The exhibition will be opened tomorrow, Reynolds, though he has I think, some better portraits than he ever before painted, does not think mere heads sufficient and having no piece of fancy sends in nothing this time' (in Fryer, 1809, vol. I, pp. 91–2). For at least four years Reynolds had already considered himself as more than a portrait painter. *The Universal Director* of 1763, among the 'Masters and Professors of Arts and

Sciences', contains the following entry: 'Reynolds, Joshua, History and Portrait Painter, Leicester Square.' Francis Hayman, Johan Zoffany, Edward Penny, and Robert Pine all receive the same appellation, whereas Reynolds's principal rivals as portraitists, Francis Cotes and Allan Ramsay, were described simply as portrait painters.[13] What gave Reynolds the right, in 1763, to be regarded as a history painter? He did not exhibit his first major history painting – *Ugolino and his Children in the Dungeon* – until 1773. He evidently painted a 'Venus' in 1759, but did not produce 'fancy pictures' in any significant quantity until the early 1770s (see Prochno, 1990a, p. 171, fig. 157). One answer lies in his painting *Garrick between Tragedy and Comedy* (colour plate 3), exhibited at the Society of Artists in 1762 – and which we shall return to shortly; another may be found in the polarity implied in Burke's phrases 'piece of fancy' and 'mere heads'. For Reynolds there was an important distinction to be made between the artist in whose work a degree of imagination or 'fancy' was evident and – to use Reynolds's own words – the 'cold painter of portraits' who produced 'mere heads' or likenesses (in Wark, 1975, p. 52). The comparison was already commonplace. In 1757 Benjamin Hoadley had praised Hogarth's portrait of Garrick and his wife (Her Majesty the Queen), which, he said, had 'not so much fancy to be affected or ridiculous, and yet enough to raise it from the formality of a mere portrait' (in Whitley, 1928a, vol. I, pp. 155–6). Later, on 28 April 1774, *The Morning Chronicle* noted that Reynolds's *Three Ladies Adorning a Term of Hymen* 'besides the exhibition of mere portraits, has an elegant design and fancy'. While in August 1779 *The Town and Country Magazine* observed that Reynolds, 'not content with being a mere portrait painter … produced several emblematical and allegorical pieces that will do him immortal honour'.[14]

As it was observed earlier, Edgar Wind contended that the principal difference between Gainsborough and Reynolds lay in their divergent attitudes towards expression. One could go further, and state that the principal means by which Reynolds felt that his own historical portraiture could transcend its own genre was by playing down the importance of individual likeness for the sake of generalized expression. In doing so, Reynolds was following a central tenet of the classical tradition with respect to the Ideal or central form. In the fifteenth century Alberti had noted how the classical painter Demetrius had failed to earn the highest praise because he placed likeness before beauty, while one hundred years later Michelangelo, when carving images of Giuliano and Lorenzo Medici, had dismissed the idea of recording their likeness because, as he said, in a thousand years nobody would know what they looked like anyway.[15]

More pertinent to Reynolds's own attitude were the writings of the French artist Roger de Piles (1635–1709), who had stated in his highly influential *Cours de peinture par principes* (English translation, 1743): 'It is not exactness of design in portraits that gives spirit and true air, so much as the agreement of the parts at the very moment when the disposition and temperament of the sitter are to be hit off' (in Gombrich, 1982, p. 118).[16] And as Reynolds himself put it in his fourth *Discourse*: 'Even in portraits, the grace, and, we may add, the likeness, consists more in taking the general air, than in observing the exact similitude of every feature' (in Wark, 1975, p. 59). According to his pupil James Northcote, Reynolds did not especially value the skills involved in taking a likeness, and 'used to say, that he could instruct any boy that chance should throw in his way, to be able in half a year to paint a likeness in a portrait; but to give a just expression and true character to the portrait was infinitely difficult and rare to be seen, and when done was that which proved the great master' (1818, vol. II, p. 49). Indeed Reynolds's own irritation at contemporary portrait-sitters' obsession with likeness bubbles over in the fourth *Discourse*, where he remarked that it was 'very difficult to ennoble the character but at the expense of the likeness, which is what is most generally required by such as sit to the painter' (in Wark, 1975, p. 72).[17]

In 1762 Reynolds exhibited 'A lady and her child, in the character of Dido embracing Cupid' – *Lady Waldegrave and her Daughter* (plate 4). A critic in *The St. James's Chronicle* (22–25 May), although he admired the picture, yet admitted that 'the lady is no very exact resemblance of Lady Waldegrave'. Lady Waldegrave, swathed in ceremonial velvet and ermine, did not bear much resemblance to Dido either – especially as 'Cupid', whom she shelters with her cloak, was actually her daughter. Without the title provided in the exhibition catalogue, the subject would be far more likely to be perceived as a Madonna and Child. And although sitters demanded likeness, it was not an aesthetic priority for those critics who valued Reynolds's precepts. In 1772 Elizabeth Judkins exhibited a mezzotint after a portrait of Mrs Abington by Reynolds at the Society of Artists.[18] *The Morning Chronicle* (19 May) stated: 'Tho' this is one of the most unflattering likenesses of Mrs Abington of all Sir Joshua's pictures of that celebrated actress, the connoisseurs call it the worst, on account of its being too close a copy of nature, unsustained by that elegance and grace which a judicious painter should always unite with similitude.' Five years later 'Gaudenzio', writing in *The St. James's Chronicle* (26–29 April 1777), described Reynolds's *Lady Herbert and her Son* (private collection) – then on show at the Royal Academy. Having noted that it was 'one of the best

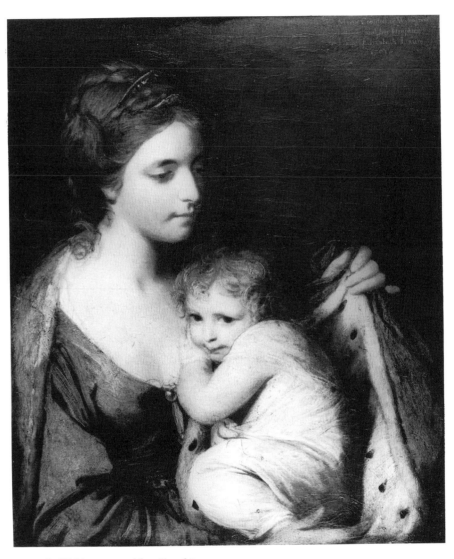

4 *Lady Waldegrave and her Daughter.*
 Oil on canvas, 76·2 × 63·5 cm. Exhibited at the Society of Artists, 1762, as
 'A lady and her child, in the character of Dido embracing Cupid'.
 Private Collection.

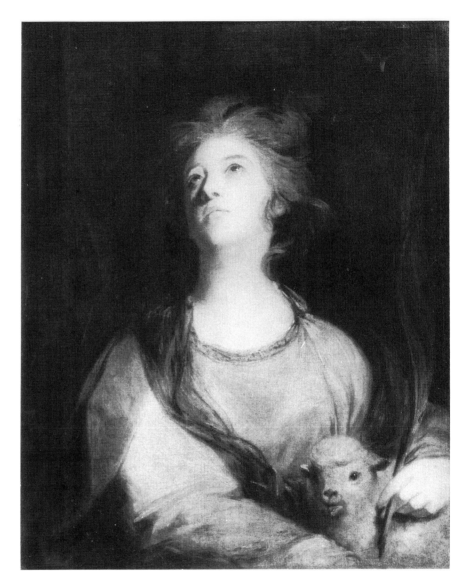

5 *Mrs Quarrington.*
 Oil on canvas, 76·2 × 63·5 cm. Exhibited at the Royal Academy, 1772, as
 'A portrait of a lady in the character of St Agnes'. Private Collection.

Portraits of this Artist', he explained: 'I do not mean for the Likeness (as I do not know who it represents) but for the great historical genius apparent in it.' Gaudenzio's comments were couched in the form of 'letters' from 'an Italian Artist in London, to his Friend an English Artist at Rome'. The writer's ignorance of the sitter's identity was doubtless feigned (especially as the sitter was well known). However, by adopting the guise of a foreign artist he evidently hoped that his comments would transcend the level of gossip, and demonstrate that the paintings were being judged purely on their merits as works of art, rather than as likenesses of private individuals.

It has been stated of Reynolds that 'while he was concerned with physiognomy as it applied to the expression of the passions, evidenced by his history paintings, this concern, appropriately, did not influence his portraiture' (Balkan, 1972, p. 73, n. 5). And yet, visual evidence shows that Reynolds, on a number of occasions, deliberately altered the expressions of portrait sitters according to accepted theories of expression. In 1772 he exhibited a 'portrait of a lady in the character of St. Agnes' – known today as *Mrs Quarrington* (plate 5). The face in this image is expressive beyond that found in standard 'historical' portraiture. The sitter's head is angled sharply upwards in the manner required by Charles Le Brun to express 'Extasy': 'the Eyes and Eyebrows...are lifted up towards heaven, where they seem fixed to discover the mysteries which the Soul cannot attain to' (see Le Brun, 1734, p. 28). Yet in an unfinished portrait of the same sitter (plate 6), though her eyes are raised, the head is far less dramatically inclined.[19] Although there is no means of knowing which of the two paintings most resembled the sitter, the unfinished work clearly describes the sitter's facial features more directly, while the exhibited version acquires an expressive air reminiscent of an ecstatic baroque saint. The existence of an unfinished portrait of Mrs Quarrington, in addition to the exhibited work, suggests that Reynolds abandoned his initial composition in order to increase the associative element in the work. A similar point was made about 'A nymph with a young Bacchus' (plate 14 below), exhibited at the Royal Academy in 1773. Of this painting, now known as *Mrs Hartley and Child*, it was noted: 'Mrs Hartley and her Child. A good likeness, and a fine attitude for an artist to show his skill, but from the foreshortening of the face, not so immediately known as she would have been if the subject had been taken in any other position' (*The Morning Chronicle*, 1 May 1773).

The need to sacrifice individual likeness for expression remained a matter of opinion among the critical public. On 28 April 1789 a

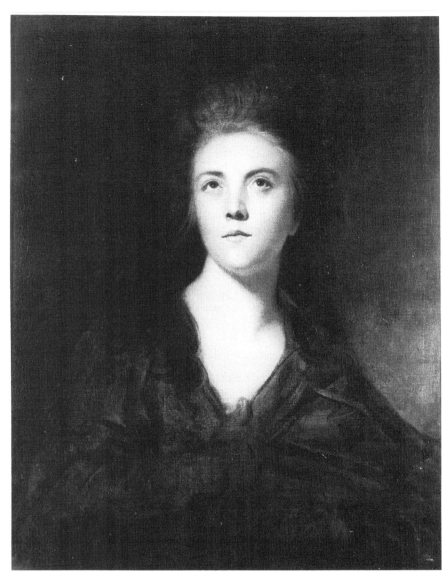

6 *Mrs Quarrington* (unfinished).
 Oil on canvas, 72·3 × 58·4 cm *c*. 1771. Private Collection.

correspondent of *The Public Advertiser* who saw Reynolds's *Mrs Billington* (Beaverbrook Art Gallery, Fredericton, New Brunswick) hanging in the artist's own gallery, commented prior to its exhibition: 'the likeness is perfect, and the figure altogether in the best style of the artist'. When Reynolds showed the portrait at the Royal Academy the following year he had evidently altered it, one critic observing that 'it appeared to more advantage when we saw it, three months since, in the President's show room' (*The Public Advertiser*, 20 April 1789). Reynolds had evidently changed the facial expression because now it was no longer considered by critics to be a good likeness: 'Of Mrs. Billington's, though a charming picture, we must say that, from the *foreshortening* of the face, it fails in point of likeness' (20 April 1790, quoted in Graves and Cronin, 1899–1901, vol. I, pp. 82–4). *The London Courant* (27–29 April), however, approved unreservedly: '[Reynolds] has seven pictures; but all except that of Mrs. Billington, are mere portraits. Fancy, however, has been admirably exerted in the delineation of this exquisite performer ... Lord Rawdon, Mr. Tompkins, &c are what Mrs Billington is not, striking likenesses.'

In 1772 – the same year that Reynolds exhibited *Mrs Quarrington* – a 'fashionable face painter' (one 'Don Tingo de Pencilino') advertised his services in *The Town and Country Magazine*: 'I have studied the necessary appearance in all situations, having proper countenances [*sic*] for the virgin, the bride, the widow; the innocent tinge for the first; the modest blush for the second; and the softness of sorrow for the third. I can express either love, anger or compassion; desire or disgust – I even have a pencil for delight' (January 1772, p. 29). The piece closely mirrors – albeit satirically – the application of theories of expression to portraiture as practised by Reynolds. Since the late 1750s Reynolds had been applying the soulful countenance found in *Mrs Quarrington* to a number of half-length female portraits including *Annetta Cage*, 1758 (Washington, Corcoran Gallery), and *Maria, Countess of Waldegrave* (plate 7) who is pictured gazing piously towards heaven in widow's weeds.[20] He continued to use this 'uplifted' expression throughout the 1770s and 1780s, where it emerges most notably in *Sophia Hope, Countess of Haddington* (private collection). It culminated in the exhibition in 1785 at the Royal Academy of a portrait of the Honourable Mrs Stanhope (private collection), which, significantly, was not exhibited as a portrait but as a subject painting, and given the title *Melancholy* in the Royal Academy catalogue. The image was not fundamentally different from any of the earlier portraits referred to above. However, circumstances – engineered largely by Reynolds – had changed.

By the mid-1770s Reynolds's position as the supreme exponent of

7 *Maria, Countess of Waldegrave.*
Oil on canvas, 127 × 101·6 cm. Exhibited at the Society of Artists, 1764.
Private Collection.

historical portraiture was virtually unchallenged. 'In the line of historical Portraits', observed *The Public Advertiser* on 28 April 1775, 'Sir Joshua seems to stand unrival'd, either by any artist of our Country, or those of Rome or Paris.' For Reynolds's principal rival, Thomas Gainsborough, the promotion of this hybrid genre had clear political as well as artistic ramifications, as he noted ironically in a letter to Lord Dartmouth of 1771. 'I shall', he stated, 'remain an ignorant fellow to the end of my days, because I never could have the patience to read Poetical impossibilities, the very food of a Painter; especially if he intends to be KNIGHTED in this land of Roast Beef, so well do serious people love froth.'[21] Implicit in Gainsborough's remarks is that Reynolds's historical portraits ('froth') attracted influential patrons ('serious people'). That paintings of this kind endowed intellectual exclusivity both on the artist and on the public is important in understanding Reynolds's desire to introduce 'poetical impossibilities' into his portraiture. Indeed, it is symptomatic of the fundamental gulf between Reynolds's attitude towards allegory and Hogarth, a generation earlier, that the latter had commented ruefully: 'I found, by mortifying experience, that whoever will succeed in this branch must adopt the mode recommended in Gay's "Fables", and make divinities of all who sit to him.'[22]

Reynolds's preference for historical portraiture rather than history painting was explained shortly after his death, in an anonymous obituary in *The General Evening Post*. It stated:

When Sir Joshua taught us how to paint, there were no historical works which called upon the painter's skill – for a true taste was wanting :- Vanity, however, was not wanting, and the desire to perpetuate the form of our self-complacency, crouded [*sic*] his sitting room with women, who would be transmitted like Angels, and men, who would be habited like Heroes – There they were sure to be contented: the apotheosis was the simple operation of the painter's mind, glowing with grandeur and grace. Unhappily therefore, history painting has not occupied his pencil.[23]

The writer suggests that Reynolds, irrespective of his own inclinations as a history painter, was subject to the vagaries of current taste, and the public's preference for portraiture. After his death, it became the norm for Reynolds's apologists to argue that, given the right circumstances, he would have painted more genuine history paintings and fewer historical portraits – a view even endorsed by James Barry (see Fryer, 1809, vol. II, p. 553). Samuel Johnson, writing in 1759, was better placed to comment on Reynolds's attitude towards historical portraiture. For even though he affected an indifference to Reynolds's paintings, he was – as Morris

Brownell has shown – acutely aware of Reynolds's aims both as artist and writer (see Brownell, 1989, pp. 37–45). According to Johnson – whose sentiments were similar to those of Hogarth – Reynolds ought not to stray from the true purpose of portraiture in an effort, as he put it, to 'transfer to heroes and to goddesses, to empty splendour and to airy fiction, that art which is now employed in diffusing friendship, and renewing tenderness, in quickening the affections of the absent, and continuing the presence of the dead' (*The Idler*, no. 45, 1759).[24] That he continued to 'transmit' women as angels until his death indicates that to Reynolds 'airy fiction' was a higher form of art than 'mere' portraiture. The real challenge which Reynolds faced in the early 1760s was not a lack of demand for history painting (Reynolds was a pragmatist and did not expect any sudden upsurge in British patronage of high art) but a means of maximizing the fictive and iconic element of his portraits in order to play down their function as likenesses. He channelled these energies into a series of large-scale female portraits exhibited at the Society of Artists between 1760 and 1768.

The different public roles which men and women were expected to play in the eighteenth century conditioned the ways in which they were portrayed by artists, and the female portrait, unlike its male counterpart, maintained a highly decorative function, as Reynolds's *Mrs Hale as 'Euphrosyne'* (plate 8) – exhibited in 1766 at the Society of Artists – demonstrates (see Mannings in Penny, 1986, cat. 61, pp. 228–9). It served a variety of interests, few of which pertained directly to the sitter's own personality. The painting, evidently derived formally from Raphael's *St Margaret*, was not commissioned by the sitter, nor was it intended to hang in her home;[25] rather, it was executed for her brother-in-law's elder cousin, Edwin Lascelles, who wanted it to decorate the music room at Harewood House, where it still belongs today.[26] Unlike the portrait of *The Duchess of Hamilton and Argyll* (plate 2) discussed earlier – where symbols, such as paired doves or a relief-sculpture, alluded to the correspondences between the sitter and the goddess Venus – Mary Hale, through her lively attitude and animated expression, forms an empathy with her assumed persona, fulfilling a role far closer to that of artist's model than portrait sitter. Also, by the inclusion of a number of subsidiary figures (some of whom are deliberately cut off by the edge of the canvas) the idea is maintained that the composition is part of a larger drama – quite literally a slice of history painting.

Mrs Hale was one of a number of works painted by Reynolds in the 1760s and early 1770s which served as chimney-pieces or as decorative

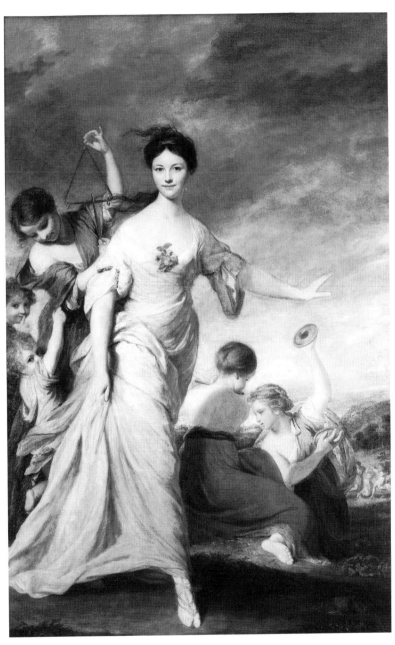

8 *Mrs Hale as 'Euphrosyne'*.
Oil on canvas, 236 × 146 cm. Exhibited at the Society of Artists,
1766, as 'A lady; whole length'. The Earl of Harewood, Harewood House.

panels. Exclusive compositions of this kind, painted on made-to-measure canvases for fashionable clientele, gave Reynolds prominent (and permanent) 'exhibition space' in some of the grandest homes in the country.[27] In 1775 Watkin Williams Wynn commissioned a number of figurative panels for the music room of his London home, which had recently been redesigned by Robert Adam. They included *Orpheus Lamenting the Loss of Eurydice* by Nathaniel Dance and *St Cecilia* by Reynolds (colour plate 2). The dominant colours in both pictures were green and maroon, and were designed to complement the colour scheme devised by Adam for the music room.[28] *St Cecilia* was probably completed around April 1774 as Reynolds at one point evidently intended to show it at that year's Royal Academy exhibition.[29] Although doubt has been expressed about the identification, the model for *St Cecilia* was almost certainly Mrs Richard Brinsley Sheridan (*née* Elizabeth Linley). Mrs Sheridan also sat to Reynolds at around the same time for a similar portrait, which was shown at the Royal Academy in 1775 as 'A lady in the character of St Caecilia' (National Trust, Waddesdon Manor). However, it was almost certainly Watkin Williams Wynn's *St Cecilia* which Fanny Burney saw on a visit to Reynolds's studio in February 1775: 'what delighted me was the beautiful Mrs. Sheridan, who is taken seated at a harp, a whole figure in the character of Saint Cecilia; a denomination she greatly merits. My father is to supply Sir Joshua with some Greek Music, to place before her' (in Ellis, 1889, vol. II, p. 10.)[30] By painting a decorative panel for Williams Wynn and a portrait of Mrs Sheridan using the same model, Reynolds was effectively using the same method to paint portraits and works which were ostensibly commissioned as subject pictures.[31] Before her marriage to Richard Brinsley Sheridan in April 1773, Elizabeth Linley (by then known under the sobriquet of 'Cecilia') was considered to have had one of the finest voices in England. It was evidently her fame as much as her voice or her beauty which attracted Reynolds. (Although, as he remarked acidly when she failed to perform at his home: 'what reason could they think I had to invite them to dinner, unless it was to hear her sing, for she cannot talk?'[32]) One of the most important factors which unites those individuals who doubled as models in Reynolds's subject pictures was their notability. It was through theatrical personalities, in particular, that Reynolds exploited the cult of personality and made the greatest inroads into allying his portrait practice to high art.

In 1762 Reynolds exhibited *Garrick between Tragedy and Comedy* (colour plate 3) at the Society of Artists. It ranks among Reynolds's finest achievements – not least because of the multiplicity of levels on which it

functions. At its most basic it is a celebration of the talents of David Garrick as both tragic and comic actor. On another level, however, it demonstrates Reynolds's familiarity with art theory; the figures of Comedy and Tragedy representing respectively the two contending traditions in post-Renaissance art of colour and line.[33] The picture also reveals, through a comic allusion to the ancient theme of the Choice of Hercules, Reynolds's wish to demonstrate to the public the need for the artist to rise to the plane of the poet through the powers of the intellect and the imagination. More difficult for a modern audience to countenance is the claim, firmly established by the early nineteenth century, that the picture was 'Reynolds's first attempt in historical composition'.[34]

In 1930 Erwin Panofsky, in a seminal study of the various pictorial interpretations of the 'Choice of Hercules' from the Middle Ages onwards, acknowledged a possible compositional debt on the part of Reynolds to Gérard de Lairesse's *Judgement of Hercules* (Louvre). More recently David Mannings has pointed to two separate works as the putative sources for Reynolds's masterpiece: the National Gallery's *Triumph of Silenus*, from the studio of Rubens, and (in common with Werner Busch) Guido Reni's *Lot and his Daughters* – also now in the National Gallery.[35] Mannings has contended that too much emphasis has been placed, in explaining Reynolds's composition, on visual associations with the 'Choice of Hercules' and instead offers a close formal analysis of the above paintings in relation to *Garrick between Tragedy and Comedy*, in order to demonstrate Reynolds's originality and inventiveness in recasting two discrete sources in a fresh setting (Mannings, 1984, pp. 262–3, 272–80). An understanding of Reynolds's pictorial method can be gained through the identification of visual 'borrowings', and yet the textual source could also be of fundamental importance to the artist. In the present instance Reynolds relied on Lord Shaftesbury's seminal three-volume tome, *Characteristicks of Men, Manners, Opinions, Times*, as well as an episode from one of Ovid's *Amores*. Indeed, it is only when Reynolds's picture is viewed as a visual parallel to, and commentary on, Shaftesbury's ideas that the suitability of one of the principal (and hitherto unidentified) visual sources for the painting, William Dobson's *Self-portrait with Nicholas Lanier (?) and Sir Charles Cotterell* (plate 9) – can be fully understood.

The third volume of Shaftesbury's *Characteristicks* includes an essay entitled 'A notion of the historical draught or tablature of the Judgement of Hercules' (see Wind, 1986, p. 23 and note; Shaftesbury, 1714, vol. III, pp. 345–91). Here Shaftesbury sets out a series of rules governing the manner in which the artist should approach high art, using as his model

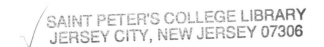
SAINT PETER'S COLLEGE LIBRARY
JERSEY CITY, NEW JERSEY 07306

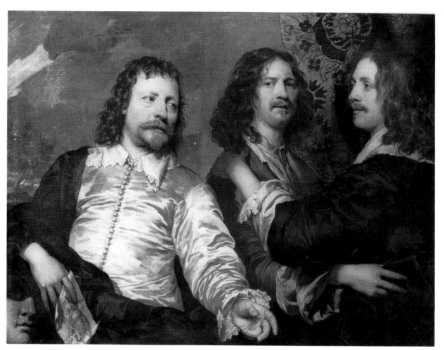

9 William Dobson, *Self-portrait with (?) Nicholas Lanier and Sir Charles Cotterell*.
Oil on canvas, 99 × 127 cm. c. 1646. The Duke of Northumberland.

an established subject in western art, Prodicus's classical narrative of Hercules's choice at the crossroads between Virtue and Pleasure. While Shaftesbury's essay has been noted in relation to *Garrick*, doubt has been cast on its relevance to Reynolds's painting.[36] Yet in view of the seminal role of Shaftesbury's text in the aesthetic education of the English gentleman, and the embryonic role it played in the formation of Reynolds's own taste, a direct correlation between the strictures set down by Shaftesbury and the iconography of *Garrick between Tragedy and Comedy* comes as no surprise.

In the essay in question Shaftesbury observes that the artist, in devising a 'tablature' or composition of the Choice of Hercules, should seize on a particular moment within the narrative in order to establish a 'Unity of Time'. This emphasis on the relation of the painter's art to the laws of dramatic unity lends significance to Reynolds's choice of the actor David Garrick as his own protagonist. In addition the emphasis on the importance of the 'Unity of Time' anticipates Reynolds's own thoughts on the subject: 'What is done by Painting', he noted in his eighth *Discourse*,

'must be done at one blow.' Shaftesbury proceeds to divide the narrative into '*four* successive Dates or Points of Time', any of which, he says, might be chosen by the artist. They are: 'Either in the instant when the two Goddesses, VIRTUE and PLEASURE, accost HERCULES; Or when they are enter'd on their Dispute; Or when their Dispute is already far advanc'd, and VIRTUE seems to gain her Cause.' The fourth moment, 'when HERCULES is entirely won by VIRTUE', is rejected as being unsuitable to the purposes of the artist – although it is permissible to the poet (Shaftesbury, 1714, vol. III, pp. 350–2). Of the three 'Points of Time' deemed suitable to the artist, Shaftesbury favours the third – 'when their Dispute is already far advanced, and VIRTUE seems to gain her Cause' – as the most appropriate for the artist who wishes to 'express the grand Event' and represent 'the decision or Judgement of HERCULES'. This is also the moment depicted by Reynolds, although in the nature of parody 'Vice' – embodied by the figure of Comedy – is about to win the dispute.[37]

In the course of his essay Shaftesbury lays down a further series of guidelines for the artist, the more important of which are worth noting as they serve to show how central the model of the Judgement of Hercules was to Reynolds's purposes. First, Shaftesbury establishes the exact moment to be depicted: 'PLEASURE has spoken. VIRTUE is still speaking. She is about the middle, or towards the end of her Discourse; in the place where, according to just Rhetorick, the highest Tone of Voice and strongest Action are employ'd' (*ibid.*, pp. 352–3). Reynolds also chooses this very moment. Secondly, in order to suggest that Hercules has, even at this moment of indecision, already decided in favour of Virtue, Shaftesbury emphasizes the importance of the hero's facial expression: 'the Mind on a sudden turning it-self some new way, the nearer situated and more sprightly parts of the Body (such as the Eyes, and Muscles about the Mouth and Forehead) taking the alarm, and moving in an instant, may leave the heavier and more distant Parts to adjust themselves, and change their Attitude some moments after' (*ibid.*, p. 356). Hence Garrick's exaggerated *contrapposto* and his backward glance towards Tragedy, as he turns towards Comedy. Indeed, the attitude of Garrick closely echoes Shaftesbury's instruction that Hercules may look towards Virtue, yet with his body 'inclining still towards *Pleasure*' (*ibid.*, p. 360). The attitudes of the two attendant figures in Reynolds's picture – Tragedy and Comedy – also reflect Shaftesbury's advice. Virtue, states Shaftesbury, ought to be soberly dressed, and represented 'as she is seen on Medals'. Reynolds's figure of Tragedy, standing in profile, recalls the figure of Virtue in the most authoritative text then available on medals – Joseph Addison's *Dialogue*

upon the Usefulness of Ancient Medals.[38] Although Virtue is allowed the benefit of oration, Pleasure, according to Shaftesbury, 'can have no other language allow'd her than that merely of *the Eyes*', a detail which again corresponds to Reynolds's own interpretation (*ibid.*, p. 369).

It is Shaftesbury's advice on colour, however, which accords most with Reynolds's composition. In his original narrative Prodicus specified that Virtue wore 'a resplendant Robe of the purest and most glossy White'. Although white is legitimate for the poet, Shaftesbury advises that artist to choose 'still quiet Colours, as may give the whole Piece a Character of Solemnity and Simplicity, agreeable with it-self' (*ibid.*, p. 375).[39] This accounts for the sombre dark blue selected by Reynolds for Tragedy's garment. Similarly, Shaftesbury notes that because Hercules wears only a 'Lion's Skin, which is it-self of a yellow and dusky colour; it wou'd be really impracticable for a Painter to represent this principal Figure in any extraordinary brightness or lustre' (*ibid.*, p. 369). In Reynolds's picture Hercules's 'yellow and dusky' pelt is appropriately transformed into a buff-coloured Van Dyck costume – an otherwise improbable choice of colour either for such an exotic garment or for an eighteenth-century actor.

Having enumerated the various similarities between Shaftesbury's text and Reynolds's picture there are significant differences between the two accounts. Hercules shows consternation; Garrick is amused. Again, Shaftesbury states that it is 'absolutely requisite that *Silence* shou'd be distinctly characteris'd in HERCULES' for the 'Image of *the Sublime* in the Discourse and Manner of Virtue, wou'd be utterly lost, if in the instant that she employ'd the greatest Force of Action, she shou'd appear to be interrrupted by the ill-tim'd Speech, Reply, or Utterance of her Auditor' (*ibid.*, p. 361). And yet Garrick grins broadly at the climax of Tragedy's speech, not only interrupting the flow of her rhetoric, but undermining Shaftesbury's edict. Reynolds does not, through departing from Shaftesbury's prose guide, demonstrate a lack of attention to the text. Rather, he deliberately contradicts the text in order to heighten the impact of his parodic conceit. After all, the figure in the centre does not show Hercules but Garrick. Indeed, in showing Garrick complying with the desires of Comedy, Reynolds may well have been tacitly acknowledging current popular opinion, for as *The Theatrical Review* of 1763 noted: 'Though Mr. Garrick's merit in Tragedy is very apparent; we are nevertheless inclined to think Comedy his more particular fort'.[40]

Shaftesbury's version of the 'Choice of Hercules' would be among the best known to Garrick, whose initial idea it was, according to Horace Walpole, to relate his own portrait to the 'Choice of Hercules'.[41] (As the

sale catalogue of his library reveals, Garrick owned a copy of Shaftesbury's *Characteristicks* as well as a French seventeenth-century translation of Xenophon's *Memorabilia*, in which Prodicus's story appears.[42]) Given Garrick's formative role in the creation of Reynolds's painting, one other putative literary source must be examined: the first poem in the third book of Ovid's *Amores* (see Kenney, 1991, p. 66).

Ovid, upon entering a sacred grove, is assailed by the Muses of 'Elegy' and 'Tragedy', who in turn compete for his favours. Tragedy makes the first move:

> ... a stormy presence,
> cowling her mantle trailing on the ground,
> Her left hand brandishing a royal sceptre – (*ibid.*)

'Elegy' then makes her own bid. E. J. Kenney, who has noted the aptness of the sylvan setting in Reynolds's picture, explains: 'Elegy, in contrast to Tragedy, wears a "gauzy dress" (*vestis tenuissima*), like Comedy's off-the-shoulder number in the picture; and as she addresses the poet she smiles "slyly" (*linis subrisit ocellis*), an accurate verbalization of Comedy's expression in the painting (*ibid.*) Ovid's story was, as Reynolds and Garrick must have been aware, a deliberate parody of the 'Choice of Hercules'. And as Kenney perceptively observes, 'Garrick's pose, pulled away by Comedy and physically closer to her than to Tragedy, and his deprecating smile, exactly reflect Ovid's position at the end of his poem:

> "Please, Tragedy, allow your bard a breather.
> You are eternal toil, her wants are short."
> She gave me leave. Quick, Loves, while I've the
> leisure!
> A greater work is waiting to be wrought.'

This is the same outcome as that implied by the position of the figures in Reynolds: 'Ovid (Garrick) leaves the scene arm in arm with Elegy (Comedy), promising Tragedy that he will not be gone for long' (*ibid.*). If, as Walpole states, Garrick was the instigator of Reynolds's painting it is tempting to see how Reynolds, by painting a work grounded upon texts by Shaftesbury and Ovid, could promote his own varied artistic ambitions while at the same time adverting to Garrick's duality as an actor.

Shaftesbury and Ovid were the principal literary sources employed by Reynolds, but there may have been others. Reynolds could, for example, have consulted either the French translation of Prodicus or the English version of 1712 (see Bysche, 1712). He may also have been familiar with the verse translation of the story by Robert Lowth (1710–87) which

10 *Terpischore* ('*Euphrosyne*').
 Oil on canvas, $127 \times 101 \cdot 6$ cm. *c*. 1761–2. Private Collection.

appeared in Joseph Spence's widely read *Polymetis* of 1747 – a copy of which Reynolds owned.[43] A third possible source was William Shenstone's poem the 'Judgement of Hercules' of 1741 (the only poem of his for which Samuel Johnson, interestingly, expressed an unreserved admiration.[44]) Shaftesbury's essay, rather than Prodicus's original story, was Shenstone's inspiration. Indeed several editions of Shenstone's poem incorporated reproductions of Paolo de Mattheis's *Choice of Hercules* (Oxford, Ashmolean Museum), the painting commissioned by Shaftesbury to illustrate his ideas (see Brett, 1951, p. 190). Finally, there is one curious detail shared by Reynolds's painting and Shenstone's poem. While Reynolds's 'Comedy' wears a plait interwoven with jewels in her hair, Shenstone had written of the equivalent figure in his poem:

> Her plaited Hair disguis'd with *Brilliants* glar'd;
> Her Cheeks the *Ruby's* neighb'ring Lustre shar'd. (1741, p. 10)[45]

In terms of visual influences for *Garrick between Tragedy and Comedy*, one convincing pictorial source which has not hitherto been considered is William Dobson's *Self-portrait with Nicholas Lanier and Sir Charles Cotterell* (plate 9).[46] The painting forms a plausible pictorial precedent not only in the light of Reynolds's known method of pictorial composition but because of its common theme of mock-heroism. There are several formal similarities between the two pictures. The figure to the extreme left of Dobson's painting (thought to be Nicholas Lanier) provides a most convincing model for Garrick; the *contrapposto* of the figure, the gesture of the left arm and the Van Dyck costume are all adapted to Reynolds's figure.[47] Similarly, the figure of Sir Charles Cotterell, in profile at the extreme right of Dobson's picture, takes up the same position as Reynolds's figure of 'Tragedy'.

Dobson's work does not account for Reynolds's figure of 'Comedy', although it does help to explain the existence of two separate paintings of this figure, as well as a related life-drawing. In both oil paintings 'Comedy' holds up a small pair of cymbals, the slighter, unfinished, oil sketch (National Art Museum, Stockholm), where the arms of the figure are held close to the body, perhaps being Reynolds's first idea for this figure, and the completed oil – known as *Terpsichore* – (plate 10) where the arms are disposed in the same manner as the figure in *Garrick between Tragedy and Comedy*, a later attempt. Both designs are related to a life-drawing of a seated female nude – attributed to Reynolds – in an album in the Royal Academy (plate 11). All three designs suggest, moreover, that 'Comedy' was originally conceived independently of the finished picture

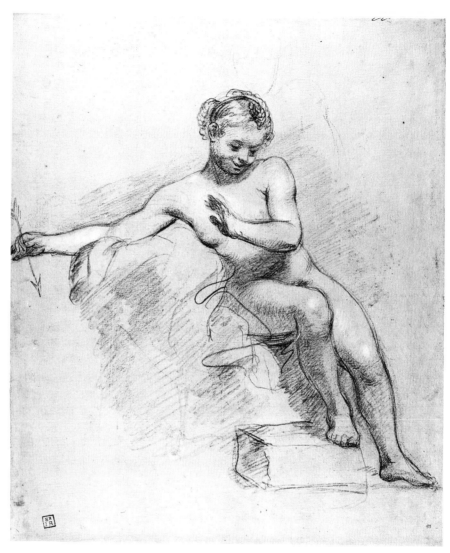

11 Attributed to Sir Joshua Reynolds, *Seated Female Figure Holding an Arrow*.
Chalk on paper, 39 × 31·5 cm. Private Collection (on loan to the Royal
Academy of Arts, London).

(although the suggestion that she was modelled on one of Reynolds's nieces does not stand up to examination[48]).

In addition to the suggestive formal similarities between the compositions of Reynolds and Dobson, there is considerable circumstantial evidence to suggest that Reynolds was well acquainted with Dobson's painting, which was then located in Northumberland House, less than a quarter of a mile away from Reynolds's studio in Leicester Fields.[49] The picture's owner was Hugh Smithson, Earl of Northumberland (1715–86), patron of Canaletto and Robert Adam, Fellow of the Royal Society and a Trustee of the newly established British Museum. The Earl and Countess of Northumberland, who sat to Reynolds for their portaits in the late 1750s and early 1760s, frequently opened their home to visitors.[50] In any case, Dobson's picture was much admired in the eighteenth century, George Vertue (1684–1756), the engraver and antiquarian, noting this 'celebrated picture of Dobson's painting' on a number of occasions when it was in the possession of the sixth Duke of Somerset – who in turn had bought it at the posthumous sale of the actor, Thomas Betterton (Vertue, 1935–6, p. 186; see also pp. 45 and 152). It featured also in Horace Walpole's *Anecdotes of Painting* of 1762 and in *The English Connoisseur* – a guide for aspiring connoisseurs published in 1766.[51] Dobson's picture was admired not least because of its obvious affinity with Van Dyck, the figure of Lanier having been borrowed by Dobson from a Wenceslaus Hollar print after Van Dyck's *Lucas and Cornelius de Wael* (see Rogers, 1983, p. 89). The composition may also have related to yet another work by Van Dyck, *George Gage (?), with two Attendants* (National Gallery, London). The similarity in particular between Garrick's facial expression and that of Gage suggests a direct influence.[52] The owner of *George Gage* in the second half of the eighteenth century – although it is not known exactly when he first acquired it – was Joshua Reynolds (Broun, 1987, vol. II, pp. 97–100).

The clearest link between *Garrick between Tragedy and Comedy* and Dobson's picture remains the common subject they share – a mock-heroic version of the 'Choice of Hercules'. If, as Malcolm Rogers has pointed out, the figure to the left is Lanier, then Dobson deliberately depicted himself 'between one of the greatest connoisseurs of an earlier generation and the most youthful of his patrons' (*ibid.*). Cotterell shields the artist from Lanier who, adds Rogers, 'in his flashy tunic would represent Pleasure, turning with seeming casualness to Dobson but gesturing persuasively' (*ibid.*).[53] It is quite possible that Lanier – if it is he represented in Dobson's picture – suggested the theme of the picture to the artist. Not only did Lanier have a thorough grounding in the traditions and iconography of western art,

but he must also have been familiar with Ben Jonson's satirical version of the 'Choice of Hercules' in the masque, *Pleasure Reconciled to Virtue* (1618) (see Orgel and Strong, 1973, vol. I, pp. 277–93). Clearly the 'Choice of Hercules' could offer the basis in the seventeenth century for a mock-heroic response to a classical theme, and one can only assume in the light of his evident 'borrowing' from Dobson's picture that Reynolds must also have recognized this possibility. Finally, there is one particular sense in which Reynolds's portrait of Garrick shares a similar ethos with Dobson's *Self-portrait*, for, just as Dobson identified himself with the Herculean character at the centre of his picture, so Garrick takes on the same role in Reynolds's painting. It was, moreover, a long-established convention of painting that Hercules often took the form of a contemporary portrait.[54]

The proposition that Reynolds, in evolving the composition of *Garrick between Tragedy and Comedy*, had united a range of discrete visual and literary conceptions, accords with the eclectic approach he adopted in his own later subject paintings. In *Ugolino and his Children in the Dungeon* (to be discussed fully in chapter 3), the artist, in joining together two separate pieces of canvas to form his composition, quite literally yoked together distinct motifs from Michelangelo and Carracci. In *Ugolino* Reynolds depicted an episode taken from Dante's *Inferno*, which had been recommended to the particular attention of artists by Jonathan Richardson. In *Garrick* he also illustrated an established narrative, interpreted for the benefit of the artist by Shaftesbury. Richardson and Shaftesbury – the twin pillars of British art theory – stressed the ties which united poetry and painting as branches of the Liberal Arts. Shaftesbury also upheld the superiority, in artistic terms, of poetic above historical truth – tenets which were to be endorsed from 1769 onwards in Reynolds's *Discourses*.[55]

Reynolds's painting of Garrick was exhibited at the Society of Artists in 1762 as 'Mr. Garrick, between the two muses of tragedy and comedy'. Shortly afterwards prints after the picture appeared in England and on the Continent. The English mezzotint, by Edward Fisher, bore the inscription 'Reddere personae scit convenientia cuique' ('he knows how to give to each what is appropriate'). An inferior pirated version of the same print was published in France and called simply 'L'Homme entre le Vice et la Vertu', thus diminishing the subtle chain of meaning established by Reynolds.[56]

Opinion was divided in England as to whether *Garrick between Tragedy and Comedy* demonstrated Reynolds's burgeoning gifts as a subject painter. In 1767 a 'Pindarick Ode on Painting, addressed to Sir Joshua Reynolds esq.', argued the case in the following way:

Verse 6

And if such meaning can be thrown
Into the single form alone –
With what fresh rapture should we gaze,
How would thy kindling genius blaze,
To what superior heights aspire,
If working on some grand design,
Where various characters combine
To call forth all its force, and rouse thy native fire!

Verse 7

And that thy hand can equally excell
E'en in this noble part,
This shining branch of thy expressive art,
To its own happy labour we appeal,
To that rich piece whose pleasing fiction
And splendid tints, with full conviction,

Strike the spectator while he views
Thalia and the Tragic Muse,
Each eager on her side to engage
The unrival'd Roscius of the British stage.[57]

Similarly, on the first night of a performance of Richard Cumberland's play
The Brothers at Covent Garden in 1770 – at which Garrick was present –
Mrs Yates declaimed in the Epilogue:

WHO has but seen the celebrated Strife,
Where *Reynolds* calls the Canvass into Life;
And, 'twixt the Tragic, and the Comic Muse,
Courted of both, and dubious where to chuse,
Th'immortal Actor stands? – Here we espy
An awful Figure pointing to the Sky;
A grave, sublime, commanding Form she bears,
And in her Zone an unsheath'd Dagger wears.
On t'other Side, with sweet attractive Mien,
The playful Muse of Comedy is seen:
She, with a thousand, soft, bewitching Smiles,
Mistress of Love, his yielding Heart beguiles.[58]

A correspondent of *The London Museum* responded crossly:

Sir, Upon hearing the bold and high mettled Prologue to the Comedy of Brothers,
I flattered myself that we had, at length, found out one writer, who relying upon
nature and himself, had set all the petty states of criticism at defiance; but the
Epilogue, which opens with that fulsome compliment to you, drawn from the

painting of Reynolds, and ending with the *immortal actor stands* – soon dashed all my hopes, and brought a very mortifying dissappointment [*sic*]. (January 1770, p. 43)

Reynolds and Garrick shared a number of personal characteristics: both craved public acclaim; both knew how to harness the vagaries of taste to suit their own interests; and both were accused of promoting their own careers above their respective art forms. And just as theatre critics voiced their objections to the promotion of the individual actor over and above broader dramatic concerns, so writers on art objected to the incorporation of popular actors as models in history paintings – even if they were unsure where to lay the blame. In 1781, for example, *The St. James's Chronicle* of 1–3 May, in discussing William Hamilton's portrait of Kemble as Richard III, stated that 'it is not the Fault of the Artists but of the Times, that their highest Efforts are directed to mimic virtues and Theatrical Performers'.

Unlike William Hamilton (*c*. 1750/1–1801) or Johan Zoffany (1733–1810), who painted faithful reproductions of theatrical personalities performing celebrated stage roles, Reynolds preferred to take a less subsidiary role *vis-à-vis* the performing arts. Even when he portrayed actors and actresses in their own favourite parts – such as Mrs Abington as Miss Prue in Congreve's *Love for Love*, or as Comedy in Garrick's *Jubilee*, or indeed Garrick himself as Kitely from Ben Jonson's *Every Man in his Humour* – Reynolds ensured that their performance did not eclipse his own.[59] Even so, he remained unwilling even in the 1770s to refer directly to the text rather than the more familiar performed versions of the plays. In this respect he was less innovative than James Barry who, like Hogarth earlier in the century, deliberately eschewed contemporary theatrical traditions, and instead followed Shakespeare's text, thus attempting to transform it into a fitting subject for high art.[60] The critic of *The Morning Chronicle* (26 April 1774) may well have been thinking of Reynolds as much as Zoffany when he praised Barry's *King Lear Weeping over the Body of Cordelia* (plate 63 below) of 1774:

A painter of less original genius than Mr. Barry would have made Mr. Garrick his model for *Lear* and by that method would have played up to the imagination of the public, by making them umpires how far he had succeeded in the likeness or not; but Mr. Barry, knowing the arcana of his profession, classically considered Shakespeare as the poet of nature, who drew his characters without intending them for particular individuals.

King Lear Weeping over the Body of Cordelia was exhibited at the Royal Academy in 1774. In the same exhibition Reynolds showed an historical

portrait of *Mrs Tollemache as Miranda* (plate 12), from Shakespeare's *The Tempest*. Contemporaries were aware that the two paintings represented diametrically opposed methods of visualising Shakespeare. Of Barry's *Lear* *The Evening Post* wrote:

> Art, jealous of Shakespeare, commenc'd a detractor,
> And long drew his heroes from each *fav'rite* actor;
> But dreading posterity thus would her scan,
> 'We all know the bard – pray who is the *man?*'
> She turn'd a reformist, bid Barry to shew it,
> The artist obey'd, and drew from the *poet*.[61]

In order to counter such claims *The Public Advertiser* championed Reynolds's painting of Mrs Tollemache a few days later – also in verse:

> Miranda's Picture when old *Shakespeare* drew,
> A beauteous Model he proposed to view,
> Whate'er could charm the reason or the Heart,
> His Pen, creative, did at once impart,
> Th'ideal Fair, through each succesive Age,
> Pleas'd all the World, but grac'd, alone, the Stage,
> Successive Years, in real Life, went round;
> In real Life was no *Miranda* found.
> Nature, to justify her Pupil's Cause,
> Submissive ever to her nicest Laws,
> At length has realised his sweet Design,
> And bids her *Reynolds* mark each Feature *Thine!*[62]

In 1776 Barry exhibited an historical portrait of Burke and himself as Ulysses and a Companion fleeing from the Cave of Polyphemus (Cork, Crawford Municipal Art Gallery). Here, as William Pressly has noted, 'unlike Reynolds's celebrated attempts at historical portraiture, Barry insists on distinguishing between the two genres' (1983, cat. 20, p. 71). (Shortly afterwards he did, however, cast himself in the role of the Greek artist Timanthes in his painting, *Crowning the Victors at Olympia* at the Society of Arts (Pressly, 1981, pp. 98–110).)

Reynolds's willingness to blend portraiture with history painting stemmed, according to Lawrence Lipking, from the artist's belief in a fixed 'standard of taste'. Lipking states: 'The habit of thinking in terms of hierarchies lent him a subtle command over the technique of pitting one rank or class against another. In their hybrids and class-consciousness, Reynolds' paintings experiment with a great chain of becoming' (1970, p. 201). This is a good explanation of the link between Reynolds's critical method and his ambiguous attitude towards genres, as a practising artist.

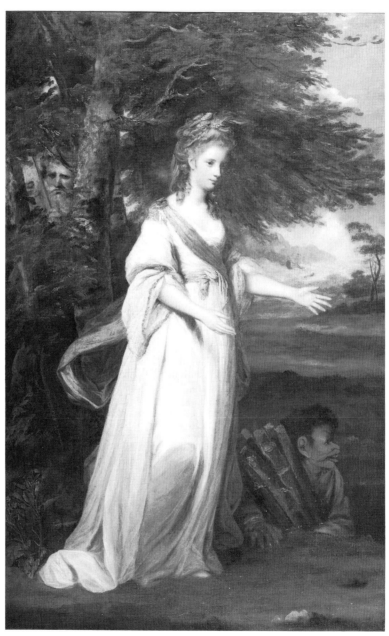

12 *Mrs Tollemache as Miranda.*
 Oil on canvas, 241·1 × 147·4 cm. Exhibited at the Royal Academy,
 1774, as 'Portrait of a lady in the character of Miranda, in the Tempest;
 whole length'. The Iveagh Bequest, Kenwood (English Heritage).

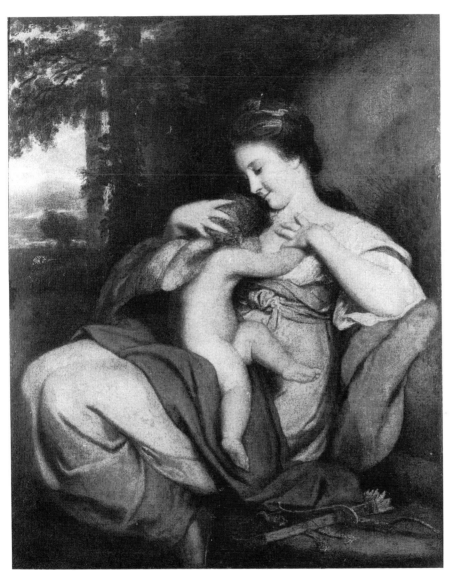

13 *Hope Nursing Love.*
 Oil on canvas, 124·5 × 100·4 cm. Exhibited at the Royal Academy, 1769.
 The Earl of Shelburne.

One can, however, adopt another approach, which relates far more directly to the vagaries of the eighteenth-century art-market. 'Whoever would reform a nation', Reynolds stated in his seventh *Discourse*, 'supposing a bad taste to prevail in it, will not accomplish his purpose by going directly against the stream of their prejudices. Men's minds must be prepared to receive what is new to them. Reformation is a work of time. A national taste, however wrong it may be, cannot be totally changed at once' (in Wark, 1975, pp. 140–1). Unlike Barry, it was not Reynolds's intention to effect a radical 'revolution' in history painting. Instead, he proposed a compromise which could at once satisfy 'national taste' and the demands of subject painting. In this sense Reynolds's system of checks and balances, which Lipking relates to the hermetic world of art theory and practice, takes on an added dimension within the context of popular and purist attitudes towards the function of subject painting in late eighteenth-century England.

So far this chapter has concentrated on works which, although portraits, were perceived at various times and by various individuals as subject paintings. What of those works which, although they were shown in public as subject paintings, are considered today as portraits? *Hope Nursing Love* (plate 13) was exhibited at the first Royal Academy exhibition in 1769, and *A Nymph with a Young Bacchus* (plate 14), was exhibited in 1773. The titles of both paintings, taken here from the Royal Academy catalogue, indicate that they were exhibited as subject pictures. *Hope Nursing Love* is, however, now generally referred to as 'Miss Morris as Hope Nursing Love' while a *A Nymph with a Young Bacchus* was – even by the time it was exhibited – referred to as a portrait of Mrs Hartley and her child. While it might appear insignificant whether these pictures are, within our own frame of reference, 'portraits-in-character' or subject pictures, the ambiguity which surrounded them reveals the degree to which Reynolds's aims were conditioned by the response of his audience and shifts in contemporary taste in matters beyond the immediate sphere of art.

In appending titles to his paintings in exhibition catalogues Reynolds distinguished between his portraits and those works which were intended to be viewed as subject paintings, not simply for the sake of propriety, but in order to condition the viewer's response. Commissioned portraits were invariably exhibited as such; *Mrs Hale as 'Euphrosyne'* was exhibited in 1766 as 'A lady; whole length', *Lady Waldegrave and her Daughter* was exhibited in 1762 as 'A lady and her child, in the character of Dido embracing Cupid', while the *Duchess of Manchester and her Son* (National Trust, Wimpole Hall), shown at the Royal Academy in 1769, was entitled

14 *Mrs Hartley and Child.*
Oil on canvas, 76·2 × 63·5 cm. Exhibited at the Royal Academy, 1773, as
'A nymph with a young Bacchus'. The Trustees of the Tate Gallery, London.

'A portrait of a lady and her son, whole lengths, in the character of Diana, disarming love'. On the surface there is little to choose between the above pictures and *Hope Nursing Love* and *A Nymph with a Young Bacchus*, for they could all be described as 'historical portraits'. *Hope Nursing Love* and *A Nymph with a Young Bacchus* were not commissioned portraits, but speculative ventures. Moreover, Mrs Hartley was not, according to eighteenth-century definition, a 'lady' but a professional actress. Miss Morris – a 'lady' whose family objected to her intention to become an actress – first sat to Reynolds in the late summer of 1766 (although it is not certain whether these sittings were related to *Hope Nursing Love*).[63] Shortly afterwards she was discovered by the producer, George Colman, who encouraged her to try her hand as a professional actress – despite pressure from friends and relations.[64] It was perhaps Colman (a friend of Reynolds and from 1773 onwards a member of the 'Club'), who introduced Miss Morris to Reynolds. Miss Morris made her stage debut on 28 November 1768.[65] On 3 December 1768, after only a few performances as the eponymous heroine of Shakespeare's *Romeo and Juliet* at Drury Lane she collapsed. In January 1769 Miss Morris sat once more to Reynolds.[66] These sittings probably relate to *Hope Nursing Love*. According to Horace Walpole, the attitude of Miss Morris was adapted from Correggio's *Leda* – although the head is reminiscent of Correggio's *Danae* (Borghese Gallery, Rome). In addition, the attitude of the figure recalls Michelangelo's *Leda*, a version of which Reynolds had purchased from Lord Spencer.[67] The *Leda* had been sold to Reynolds by Lord Spencer, apparently, because the subject was too *risqué* for display in the family home. Significantly, the intimate character of *Hope Nursing Love*, a seated woman suckling an *amorino*, lay beyond the usual boundaries of historical portraiture – especially as the sitter was not married and had no child of her own. (The picture is, however, reminiscent of a painting which has been identified with the 'Venus' which Reynolds is believed to have executed in 1759 (see Prochno, 1990a, pp. 170–1). Barely a week after *Hope Nursing Love* was exhibited at the Royal Academy Miss Morris died.[68] The picture remained unsold in Reynolds's studio. A mezzotint was, however, made from the work by Edward Fisher in 1771. Like the painting it was entitled *Hope Nursing Love*. As the sitter was now dead – and largely forgotten – the image would not, unlike his earlier depiction of Kitty Fisher as Cleopatra, carry any additional association beyond the immediate allegory visible in the image.

Reynolds's acquaintance with Mrs Hartley is equally intriguing. Elizabeth Hartley first appeared on stage in Edinburgh in December 1771.

In the spring of 1772 David Garrick seems to have taken an interest in her, and in October of that year she made her professional debut at Covent Garden.[69] Reynolds had, however, recorded sittings with her as early as August 1771, and had already noted down her private address in his pocket-book.[70] It was evidently during this time that he painted 'A nymph with a young Bacchus' – a composition based on Michelangelo's *Doni Tondo* (see Wind, 1986, p. 20, and figs. 5 and 6). Reynolds had therefore been introduced to Mrs Hartley before she had received any public notice, but at a time when she was presumably being groomed for stardom. Significantly, by the time she sat to him again in the summer of 1773 she was an established actress.[71] The picture for which Mrs Hartley probably sat at that time depicted her in the role of Jane Shore (plate 15), the maligned mistress of Edward IV, as well as the eponymous heroine of Rowe's play, in which she had made her debut the previous autumn. As Waterhouse noted, the painting was 'a deliberate attempt at doing a Romney one better' (ms. notebook 22, p. 18).[72] In the event Reynolds did not finish the painting, even though he went as far as considering having a print made from it.[73] It may, however, have been in part owing to Mrs Hartley's burgeoning reputation that Reynolds's studio assistant, Giuseppe Marchi, made a mezzotint of 'A nymph with a young Bacchus', which was published in February 1773, and exhibited the following April at the Society of Artists. There, it was shown not as a subject picture but as a portrait of Mrs Hartley.[74]

Prints of portraits were published at the instigation of either one, or a combination of, several interested parties including the artist, the engraver, the print-seller, the sitter – or a pirate print-maker.[75] Despite the introduction of the Copyright Law in 1735, pirate editions remained common in the late eighteenth century. Through the alteration of an inscription, or even a face, one portrait sitter could easily be transformed into another, or even into a subject piece (see Alexander and Godfrey, 1980, p. 21; Latham, 1927, *passim*). In 1754 James McArdell had published, with Reynolds's permission, an engraving of *Lady Anne Dawson in the character of Diana* (private collection). Two years later Richard Purcell, using McArdell's image, produced his own version of the print, transferring the figure to a landscape, complete with a setting sun and a figure of Actaeon attacked by hounds in the distance (see Smith, 1833, vol. III, pp. 1013–14 (state II)). The print was inscribed 'Cynthia', together with some suitable verses by Spenser. Liberties were also taken by more reputable engravers. William Doughty, who had trained in Reynolds's own studio, produced a number of engravings after his

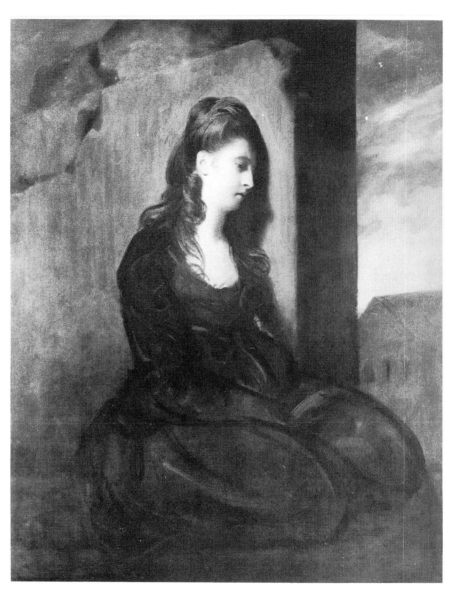

15 *Mrs Hartley as Jane Shore* (unfinished).
 Oil on canvas, 127 × 101·6 cm. 1773. Private Collection.

paintings, including one entitled *Ariadne* (private collection) which was published in 1779. Reynolds's painting may have been related to an uncompleted portrait commission. In adapting the image for the print market Doughty made one minor, but significant, alteration to Reynolds's design. Whereas the figure's breast had been modestly concealed in Reynolds's painting, it was provocatively bared in the print – presumably to make it more attractive to clientele. A similar operation was effected by Francesco Bartolozzi (1727–1815) in his translation of Hogarth's oil sketch, the *Shrimp Girl* (National Gallery, London) into a stipple-engraving. The girl's nipple – not apparent in the original painting – was inventively exposed by the engraver, and the print given the suggestive title, *Shrimps!* (see Tuer, 1881, vol. I, p. 146, vol. II, p. 126).

The aims of the artist and the engraver were often quite different, and in conflating them writers have at times arrived at untenable conclusions. In 1791 Reynolds's *Lady Cockburn and her Three Eldest Children* (National Gallery, London) was engraved in stipple by Charles Wilkin (1750–1814) with the title *Cornelia*, prompting at least one modern commentator to note that 'Reynolds's interest in the theme of Cornelia, closely identified with neo-classicism, again points to his forward-looking tendencies' (Balkan, 1972, p. 205). The title of the print was, however, Wilkin's, and he had chosen it pragmatically, because Lady Cockburn's husband, for whom the print was made, disliked it and would not allow his wife's name to be appended to it (see Graves and Cronin, 1899–1901, vol. I, pp. 181–2; Penny, 1986, pp. 259–60). Earlier, in 1768, James Watson, who was regularly employed to engrave work for Reynolds, produced a mezzotint of *Mrs Hale as 'Euphrosyne'* entitled *L'Allegro*. It has accordingly been suggested that 'the painter had in mind Milton's famous poem. of that name' (see Mannings in Penny, 1986, p. 228; see also Pointon, 1970, pp. xxxviii–xxxix). While, in this instance, Reynolds may well have been inspired by *L'Allegro*, one cannot assume that the title of the engraving corresponded precisely with Reynolds's own intentions.[76]

Reynolds valued the role that engravers played in publicizing his art. Indeed, as the engraver Robert Strange commented rhetorically in 1775: 'How shall posterity judge of the generality of Sir Joshua's works, but by the prints which shall be transmitted from them?' (Strange, 1775, p. 12).[77] (Later, in 1787 *The World* (3 November) reported that Reynolds, 'more than any other painter who ever lived, is endebted to engraving'.) None the less – unlike contemporaries such as Angelica Kauffman – he did not seek financial gain from them.[78] For the majority, Reynolds's works were accessible through engravings rather than through the originals,

sometimes even before the painting itself had been exhibited. Of Marchi's mezzotint of 'A nymph with a young Bacchus', 'A Critic' in *The Public Advertiser* (28 April 1773) observed at the opening of the 1773 Royal Academy exhibition that 'Sir Joshua will very probably be blamed for exhibiting Pictures which are already known to the Public by Prints of them.'[79] More mezzotints were made from Reynolds's works than from any of his contemporaries' and, as Richard Godfrey has suggested, 'in some cases his predilection for broad effects of light and shade was partly conditioned by the requirements of the mezzotint' (1978, p. 48). Conversely, the reason why engravers chose to engrave Reynolds's work – aside from his popularity and the ease with which his portraits could be converted into mezzotints – was the suitability of his portraits for transformation into more generalized subject pieces. And as we shall see in the following chapter, during the 1770s and 1780s a whole series of Reynolds's portraits, especially those of children, were inscribed and marketed as subject paintings.

Reynolds was bound by transient convention to a much greater extent than we are accustomed to allow. As a result one is apt to forget that he had to work constantly to maintain his reputation in the face of opposition from fellow artists and other interested parties. Reynolds, who was referred to on more than one occasion as the 'fashionable artist' (*The Morning Post* noting, for example, on 2 May 1780 how 'this fashionable artist has not exhibited many pictures the present season') was as susceptible to current trends as any of his fellow portrait painters. Gainsborough's famous outburst, 'Damn the man, how various he is' (made apparently while viewing an exhibition at the Royal Academy) had as much to do with Reynolds's ability to accommodate his art to passing fancies as to his penchant for painting in different styles ('various' having at least one quite different meaning in the eighteenth century from its present connotation).[80] The more ephemeral interests of his contemporaries – theatre, the masquerade, and the popular print – played as important a role in Reynolds's art as they did in Gainsborough's. And although Edgar Wind quite correctly considered expression as a key area through which contrasts between Reynolds and Gainsborough can be made, his conclusion that it was 'Gainsborough's tendency to cling to the material world and Reynolds's desire to free himself from it' (1986, p. 17) is less easy to accept.

By the late 1770s Reynolds had established a reputation as a history painter, quite apart from his work as a portraitist. And yet during the 1780s he continued to invest his subject pictures with a strong portrait

element. In 1779 he exhibited *The Nativity* (destroyed) at the Royal Academy. The Virgin was modelled on Mrs Sheridan. For St Joseph he relied on the face of an old beggar called George White. Both individuals had featured in previous works by the artist, and White, at least, was instantly recognizable, as *The Gazetteer* (26 April 1779) observed at the time:

his Virgin, a fine blooming young lady, about seventeen, seems very ill matched with poor Joseph, who, by way of contrast, appears to be above eighty, and extremely ugly; upon a nearer view Joseph is our old acquaintance Count Hugolino, who was starved with his children in a former exhibition, but with less aggravated features, and in better care.[81]

White – although then working as a professional artist's model – was by the later 1770s recognizable in his own right, rather than as the wizened patriarch for which he had so often sat to Reynolds.[82] And while Reynolds did use other professional models, apart from White, in *The Nativity*, the central figures were based on his family, his friends, and even himself. The models for the 'Virtues' included Reynolds's niece Elizabeth Johnson, Julia Bosvile (later Lady Dudley and Ward), Elizabeth Cadwallader Edwards (the wife of Reynolds's nephew, Joseph Palmer) and for the figure of 'Charity', Mrs Sheridan.[83] In one side panel Reynolds and Thomas Jervais (the artist who had painted the window from Reynolds's designs) appeared in the guise of startled shepherds.

Reynolds's contemporary, Anton Raphael Mengs (1728–79) had also introduced his own portrait into his *Adoration of the Shepherds* (Madrid, Prado).[84] Indeed, western artists had introduced their own features into subject paintings for hundreds of years, and the presence of contemporary faces in history paintings was an accepted convention. Donors and their families featured prominently in sacred commissions, while in secular works mistresses took on the role of Venus. Just as sitters for subject painters were identifiable as recognizable individuals in the eighteenth century so they had apparently been in the fifteenth century (Savonarola having objected, for example, 'to the use of beautiful contemporaries as models in devotional art, so that the people in the streets of Florence would say "there goes the Magdalene"'; Steinberg, 1977, p. 51). With reference to Reynolds's deliberate incorporation of portraiture into the New College designs, Robert Rosenblum has noted: 'Such intrusion of contemporary faces within the respectful restatement of a venerable Renaissance masterpiece underlines the distance that both artists [Reynolds and Mengs] sensed between past and present' (Rosenblum in Penny, 1986, p.

45). While accepting Rosenblum's point that there was in the late eighteenth century a conscious rift with the past, it alone cannot account satisfactorily for Reynolds's introduction of portraiture into his own subject paintings. Reynolds was not, by the inclusion of contemporary portraits in his *Nativity*, implicitly diminishing his own achievement. He included portraits in *The Nativity* because his method of history painting emerged from his portrait practice, and presumably because, like the Renaissance artists and donors who had preceded him, he wished to secure a modicum of immortality for himself and his family.

The press delighted in spotting the identity of models in Reynolds's subject pictures. And, far from objecting to the practice, Reynolds evidently exploited personalities and fuelled gossip through his choice of models. In 1781 he exhibited *Thaïs* (colour plate 4) at the Royal Academy (see Waterhouse, 1967, pp. 92–4). The *Thaïs* of classical legend was a pyromaniacal courtesan who had persuaded Alexander the Great to set fire to the city of Persepolis. In eighteenth-century England the public were acquainted with her via Dryden's celebrated poem, *Alexander's Feast; or the Power of Musique. An Ode in Honour of St. Cecilia's Day* of 1697:

> And the king seiz'd a flambeau with zeal to destroy;
> Thaïs led the way,
> To light him to his prey,
> And, like another Helen, fir'd another Troy. (lines 151–4)

Whether Dryden's poetry was the literary source for Reynolds's painting is uncertain. In any case, when the picture was shown at the Royal Academy critical speculation centred less on Reynolds's employment of allegory than upon the identity of his model, a prostitute named Emily Warren (by 1780 known as Emily Pott, after Robert Pott, whose mistress she then was).[85] In 1776 Emily had been housed in a brothel in King's Place, Covent Garden. According to William Hickey (the son of Reynolds's attorney, and himself a friend of the artist) Reynolds 'had painted Emily's portrait many times and in different characters. He often declared every limb of hers perfect in symmetry, and altogether he had never seen so faultless and finely formed a human figure' (in Spencer, 1913–25, vol. II, p. 250).[86] When *Thaïs* was exhibited it attracted the attention of the author of an anonymous pamphlet entitled *The Earwig; or An Old Woman's Remarks on the present Exhibition of Pictures at the Royal Academy*. The publication (which was dedicated to Reynolds) stated:

This picture long remained in the Painter's Gallery, after the first sitting – the face was painted from the famous Emily Bertie, to which the artist had added great

animation ... it was a cruel *snouch* in the Painter, a fine girl having paid him seventy-five guineas for an hour's work, and being unable to pay for the other half of her portrait, to exhibit her with such a sarcastic allusion to her private life – to call her Thaïs – to put a torch in her hand, and direct her attention to set flames to the Temple of Chastity. (Anon., 1781, pp. 5–6)

While artists were accustomed to jibes made in the press by anonymous critics, the Earwig's speculations evidently ruffled a number of feathers, as *The Morning Chronicle* (11 May 1781) observed: 'The artists are in an uproar, occasioned by the "Earwig", or an "old woman's remarks" on the Exhibition ... and each man, who smarts under the lash of the critics, thinks he can discover the writer by his manner; some painters are so sore as to talk of taking the criticism of a certain luminary of the law'. Earlier this century William Whitley suggested that the 'Earwig' was Mauritius Lowe (1746–93), a splenetic, and none too successful history painter who had attracted the patronage of Samuel Johnson.[87] If the 'Earwig' was indeed Lowe, he would certainly have been in a position to know about the origins of *Thaïs* – even if his account appears to be somewhat twisted. (However, the figure quoted by the Earwig – seventy-five guineas – was the sum then demanded by Reynolds as a down-payment for a whole-length portrait.)

In his biography of Reynolds, published in 1813, James Northcote mentioned 'an anecdote ... circulated by the enemies of Sir Joshua' concerning *Thaïs*:

The whisper insisted that the face of this picture was painted for the famous Emily Bertie, that she paid him seventy-five guineas down, and was to pay him the like sum when the picture was finished, which she was unable to do; the picture remained with Sir Joshua some time, when he, finding it not called for, took it into his head to metamorphosise Emily Bertie into Thaïs, and exhibit her to the world in her proper character, rushing with a torch to set the Temple of Chastity on fire. (p. 280)

According to Northcote (who had been in Italy between 1776 and 1780), Reynolds never painted 'Emily Bertie'. *Thaïs*, he affirmed, was painted from the face of 'Emily Coventry', who 'accompanied a gentleman to the East Indies and died there young' (*ibid.*, p. 281). However, as William Hickey stated in his memoirs, Emily Bertie was also known as Emily Coventry and Emily Warren (in Spencer, 1913–25, vol. IV, p. 488). Moreover, Robert Pott and Emily Warren emigrated to India in March 1781 – although she died *en route* (*ibid.*, vol. III, pp. 139–40).

In eighteenth-century England the sobriquet 'Thaïs' was synonymous with prostitution. In 1770, for example, *The Town and Country Magazine* referred to Kitty Fisher as the 'Thaïs of her time', while in 1776 it also noted that 'Our young men of quality who go abroad propose to themselves, not only the sight of the Venus de Medicis in the Florentine Gallery, but to enjoy every beautiful Thaïs and woman of gallantry in the course of their travels'.[88] (Of Francis Wheatley's lost painting of *Thaïs*, engraved by Thomas Watson and published in March 1779, Mary Webster noted how it 'appealed equally to the moral and the dissolute' (1970, p. 58, fig. 67).) Despite the conflicting accounts of the picture's origins, it is quite possible that Reynolds had painted the face only of Emily Pott around 1776, only to complete it at a later date. Fanny Burney, who saw the picture in Reynolds's studio prior to its exhibition, described it in her diary as 'a Thaïs, for which a *Miss Emily*, a celebrated courtesan, sat, at the desire of the Hon Charles Greville' (in Barrett, 1842–6, vol. II, p. 14). As Waterhouse has stated, Charles Greville (1749–1809), second son of the Earl of Warwick, had been among Emily's 'earliest admirers', and the commission may have been suspended because of her attachment to Robert Pott from 1778 onwards (1967, p. 92). However, as Nicholas Penny has shown, Reynolds almost certainly discussed Greville's commission at a dinner engagement at his home, just prior to the 1781 exhibition, when he noted in his sitter book 'Frame for Thaïs'. Greville eventually paid a hundred guineas for the painting some time between June 1786 and June 1787.[89] He did not keep it for long, selling it in 1787 to Wilbraham Tollemache (later sixth Earl of Dysart). According to a newspaper report in 1787, Tollemache attempted to purchase Reynolds's portrait of *Mrs Musters as Hebe* (Iveagh Bequest, Kenwood House) as a pendant for *Thaïs* (see Graves and Cronin, 1899–1901, vol. II, pp. 682–5). The newspaper, however, refers to Tollemache's painting not as *Thaïs* but as 'Ceres'. According to Ovid's *Metamorphoses*, Ceres searched throughout the night for her daughter, Proserpine (who had been abducted by Pluto), lighting her way with a torch kindled from Mount Etna. And indeed, the link between the torch-brandishing *Thaïs* and the goddess Ceres is made even stronger by the realization that a source for Reynolds's picture was Ludovico Carracci's *Ceres in Search of Proserpine* (Palazzo Sampieri, Bologna; plate 16). (As Michael Kitson has observed, Ludovico Carracci was not an artist who had hitherto greatly attracted the attention of eighteenth-century British artists and critics, although Reynolds had developed an appreciation for his art since his visit to Bologna in 1752 (see Kitson, 1990, pp. 439–41; Perini, 1988, pp. 157–9).) Even if the majority

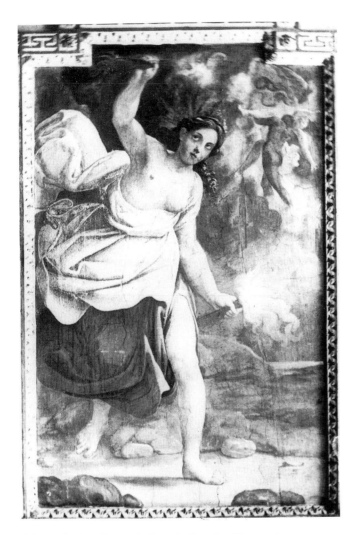

16 Ludovico Carracci, *Ceres in Search of Proserpine*.
c. 1593–4. Palazzo Sampieri, Bologna.

of Reynolds's contemporaries were unaware of his visual source, Ovid's
popularity no doubt ensured that at least some of his audience would be
aware of the comparison. Reynolds, presumably, decided against painting
Emily Warren as 'Ceres' not only because the result would have resembled
his visual source too closely, but because it would have dulled the satirical
edge of his own work – including the double entendre of Thaïs's flaming,
phallic, torch. It is very doubtful whether Reynolds ever intended to paint

Emily Warren as *Thaïs* in order to gain revenge – as the 'Earwig' suggested. Rather, the intention – as in the earlier *Kitty Fisher as Cleopatra* – was to please his patron, amuse his audience, and demonstrate his own ability to adapt the conventions of high art to his own devices.

The methods employed by Reynolds in works such as *Thaïs* differed from his portraiture in degree rather than in kind, and the prices he charged for them reflect the scale of fees set for portraiture. In 1787 Thomas Macklin commissioned two works from Reynolds for his Poets' Gallery, *Tuccia* (plate 78 below; also known as *The Vestal*), and *The Cottagers* (plate 79 below). In the second picture Reynolds employed as models, Thomas Macklin's wife, his daughter, and a family friend, Miss Jane Potts (who was also the future mother of Sir Edwin Landseer). Because the identity of the models was known – and because they were associated with the individual who had commissioned the work – *The Morning Herald* objected: 'Of the historical picture for MACKLIN, for which one thousand guineas is to be paid', it reported, 'we like it not ... we warn some of the figures are portraits chosen by Macklin – the female, who is seated, is not the happiest selection – the dog is painted with great spirit'.[90] Macklin – whose Poet's Gallery will be discussed at greater length in chapter 6 – paid Reynolds 600 guineas for *The Cottagers*. At that time Reynolds was charging 200 guineas for a single full-length portrait, although since the present picture contained three separate figures Reynolds could legitimately triple the price.[91]

Macklin's other acquisition, *Tuccia*, was exhibited in Macklin's Poet's Gallery in 1788. The subject was the trial of the Roman Vestal, Tuccia, who proved her virginity by carrying water in a sieve. Two versions of the painting exist, each employing a different model. In one version, the features of Tuccia were based upon the features of the Duchess of Rutland, the likeness being taken from a profile portrait Reynolds had painted of her in 1779.[92] Charles Manners, fourth Duke of Rutland, was one of Reynolds's most generous patrons. There would probably not have been, therefore, any satirical intent in comparing his wife with a Vestal Virgin. The model for the version sold to Macklin was a certain Mrs Seaforth. And, as with *Thaïs*, the identity of Reynolds's model was known, and, like *Thaïs*, the sitter proved of greater fascination than the painting's subject. In July 1787, when the painting was still in Reynolds's own gallery, *The Morning Herald* stated: 'The subject of Sir Joshua Reynolds's picture of the female proof of her chastity by carrying water in a seive is Mrs SEAFORTH, whom Mr. Barwell very well knows' (25 July 1787). Similarly, in October 1787 *The World* confirmed: 'The Vestal is a portrait – Mrs SEAFORTH – she

was painted long ago by Sir Joshua we mean, as well as by herself – Mr BARWELL has had her some time. And every body may know her'.[93] Richard Barwell (1741–1804), a former director of the East India Company, had retired to England with a vast fortune in 1780. Mrs Seaforth was Barwell's second wife, his first having died in 1778. The reason for the intense public interest in Mrs Seaforth was presumably centred on the fact that while Barwell was, at the time of his marriage to Mrs Seaforth, forty-seven, she was a mere fifteen years old. Moreover, as newspaper reports implied, she was no *ingénue*. The question of her virginity – like Emily Warren's promiscuity – was therefore inextricably bound up with the subject of Reynolds's picture. As with *Thaïs*, not only would the aptness of Reynolds's choice of allegory have been known to him, but it must surely have provided the initial impetus for a satirical treatment of the theme. Henry Fuseli, writing in *The Analytical Review*, believed that Reynolds's use of Mrs Seaforth as the model for Macklin's picture was no coincidence:

It is not necessary to know that the *Vestal* is the portrait of Mrs B-----ll [i.e. Barwell's mistress], to discover the whole is an irony; the humid side-leer of this eye can as little issue form the face of chastity, as a vestal from such a mother – but the picture itself – as a composition of certain beauties, and certain character, its expression, tones and forms ... never let us once remember that it ridicules what it pretends to celebrate. (*The Analytical Review*, 1789, vol. 1, p. 369).[94]

As will be discussed further in chapter 6, it was suggested at the time that *Tuccia* was an earlier design by Reynolds, resurrected for Macklin. Nor was it the first time that such an accusation had been levelled against Reynolds: in 1785 *The General Advertiser* (2 May 1785) had remarked: 'in vain does Sir Joshua raise from obscurity Pictures which he has long since finished'.

While Reynolds was accused in certain quarters of rehabilitating old portrait compositions to satisfy the market for his subject paintings, supporters asserted that by the end of his career he had successfully elevated the portrait to the level of high art. In 1793 even James Barry (admittedly prone to hyperbole) had something positive to say about one of his pictures. *Mrs Siddons as the Tragic Muse* (plate 17) was, he stated: 'the finest picture in the land, perhaps in the world, indeed it is something more than a portrait, and may serve to give an excellent idea of what an enthusiastic mind is apt to conceive of those pictures of confined history, for which Apelles was so celebrated by the ancient writers' (Royal Academy lecture, VI, 'On colouring', in Fryer, 1809, vol. I, p. 553).

17 *Mrs Siddons as the Tragic Muse*.
Oil on canvas, 236·2 × 142·2 cm. Exhibited at the Royal Academy,
1784, as 'Portrait of Mrs. Siddons; whole length'. Huntington Art
Gallery, San Marino.

Desmond Shawe-Taylor has skilfully enumerated the ways in which the portrait took on the mantle of history painting in the eighteenth century, and how it resurfaced particularly emphatically in the writings of Reynolds's apologists such as Barry, Fuseli and Northcote. 'According to the ideas of this generation', Shawe-Taylor states, 'any truly thematic portrait could be history whether it embodied the valour of a soldier, the sensibility of a girl, or the genius of a man of letters' (1987, p. 8; see also 1990, p. 42). The argument had been taking shape since at least the 1760s. On 10 May 1769 an *Epistle to Sir Joshua Reynolds, on his receiving the Honour of Knighthood*, published in the *Public Advertiser*, included the following lines:

> Thy favour'd Works, O Reynolds shall remain
> A Monument of young Augustus' Reign –
> You trace the Passions, catch the thoughts that roll,
> And from the Face inform us of the Soul.
> A Northmore, charming as the Cyprian Queen;
> A Monarch, glorious as the God of Day;
> Receiving Science with his genial Ray;
> A Granby, brave and generous to Excess;
> A Willes, distres'd whene'r he sees Distress.

Notices of this kind re-emerged periodically over the next twenty years, and must have contributed greatly to the cumulative promotion of Reynolds's portraiture to the plane of history painting.

From 1769 onwards a common complaint voiced among the press was that far too many portraits – and far too few subject paintings – were exhibited at the Royal Academy. Priority in critical notices was therefore given to history paintings at the expense of portraiture. Reynolds was treated as an exception; his portraits invariably received at least a few lines in any exhibition review. In 1774 (7–10 May) a 'Friend to the Arts', writing in *The London Chronicle* explained the reason for the elevation of Reynolds's portraits with reference to *Mrs Tollemache as Miranda* and *Three Ladies Adorning a Term of Hymen*: 'I only mention these (though no historical paintings) as the production of this capital artist, of whom it may be affirmed, that while some Artists paint only to this age and this nation, he paints to all ages and all nations; and we may justly say with the Artist of old, *In aeternitatem pingo*.' In the third *Discourse*, presented to the Royal Academy in December 1770, Reynolds had stated that the ideal artist 'addresses his works to the people of every country and every age; he calls upon posterity to be his spectators; and says with

Zeuxis, *in aeternitatem pingo*' (in Wark, 1975, p. 49; see Hilles, 1936, p. 108). The 'Friend to the Arts' was also clearly a friend of Reynolds. It was common knowledge that artists promoted their own work through 'puffs' written by friends or even by themselves. By the 1770s Reynolds's adherents were increasingly intent on promoting his portraits as history paintings. 'Sir Joshua in his Portraits', claimed 'Dilettante' in *The Public Advertiser* in 1774 (28 April), 'generally gives the most agreeable Idea of the Person, and at the same Time so much of the true character, that he seems to delineate the mind'. And, noted 'No Connoisseur' in *The Morning Chronicle* three years later: 'As the face of every portrait is the speaking part of the picture, Sir Joshua is particularly happy in giving all his figures such force of expression, that scarce a person looks at them without entering into a kind of colloquy with the picture' (25 April 1777).

That Reynolds's portraits had by the early 1780s acquired a distinct 'philosophical' edge over those of his contemporaries emerges forcibly in the writings of 'Ensis', critic of *The London Courant*, and a vigorous defender of Reynolds's art. His introductory comments on Reynolds at the Royal Academy exhibition of 1781 deserve to be quoted in full, for they provide an insight into the elitism which surrounded Reynolds's portraits:

As now every man who can escape with a shilling from the taxes may be a connoisseur, thousands will exercise their criticisms on the mute victims of Somerset House; some of these will undoubtedly oblige the public with their remarks, and to those I take the liberty of giving this salutory advice: not to confound the classes of artists. A morning paper, that struggles to erect itself into the Herald of renown and infamy, has sounded the first blast with the name of Gainsborough; a name, however honourable in its rank, not great enough to head a class, or to be often repeated by posterity. According to that critic, G. has left behind him all who painted the Royal Pair before him; his King is grand; in his Queen he has unveiled the Graces; his Bishop is the warm truth of life; in his landscapes he has silenced nature; but beggared pathos and description in the Beggar Boy of St. James' Street.

Such is his impertinent and ignorant rapture in that place that sixteen pieces of Reynolds, the least of which exceeds the power of Gainsborough as far as Johnson's that of B-te [i.e. Henry Bate]. Gainsborough is too respectable an artist not to be sensible that the dignity of Reynolds' King, the bleak heroism of his Cavendish, the wanton frenzy of his Thaïs, the domestic elegance of his Waldegraves, the infant grace of his Rutlands, the simplicity of every dimpled babe that sprung from his hands, are in a line of art which the vaunted painter of the King and Shepherd *must never hope to attain*, whilst the Dido and the Virtues shall probably remain for ever beyond the reach of his eye. Let me then repeat, that the

first rule of good criticism on the art is, not to confound the classes of the Artists. (*The London Courant*, 3 May 1781)

Ensis was responding directly to Henry Bate's promotion of Gainsborough over Reynolds in the pages of his rival paper, *The Morning Herald*. He was, however, clearly over-reacting since Bate's review of Reynolds's exhibits in *The Morning Herald* was by no means entirely unfavourable.[95] In fact, Bate's actual crime was not to suggest that Gainsborough was a more accomplished artist than Reynolds, but to suggest that it aspired to the same intellectual level. The classification of a work of art was clearly no longer confined to its place within the recognized genres but related to the social and intellectual 'class' of the viewer, whose ability to perceive the historical element in a portrait elevated him beyond the level of the ordinary spectator.

Reynolds's portraits had been favourably compared to history paintings from the 1760s onwards. The first instance, however, of a portrait by Reynolds being described unambiguously as a history painting in its own right occurred in 1784. The picture in question was *Mrs Siddons as the Tragic Muse*, and was exhibited at the Royal Academy as a 'Portrait of Mrs Siddons; whole length' (see Wark, 1971, pp. 43–57; Mannings in Penny, 1986, pp. 324–6; Wind, 1986, pp. 44–6). To refer to a sitter by name in the exhibition catalogue was not usually considered protocol. (It was not until 1798 that sitters, other than Royalty, were specifically named in the Royal Academy's exhibition catalogue.) Reynolds had, however, broken the rule once before, with *Garrick between Tragedy and Comedy*. Unlike Garrick, Mrs Siddons was not depicted alongside an emblematic figure or Muse, but was herself an embodiment of the Tragic Muse, flanked by the figures of Terror and Pity. *The Public Advertiser* (a newspaper which, like *The Courant*, was invariably biased in Reynolds's favour) did not doubt that *Mrs Siddons* was a history painting:

Hitherto, whenever we have been at the Exhibition, we have found Attention irresistibly drawn to two exquisite works of Sir Joshua, the *Nymph and Child* and the sublime Picture of Mrs Siddons. These two inimitable pictures of our modern Raphael – inimitable since the Aera of Raffaela d'Urbino – cannot be all considered as mere Portraits; they are much better, they are HISTORICAL PAINTINGS, and most gloriously splendid in Composition, Outline and Effect. (1 May 1784)[96]

Prior to the exhibition of *Mrs Siddons*, the sitter had already been characterized, in verse, as the 'Tragic Muse'.[97] Subsequently, however, the picture was transformed into an embodiment of the Tragic Muse, quite irrespective of any link with Mrs Siddons. On 1 March 1786 *The Public*

Advertiser stated that the 'picture of the Tragic Muse (for it is really more than a portrait of Mrs Siddons) is yet in Sir Joshua's possession which it would not be was this the period of the Tenth Leo, or the family of the Medici'. Reynolds evidently agreed, for he put a price tag of 1,000 guineas on the work – far more than he could ever have hoped to charge for a standard full-length portrait. No British buyer was forthcoming, however, and it was eventually purchased by Louis XVI's former Director of Finance, Charles-Alexandre de Calonne (1734–1802), for 700 guineas (see Cormack, 1970, p. 164; Mannings in Penny, 1986, p. 324).

Mrs Siddons was regarded by *The Public Advertiser* as a history painting because she represented a convincing embodiment of Tragedy. A few years later Reynolds's portrait of Lord Heathfield (plate 18) acquired similar iconic status, although the reasoning was centred on jingoistic concerns rather than on theatrical or aesthetic interest. Heathfield had sat to Reynolds in the late summer of 1787 and the work was exhibited the following year at the Royal Academy. Reynolds's picture alluded indirectly, via the cannon and the key clasped in the sitter's hand, to Heathfield's defence of Gibraltar against French and Spanish forces between 1779 and 1783. It also carried, as Shawe-Taylor has persuasively suggested, a covert comparison between between Heathfield and St Peter, as the illustrious military hero is transformed into 'the rock upon which Britannia builds her Mediterranean interests' (1990, p. 49). The circumstances surrounding the commissioning of the painting support such a reading. It was commissioned not by the sitter but by the entrepreneur, John Boydell, who after permitting it to be shown at the Royal Academy in 1788 had the work transferred to his own Shakespeare Gallery. Here it was exhibited flanked by three small sea-pieces by Richard Paton (1717–91) which illustrated episodes from the siege. (In 1794 the arrangement was again put on display in the Council Chamber of the Guildhall.[98]) In 1788 Fuseli, writing in *The Analytical Review*, stated that 'of the many instances in the present exhibition any one should more eminently challenge the contemplation of the physiognomist, and the raptures of the poet, it is the portrait of the hoary old warrior, who launched his thunder from the rock of Gibraltar' (June 1788, vol. 1, p. 220). (In the 1830s, Constable could still nostalgically refer to Reynolds's painting as 'almost a history of the defence of Gibraltar' (quoted in Leslie and Taylor, 1865, vol. I, p. 517).) The following year Fuseli focussed the argument more closely on the issue of nationalism: 'Among the portraits … there are some, which merely as transcripts of faces, must be at least as interesting to a *British* public, as the most sublime or impassioned piece of

18 *Lord Heathfield.*
 Oil on canvas, 142·3 × 111·8 cm. Exhibited at the Royal Academy, 1788, as
 'Portrait of a nobleman; half length'. National Gallery, London.

history. It is not necessary to say that these are the performances of *Sir Joshua Reynolds*' (*The Analytical Review*, May–August 1789, vol. 5, p. 106). The remark is curiously reminiscent of an observation made by Richard Steele in *The Spectator* (6 July 1712) at the beginning of the century: 'What the antique statues and bas-reliefs which Italy enjoys are to the history painters, the beautiful and noble faces with which England is confessed to abound, are to the face-painters.' Among Reynolds's principal aims as first president of the Royal Academy had been to bring British artists into a European orbit. It was therefore ironic that by the end of his life his portraiture was promoted as emblematic of British nationalism. Moreover, Reynolds's own portaits were now promoted on a par with history painting, a branch of art which Reynolds held up as the supreme form of artistic expression.

A measure of the changes that had been wrought over the twenty years since the foundation of the Royal Academy can be taken by comparing the two following pieces of criticism, one of 1769 and one of 1788, which assess the relative achievements of Reynolds and his successor as president of the Royal Academy, Benjamin West. On 26 May 1769, just after the opening of the inaugural exhibition at the Royal Academy, a correspondent of *The Public Advertiser* wrote:

I do not mean to depreciate any Painter, because I extol the Works of another. But what can exceed our Charming History Painter, Mr. West, in the Correctness of his Composition, the Harmony of his Stile, or the Delicacy of his Colouring?... Portrait-Painting has had its Day, and the Name of Sir Joshua Reynolds must be handed down with Honour to Posterity, for the great Share he took in reducing Painting to a Science at the same Time that he abolished by his Example that false Taste which Sir Godfrey Kneller's Pieces had everywhere authorised. But the Superiority of History-Painting over Works of every kind is now universally acknowledged.

The writer went on to argue that West had superseded Reynolds as the innovative force in British art, not by the quality of his work but by virtue of the fact that he was a history painter rather than a portraitist. 'Mr. West, indeed, is one of our first History Painters', reported *The London Chronicle* in 1773, 'that is, he is one of our first Painters: for History Painting is universally acknowledged to be the noblest branch of the art. A History Painting is as much superior in greatness of design, and difficulty of execution, to a portrait, a landscape, a prospect, and the like kind of pictures, as an Epigram, or a regular Tragedy to a Farce' (18–20 May 1773).[99] On 10 May 1788 'Ensis' addressed Benjamin West in *The London Courant*:

Such is the second of that series of pieces to which you have dedicated your life, to inform future times of the heighth [*sic*] of the British School of History – but the age to come must, in gravity, exceed the present, if it can hear without a smile, that your work pretended to the first rank, at the side of performances which do now and ever will fill the eye and mind with sentiment and pleasure; at the side of the man who wraps us in adoration with his *Angel*, fills our ear with the din of war in *Tarleton*, hushes the clamour by the front of *Thurlow*, or unbends our cares with the arch simplicity of his *infant scenes*.

Ten years earlier 'Ensis' had attacked Henry Bate for preferring Gainsborough's portraits to those of Reynolds. Now he pitted portraits by Reynolds against the history paintings by West.

Shortly after Reynolds's death an obituary stated that 'he has left us such specimens of what he was competent to, as will be the boast long of the British School – the Ugolino, the Beaufort, etc. His very portraits are indeed Historic, or rather perhaps Epic' (*The General Evening Post*, 25–8 February 1792). Looking back to Reynolds's portraits of the 1750s and 1760s, it is possible to endorse the view put forward by Chauncey B. Tinker that 'they must not be thought of in any way peculiar to him or to the English School. It was a fine old convention of portrait-painting, which extended back, through Kneller and Lely, to Van Dyck and Rubens' (1938, p. 14). During the 1770s and 1780s, however, Reynolds had effectively altered the very *raison d'être* of historical portraiture, exploiting its ambiguities, its multiplicity of meaning and function, to the point where this 'fine old convention' had exceeded previous boundaries and colonized territory which had previously been the province of history painting.

2 *The infant academy*

In 1771 Reynolds exhibited a picture which he entitled 'A girl reading' (plate 19) at the Royal Academy. The sitter, as Horace Walpole recognized (Graves, 1906, p. 271), was the artist's neice Theophila Palmer (1757–1848). 'Miss Offy, now about 14', observed Tom Taylor in the mid-nineteenth century, 'was highly offended at the title of the picture in the catalogue. "I think", she said, "they might have put 'A Young Lady'"'(in Leslie and Taylor, 1865, vol. I, p. 400, n. 1).[1] Reynolds did not, however, consider his paintings of Theophila as portraits. Maria Edgeworth, a friend of Theophila's in adulthood, reminisced: 'He painted Mrs. Gwatkin [*née* Palmer] seven times. "But don't be vain, my dear, I only use your head as I would that of any beggar – as a good practice."'[2] Among the earliest works painted by Reynolds 'as a good practice' was *A Boy Reading* (plate 44 below) of 1747. He produced little to compare with it for nearly twenty-five years. And yet, from the 1770s until his death the 'fancy picture' – as such paintings were generally termed – formed an increasingly important aspect of Reynolds's *œuvre*, as well as a significant contribution to his reputation as a subject painter.

The word 'fancy', as noted in chapter 1, was used in the context of portraiture to distinguish more straightforward depictions of a sitter ('mere' portraits) from those where an image was enhanced imaginatively, by a combination of exotic or historical costume, or by the introduction of allegorical figures. The term 'fancy picture', however, had a more specific connotation beyond designating imagination, and was a genre in its own right – although its terms of reference were quite broad. A child reading, an old beggar, an infant saint, a maid performing domestic duties, or even an illustration to a light, fictional romance, could all be brought together under the umbrella of the fancy picture. The common trait among such works was that the image – whatever its specific iconography – presented a vignette; either a detail extracted from some larger drama, a parodic conceit, or a meditation on a commonplace activity, usually involving one or two figures only. The fancy picture gained considerable popularity in the Low Countries during the seventeenth century, where it evolved as an aspect of genre painting, taking the form of character studies of carousing musicians, women sewing, or children teasing small caged animals. The genre was taken up in France

19 *A Girl Reading.*
 Oil on canvas, 74 × 62 cm. Exhibited at the Royal Academy, 1771.
 Lord Hillingdon.

during the early eighteenth century, first by Watteau and Chardin, and later by Jean-Baptiste Greuze.

In tracing the roots of the fancy picture in English art it is customary to stress the seminal role played by the French Huguenot emigré, Philip Mercier (1689–1760).[3] Engravers such as John Faber and Richard Houston promoted the new genre, which George Vertue described in 1737 as 'pieces of some figures of conversation as big as the life: conceited plaisant Fancies and habits: mixed modes really well done – and much approved of' (in Waterhouse, 1953, p. 131). The tradition was explored further by native English artists, notably Joseph Highmore, Francis Hayman, and Henry Morland. Reynolds's approach to the fancy picture, although he shared a common debt to Dutch painters such as Rembrandt, was influenced to a greater extent by Southern painters such as Murillo, Correggio, and Guido Reni, whose art proved especially attractive to adherents of the cult of sensibility in France and in England (see Brookner, 1972, p. 37). Reynolds was also fully cognizant of the activities of continental contemporaries such as Jean-Baptiste Greuze, as well as artists closer to home, including his close rivals, Gainsborough and Romney.

From the early 1770s, when Reynolds first began to produce fancy pictures on a regular basis, the practice held a unique fascination for him, as Northcote recalled:

So desirous was Sir Joshua to arrive at excellence, that I have known him to work days and weeks on his fancy subjects, on which he could practise every experiment at pleasure, while numbers of his portraits remained unfinished, for the completion of which the most earnest solicitations were made; and when he also well knew he should have received his price for them the moment they were sent home. Such was his delight in working on those fancy subjects that he was content to indulge it even at the expense of his immediate interest. (1818, vol. II, p. 23)

More than any other genre, the fancy picture allowed Reynolds freedom to try out new ideas. And it is partly because of the experimental nature of such pictures that there is not the same discernible pattern in the development of these works as can be found in public commissions. In a fancy picture Reynolds would explore an idea, sometimes abandoning it, sometimes repeating it straight away, and sometimes returning to the composition years later.[4] He also responded to specific influences and situations, whether it was a picture by another artist, a request from a patron, or simply the spontaneous gesture of a child model. Indeed, in no other area of his practice is the analogy of the 'apothecary' – a trade which he had been so anxious to avoid – so apt. 'When he was at any time

accused of having spoiled many of his portraits, by trying experiments upon them,' stated Northcote, 'he answered, that it was always his wish to have made these experiments on his fancy pictures, and if so, had they failed of success, the injury would have fallen only on himself, as he should have kept them on his hands' (1813, p. lxxxi).

Although the fancy picture was a vehicle for private experimentation, Reynolds was not secretive about these paintings, allowing pupils and students to copy them freely.[5] Their extensive duplication has raised a series of problems relating to attribution. After his death Reynolds's fancy pictures continued to command high prices in the saleroom, and were copied extensively when exhibited at the British Institution in the early to mid-nineteenth century. (Reynolds's *A Sleeping Girl* (plate 50 below) was exhibited at the Royal Academy in 1788. When shown at the British Institution, eighteen full-size copies, three reduced, and three miniatures were made from it.[6]) A further preliminary point concerns dating and identification of Reynolds's fancy pictures. The artist's own references to fancy pictures in sitter-books and sales ledgers are cursory.[7] Engravings made from fancy pictures are helpful in dating works, as mezzotints were often produced within a few years of a picture's completion. However, cheaper, and increasingly widespread, stipple engravings could appear as many as fifteen years after the original painting, as print publishers quarried for suitable subject matter to convert into fashionable furniture-prints. Finally, the identification of fancy pictures through sales catalogues is also fraught with difficulty, as the titles by which particular works were known changed for the sake of fashion or saleability.[8]

Reynolds had painted child models before the 1770s, although notations in the sitter-books are sporadic. The first reference is on 5 April 1759 and reads 'Boy 6' – that is, a sitting for a boy model at 6 p.m. Similar entries recur over the next decade, although they total fewer than a dozen. Moreover, they are isolated sittings spread out over long intervals – a boy at 11.30 a.m. on 13 October 1761, another at 11 a.m. on 18 December 1761, and so on. Significantly, such appointments invariably fall within a day or so of sittings for portraits of named child sitters. (On 16 December 1767, for example, a 'child' sat at 10 a.m., while the previous day at 11 a.m. Master Vansittart had sat to Reynolds for his portrait.) The principal role of these young models before the 1770s was therefore to serve as substitutes for portrait sitters. Having completed the face of a sitter, Reynolds often finished the portrait in their absence, hands, arms, and legs being modelled, as he casually informed one sitter, on members of

his own household – and, in the case of their children, from street urchins (Northcote, 1818, vol. I, p. 267).

And yet, between 1770 and 1773 at least 150 separate sittings with child models are recorded in Reynolds's sitter-books, revealing that these children had assumed a far more significant – and independent – role in his practice, even though they clearly continued to fulfil their previous function. (On 22 October 1773, for example, at 12.30 p.m. Lady Cockburn's son sat for the group portrait exhibited the following year at the Royal Academy, while half an hour later Reynolds recorded an appointment in his pocket book with a 'child'.) James Northcote, who entered Reynolds's studio as a pupil in May 1771 – at a time when Reynolds was painting intensively from child models – observed: 'Sir Joshua was incessantly practising from hired models, and from children – beggar children – and hundreds of times did he practise from his own head as he saw it in a looking glass … his incessant practice from the models enabled him to acquire that mechanical dexterity which made him so famous' (in Fletcher, 1901, p. 77). None the less, Northcote's reminiscences also reveal that these models were not treated, either by himself or by Reynolds, with the respect accorded to portrait sitters – not least because they had no financial control over the transaction:

The hired models, being dependant people were quiet and gave no trouble. The Prince of Wales one day sent to offer me any of his horses to paint from, but I didn't avail myself of his kindness, for I found I could obtain what I wanted so much more comfortably at a livery stables. Now Sir Joshua felt this same thing strongly, and was for ever painting from beggars, over whom he could have complete command, and leave his mind perfectly at liberty for the purposes of study. Good G-d! how he used to fill his studio with such malkins; you would have been afraid to come near them, and yet from these people he produced his most celebrated pictures. When any of the great people came in, Sir Joshua used to flounce them into the next room until he wanted them again. (in Fletcher, 1901, pp. 120–1)

The impression given by Northcote is that Reynolds's child models were slotted into gaps in the artist's portrait schedule. At times the packed timetable of the sitter-books supports such a view. And yet there were times, especially during the early 1770s, when Reynolds devoted whole weeks, and even months, solely to painting fancy pictures from child-models. Reynolds was able to spend so much time on fancy pictures at this time principally because he had fewer portrait sitters in his studio now since 1755 – the year he began to record appointments in sitter-books. A number of reasons have been given for the dramatic decline in Reynolds's portrait clientele during this period. Charles Robert Leslie stated that

Reynolds deliberately reduced the volume of sitters, owing to the extra burden imposed upon him by the presidency of the Royal Academy (Leslie and Taylor, 1865, vol. I, p. 377). After Reynolds's death, James Barry insisted that he had intentionally avoided portrait commissions in order to allow himself to devote more time to imaginative works – even though during his life-time he suggested that Reynolds's loss of business was due to the competition of George Romney (in Fryer, 1809, vol. I, p. 217). Despite any temporary fluctuation in his fortunes, Reynolds was, during the early 1770s, probably as busy as he chose to be, and his increased attention to fancy pictures must therefore be seen – like his more ambitious subject pictures – as concomitant with a desire to match the burgeoning rhetoric of the *Discourses* with the scope of his own practice.

A detailed inspection of his sitter-books during the period 1770–3 reveals the increasingly significant part played by the fancy picture in Reynolds's practice during the early 1770s. In March 1770 – the month before the opening of the annual Academy exhibition – Reynolds's portrait practice was quite slack, and child models were often the only sitters. The year continued quietly, Reynolds receiving on average only four portrait sitters per week. During the autumn (aside from a prolonged sojourn in the West Country in September and October) and winter Reynolds painted regularly from child models who sat to the artist every three days or so (invariably at 10 a.m., and occasionally at 11 a.m. – it being exceptional for Reynolds to paint from the model in the afternoon). Although his portrait practice picked up in spring 1771, Reynolds continued to have regular appointments with child models – a practice which continued unabated until at least the close of 1773 (the sitter-books for 1774–6 are missing).

Reynolds's first regular appointment with a child model was at midday on Tuesday 6 March 1770 (denoted by the entry 'Beggar child' in his sitter-book). Reynolds had already had one other child in his studio that morning. George Seymour Conway (1763–1848) had sat to him at 10 a.m. – probably for the bust-length portrait in Van Dyck costume (private collection; see Graves and Cronin, 1899–1901, vol. I, pp. 191–2). His young model may, therefore, have been employed to assist Reynolds in the aforementioned portrait. However, on 9 and 10 March a child model – Reynolds's only recorded sitter on both days – sat again. Reynolds continued these sittings throughout March and the first part of April 1770, perhaps in an effort to complete the picture entitled *The Children in the Wood* (plate 20) which he showed at the Royal Academy that year. The picture, as the title suggests, was based on a popular fairy tale. Reynolds

20 *The Children in the Wood*.
Oil on canvas, 91·4 × 94 cm. Exhibited at the Royal Academy, 1770.
Unlocated.

21 *A Boy Holding a Bunch of Grapes.*
 Oil on canvas, 76·2 × 63·5 cm. *c.* 1773. Art Museum, Cincinnati.

probably knew the story well, as he is known to have kept his younger portrait-sitters amused by telling fairy stories (Whitley, 1928a, vol. I, p. 369; Dorment, 1986, cat. 82, pp. 294–6). Given the real-life circumstances of his model, Northcote's explanation of how *The Children in the Wood* came about seems quite poignant:

It happened, once, as it often did, that one of these little sitters fell asleep, and in so beautiful an attitude, that Sir Joshua instantly put away the picture he was at work on and took up a fresh canvas. After sketching the little model as it lay, a change took place in the position; he moved his canvas to make the change greater, and, to suit the purpose he had conceived, sketched the child again. (1818, vol. I, p. 258)

It was by no means unusual for Reynolds, in fancy pictures of the early 1770s, to arrive at the subject of his painting in an arbitrary manner – as he admitted to the sculptor, John Bacon:

The charming and characteristic expressions of the countenances of some of his fancy subjects were effected by a very justificable [*sic*] method which he adopted in several instances ... if he saw a young person, male or female, having a beautiful or striking countenance which he considered would make an interesting fancy picture, he would paint the face and nothing more in the first instance; he would then say to himself, 'what will that face and expression be best suited to?', and then he would add the figure to the face – a sure way of securing a correct representation of what he aimed at. (in Williamson, 1903, p. 31)

In one recorded instance, the portrait painter John Jackson recalled how an unfinished picture by Reynolds – only the head of which had been painted – was later completed by Richard Westall, using his younger brother as a model (see Hamilton, 1874, p. 112). Reynolds's practice can be illustrated by four fancy pictures which he painted during the early 1770s: *A Boy Holding a Bunch of Grapes* (plate 21), *Hannibal* (unlocated), *Mercury as a Cutpurse* (plate 22), and *Cupid as a Link Boy* (colour plate 5). In all these pictures the facial expression of the model is identical (although *Cupid as a Link Boy* is painted from a different angle). Indeed, all four studies probably date from 1773 (in Reynolds's sitter-book for Wednesday 10 February at 10 a.m. is the note 'Hannibal' – presumably a playful reminder by the artist of the picture on which he was then working). And in any case, both *Cupid* and *Mercury* were certainly finished by 1774 when the Duke of Dorset purchased them from Reynolds.[9]

One of the most striking aspects of works such as *Mercury as a Cutpurse* is the lack of expression on the model's face, which forms a marked contrast to the animation of his child-portrait sitters. In 1774 Reynolds

22 *Mercury as a Cutpurse.*
 Oil on canvas, 76 × 63·5 cm. *c.* 1773. The Faringdon Collection Trust, Buscot.

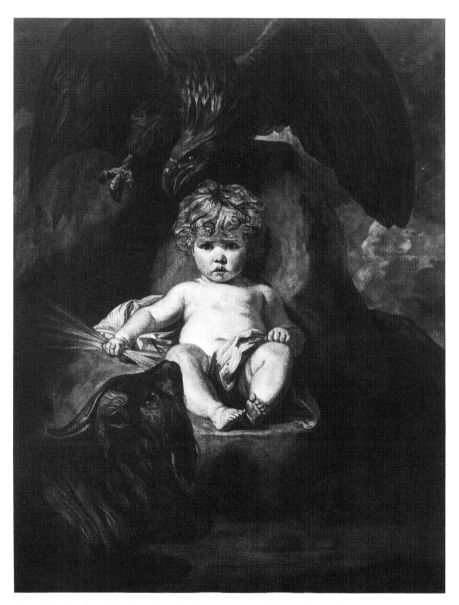

23 John Raphael Smith (after Sir Joshua Reynolds), *An Infant Jupiter*.
Mezzotint, 47×35 cm. 1778, after the painting of the same title exhibited at
the Royal Academy, 1774. The Trustees of the British Museum.

exhibited *An Infant Jupiter* (plate 23) at the Royal Academy. The conception, as it has been pointed out, was based on Maratta's *Infant Christ with Angels* (Newman in Penny, 1986, pp. 264–5). Yet, as Hazlitt subsequently observed, the boy looked less like an infant deity than 'a sturdy young gentleman…without its swaddling clothes'.[10] The picture forms an interesting contrast with *Master Herbert as an Infant Bacchus* (plate 24) which Reynolds exhibited two years later at the Royal Academy, in 1776. Both Master Herbert (Henry George Herbert (1772–1833), subsequently second Earl of Carnarvon) and the Infant Jupiter are flanked by animals – Jupiter by the she-goat Amalthea, and Bacchus by a pair of nondescript big cats (clearly painted from a badly stuffed tiger's head).[11] Although the similarities between the two paintings point out the close connection between Reynolds's portraits and fancy pictures, there are also marked differences – as a comparison of the facial expressions of the two infants reveals. While Jupiter stares vacantly at the viewer, Master Herbert cheerfully plunges his hand into the basket of grapes by his side. As Patricia Crown has pointed out, there is a notable disparity between the pictorial treatment of beggar children by Reynolds and Gainsborough and that of 'society' children, the evident happiness of young sitters like Master Herbert and Master Crewe forming a contrast with the soulful solemnity of the anonymous beggar boys who modelled for works such as the *Infant Jupiter* and *Cupid as a Link Boy*. 'Children of rank', says Crown, 'are painted in bright or pastel colours, they display the evidence of careful nurturing, they bloom like horticultural specimens. Fuscous colours characterise the paintings of neglected, mendicant children, who seem to appear like weeds outside of conservatories and gardens' (1984, p. 161). Neither Reynolds nor Gainsborough was attempting, through their fancy pictures to draw attention to the plight of London's poor. However, their fancy pictures, as Crown remarks, 'begin to locate and define a class of children and an emotional response to that class which had not had conscious configuration before' (*ibid.*, p. 162).

The emblematic aspect of Reynolds's fancy pictures emerges strongly in a series of related paintings of shepherds and shepherdesses, among which was a three-quarter-length canvas depicting a tousled-haired boy holding a crook – known as *The Young Shepherd* (plate 25). (He was perhaps the same boy who modelled for the figures in *The Children in the Wood*.) *The Young Shepherd* was the first fancy picture to be sold by Reynolds. In July 1771 Charles Ingram, tenth Viscount Irvine (1726/7–78), sat to Reynolds for his portrait (Graves and Cronin, 1899–1901, vol. II, pp. 509–10). The following June he bought *The Young Shepherd* from Reynolds, who noted in

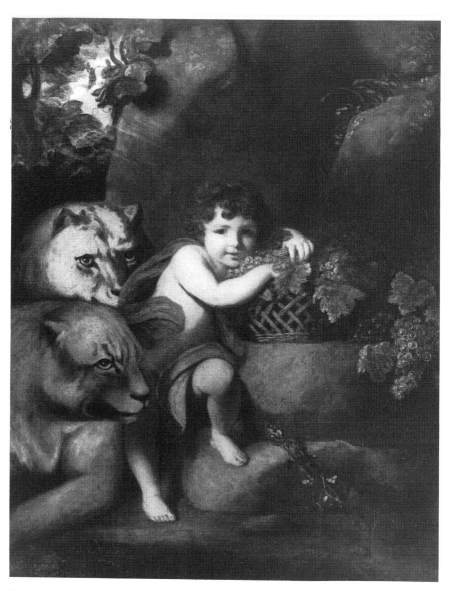

24 *Master Herbert as an Infant Bacchus.*
 Oil on canvas, 127 × 101·7 cm. Exhibited at the Royal Academy, 1776 as
 'Portrait of a child in the character of Bacchus'. Lord Carnarvon.

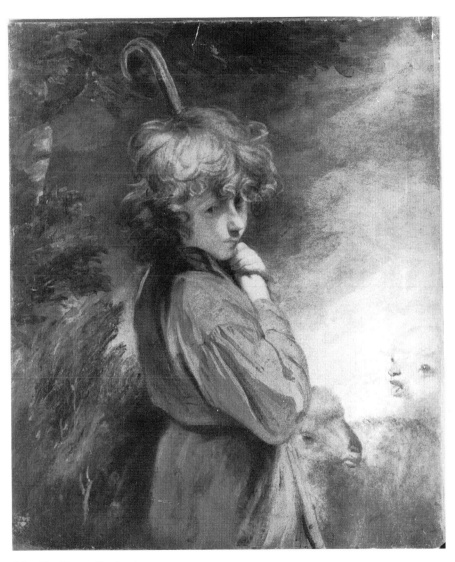

25 *The Young Shepherd.*
 Oil on canvas, 76·2 × 63·5 cm. *c.* 1771. Lord Halifax.

his sitter-book during the week beginning 22 June: 'lord Irwin, Temple Newsham [*sic*], near Leeds, Yorkshire. His Lordship's picture and the Shepherd boy to be sent'. The half-length portrait (50 by 40 inches) cost Lord Irvine 70 guineas, while the three-quarter-length *Young Shepherd* (30 by 25 inches) was purchased for 50 guineas – a price Reynolds usually charged for his slightly larger 'kit-cat' sized portraits (36 by 28 inches).[12] The transaction, which almost certainly stemmed from Irwin's seeing the fancy picture in Reynolds's studio during the sitting for his own portrait, was typical of the informal manner in which such pictures entered the collections of friends, acquaintances and *cognoscenti*. According to Ellis Waterhouse, Reynolds's *Young Shepherd* was 'in all but name, a Christ Child as The Good Shepherd' (ms. essay, p. 3). Waterhouse also argued here that the picture was inspired by a copy of a painting by Murillo imported into England in 1772 by the engraver Thomas Major, and which Major subsequently engraved as *The Christ Child as the Good Shepherd*. Although Reynolds's picture was almost certainly painted at least one year before the publication of Major's print, the general point remains valid. *Cupid as a Link Boy* and *Mercury as a Cutpurse* were painted (and sold) as pendants. A pendant to the *Young Shepherd* – although it was never sold by the artist – may have been a work now known as *The Piping Shepherd* (plate 26). Although Reynolds's *Piping Shepherd* was not engraved until 1788, a comparison with *The Young Shepherd* suggests strongly that it also belongs to the early 1770s. Just as *The Young Shepherd* is reminiscent of Murillo, the *Piping Shepherd* has, as Waterhouse commented, strong affinities with Giorgione's *Piping Boy* (Her Majesty the Queen).[13] Like a number of Reynolds's fancy pictures, it remained in the artist's possession until his death. It was eventually bought in 1821 by Sir George Phillips on the recommendation of Benjamin Robert Haydon, who noted in his diary:

The Piping Shepherd is in my estimation one of his finest emanations of his sentiment. The look of his eyes, the tone of his complexion, the grace of his motion, the pressure of the upper lip on the flageolet, the actions of the fingers, the tone of the background fill the mind with those associations of solitude and sound which are so affecting in Nature when the melancholy strain of a flageolet comes to my ear across a meadow or dell. The colour of this exquisite harmony with the idea of a yellow leaf in Autumn opposed by a dark sky, fills the mind with associations of melancholy and music. I think it the most complete hit in expression and colour that he ever made. (in Pope, 1960–3, vol. II, p. 337)

Haydon's description, although written fifty years after the painting was executed, recaptures the picture's location within the aesthetic of

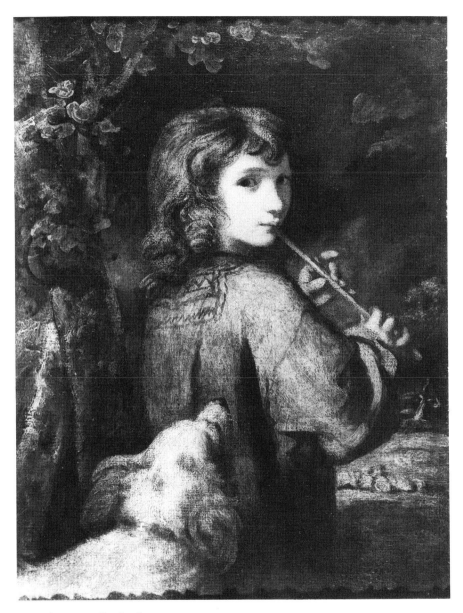

26 *The Piping Shepherd.*
 Oil on canvas, 83·8 × 62·2 cm. *c.* 1771–3. Private Collection.

sensibility. Reynolds, as Ellis Waterhouse pointed out in an essay on Gainsborough's fancy pictures, was among the first British artists to address the rustic, pastoral theme in such works (see Waterhouse, 1946, pp. 134–40). While Gainsborough explored the subject extensively in the 1780s with works such as *The Cottage Girl with Dog and Pitcher* (Sir Alfred Beit, Bt) of 1785 and his *Beggar Boys* (private collection) of the same year (both exercises in the manner of Murillo), few pictures on the theme were shown at the Royal Academy – an exception being Nathaniel Hone's *Piping Boy* (private collection) which was shown at the Royal Academy in 1769. Indeed, as Waterhouse stated, it was 'Reynolds alone who in any way anticipated Gainsborough in this new mode' in his shepherd-boy pictures of the early 1770s (*ibid.*, p. 137).

During the early to mid-1770s Reynolds also painted young shepherdesses, as well as young shepherds. Yet here the iconography was secular rather than sacred. One such painting was engraved in mezzotint in 1775 by Elizabeth Judkins with the title, *The Careful Shepherdess* (plate 27; see Graves and Cronin, 1899–1901, vol. III, pp. 1206–7). (The whereabouts of the finished picture on which this print is based is unknown, although at least one oil sketch, which bears a close resemblance to Judkins's mezzotint, exists to indicate that it was a subject which Reynolds turned to on more than one occasion.[14]) There is in addition a single appointment in Reynolds's sitter-book on Tuesday 19 January 1773 at 10 a.m. which reads 'Shepherd Girl' (in addition to several notes of 'Shepherd Boy' of around the same period). The device of depicting a young woman or girl with a lamb had been commonplace in British portraiture since the seventeenth century, and continued to be used frequently by Reynolds, and contemporary portraitists such as Francis Cotes. Owing to its close metaphorical links with Christ and John the Baptist, the lamb had – so to speak – an established pedigree in western art as the pictorial companion of Saints Agnes and Genevieve. Its ready association with gentleness, innocence, and humility also made it an ideal visual plaything for girls and young ladies of marriageable age. More specifically, following the publication of Marmontel's hugely popular *Bergère des Alpes* in 1759, the shepherdess – surrounded by her flock – was affirmed as a central emblem for sensibility in France and, subsequently, in England (Brookner, 1972, pp. 25–6). Reynolds's *Careful Shepherdess* – although it was not modelled directly on French literary sensibility, was none the less highly reminiscent of French artistic sensibility. Rather than depicting a young lady in the polite ritual of garlanding the lamb with flowers or ribbons, the *Careful Shepherdess* embraces it like a lover, rather than a pet. The closest pictorial

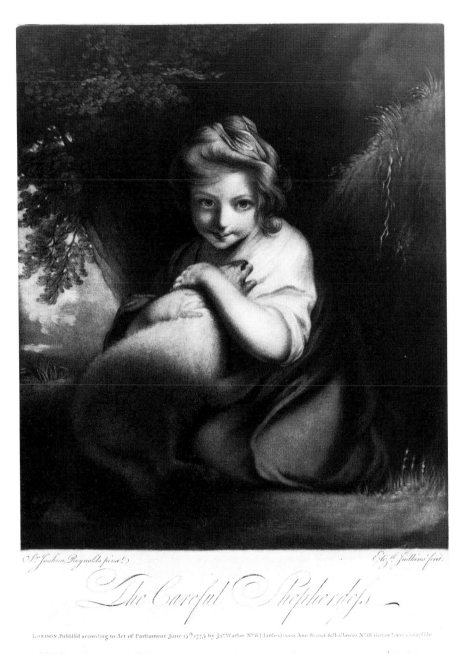

Sr. Joshua Reynolds pinxt.

Eliz.th Judkins fecit.

The Careful Shepherdess

LONDON. Publish'd according to Act of Parliament June 15.th 1775. by Jas. Watson No. 6 4 Little Queen Ann Street & B. Clowes No. 6B Gutter Lane cheapside.

27 Elizabeth Judkins (after Sir Joshua Reynolds), *The Careful Shepherdess*.
Mezzotint, 27·7 × 22·8 cm. 1775. The Trustees of the British Museum.

28 Jean-Baptiste Greuze, *Innocence*.
 Mahogany panel, 63 × 53 cm. (oval). ? 1790s. The Trustees of the Wallace
 Collection, London.

equivalent is to be found in the work of Jean-Baptiste Greuze, in such
paintings as the inaptly titled *Innocence* (plate 28), which depicts a scantily
clad girl clasping a lamb passionately to her breast.

As Anita Brookner has noted, the relationship between Greuze and late
eighteenth-century British artists poses problems (*ibid.*, p. 150). The
principal problem, however, does not just lie in the question of Reynolds's
familiarity with Greuze's art (the thriving print trade between England and
France made his work accessible to English artists and collectors alike) but
the extent to which he was consciously influenced by his art, rather than
moving along parallel lines. Reynolds had visited Paris in 1768, and again

in 1771. According to C. R. Leslie, writing in the nineteenth century: 'The mannerism of Vernet, the mingled *minauderie* and indecency of Boucher, the prurient sentimentality of Greuze, the cold classicality of Pierre and his old friend Doyen, would leave him nothing to envy Paris' (Leslie and Taylor, 1865, vol. II, p. 415). Yet, as it has recently been affirmed, Reynolds was very aware of current trends in contemporary French art.[15] He knew a number of prominent French artists including Carle Van Loo, Falconet, Doyen, and Boucher – whose studio he had visited in 1768. An obituary of Greuze in the *Journal de Débats* mentioned the 'celebrated Raynolds [*sic*], whose admiration for Greuze was such that he wished to come to France in order to make his acquaintance' (Brookner, 1972, p. 150). Certainly Greuze's name ('Creux') appears in Reynolds's note-book of 1771, alongside Tocqué ('Toque'), and Cochin ('Cochen') – even though by the late 1760s Greuze was increasingly at odds with the French Academy (as well as being personally irascible; Hilles 1969, p. 203). The parallels between their art are, however, striking, as for example in the comparison, which Robert Rosenblum has made, between Greuze's mid-1770s painting of a young girl kneeling by her bedside, *La Prière du matin* (Musée Fabre, Montpellier) and Reynolds's *Infant Samuel* of the same period (in Penny, 1986, p. 48, fig. 30).

Aside from comparisons between specific paintings, Reynolds and Greuze are united by their exploitation of nascent sexuality in children – a theme which percolates through many of Reynolds's fancy pictures in the 1770s and 1780s. However, while Greuze uncomfortably transferred the ecstatic, swooning, countenances of female baroque saints to pre-pubescent girls, Reynolds's sexual allusions, as in *The Careful Shepherdess* of the mid-1770s, or the figure of *Comedy* of the previous decade, maintained a satirical edge. Child models in Reynolds's fancy pictures of the 1770s were depicted as incarnations of vice or virtue, the two opposing forces which underpinned the aesthetic of sensibility. Indeed, Reynolds's *Girl Reading* may have avoided drawing attention to the identity of the sitter, Theophila Palmer, not simply because she was being used in the capacity of a model, but because to have done so would have obscured the general point that the girl is reading one of the key texts of sensibility – Samuel Richardson's *Clarissa Harlowe*. In this light, the painting becomes not merely a depiction of Reynolds's niece with a book, but a representation of the way in which sensibility enters the consciousness, through the self-educative discipline of reading.

While it was a genre in its own right, there was no clear-cut division between the fancy picture and Reynolds's portraiture. Formally, there is

30 Joseph Grozer (after Sir Joshua Reynolds), *The Young Shepherdess*.
Mezzotint, 41·2 × 35·3 cm. The Trustees of the British Museum.

31 *Miss Sarah Price.*
 Oil on canvas, 125 × 99·6 cm. Exhibited at the Royal Academy, 1770, as
 'Portrait of a child'. Private Collection.

by Reynolds. 'He considered it', stated Northcote, 'one of his best works, observing that no man ever could produce more than about half-a-dozen really original works in his life; "and this picture", he added "is one of mine"' (1818, vol. II, p. 7).[19] It continued to attract intense admiration in the nineteenth century, including that of Charles Robert Leslie:

She might be little Red Riding Hood hearing the first rustle of the wolf in the wayside bushes, could we substitute a red hood for the odd turban-like headdress with which the painter has crowned his little maiden, and which even Sir Joshua's taste can barely make becoming, and hang on her arm the basket with butter and eggs for her sick grandmother, instead of the strawberry-pottle which gives her a name. (Leslie and Taylor, 1865, vol. II, p. 3)

Pointon has suggested that the elision of the fancy picture and the child portrait effected by Reynolds allowed Victorian commentators – such as Leslie – to conflate the image of childish innocence with poverty, as the poor girl, for example, becomes the confused object of pity and desire (1993, pp. 186–7). In any case, Reynolds's inspiration was not – as Leslie permitted himself to imagine – simply a fairy tale. The attitude of the girl derived from an earlier painting of a girl with a muff, of 1767, which has been identified as a portrait of Reynolds's niece Theophila Palmer (1757–1848; plate 33).[20] Theophila – or 'Offy' as she was known by her family – was the daughter of Reynolds's sister Mary Palmer, and had been sent to live with Reynolds in London in 1770 (Leslie and Taylor, 1865, vol. I, p. 369). *A Strawberry Girl* depicts a child no more than nine or ten years old (roughly Theophila's age in 1767). Of the subject of Reynolds's picture Waterhouse has noted:

In the eighteenth century a 'Strawberry Garden' was a place of public resort during the summer of a kind which hardly exists today and is perhaps most easily paralleled by the German 'Beer Gardens'. I imagine that the 'Waitresses' (to use an anachronistic term) were sometimes little girls, who must have been considerably dismayed at what went on around them. Some glances such as this, seized from the life, may well have been the first idea for the painting and Sir Joshua dressed it up in all the resources of the traditions of Western Painting. (ms., p. 8)

Just as small boys earned a living by carrying 'links' or torches around eighteenth-century London, girls from poor families made money hawking strawberries. (Francis Wheatley, who produced a whole series of works depicting street-traders, also produced a picture – now lost – of a strawberry girl (Webster, 1970, p. 191, no. E198). Nevertheless, as Waterhouse makes clear, Reynolds's picture was not intended primarily as an

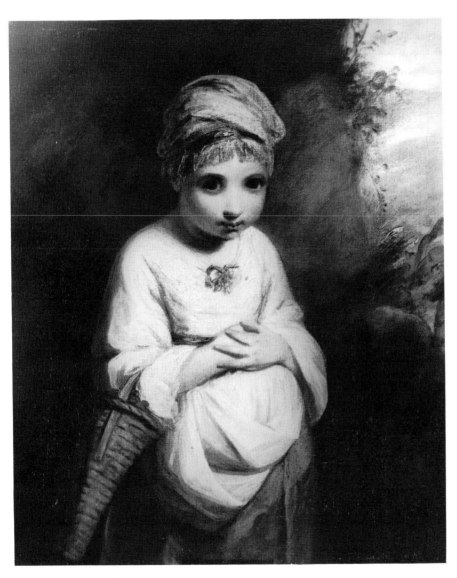

32 *A Strawberry Girl.*
Oil on canvas, 76·2 × 61 cm. Exhibited (?) at the Royal Academy, 1773.
The Earl of Shelburne.

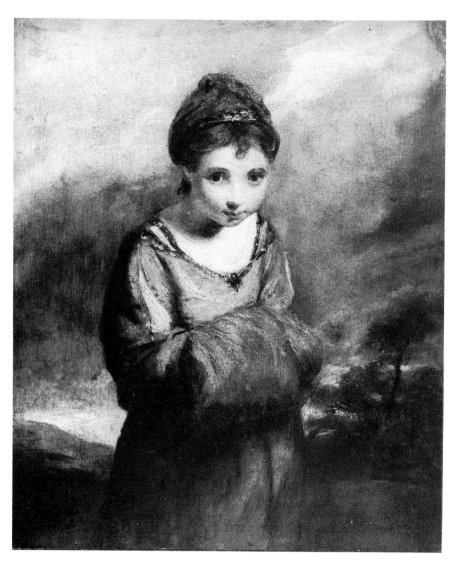

33 *Miss Theophila Palmer.*
 Oil on canvas, 76·2 × 63·5 cm. *c.* 1767. Private Collection.

illustration of a girl selling strawberries, or an image of pre-pubescent sexuality, so much as an exercise in the old-master tradition. *A Strawberry Girl*, as it has been observed, bears a resemblance to a young girl holding a medal, then attributed to Rembrandt, with which Reynolds would have been familiar. As Renate Prochno has suggested, Reynolds's actual source seems to have been an obscure figure from Albani's *Birth of the Virgin*, which Reynolds had seen in Bologna (Hendy, 1926, p. 83; Prochno, 1990b, p. 464, figs. 9 and 10).

Reynolds sold a version of *A Strawberry Girl* to Lord Carysfort in June 1774 (plate 32), although he retained a number of others, working on several different versions at the same time – as Northcote recalled:

The picture was exhibited and repeated by him several times; not so much for the sake of improvement; for he always advised, as a good mode of study, that a painter should have two pictures in hand of precisely the same subject and design, and should work on them alternately; by which means, if chance produced a lucky hit, as it often does, then, instead of working on the same piece, and perhaps by that means destroy that beauty which chance had given, he should go to the other and improve upon that. Then return again to the first picture, which he might work upon without any fear of obliterating the excellence which chance had given it, having transposed it to the other. Thus his desire of excellence enabled him to combat with every sort of difficulty or labour. (1818, vol. II, p. 8)

Northcote was well placed to comment on the practical function of Reynolds's fancy pictures not only because he was then working in the artist's studio, but because one of the duties of Reynolds's pupils was to block in the composition of fancy pictures in black and white ready for Reynolds to work on them (Fletcher, 1901, p. 108).[21] Northcote, who stated that he had prepared a monochrome copy of *The Infant Jupiter*, noted how Reynolds 'made his pupils commence with black and white, and always prohibited the use of many colours' (1818, vol. I, p. 285 fn.).

Reynolds's single-figure character studies of children form the most straightforward aspect of his attention towards the fancy picture in the early 1770s. A more ambitious aspect – and one which encroached further on the genre of high art – was a growing preoccupation with mythological and biblical subjects. In 1771 he exhibited *Venus Chiding Cupid for Learning to Cast Accounts* (colour plate 6) and *A Nymph and Bacchus* (plate 34) at the Royal Academy.[22] They were among the first works in which the artist consciously moved away from portraiture towards entirely imaginative compositions. Even so, the author of *Observations on the Pictures now on Exhibition* thought Reynolds's nymph had 'too much the air of a portrait', while of Venus, 'one would imagine

34 *A Nymph and Bacchus.*
Oil on canvas, 127 × 101·7 cm. Exhibited at the Royal Academy, 1771.
Private Collection.

the painter had drawn her from some girl in low life of thirteen or fourteen years of age' (Baker, 1771, quoted in Graves and Cronin 1899–1901, vol. IV, pp. 1480 BBB and 1480 AAA). The subject of Venus chastising Cupid was not derived directly from the canon of classical mythology. It was, however, a common subject in eighteenth-century France and exists, for example, in the form of a marble statuette by Etienne Falconet, whom Reynolds knew and with whom he corresponded (see Murray, 1972, p. 26). (The English sculptor, Joseph Nollekens, also made a statue of the subject later in the decade (Usher Gallery, Lincoln).) Reynolds's *Venus Chiding Cupid* drew, however, on more than one source. Correggio's soft-focussed nymphs, Murillo's chubby putti, and Boucher's more recent exercises in languid sensuality all exerted some influence on the final appearance of the picture. Reynolds's compositional source – as Giovanna Perini has noted – was probably a work by a less familiar seventeenth-century Bolognese artist, Alessandro Tiarini (1577–1668), a detail from whose *Madonna of the Rosary* Reynolds had sketched in Bologna (in Prochno, 1990b, p. 459, and n. 7). *Venus Chiding Cupid* does not conform to the norm in British late-eighteenth-century genre painting, the closest parallel being the decorative panels and prints of the Swiss emigré, Angelica Kauffman (see Roworth, 1992, *passim*). And yet set alongside the art of the Continent it can be seen as a demonstration of Reynolds's commitment to European standards and conventions.

Having explored pastoral and mythological themes in the fancy picture during the first half of the 1770s, in 1776 Reynolds turned towards religious subject matter with two paintings, 'St John' and 'Samuel', which he exhibited at the Royal Academy that year. *St John* (better known today as *The Infant Baptist* or *The Child Baptist in the Wilderness*) (plate 35) is among his most successful paintings in the fancy-picture genre, and he produced several versions. The exhibited version was purchased by Charles Manners (1754–87), Lord Granby (who, in 1779, became the fourth Duke of Rutland). Lord Granby bought *The Child Baptist in the Wilderness* for 100 guineas – the highest price Reynolds had yet commanded for a fancy picture (a portrait of the same size then cost 70 guineas). As Perini has observed, Reynolds's principal compositional source for *The Child Baptist in the Wilderness* may have been a sketch he had made in 1752 in Italy of a work by Battista Franco, although several other images may well have contributed to the final result.[23] None the less, the subject of St John in the Wilderness had innumerable pictorial precedents in the art of Raphael, Murillo, Van Dyck, Caravaggio, Guido Reni and a host of Neapolitan artists.

35 *The Child Baptist in the Wilderness.*
 Oil on canvas, 132 × 102·2 cm. A version of the painting exhibited at the
 Royal Academy, 1776, as 'St John'. The Trustees of the Wallace Collection,
 London.

Like the majority of individuals who sat to Reynolds for fancy pictures, almost nothing is known of the boy who modelled for *The Child Baptist in the Wilderness*. Yet, unlikely as it may seem, the Victorian painter William Powell Frith may have come across him sixty years later, in 1838, as an old man. Frith, who wanted the old man as a model, asked him (his name was Ennis) whether he had ever modelled before:

'Yes once, when I was a boy. A deaf gent done it; leastways he had a trumpet, and I shouted at 'im.'
'A deaf man?' (Gracious goodness, could it be Reynolds!). 'What kind of man was he – where did he live?'
'what kind of man? Ah! it's a vast of years ago, you see, and I didn't take particular notice. Civil spoken he was, and gave me a kind of crook to hold.' (Frith, 1889, vol. II, p. 104)

The old man finally agreed to model to Frith:

'Oh all right then! You'll want my coat and waistcoat and shirt off, as the deaf gent did, and you see I was young then and didn't mind it; but I should get the rheumatics or something. No. I couldn't do it.'
'Bless the man! I don't want to take off any of your clothes. I only want just to take your likeness – that is, the likeness of your face.'
'Oh, is that all? Then why did the old gent make me take off all but my trousers, and give me a crook to hold? There was a lamb in the picture as the old gent done.' (*ibid.*, p. 108)

While Frith's anecdote is not admissible as 'evidence', it is quite an intriguing story. (His reference to shouting at 'Reynolds' could have related not only to his deafness but to the open-mouthed expression of the boy-saint.) Of the several versions of *The Child Baptist in the Wilderness*, at least one (the Trustees of the Wallace Collection) – remained in his studio, along with a number of related oil sketches (see Graves and Cronin, 1899–1901, vol. III, p. 1198; Ingamells, 1985, pp. 160–1; Penny, 1986, p. 273). Both the completed picture in the Wallace Collection and the surviving oil sketch (Minneapolis Institute of Art) are half-lengths, and so, presumably, was the exhibited version. While the completed version provides an indication of the appearance of the exhibited version, the unfinished sketch gives a useful insight into Reynolds's working methods. In the nineteenth century, presumably in an effort to make the work more saleable, the sketch was finished by a restorer who extended the infant's cross and included the scroll which is visible on the Wallace picture. And, as Waterhouse observed, 'the lamb – perhaps to avoid the slightly amusing effect of a duet with the boy – had been repainted into a close-

mouthed, rabbity-looking animal which faced the other way' (see Waterhouse, 1968, pp. 51–3). The picture, which has since had the overpainting removed, reveals that Reynolds worked rapidly, concentrating his attention on tonal effects, rather than on colour. The handling is sketchy and the lights are heavily loaded. Reynolds, as the notes made in his Italian sketch-books suggest, was fascinated by the manipulation of tone to produce dramatic effects (see Binyon, 1902, vol. III, pp. 198–220; Perini, 1988, pp. 141–68; 1991, pp. 361–412).[24] 'Rubens', he wrote later in his notes on Du Fresnoy's *Art of Painting*, 'appears to have admitted rather more light than a quarter, Rembrandt scarce an eighth; by this conduct Rembrandt's light is extremely brilliant, but it costs too much – the rest of the picture is sacrificed to one object' (Mason in Malone, 1819, vol. III, p. 148, n. xxxix)

'Samuel', the title of the second biblical painting shown by Reynolds at the 1776 Royal Academy exhibition, could be one of two quite separate treatments of the subject by the artist. One painting, known as *The Calling of Samuel* (colour plate 7), depicts a young boy, wrapped in a cloak, with his eyes turned to heaven and his right arm upraised. The other, called *The Infant Samuel* (plate 36), shows a kneeling boy, in a white shift, his hands joined together in prayer. The situation is further complicated by the existence of at least three versions of *The Calling of Samuel* and four versions of *The Infant Samuel*, all of which are attributable to Reynolds and his studio assistants (quite aside from those other copies made in the nineteenth century (Graves and Cronin, 1899–1901, vol. III, pp. 1199–1202)). It has always been assumed that the picture shown at the Royal Academy in 1776 was *The Infant Samuel* – although there are grounds for believing that the picture shown was *The Calling of Samuel*, the principal version of which Reynolds sold to the Duke of Dorset in August 1776 for 75 guineas (Graves and Cronin, 1899–1901, vol. III, p. 1202).[25] Hannah More, a frequent visitor to Reynolds's home during the period, saw versions of both 'St John' and 'Samuel' in the artist's studio:

I wish you could see a picture Sir Joshua has just finished, of the prophet Samuel, in his being called 'The gaze of young astonishment' was never so beautifully expressed, Sir Joshua tells me that he is exceedingly mortified when he shows this picture to some of the great – they ask him who Samuel was? I told him he must get someone to make an Oratorio of Samuel, and then it would not be vulgar to confess they knew something of him. He said he was glad to find that I was so intimately acquainted with the devoted prophet. He has also done a St. John that bids fair for immortality. I tell him that I hope the poets and painters will at last bring the Bible into fashion and that people will get to like it from taste, though

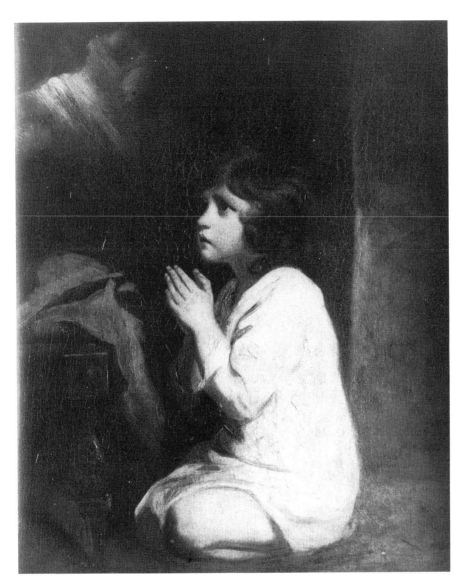

36 *The Infant Samuel.*
 Oil on canvas, 86·4 × 69·8 cm. *c.* 1776. The Trustees of the Tate Gallery,
 London.

they are insensible to its spirit, and afraid of its doctrines, I love this great genius, for not being ashamed to take his subjects from the most unfashionable of all books. (in Roberts, 1834, vol. I, pp. 71–2)

While we cannot be certain which version of 'Samuel' was seen by Hannah More, her reference to the 'gaze of young astonishment' approximates more closely to *The Calling of Samuel* than the better-known *Infant Samuel*. The infant St John was a common subject in the iconography of western art. Samuel was not; which could explain why the title of the picture was printed as *Daniel* in a number of Royal Academy catalogues – including that of Horace Walpole. (Graves and Cronin, 1899–1901, vol. III, p. 1199). It is doubtful whether Reynolds was attempting through 'Samuel', to 'bring the Bible into fashion'. His general aim was not to educate the public in the Old Testament but the old masters. In any case, of Reynolds's two treatments of Samuel, *The Infant Samuel*, was clearly the more popular of the two, not least because he could be viewed simply as a small boy saying his prayers rather than an embryonic Hebrew prophet, and as such was more in tune with contemporary sensibility. As Alexander Bicknell noted in 1790: 'it appears to my (perhaps *enthusiastic*) Imagination to abound with Sentiment, though surrounded by no expressive Decorations, and drawn at an Age when the Emotions of the Mind are not usually visible in the Features, or Gestures of the Person' (p. 169).

A painting which in many ways most closely resembles Reynolds's *Infant Samuel* was not by a British artist, but the French painter Jean-Baptiste Greuze, whose *Morning Prayer* (Montpellier, Musée Fabré) of *c.* 1775–80 depicts a young girl kneeling by her bedside – although the image is wholly bereft of childlike innocence (see Rosenblum in Penny, 1986, pp. 47–8). More significantly, French interest in *The Infant Samuel* is evident from the reaction of Marie Vigée-Lebrun (1755–1842), who on a visit to London, singled out for attention in Reynolds's studio 'a "Child Samuel"...whose completeness and colouring both pleased me' (Strachey, 1904, p. 185). Reynolds's image was also, as it has been noted, the prototype for a French patriotic print, 'Je prie Dieu pour mon père et pour la France', which showed a child praying for the safe return of the father who has gone to fight in the Napoleonic Wars (Barbin, 1969, pp. 97–104).[26] Aside from John Dean's engraving of 1777 – on which the aforementioned print may have been based – at least one painted version of *The Infant Samuel* found its way to France in the eighteenth century. It was purchased from Reynolds in February 1779 by the artist's friend

Anthony Chamier, whose Huguenot grandparents had settled in England in the seventeenth century. Although it is not known for whom Chamier purchased the picture, it was – as Reynolds's ledger indicates – intended for export to France.[27]

The principal version of *The Infant Samuel*, like *The Child Baptist in the Wilderness*, was purchased from Reynolds by Lord Granby for 100 guineas, and installed at Belvoir Castle. (Although the same size, this painting cost Lord Granby twice as much as the Duke of Dorset had paid for *The Calling of Samuel* – an indication of the importance Reynolds attached to it (Graves and Cronin, 1899–1901, vol. III, pp. 1199–1200, vol. IV, p. 1461; Waterhouse, 1941, p. 67; Cormack, 1970, pp. 150 and 153).) At least two versions, besides the Duke of Rutland's and Chamier's pictures, were made in Reynolds's studio. They were even used as a form of currency, Reynolds swapping one with the connoisseur, Charles Long (Tate Gallery), for an old master painting – as Long told George Cumberland in 1789: 'Sir Joshua Reynolds fell in love with a little bit of Julio Romano [*sic*] which I gave a few sequins for at Bologna, and which I have exchanged with him for a fancy of his own that I like extremely' (British Museum, Add. ms. 36496). Long bequeathed his *Infant Samuel* to the National Gallery in 1838 (Graves and Cronin, 1899–1901, vol. III, p. 1201; Waterhouse, 1941, p. 67). Reynolds, on the other hand, scraped down his putative Giulio Romano 'almost to the outline & then worked upon it several days' (Farington, 3 May 1796, in Garlick, Macintyre, and Cave, 1978–84, vol. II, p. 540).[28] A second version of *The Infant Samuel* was made under Reynolds's personal supervision by his pupil and copyist, John Rising (1753–1817) at Belvoir Castle.[29] The interest shown in *The Infant Samuel* by Lord Granby, Anthony Chamier, and Charles Long – all recognized connoisseurs in their own right (as well as friends of the artist) – is indicative of the way in which Reynolds's influential coterie guided late eighteenth-century taste. Indeed, William Hazlitt, writing in *The Champion* in 1814, and who considered that *The Infant Samuel* showed Reynolds's imagination at its most impoverished, blamed the sycophancy of his friends as much as the artist:

Many of those to which his friends have suggested historical nick-names, and stood poetical god-fathers and god-mothers, are mere common portraits or casual studies. Thus we cannot agree with Mr. Sotheby in his description of the Infant Jupiter and the Infant Samuel. The one is a sturdy young gentleman sitting in a doubtful posture without its swaddling clothes, and the other is an innocent little child, saying its prayers at the foot of its bed. They have nothing to do with Jupiter or Samuel, the heathen god or the Hebrew prophet. (1873, p. 33)

The purchasers of Reynolds's fancy pictures had several things in common – aside from money and influence. John Brummell, Lord Sackville, Lord Granby and Anthony Chamier were all personal friends of the artist. Henry Temple, John Wolcot, the Earl of Aylesford, Lord Charlemont, and Lord Shelburne were all noted collectors. Most significant, however, was the comparative youth of patrons such as Heneage Finch, John Bampfylde, the Earl of Carysfort, Lord Dysart, and Lord Sackville. During their formative years Reynolds was acknowledged as the foremost arbiter of taste in England. To own a fancy picture by Reynolds – a comparatively modest investment – contributed to their connoisseurial credibility. Lord Sackville and Lord Dysart also purchased fancy pictures from Gainsborough – as did Reynolds, who in 1782 bought Gainsborough's *Girl with Pigs* (although he subsequently sold it for a handsome profit to the French collector and politician, Charles-Alexandre de Calonne) (Waterhouse, 1946, p. 139).[30]

By far the most prolific purchaser of Reynolds's fancy pictures was John Frederick Sackville, the third Duke of Dorset (1754–99). Lord Sackville, immensely wealthy, was at once a patron of the arts, cricket, and a succession of beautiful mistresses. In addition to his acquisition of Reynolds's first major history painting, *Ugolino and his Children in the Dungeon* (to be discussed in the following chapter), Lord Sackville also acquired no fewer than eight fancy pictures from Reynolds, including *Cupid as a Link Boy*, *Mercury as a Cutpurse* (purchased in 1774), *A Boy with a Drawing in his Hand*, *A Beggar Boy and his Sister*, *The Calling of Samuel*, *A Fortune-teller* (bought in 1776) and *Lesbia* (also known as *Robinetta*). Significantly Sackville's exotic taste was shaped by his extensive contacts with continental – and more specifically – French art, not least through his position as ambassador to the court of Louis XVI. (Aside from decorating his seat at Knole with paintings by Reynolds and Gainsborough, he installed a life-size statue of his mistress, Giovanna Baccelli, in the attitude of the Borghese Hermaphrodite (see Einberg, 1976, *passim*). Lord Sackville was extravagant in his tastes: the same year he paid Reynolds 400 guineas for *Ugolino and his Children in the Dungeon* (1775), he lost 500 guineas on a single bet on the result of a cricket match (Simon and Smart, 1983, p. 1). In the circumstances, James Northcote's eulogy on the Duke's self-sacrificing artistic patronage takes on an ironic edge:

The Duke of Dorset loved and distinguished excellence amongst the professors of his own country, even whilst he was engaged in studying and collecting the *chefs d'œuvre* of foreign art. Indeed he frequently denied himself the common

necessaries, for a person of his high birth and station, that he might indulge himself in the possession of the best known modern pictures. (1818, vol. II, p. 182)

Lord Sackville may have been lavish; he did not, however, buy indiscriminately from Reynolds, as his initial purchases – *Mercury as a Cutpurse* (plate 22) and *Cupid as a Link Boy* (colour plate 5) – indicate. These pictures were painted and purchased as pendants; their theme sexual conquest. In the eighteenth century beggar-boys made a living on city streets lighting people's way with the use of 'links' – or torches of flaming pitch. As David Mannings has observed, 'link boys were notorious little thieves, and those most likely to suffer at their hands were the very people who trusted them as guides – an obvious parallel to the traditional role of Cupid' (in Penny, 1986, p. 264). A second parallel, which Reynolds emphasizes via the boy's obscene gesture and the phallic nature of the 'link', is Cupid's role as the god of love. Similarly, the 'cutpurse' – or pickpocket – is equated with Mercury the god of commerce, although in Reynolds's picture the way he holds the limp tubular-shaped purse indicates that he is, as Mannings states, 'in a double sense, "spent"' (*ibid.*). Together the pictures form a satirical commentary on the sexual act, echoing Hogarth's two earlier series paintings *Before* and *After* which made the same point in a far more graphic way. (Significantly, Hogarth's second version of *Before* and *After* features on the wall of the apartment a pair of pendant pictures depicting Cupid setting light to a rocket – which turns out to be a damp squib.[31])

Several of Lord Sackville's other fancy-picture acquisitions from Reynolds are also linked by a common thread; namely Reynolds's favourite young male model of the mid-1770s, whom William Mason, a frequent visitor to Reynolds's studio at the time, remembered particularly well:

He was an orphan of the poorest parents, and left with three or four other brothers and sisters, whom he taught, as they were able, to make cabbage nets; and with these he went about him, offering them for sale, by which he provided both for their maintenance and his own ... This boy (at the time about fourteen) though not handsome, had an expression in his eye so very forcible, and indicating so much sense, that he was certainly a most excellent subject for his pencil. (in Cotton, 1859a, p. 57)

Reynolds's first exhibited painting involving the boy was *A Beggar Boy and his Sister* (plate 37) shown at the Royal Academy in 1775. A second entitled *A Fortune-teller* (colour plate 1) was shown in 1777. (He was presumably still being used by Reynolds as late as winter 1777, 'Net Boy' appearing for the last time in the sitter-book on 2 December at 10 a.m.)

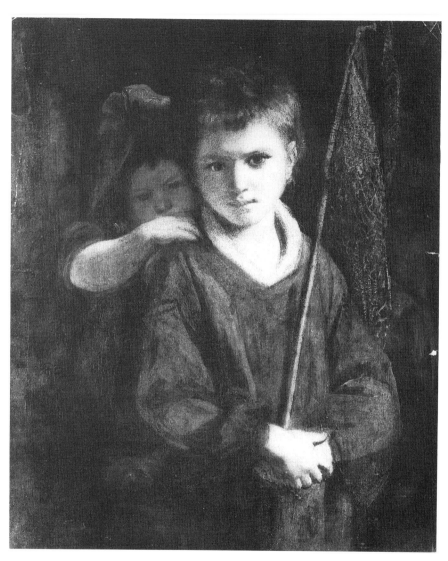

37 *A Beggar Boy and his Sister*.
 Oil on canvas, 76·2 × 63·5 cm. Exhibited at the Royal Academy, 1775.
 The Faringdon Collection Trust, Buscot.

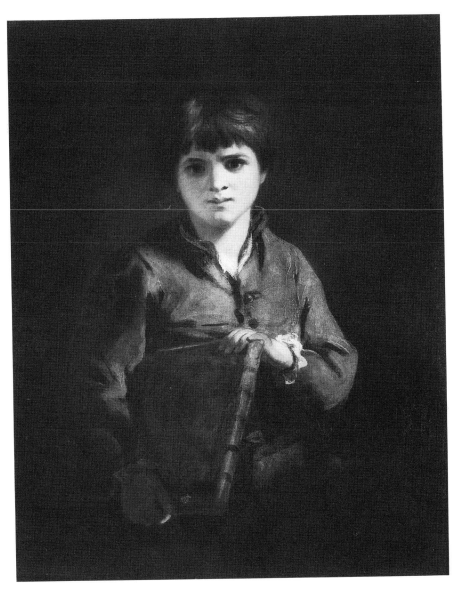

38 *A Boy with a Portfolio.*
Oil on canvas, 90 × 70 cm. *c.* 1775–6. Private Collection.

Lord Sackville purchased both works from Reynolds. Waterhouse noted how in *A Beggar Boy and his Sister* Reynolds combined Rembrandtesque *chiaroscuro* with elements of Spanish *picaresque* painting, reminiscent of Murillo (1946, p. 6). *A Beggar Boy and his Sister* depicts the 'net boy' and his young sister much as they must have appeared on the streets of London – selling cabbage nets. And yet, it is quite different from contemporary depictions of labourers such as Wheatley's *Girl Making Cabbage Nets at a Cottage Door* of 1786, where the industrious female net-maker is shown being eyed lustfully by a slobbish, soup-slurping, bumpkin (Webster, 1970, p. 134, cat. 53). Reynolds's painting, while it owes a firm allegiance to convention, retains an unnerving air of reality. As Patricia Crown acutely observes of such pictures, 'time and again there is a sense of the tension between recognition and suppression, between factual immediacy and poetic distance' (1984, p. 163). Reynolds's *Boy with a Portfolio* (plate 38), for example, and his *Boy Reading* (plate 39), which was exhibited at the Royal Academy in 1777, are both modelled on Reynolds's 'net-boy'. On the one hand, they are unpretentious records of a particular individual in a quite ordinary situation; on the other hand, the individual in question would not, in life, have had any use for a book or a portfolio – being unable to read or write. Less ambiguous, in terms of its relationship to reality, was the *Fortune-teller* – another painting involving the anonymous 'net-boy'. Here Reynolds combined the current popularity of the character of the gypsy fortune-teller (by then firmly established as a popular character in the masquerade) with his own painterly interests. Already in 1775, Reynolds had exhibited a portrait of the children of the fourth Duke of Marlborough, Lord Henry and Lady Charlotte Spencer, in which the young boy is depicted having his fortune told by his sister (Huntington Art Gallery, San Marino, California). Now, in the *Fortune-teller*, he located the subject within the old-master tradition, basing his composition on Caravaggio's *Fortune-teller* (Louvre) – a picture which the Duke of Dorset would have known well, as it then belonged to Louis XVI (Guttoso, 1981, cat. 14).

The extent to which the particular interests of Reynolds's patrons coloured his choice of subject matter is difficult to determine, although there is, for instance, a clear correlation between the extravagant tastes of the Duke of Dorset and those fancy pictures by Reynolds he purchased. Other patrons, too, appear to have selected fancy pictures suited to their own situation. One particularly intriguing example is *A Girl with a Dead Bird* (plate 40). In 1788 Francesco Bartolozzi engraved the picture in stipple, with the title 'Lesbia'. It has been presumed that Reynolds's

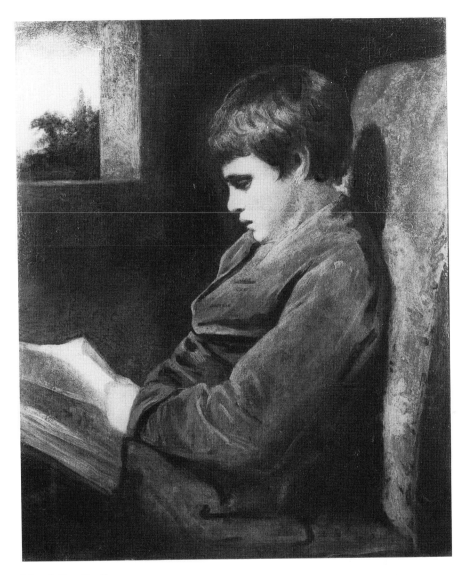

39 *A Boy Reading.*
 Oil on canvas, 76·2 × 63·5 cm. Exhibited at the Royal Academy, 1777.
 Private Collection.

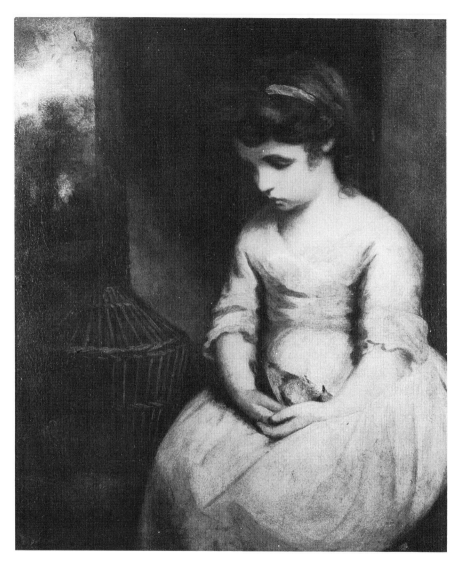

40 *A Girl with a Dead Bird.*
Oil on canvas, 73·7 × 61 cm. *c.* 1778–9. Private Collection.

picture was painted around the same time. It had, however, been painted at least ten years earlier and corresponds with the record in his sales ledger, 'Mr Banfield, for "A Girl with a Dead Bird"' (Cormack, 1970, p. 146). 'Mr Banfield' was John Codrington Bampfylde (1754–96), who in January 1778 and again in February 1779 had sat to Reynolds for a double portrait with his friend George Huddesford (Graves and Cronin, 1899–1901, vol. I, pp. 488–9). At the time, Bampfylde, an accomplished musician and poet, also fell in love with Reynolds's niece, Mary Palmer, dedicating several sonnets to her. She, however, rejected his advances, and the whole sorry affair culminated in Bampfylde's appearance in court following his arrest for lobbing stones through the windows of Reynolds's home in Leicester Fields (see Hudson, 1958, pp. 153–7; Lonsdale, 1988, pp. 18–19). Although the case was dropped, Bampfylde was by then deeply afflicted and rapidly lapsed into insanity, from which he only recovered just before his death from consumption in 1796. Although Reynolds gives no date in his ledger for Bampfylde's purchase of *A Girl with a Dead Bird* it must have been before the time of his arrest in March 1779. Bampfylde's painting is in every respect but one virtually identical to a second version bought from Reynolds in 1778 by George Hardinge (plate 41), along with *A Boy Reading* (plate 39).[32] In Hardinge's painting there is no bird in the girl's lap. The picture, when sold in 1801, was described as an 'idle girl in disgrace, seriously reflecting, and seemingly resolved upon future amendment' (sale catalogue, Christie's, 17 June 1801, lot 101). Hardinge's picture was, therefore, a suitable contrast to its pendant, *A Boy Reading*, the two paintings acting as allegorical commentaries upon the Hogarthian theme of 'industry' and 'idleness'. Through the addition of the dead bird and cage Bampfylde's painting took on a meaning more akin to Greuze's *Jeune fille qui pleure la mort de son oiseau* (Edinburgh, National Gallery of Scotland), where the young girl's loss of her pet bird symbolizes the heartache of unrequited love (Tinker, 1938, p. 52; National Gallery of Scotland, 1957, cat. 435, p. 113; Brookner, 1972, plate III). In Bampfylde's case, the allegory was especially poignant – although one can only wonder whether the choice of motif was suggested by Reynolds or the lovelorn Bampfylde.

From 1777 to 1779 Reynolds directed much of his energy towards his designs for the west window of the chapel at New College, Oxford, including the ambitious central panel of *The Nativity* to be discussed fully in chapter 4. Probable by-products were the series of paintings of small babies, including *A Cupid Asleep* (Earl of Carnarvon), exhibited in 1777; *A Child Asleep* (Earl of Aylesford), exhibited in 1781; *Moses in the Bullrushes*

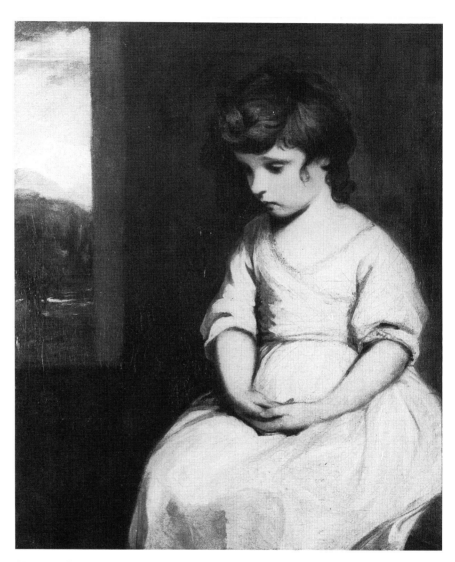

41 *A Girl Crying.*
 Oil on canvas, 75 × 61 cm. 1778. Private Collection.

(private collection) and *A Child with Guardian Angels* (unlocated), shown at the Royal Academy in 1786 (see Postle, 1989, catalogue, pp. 21–2, 27–8, 105–6). Although he adapted the subject matter in different ways, his studies of babies provided Reynolds with an extensive opportunity to paint flesh tones. (Reynolds even used a small baby as model to assist him in painting the flesh tones of his *Venus* of 1785 (Cotton, 1859a, p. 55).) The various studies of babies and small children culminated in *The Infant Academy*, which he exhibited at the Royal Academy in 1782 with the prosaic title, 'Children' (colour plate 8).[33] The following year Francis Haward's engraving of the picture was published with the more familiar title *The Infant Academy*. The painting itself remained in Reynolds's gallery, where its presence was commented upon by a correspondent for *The World* on 9 January 1787: 'Bye the bye, of the Infant Academy – how came Mr *Boswell* & Mrs *Piozzi*, both of whose books we profess most politely to *like* – how came they to forget, that this pretty whimsical figure, had its *name given* by Samuel Johnson?' Johnson had died in 1784. The two books referred to by the critic of *The World* – *The Journal of the Tour to the Hebrides* by James Boswell and Hester Piozzi's *Anecdotes of the Late Samuel Johnson, LL. D., during the Last Twenty Years of his Life* – were published in 1785 and 1786 respectively. The suggestion that Johnson was the author of the title of *The Infant Academy* is an interesting one, not least because of the existence of a fancy picture by Reynolds known as *The Infant Johnson*, which depicted a small child similar to those found in *The Infant Academy*. Evidence suggests that Reynolds may have intended *The Infant Johnson* as a kind of *Jüngen-Legend*, whose Herculean status in manhood could be traced back to infancy.[34] That being so, there is no reason why Johnson, himself, may not have taken enough interest in Reynolds's *Infant Academy* to provide a title for it. Nor is there any reason to suppose that the information provided by the correspondent of *The World* was not provided by Reynolds, who habitually allowed critics (notably from *The World*) into his own gallery. If, indeed, the child represented in *The Infant Johnson* was his old mentor, is it not feasible that Reynolds had intended the child-artist in *The Infant Academy* as a retrospective satire on his own vocation?

According to *The St James's Chronicle* (30 April 1782), *The Infant Academy* 'was painted immediately on his Return from Flanders', – that is in September 1781. 'He seems', it continued, 'to have recollected at the Time all the beauty and force of colouring so characteristic of the Flemish School.' Although the picture's colour was indebted to Rubens, the subject and its treatment were far closer to more recent confections by Boucher, Van Loo, and Amigoni, as well as his own *Venus Chiding Cupid* of 1771. An

important precedent for Reynolds's painting, as Rosenblum has observed, was Carle Van Loo's *Allegory of Painting* (Mildred Anna Williams Collection, Fine Arts Museum of San Francisco) of 1753.[35] The principal difference between Reynolds's infant model and that of Van Loo, notes Rosenblum, is the infant model's fashionable headdress – a feature commented on by contemporaries as an error of judgement. *The Morning Herald* stated that 'the one with the cap on is too violent an approach to caricature to be tolerated as representative of infancy', while *The St James's Chronicle* (30 April 1782) suggested that 'a wreath of flowers on the girl's head would have been better than a cap, as the fashion of caps is perpetually changing'. (Hannah More would have approved of Reynolds's satire, observing at the time 'the foolish absurdity of the present mode of dress. Some ladies carry on their heads a large quantity of fruit, and yet they would despise a poor useful member of society, who carried it there for the purpose of selling bread' (in Roberts, 1834, vol. I, p. 65).)

While it was not Reynolds's intention to pour scorn on the upper echelons of society, he was, through the device of the hat, evidently commenting on the way vagaries of fashion impinged upon his desire to produce a more elevated portrait-image. 'The witty mixture of high-seriousness', states Rosenblum, 'and the true-life facts of the learned artist confronted with the perpetual demand for high-style portraiture is virtually a comment, couched in French Rococo language, on the amusing disparity between the lofty pretensions of the Royal Academy and the realities of British patronage and practice' (in Penny, 1986, p. 47).

Aside from *The Infant Academy* Reynolds exhibited one other fancy picture in 1782, entitled 'Girl' (plate 42), a picture which has not hitherto been identified. It is, however, possible to link the picture to an existing composition by Reynolds known as *A Girl Leaning on a Pedestal* or *The Laughing Girl*. Of the picture exhibited as 'Girl', the self-styled 'Fresnoy', writing in *The Public Advertiser* on 30 April 1782, stated that it was 'a female head painted for Mr. Campbell as a companion to his Rembrandt' (see also Whitley, 1928a, vol. II, p. 391). It has been suggested that around 1780 Reynolds painted a copy of Rembrandt's *Girl at a Window* (Dulwich Picture Gallery) – a picture which has also been erroneously linked with a version of the painting now in the Hermitage.[36] It has been further suggested that the Rembrandt copy was the same 'Girl' exhibited by Reynolds at the Royal Academy in 1782 (Waterhouse, annotation to Graves and Cronin, 1899–1901, vol. III, p. 1119; White, *et al.*, 1980, p. 39; Brown, ed., 1992, p. 35). However, rules drawn up in January 1769 clearly stated that no 'Picture copied from a Picture or Print, a Drawing

42 *A Girl Leaning on a Pedestal* ('*The Laughing Girl*').
 Oil on canvas, 75 × 62·2 cm. Exhibited at the Royal Academy, 1782, as 'Girl'.
 Private Collection.

from a Drawing, a Medal from a Medal ... or an Copy be admitted in the Exhibition' – a convention which Reynolds, as president of the Royal Academy, was unlikely to flout (Hutchison, 1968, p. 54). A clue to the exhibited painting's true identity can be found in the exhibition review in *The London Courant* on 10 May 1782, which noted: '198. Girl. Sir J. Reynolds. A sweet picture. The arch and comic look of the girl is peculiar to Sir Joshua's pencil'. There is only one composition – known as *The Laughing Girl* – which matches the description in *The London Courant* – although it exists in two distinct versions (see Postle, 1989, catalogue, pp. 44–9). Although it is not known who owned the painting in 1782, the intriguing possibility exists that Reynolds painted his own *Laughing Girl* (which he referred to in his ledgers as a 'Girl leaning on a pedestal' (Cormack, 1970, p. 161)) as a companion to Rembrandt's *Girl at a Window*, which may in turn have belonged to 'Mr Campbell'.[37] It is also significant that *The Laughing Girl* is formally related to *The Infant Academy* of 1782, as she is virtually a reversal of the figure of the young girl at the right-hand corner of that painting.

In addition to the version of *The Laughing Girl* painted for Campbell, Reynolds produced a second version in which a different young girl is shown in an identical attitude, but dressed in grey rather than white, and wearing a headband (colour plate 9). Both Viscount Palmerston and Lord Carysfort purchased copies of the painting, which was engraved in 1784. The exhibited version of *The Laughing Girl* was not, however, engraved until 1813. It was however reproduced towards the end of the 1780s in the form of a 'polygraph' – a process which involved stretching a silk screen across the original painting, tracing the design, and then squeezing colour through the screen onto a blank canvas. The first exhibition of the Polygraphic Society opened on 28 May 1784 at the home of Joseph Booth, at 6 Upper James Street, Gordon Square, and by 1787 had moved into more prestigious quarters in the Strand. On 28 July that year *The Times* reported that 'Sir Joshua is now employed on a capital picture for the Polygraphic Society.' In 1791 the Society, by then established in Richard Cosway's house in Pall Mall, held its eighth exhibition, where Reynolds's *Laughing Girl* was exhibited alongside other fancy pictures, including Joseph Wright's *Boy Blowing a Bladder by Candle-light*, John Opie's *Blind Beggar and Daughter*, as well as works by Rubens, Claude Lorrain, and Greuze. At the exhibition, each original painting was shown alongside a polygraph, versions of which could be purchased for 7 guineas (which probably accounts for the continual appearence of 'copies' of *The Laughing Girl* on the art market) (see Graves and Cronin, 1899–1901, vol. III,

43 George Engleheart (after Sir Joshua Reynolds), *A Boy Laughing*.
 Watercolour on ivory, 6·1 × 5·4 cm (oval). 1778. Private Collection.

pp. 1167–8). Although polygraphs remained in vogue during the early
1790s and spawned a number of imitations (such as the Mimeographic
Society), the proprietor of the Polygraphic Society, Thomas Goddard, died
in 1795, and the original paintings were auctioned off. John Opie bought
Reynolds's *Laughing Girl*, which was in turn auctioned off after Opie's death
in 1807. It was described at the time, in the sale catalogue as uniting 'all
the great merits of REMBRANDT with the taste and beauty of CORREGGIO'
– an accurate summary of Reynolds's intentions in painting the picture.[38]
 The identification of *The Laughing Girl* as the picture exhibited by
Reynolds at the Royal Academy in 1782 gives added significance to the
exhibition of *A Boy Laughing* by Reynolds the previous year. Like his 'Girl',
this painting was also presumed to have been lost. However, it is possible
to identify it via a copy in miniature by George Engleheart, who worked in

Reynolds's studio in the late 1770s. The miniature in question depicts a laughing boy, in profile (plate 43). Engleheart, who kept a record of his miniatures and of the year in which they were executed, noted having painted the 'Boy laughing' in December 1778.[39] Compositionally the work bears a close resemblance to Reynolds's *Infant Samuel*. Like *The Infant Samuel*, the boy wears a white shift, and is shown from the waist up, in profile with his hands joined in prayer. The principal difference, as the title of the picture suggests, is that he is laughing. (Dr Beattie, who saw the picture at the Royal Academy, described it as 'a Boy, supposed to be listening to a wonderful story' (in Leslie and Taylor, 1865, vol. II, p. 328).) The identification of the picture as *A Boy Laughing* of 1781 is further strengthened by the record made by Reynolds in his sales ledger in July 1781 of the sale of a 'Laughing Praying Boy' to John Brummell for 50 guineas.[40] No full-size picture by Reynolds corresponds with Engleheart's miniature, although there is a cut-down fragment which closely resembles the head of the figure (Postle, 1989, catalogue, pp. 14–15).

A Boy Laughing and *The Laughing Girl* were evidently intended as pendants. It was probably in the same spirit that during, or just before, 1784 he turned to a picture which he had painted almost forty years earlier – *A Boy Reading* of 1747 (plate 44) – as the basis of a composition engraved that year as 'The studious boy' (plate 45). Although well known today, *A Boy Reading* of 1747 was never engraved or exhibited during Reynolds's life-time (see Mannings in Penny, 1986, p. 169). Even after his death it was not retained by the artist's family, but sold at Reynolds's studio sale in 1796 to Sir Henry Englefield for the comparatively small sum of 35 guineas. (The later *Studious Boy* was, however, selected as a keepsake by Philip Metcalfe from the remaining contents of the studio, shortly after Reynolds's death.) Despite the relative obscurity of *A Boy Reading*, Northcote explained Reynolds's renewed interest in the paintings of his youth, 'particularly one of a boy reading by reflected light, and several others which are undoubtedly very fine, as he himself acknowledged on seeing them at the distance of thirty years; when he lamented that in so great a length of time he had made so little progress in his art' (Northcote, 1818, vol. I, pp. 20–1) Reynolds, in fact, had returned several times before the 1780s to this format, notably in *A Girl Reading* of 1771 and *A Boy Reading* of 1777, although without the same conscious reliance on his own earlier composition.

Reynolds's *Boy Reading* of 1747 had been painted as a youthful exercise in the manner of Rembrandt, imitating not only Rembrandt's reliance on the strong contrast of light and shadow but on the content of his work. (It

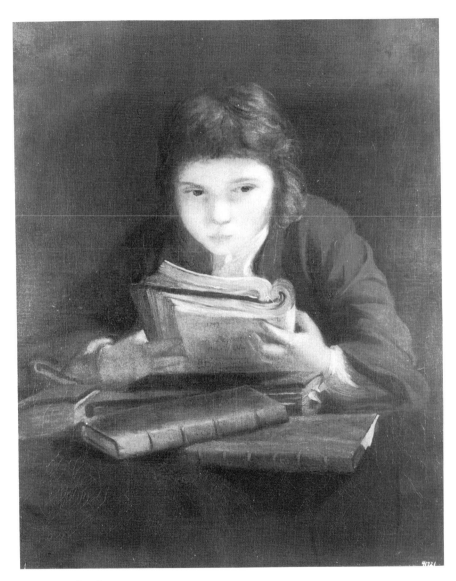

44 *A Boy Reading.*
Oil on canvas, 78·7 × 63·5cm. Inscribed ʿ1747/J. Reynold/Pinxit Novʾ.
Private Collection.

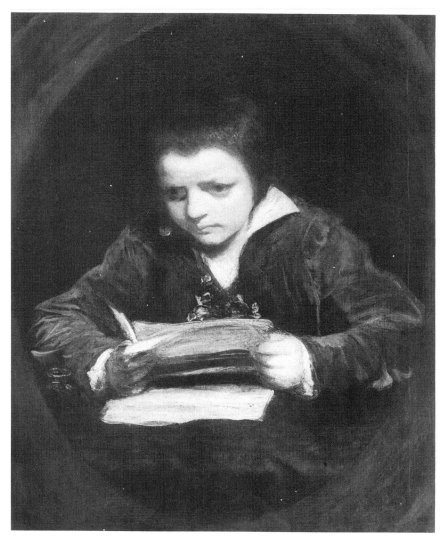

45 *The Studious Boy.*
 Oil on canvas, 76·2 × 63·5 cm. *c.* 1784. Unlocated.

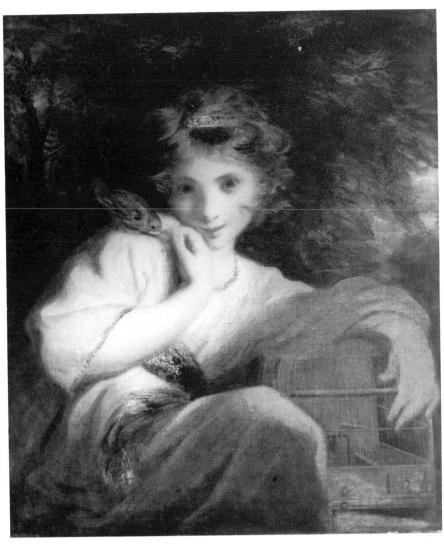

46 *Lesbia* ('*Robinetta*').
 Oil on canvas, 76·2 × 63·5 cm. *c.* 1785–6. Lord Sackville.

has been suggested that Rembrandt's portrait of *Titus Reading* (Rotterdam, Boymans van Beuningen Museum), which may have passed through the London salerooms in 1747, acted as a formal influence on Reynolds's picture.[41]) *A Boy Reading* is also similar to two other works by Rembrandt – his etched self-portrait by a window (of which Reynolds made a small sketch) and the figure of the young boy in *The Mathematician* (Chequers), which was engraved by James McArdell.[42] In the later *Studious Boy* Rembrandt remained the dominant influence on Reynolds, although the later picture is far more sumptuously painted, as the muted browns of the earlier picture are displaced by bright complementary colours of the scarlet jacket and green cushion.

The sensuous treatment of colour in Reynolds's fancy pictures of the 1780s was matched by the heightened air of sensuality present in a group of fancy pictures depicting girls holding small animals. These include *Felina* (Institute of Fine Arts, Detroit, Michigan), *Muscipula* (plate 49), and *Lesbia*. The principal version of *Lesbia* (plate 46) – which is more commonly known as *Robinetta* – was purchased in 1786 by the Duke of Dorset.[43] As with earlier fancy pictures, the face of the model in *Lesbia* appeared with the identical expression in at least one other work known as *A Girl Warming her Hands* (plate 47) – suggesting that Reynolds had initially painted the face and added the figure on a separate occasion.[44] Indeed, the practice went even further to the 1760s, when Reynolds had painted two pictures of the courtesan Nellie O'Brien in two different guises but with the identical expression.[45] In one picture she is shown leaning on a bas-relief of Jupiter and Danae (University of Glasgow), while in the other, a smaller oval painting (private collection), she holds a robin to her breast. Given the subject matter of these two pictures – and the fact that they were not commissioned portraits – they stand as precursors of *The Laughing Girl* and *Lesbia*. The principal difference between the paintings of the 1760s and the 1780s was that Reynolds flagrantly invested his allegories of love in the figures of young girls rather than young women.

The version of *Lesbia* sold to the Duke of Dorset – as relevant to his predilection for innuendo as *Cupid* and *Mercury* – was described by Reynolds, in his sales ledger, as *Lesbia* – a title also appended to Bartolozzi's 1788 stipple engraving of *A Girl with a Dead Bird* (see Cormack, 1970, p. 151). Historically, Lesbia was the lover of the Latin poet Catullus (*c.* 84–54 BC), who inspired the twenty-five Lesbia poems, including one on the death of her pet sparrow. Allegorically, the depiction of a live sparrow in the hands of a young woman signified promiscuity, owing to popular notions concerning the bird's breeding habits. In Lord Sackville's

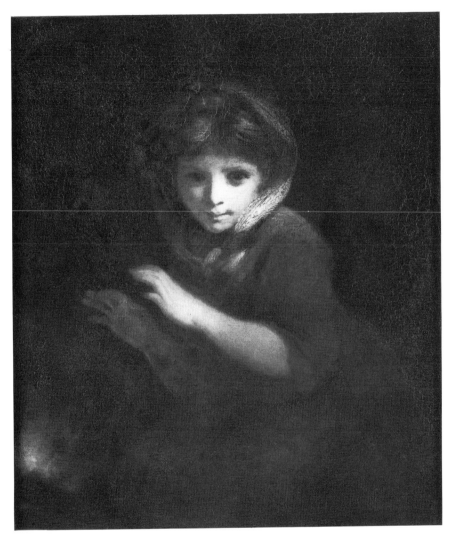

47 *A Girl Warming her Hands.*
 Oil on canvas, 76·2 × 63·5 cm. *c.* 1784–6. Private Collection.

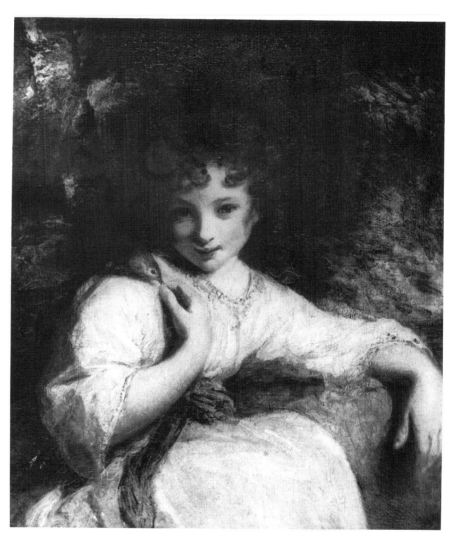

48 *Robinetta.*
 Oil on canvas, 75 × 62·2 cm. *c.* 1786. Private Collection.

picture, as well as in the studio version now in the Tate Gallery, the small bird near the girl's hand is clearly a sparrow rather than a robin, or the dove (a symbol of constant love). The girl leaning over the birdcage in the present picture wears a classical white robe trimmed with gold, reinforcing the allegorical aspect of the painting. The motif of the caged animal or bird had long been recognized as an allusion to captive love, both in England and on the Continent. Reynolds himself had used the motif in his portrait of Miss Sarah Child (Earl of Jersey), shown at the Royal Academy in 1773 – although there, as one would expect, no reference was made , via the girl's expression or attitude, to the subject's burgeoning sexuality. Similarly, in *c.* 1786 Reynolds painted a variation of *Lesbia* for Lord Tollemache (plate 48), which he refers to in his sitter-book for 1786 as 'Robin Readbreast', and engraved the following year as 'Robinetta', the title by which Lord Sackville's *Lesbia* is now more commonly known (Hamilton, 1874, p. 117). Although similar to Lord Sackville's *Lesbia*, the substitution of the lecherous sparrow for the altogether more wholesome robin redbreast of children's fairy-tales was presumably intended to play down the association of sexual promiscuity. The reason was possibly that the sitter was not an anonymous beggar-child but a young relation of Reynolds's patron (although she was not – as it has been suggested – his wife).[46]

Muscipula (private collection), which depicted a young girl gloating over a caged mouse (which is in turn being eyed by a predatory cat), was conceived during the same period, and in a similar spirit to *Lesbia*. The image was derived from a genre which had been extensively exploited by seventeenth-century Dutch artists such as Gerard Dou and Adriaen van der Werff, examples of whose work Reynolds had seen on his recent visit to the Low Countries (see Malone, 1819, vol. II, esp. pp. 345–74). As Peter Sutton has noted, 'for classical authors the trapped mouse was a metaphor for unpunished immoderation, an idea that was given a more specifically amorous meaning in Dutch literature: as the mouse sacrifices its life for treats, the man pays for stolen kisses with his heart' (1984, p. 357). The closest parallel to Reynolds's *Muscipula* is Adriaen van der Werff's *Boy with a Mousetrap* of 1676 (private collection), although the resemblance is probably generic rather than specific. However, van der Werff's picture did have a pendant, now lost, incorporating a caged bird, which suggests in turn that Reynolds's *Lesbia* and *Muscipula* were also planned as pendants. (Reynolds would, in any event, have been acutely aware of the symbolism of the caged bird through his familiarity with seminal iconographical texts such as Jacob Cats's *Book of Emblems*.[47])

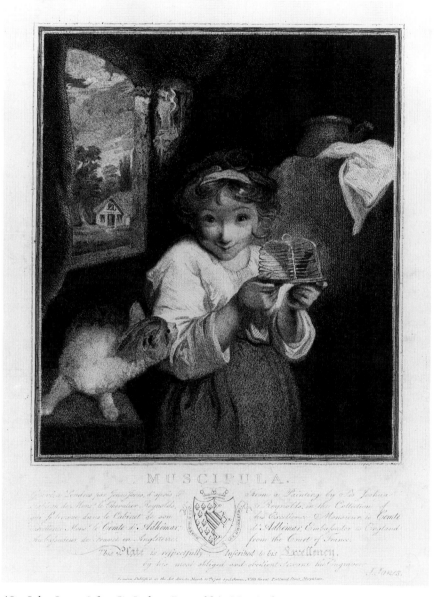

MUSCIPULA.

49 John Jones (after Sir Joshua Reynolds), *Muscipula*.
 Stipple engraving 28 × 23·5 cm. 1786. The Trustees of the British Museum.

Muscipula was completed by early in 1785, as on 12 January *The Public Advertiser* noted that 'Sir Joshua has finished a fancy picture for the ensuing exhibition, of a peasant girl, with a mouse trap in her hand and a cat on a stool looking up at it, in the manner of Rembrandt.' The picture was not exhibited, however, and its subsequent absence from the 1785 exhibition was bemoaned by one critic, who had seen it on view in Reynolds's gallery: 'Bye the bye, the President might have exhibited even more largely than he has done. The beautiful picture of the Mousetrap Girl would have added much to the attention of the room.'[48] The picture was not exhibited in public during Reynolds's lifetime, being purchased by the French ambassador, Count D'Ademar.[49] As with *Lesbia*, the painting's appeal clearly revolved around its promotion of sexual innuendo. *The Morning Herald* observed (29 May 1785): 'The French Ambassador has purchased Sir Joshua Reynolds's picture of the Mouse-Trap Girl. A trap baited with a girl, is surely sufficient to catch the Viceroy of the kingdom of gallantry.' Yet, as Patricia Crown observes, there is a more unsettling aspect to such images, the sexual exploitation of young girls through child prostitution in eighteenth-century London lending 'a more sinister cast to the repeated use of adjectives like "pretty" and "charming" used in describing the children in fancy pictures' (1984, p. 164). Although Lord Sackville (Count D'Ademar's counterpart in England) was not in this instance the purchaser of the picture, his influence in promoting Reynolds's work within the French court is significant. In turn, the purchase of the picture by a French buyer serves to emphasize the close attention which Reynolds paid to continental trends and tastes during the 1780s.

Although initially purchased by D'Ademar, *Muscipula* remained in England, being purchased at his sale in 1788 by the sybaritic Whig politician, Charles James Fox. It was, in any case, already accessible to a wider audience through the stipple engraving by John Jones (plate 49) published in 1786 (the present title of the painting derives from the inscription on the engraving) (Hamilton, 1874, p. 115). As it was noted in the previous chapter, the print market played an important role in the promotion – and interpretation – of Reynolds's work. Indeed, its impact on the reception of Reynolds's fancy pictures was more marked than in any other sphere of his output. Moreover, John Raphael Smith, who produced a number of mezzotints after Reynolds's pictures, did more than anyone to enlarge the market for the print in the 1770s (see Godfrey, 1978, pp. 53–4). Working as a publisher, Smith encouraged the expansion of the stipple engraving, and exported thousands of prints, at times hand-

coloured, to the continent. The function of such prints was chiefly decorative. More important than the quality of the impression or the rarity of the print was its suitability to the sensibilities and reading habits of the burgeoning middle-class audience (see Alexander, 1992, *passim*). Increasingly prints based on subject pieces by Cipriani and Angelica Kauffman and the novels of Sterne and Prior adorned the walls of bourgeois homes in the same way as old-master paintings based on secular and sacred mythology hung in the grander establishments of their aristocratic counterparts. Reynolds, although influenced by this trend, was, like other artists, subject to the vagaries of the market, as James Northcote recalled: 'It was impossible to tell before hand what would hit the public. You might as well pretend to say what ticket would turn up a prize in the lottery. It was not chance neither, but some unforeseen coincidence between the subject and the prevailing taste, that you could not possibly be judge of' (in Hazlitt, 1830, p. 145). Earlier in his career Reynolds had regarded the print as a secondary work of art which could serve to advertise his portraits. By the 1780s both portraits and fancy pictures were increasingly quarried by engravers and publishers to satisfy the demands of an ever-expanding audience for prints. It is ironic that Reynolds's works, which ransacked the past in order to elevate his *œuvre* were now used to fuel popular tastes which ultimately undermined his goals for educating his audience in high art. By the 1780s Reynolds's portraits of children were as liable to be presented as fancy pictures as those works which genuinely aspired to the genre. In 1789 Reynolds painted a portrait of the two-year-old Francis George Hare (1786–1842) (Louvre). The following year it was engraved as 'Infancy'. In 1791 his portrait of the Lamb brothers (Earl Cowper) was engraved by Bartolozzi as 'The affectionate brothers', while a painting of his great-niece, exhibited at the Royal Academy in 1789 as a 'Portrait of a young lady', appeared as a print entitled 'Simplicity'. Even earlier portraits were resurrected at the end of Reynolds's life to serve as surrogate fancy pictures. In 1761, for example, Reynolds had painted a double portrait of Amabel and Mary Jemima Yorke (Cleveland Museum of Art). In 1762 the painting was engraved in mezzotint by Edward Fisher. In 1792, however, Mary Jemima (seen in the original picture holding a dove) was engraved as a single figure in stipple by John Ogborne, with the title 'Protection'.

Initially taken up as a means of bridging the gap between the more routine concerns of portrait painting and his concerns with imaginative art, Reynolds's fancy pictures had by the late 1780s touched almost every aspect of the taste of his peers. And yet it was ultimately for his own

50 *A Sleeping Girl.*
Oil on canvas, 73·7 × 61 cm. Exhibited at the Royal Academy, 1788.
Unlocated.

pleasure and instruction that he produced such works. Towards the end of his career, in 1788, he exhibited *A Sleeping Girl* (plate 50) at the Royal Academy. Although the girl's attitude echoes his *Laughing Girl*, painted at the beginning of the decade, there was no attempt here at characterization. Formal aspects – light and colour – were the artist's exclusive concerns. Walpole, perhaps disenchanted by Reynolds's exploration of technique at the expense of sentiment, thought it 'coarse' (Graves, 1906, vol. IV, p. 276). Opie and Northcote, who had the responsibility of hanging works at the Academy that year, also encountered problems with the work. 'We found', recalled Northcote, 'great difficulty in placing it, being so powerful in effect that it seemed to annihilate every picture near it' (quoted in Graves and Cronin, 1899–1901, vol. III, p. 1209). And when it was shown, at least one critic felt that Reynolds had outpaced his audience:

To insist on the merits of this performance would be superfluous – it may be remarked, however, that this piece in the Pictorial line, like the refined wit in the Drama, may be considered as Caviare to the multitude. Few would applaud, were they not instructed to do so. In the contemplation of such performances, admiration, not sympathy, is the tribute we pay to genius. (quoted in Graves and Cronin, 1899–1901, vol. IV, p. 1480BBB)

The following summer, on 27 July 1789, *The Morning Herald* carried the following report:

Sir Joshua has mentioned to several of his friends that his practice in the future will be very select in respect to portraits, and that the remnant of his life will be applied chiefly to fancy subjects which will admit of leisure and contribute to amuse. Sir Joshua feels his sight so infirm as to allow his painting of about thirty or forty minutes at a time only; and he means in a certain degree to retire.

On 13 July, Reynolds had experienced a partial loss of vision in his left eye. A week later, on 20 July, 'children' appeared for the last time in his sitter-book – and his studio.

3 'Patriarchs, Prophets and Paviours': Reynolds as a history painter, 1770–1773

> I long to see you a History Painter. You have already done enough for the Private, do something for the Publick; and be not confined, like the rest, to draw only such silly stories as our own faces tell of us. (Sherburn, 1956, p. 377)

These sentiments, expressed in 1716 by Alexander Pope to the portrait-painter Charles Jervas (c. 1675–1739), would have been equally appropriate to Reynolds as he assumed the presidency of the Royal Academy in 1768. From this time onwards the public aspect of Reynolds's art assumed an increasing significance within his *œuvre*. Up to the late 1760s Reynolds, although he had propagandized through pictures like *Garrick between Tragedy and Comedy*, had not been required to play the role of didact, and as a result his choice of subject matter was largely dictated by the circumstances of his profession. Through the presidency, however, Reynolds was catapulted from the essentially passive role of *primo inter pares* to the far more self-conscious position of spokesman for the burgeoning British School. It was incumbent upon Reynolds as a public figure to actively endorse a 'public' art form – high art. One way in which Reynolds drew attention to the pre-eminence of high art was through his *Discourses*. And yet his practice, it has often been asserted, did not match his rhetoric. Between 1769 and 1773, however, Reynolds exhibited thirteen subject paintings, in addition to thirty-seven portraits. In the last chapter the role of the fancy picture was evaluated within Reynolds's *œuvre*, including several works of this period. Now, within the context of Reynolds's public position as president of the Royal Academy and ideas expressed in the *Discourses*, I would like to consider the circumstances surrounding the evolution of Reynolds's first major history painting, *Ugolino and his Children in the Dungeon* of 1773, as well as the various related studies of old men's heads, which form the nucleus of his initial venture into high art.

In 1758 Hogarth told James Caulfeild, first Earl of Charlemont, who had just purchased an 'old man's head' attributed to Rubens, how easy it was to fake such pictures:

Recipe an old bit of coarse cloth and Portray an old bearded Beggars head upon it with the features much in shaddow make the eye red and row some slurrs of the

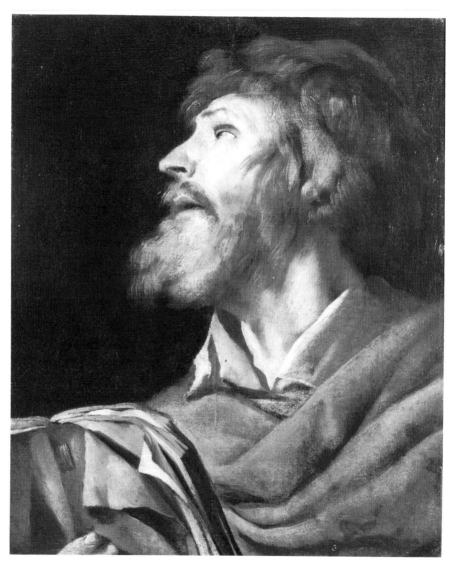

51 *Joab.*
 Oil on canvas (laid on panel), 55·8 × 44·5 cm. *c.* 1773. Private Collection.

Pencill by way of freedom in the beard and band clap a vast splash of light upon the forehead from which gradate by degrees from the Blacking pot, varnish it well, and it will do for Langford or Prestage. I scarce ever knew a fizmonger who did not succeed in one of these masterpieces. One old Peters famous for Old Picture making, use[d] to say, even in contempt of those easiest parts of Rubens productions that he could sh-t old mens Heads with ease.[1]

Reynolds had painted his first 'old men's Heads' in Rome in 1750, including a copy of a Rubens.[2] He had also been buying similar pictures from the dealer, Prestage, since at least the early 1760s.[3] And in 1766 – as his sitter-book shows – he employed a beggar to model for an 'old head' of his own.[4] It was a practice which he turned to with increasing frequency in the years immediately following the foundation of the Royal Academy.

An old head, known as *Joab* (plate 51), has long been thought to be among Reynolds's earliest works in this genre, the suggestion being that it was copied in Rome from a painting by one of the Carracci (Graves and Cronin, 1899–1901, vol. III, p. 1241). And yet as a comparison reveals, it was actually based on a painting imported into England in 1773 by Henry Temple, second Viscount Palmerston (plate 52) (see Goodison and Robertson, 1967, vol. II, p. 16). Currently described as a 'hermit' and ascribed to Federico Bencovich, the picture was in the eighteenth century believed to be by Domenico Fetti. Given Lord Palmerston's friendship with Reynolds by the 1770s (they corresponded in 1773), it seems likely that Reynolds produced his version around this time, rather than during his Roman sojourn. Another reason to assume that Reynolds's picture dates from the 1770s is that it is not simply a straightforward copy. The features of the hermit are noticeably more haggard than Reynolds's *Joab*, while Reynolds, in an attempt to dissociate the figure iconographically from St Jerome, has replaced the *memento mori* by a large tome. The reasons for the divergence between the two pictures can be located in Reynolds's theories concerning the nature of imitation. In his second *Discourse* of December 1769 Reynolds stated:

What I would propose is, that you should enter into a kind of competition, by painting a similar subject, and making a companion to any picture that you consider as a model. After you have finished your work, place it near the model, and compare them carefully together. You will then not only see, but feel your own deficiencies more suitably than by precepts, or any other means of instruction. (in Wark, 1975, p. 31)

Reynolds, as in his fancy pictures, regarded pictures such as *Joab* as 'companions' rather than copies. Ellis Waterhouse noted of Reynolds's

52 Federico Bencovich, ascr., *A Hermit*.
Oil on canvas, 72·7 × 61·2 cm. The Syndics of the Fitzwilliam Museum,
Cambridge.

fancy pictures, to which *Joab* can be favourably compared, that they 'were
designed to be able to be hung as companions, or at least acceptable
neighbours, in galleries in which nothing but old masters were normally
admitted' (1973, p. 26). *Joab*, when it belonged to the Duke of Marlborough
during the nineteenth century, occupied such a position (see Scharf, 1860,
p. 42). By generalizing the features of the 'Bencovich' hermit, Reynolds
was surely expressing in pictorial terms a central tenet of the *Discourses*
concerning the need for the history painter to transcend the features of the

individual model in order to create an archetype which could in turn promote the moral argument of the piece. It was a point which Reynolds reaffirmed towards the end of his life in 1791. That year Reynolds included in an exhibition of his old-master collection a study for an old head by Ludovico Carracci in *St Antony and his Disciples*, then in S. Antonio, Bologna. Ludovico Carracci was an artist whom he had particularly recommended to students in the *Discourses*. In the catalogue which accompanied the exhibition Reynolds observed:

In the finished picture, all the more minute parts which are here expressed, are there omitted; the light part is one broad mass, and the scanty lock of hair which falls on the forehead, is there much fuller and larger. A copy of this picture, seen at the same time as this, would be a good lesson to students, by shewing the different manners of painting a portrait, and an historical head; and teach them at the same time, the advantage of always having recourse to nature.[5]

In 1770, at least three years before he painted *Joab*, Reynolds had come across an old man in London called George White, who possessed those features which he had observed, and evidently admired, in old-master paintings of patriarchs and saints – as John Jehner's engraving of Reynolds's lost painting of this model clearly shows (plate 53). During the early 1770s Reynolds used White as a model in number of subject pictures, the most ambitious being *Ugolino and his Children in the Dungeon*, exhibited at the Royal Academy in 1773. Suitable models of White's vintage were apparently uncommon in Britain, a problem which the Scottish artist David Allan reported to Gavin Hamilton in Rome:

Great Britain has some advantages, and some disadvantages. The youth of both sexes are in general well-formed, and of graceful proportions; but in the middle stages of life, and in old age, our natural models are greatly deficient, both in action and expression. We rarely see in this country a countenance like that of a Franciscan, or an Italian beggar, so full of character and expression, and so useful to the study of History-Painting. (Dedication by David Allen to Gavin Hamilton, in Ramsay, 1788, p. i)

Reynolds was fortunate in finding George White almost on his own door-step, although his infrequent excursions from his studio by day suggest that it was not a chance encounter.[6] White, principally through his promotion by Reynolds, achieved brief notoriety during the 1770s, his personal history being recounted in *The European Magazine* of 1803, by

55 *The Captive*.
 Oil on canvas, 76·2 × 63·5 cm.? mid-1770s. Lord Lambton.

56 *Pope Pavarius.*
 Oil on canvas, 76·2 × 63·5 cm. *c.* 1772–4. The Corporation of London.

57 Nathaniel Hone, *The Conjuror*.
Oil on canvas, 145 × 173 cm. 1775. The National Gallery of Ireland.

England and on the Continent. John Hamilton Mortimer, Joseph Wright, and Benjamin West all produced similar graphic depictions of the emaciated figure languishing in a dank cell.[11] Reynolds's *Captive* (plate 55) is quite different, and contains no specific allusion within the work to Sterne's text, aside from the woebegone expression on the model's face. The painting was also variously known as *Caius Marius*, *A Study from Nature*, and – not inappropriately – the *Banished Lord*; a point which suggests that Reynolds did not necessarily have Sterne's prose in mind when he painted *The Captive*, even though he sanctioned such an association via the medium of engraving.

Reynolds's old men were essentially generic, and 'form' was invariably

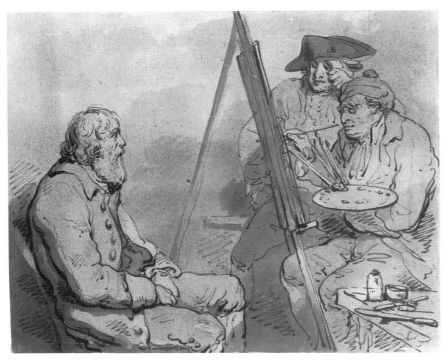

58 Thomas Rowlandson, *The Artist's Studio*.
 Pen, ink, and wash, 15·9 × 19·7 cm. Private Collection.

more important than 'fable' in their conception. Some of them did,
however, have specific points of reference. One, for example, shows George
White in an improbable ermine-trimmed crimson mantle (plate 56), an
image which was ultimately derived from papal portraits by Raphael and
Titian. Long mistitled the *Banished Lord*,[12] what may have been Reynolds's
original title – *Pope Pavarius* – appears in the fee book of George Engle-
heart, who made a miniature of the painting while he was a pupil in
Reynolds's studio.[13] The tongue-in-cheek title referred to White's former
trade as a pavior. In this respect it was similar in intent to Nathaniel
Hone's lost painting, *Saint Pavarius*, which also featured George White. In
the catalogue of his 1775 one-man show Hone stated: 'St. Paviarius [*sic*],
the head finished at once [*sic*] painting, from the head of the same man
who sat for the conjuror. This poor but honest fellow was formerly a
pavior, for which reason he is thus named, as heretofore have been
St. Veronica, and St. Christopher, from some particular action' (1775,
cat. 54, p. 7 (copy deposited in the Tate Gallery library)).

Hone's most celebrated use of White was in his infamous painting, *The Conjuror* (plate 57). It was rejected by the Hanging Committee of the Royal Academy in 1775, on the grounds that it contained among other things an indecent allusion to Angelica Kauffman dancing naked round a cauldron. The principal target, however, was Reynolds, for the eponymous conjuror was Reynolds's old model who, dressed as a wizard, was depicted waving a wand over a series of dog-eared prints after the old masters. It was – as Reynolds must have been aware – a cleverly constructed satirical attack not only on Reynolds's frequent borrowing of attitudes from old masters for his portraits, but on his extensive use of the thinly disguised figure of George White in his subject paintings.[14]

A further satirical reference to Reynolds's penchant for investing his old models with patriarchal status may underlie Thomas Rowlandson's drawing, *The Artist's Studio* (plate 58), which is curiously reminiscent of one particular encounter in Reynolds's studio between a connoisseur and George White, recorded by Joseph Moser:

This gentleman was, with his family, viewing the pictures in the Exhibition Gallery, Leicester Fields. Sir Joshua respectfully attended them. The head of Old George the pavior (so frequently depicted in Count Ugolino, Belisarius, and other characters), particularly struck him. He examined the portrait with his glass, retired, advanced, and then with much solemnity and importance, exclaimed to the knight: 'Fine! very, indeed! Character – dignity! Only a pavior, and have such a head! Singular, very singular! Why I think, Sir Joshua, that a head is a very capital part of a picture.' To this *acute* observation, the obsequious knight, bowing low, replied, 'I am happy, Sir, to have the honour of being of the same opinion.' (1803, p. 12)

The uncanny similarity between the details of Moser's anecdote and Rowlandson's drawing may be more than coincidental, especially since the artist in Rowlandson's caricature bears a passing resemblance to Reynolds (who later wore spectacles to paint). Whatever the specific source of Rowlandson's satire, its intention was surely to undermine the self-conscious intellectualizing which underpinned the vogue for patriarchal old men, as well as the abiding gap between the physical reality of the studio model and the idealized persona conceived by the artist.

However 'singular' visitors to Reynolds's studio felt George White to be, Reynolds considered that it was the duty of the artist to improve on, or to 'generalize', the model according to prescribed rules. In his third *Discourse*, of December 1770, he remarked on how individuals – young or old – belonged to a classification: 'Thus, though the forms of childhood and age differ exceedingly, there is a common form in childhood, and a common

form in age, which is the more perfect, as it is remote from peculiarities' (in Wark, 1975, p. 47). He simultaneously applied this dictum to his own paintings of White. In one instance, although the face of White is clearly recognizable, Reynolds even displaced the model's own grizzled hair with lank silver locks (private collection). In 1771, in his fourth *Discourse*, Reynolds, using Raphael as a paradigm, again reaffirmed the importance of poetic truth over historical accuracy:

In all the pictures in which the painter has represented the apostles, he has drawn them with great nobleness; he has given them as much dignity as the human figure is capable of receiving; yet we are expressly told in scripture they had no such respectable appearance; and of St. Paul in particular, we are told by himself, that his *bodily* presence was *mean*. (in Wark, 1975, pp. 59–60)

James Northcote, in conversation with James Ward, recalled how Reynolds had attempted to practise what he preached. 'It might be necessary to paint codgers', he stated, 'but they ought to be kept out of sight. Sir Joshua of course painted codgers, but he managed to make them agreeable some way or other' (in Fletcher, 1901, p. 191). Those artists who listened to Reynolds's *Discourses* had the opportunity to pit nature, in the form of George White, against the Ideal, as the old man was by this time modelling in the Academy's Life School.[15] A number of portrayals of George White by Reynolds's contemporaries survive (see Postle, 1988a, pp. 204–5; 1988b, pp. 735–44). Visual evidence suggests that scant attention was paid to Reynolds's strictures. Neither John Russell, in a characteristically frank portrayal of White as St Peter (plate 59), nor John Sanders's painting of White as a philosopher (private collection), exhibited at the Royal Academy in 1771, makes any attempt to disguise the idiosyncrasies of the model's careworn features.[16] Indeed, in his version of *Caritas Romana* (plate 60) Zoffany emphasized White's infirmity, from his angular frame, down to his varicosed and misshapen feet. According to Reynolds's fourth *Discourse* of 1771 – where he continued his discussion of the essential principles of the 'grand style' – these artists were missing their mark: 'A Portrait-Painter ... when he attempts history, unless he is upon his guard, is likely to enter too much into the detail. He too frequently makes his historical heads look like portraits ... An History-Painter paints man in general; a Portrait-Painter, a particular man, and consequently a defective model' (in Wark, 1975, p. 70) The history painter, according to Reynolds, avoided the 'defective model' in order to idealize his subject. An unidealized model, especially if he was old, was also liable to be distasteful – without the cosmetic intervention of the artist.

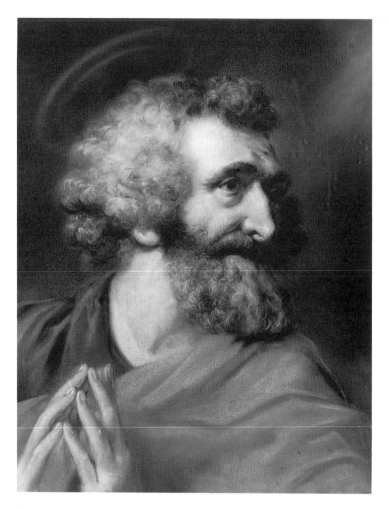

59 John Russell, *St Peter*.
 Pastel, 59·5 × 44 cm. *c.* 1773. Private Collection.

In the course of his seventh *Discourse*, Reynolds commented upon Jean-Baptiste Pigalle's recent statue of Voltaire (Paris, Institut), 'made entirely naked, and as meagre and emaciated as the original is said to be'. It had failed to be accepted by the public, explained Reynolds, not because of any lack of instrinsic artistic merit but because it offended current concepts of taste: 'whoever would reform a nation', stated Reynolds 'will not

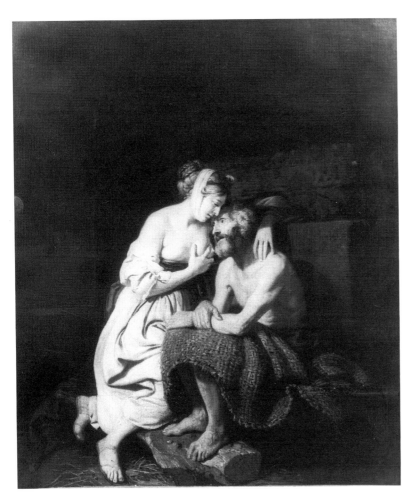

60 Johan Zoffany, *Caritas Romana*.
Oil on canvas, 76·3 × 63·5 cm. *c.* 1770–1. National Gallery of Victoria,
Melbourne.

accomplish his purpose by going directly against the stream of their
prejudices. Men's minds must be prepared to receive what is new to them.
Reformation is a work of time.'(*ibid.*, pp. 140–1). At the end of his life
Reynolds, in reviewing his *Discourses*, noted with pride that he had 'in no
part of them, lent my assistance to foster *newly-hatched unfledged* opinions'
(*ibid.*, p. 269). By way of contrast, Henry Fuseli, with reference to his
scheme for a series of paintings based on Milton, expressed a determination

to 'lay, hatch and crack an egg for myself' (in Knowles, 1831, vol. I, p. 174). Fuseli's attitude reflects the abiding gap between Reynolds and his younger contemporaries during the remaining period of his presidency of the Royal Academy, as well as the increasing divergence between the neo-classical creed of imitation and the essentially Romantic reliance on innovation.

In 1772 Reynolds exhibited a second picture at the Royal Academy which featured his model, George White. Entitled *A Captain of Banditti* (plate 61), it was engraved as a portrayal of the French bandit Louis Dominique Cartouche. The choice of subject derived from the current vogue for Salvator Rosa's bandit pictures, explored most notably by John Hamilton Mortimer, while the figure's attitude is reminiscent of a half-length painting of St Paul, of which there are versions attributed to both Rubens and Van Dyck.[17] The ultimate inspiration for the work, however, was probably Rembrandt's *Man in Armour* (Glasgow City Art Gallery), which Reynolds owned (see Broun, 1987, vol. II, pp. 50–1). Although Reynolds's own picture is now known only through John Dean's 1777 mezzotint, it is clear that the artist's main concern was to emulate the textures and lighting effects found in Rembrandt's original.

Reynolds's studies of George White culminated, in 1773, in the painting in which he attempted to synthesize his evolving theories on history painting, *Ugolino and his Children in the Dungeon* (colour plate 10). James Northcote provided an account of its genesis:

The fact is, that this painting may be said to have been produced as an historical picture by an accident: for the head of the Count had been painted previous to the year 1771, and finished on what we painters call 'a half length canvas', and was in point of expression, exactly as it now stands, but without any intention, on the part of Sir Joshua, of making it the subject of an historical composition, or having the story of Count Ugolino in his thoughts. Being exposed in the picture gallery, along with his other works, it was seen either by Mr. Edmund Burke, or Dr. Goldsmith, I am not certain which, who immediately exclaimed, that it struck him as being the precise person, countenance, and expression of the Count Ugolino, as described by Dante in his 'Inferno'... the idea started by Burke was adopted by Sir Joshua, who immediately had his canvas enlarged, in order that he might be enabled to add the other figures, and to complete his painting of the impressive description of the Italian poet. (1818, vol. I, pp. 278–83)

With respect to the picture's enlargement, Northcote was correct. A seam – now clearly visible – down the centre of the picture indicates that the painting originally consisted of two separate pieces of canvas. Significantly, the section on which the figure of Ugolino is painted

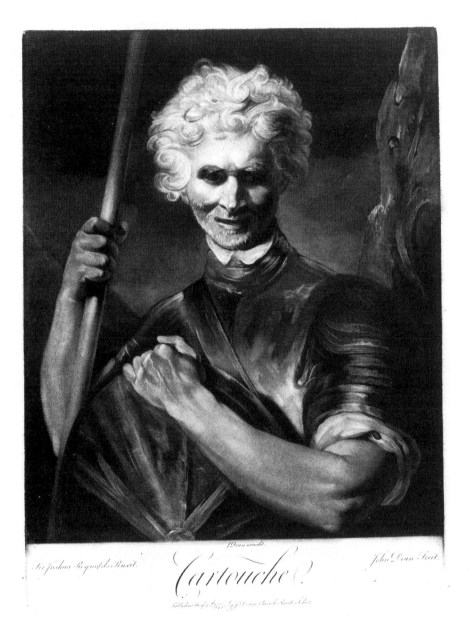

Sir Joshua Reynolds Pinxit.

J. Dean excudit.

John Dean Fecit.

Cartouche

Published Aug.t 1.t 1777. by J. Dean Jacob Street Soho.

61 John Dean (after Sir Joshua Reynolds), *Cartouche*.
 Mezzotint, 30·8 × 25·1 cm. 1777. After a painting entitled *A Captain of Banditti*
 exhibited at the Royal Academy in 1772. The Trustees of the British Museum.

during the early 1640s, was instrumental in the foundation of the French Academy in 1648. His seminal theoretical text on expression, the *Conférence sur l'expression générale et particulière* of 1698, derived from lectures delivered to students at the Academy (see Montagu, 1959, *passim*). While there has been a tendency to view Le Brun's theories on expression as a piece of prescriptive dogma, it was, as Jennifer Montagu has stated, 'never his intention to provide a pattern-book of facial expressions, but rather to work out the physical consequences of the current theories of Descartes on the passion of the soul, so as to establish the principles of their visual manifestations, which could be applied to any emotion the painted wished to express' (Montagu *et al.*, 1990, p. 12). Even so, by the early eighteenth century Le Brun's treatise – which was first translated into English in 1701 – was increasingly recognized as a pattern book by writers on art theory. In 1707 Gérard de Lairesse expanded and codified Le Brun's ideas in his *Groot Schildeboek*. As Alastair Smart pointed out, Lairesse's book – translated into English in 1738 as *The Art of Painting in all its Branches* – had at least as much influence as Le Brun on British writers on art (1965, p. 91). Hogarth and Reynolds were both familiar with Le Brun and Lairesse. In his fourth *Discourse* Reynolds stressed the important role played by standards of expression in the art of the history painter: 'Those expressions alone should be given to the figures which their respective situations generally produce. Nor is this enough; each person should also have that expression which men of his rank generally generally exhibit. The joy, or the grief of a character of dignity, is not to be expressed in the same manner as a similar passion in a vulgar face' (in Wark, 1975, pp. 50–1).

In Reynolds's own *Ugolino* facial expression was of seminal importance in the overall didactic intention of the painting for several related reasons. In addition to demonstrating his familiarity with accepted theories of the passions, Reynolds hoped, through a judicious selection of the appropriate expression, to express the exact moment in the narrative he wished to illustrate. As Reynolds was surely aware, there was by the 1770s a burgeoning interest in expression which went beyond the confines of art theory. Across the field of Liberal Arts – in literature, theatre, and music – there was by the mid-eighteenth century a concern with the 'Pathetic' style, and, as Brewster Rogerson has observed, 'not only the softer emotions belonged to it, but the more dynamic ones as well, for any true imitation of a passion was by definition "pathetical"'(1953, p. 68). And as Frances Yates stressed, from an eighteenth-century British viewpoint the twin peaks of pathos in Dante's *Divine Comedy* were the stories of Count

Ugolino and Paolo and Francesca (1951, pp. 95–6). As Stefan Germer and Hubertus Kohle have observed, Reynolds's concentration on the inner turmoil of Ugolino anticipates – and may even have influenced – Jacques-Louis David's later exploration of the mental state of his heroic protagonists, allowing the viewer to arrive at a subjective understanding of feeling through reading expressions. As they state: 'Only the viewer knows, like Ugolino himself, what the outcome of the event will be: the gaze of the Count is directed at him. The interpretation of the painting, like that of David's *Brutus*, necessitates entering into the psyche of the protagonist, completing through the imagination that which is not represented' (Germer and Kohle, 1986, p. 176).

Ugolino's facial expression was specifically modelled closely on the representation of *horreur* in Le Brun's *Expression des Passions*, down to the positioning of the eyeballs where 'the Pupil, instead of appearing to situate in the middle of the Eye, will be sunk low' (Le Brun, 1734, p. 30) In his English translation of Le Brun, of 1734, from which the above quotation is taken, John Williams stated that 'the face will appear a pale colour; the Lips and Eye a little upon the livid' (*ibid.*). The description forms an interesting comparison with Jonathan Richardson's earlier allusion to *Ugolino* – to be discussed below – in which he envisages how some future British artist might capture 'the pale, and livid flesh of the dead, and dying figures, the redness of the eyes, and the blewish lips of the Count, the darkness and horror of the prison' (1719, p. 30). Reynolds's use of Le Brun's model for the expression of Ugolino reaffirmed the validity of an existing tradition. However, by directing the central figure's expression towards the viewer, rather than towards his protagonists, Reynolds was – as it has been observed – breaking new ground.

The facial expression of Ugolino particularly impressed the French sculptor Etienne Falconet (1716–91), to whom Reynolds sent John Dixon's mezzotint in exchange for a plaster modello by him.[21] Although he never saw the painting he yet affirmed that 'Mr. Reygnolds [*sic*] y a peut le sentiment & l'âme de son sujet' (Falconet, 1781, vol. II, p. 74 n.). Reynolds and Falconet were evidently on close terms during the 1770s – Reynolds referring to him in his diary as 'my friend Falconet', as well as quoting from his translation of Pliny in the eighth *Discourse* (see Hilles, 1936, p. 77; Wark, 1975, pp. 164–5). In his *Œuvres* of 1781 Falconet repaid Reynolds the compliment, as he discussed *Ugolino* in the context of a disquisition on facial expression in works of art, and their effect on the viewer. *Ugolino*, he affirmed, possessed an expressive power comparable to the classical statue, *Niobe*, and the more recent *Milo of Crotona* sculpted by

Pierre Puget (1620–94) for Louis XIV. All three works of art evoked in the
onlooker a sense of horror which, although profound, was not excessive or
so graphic as to be distasteful:

Mr. Reynolds a fait un tableau expressif. Il est vrai qu'il n'a pas fait Ugolino se
dévorant les mains, se trainant à quatre pattes; il a su choisir dans le Poète. Il n'eut
pas fait non plus dans les enfers les yeux hagards, enfonçant dans un malheureux
crâne ses dents aussi fortes que celles d'un chien; mais connoissant les
convenances, ainsi que l'étendue de son art, il s'est autant éloigné d'l'exces
d'horreur dégoûtante et révoltante, que du foible et maladroit subterfuge d'un
voile. (Falconet, 1781, vol. II, p. 73)

As Anne Betty Weinshenker has noted, Lessing, writing in the *Laocoon* of
1766, had regarded Dante's story of Ugolino as 'loathsome, horrible and
disgusting, and as such thoroughly unfit for painting' (1966, p. 20). The
subject was, however, already familiar in the form of a bas-relief by Pierino
da Vinci (d. 1553), Leonardo's nephew (although in England it was
generally ascribed to Michelangelo; Yates, 1951, p. 104). Falconet –
although he admitted that he had not seen the bas-relief, and only the
print after Reynolds's painting – preferred the latter:

le choix de Mr. Reynolds me paroit préférable, soit par la simple vérité historique,
soit par la gradation plus touchante, & la diversité dans les actions des fils, soit par
l'anéantissement du père à la proposition étrange du plus jeune de ses enfants. Le
reste est affaire d'execution; je n'ai pas vu le bas-relief. Je n'ai vu non plus que la
gravure du tableau de Mr. Reynolds. (Falconet, 1781, vol. II, p. 74 n.)

It has since been suggested that Reynolds's composition was influenced
by Pierino da Vinci's bas-relief, Frances Yates noting how, as in the bas-
relief, 'the father is seated, with one of his sons closely touching him,
whilst the other three are arranged in a descending line, the middle one
supporting the dying, or fainting one' (1951, p. 106). Reynolds was
probably familiar with the bas-relief (the artist William Hoare (1707–92)
owned a terracotta copy), and it may indeed have guided the general
grouping of the figures. However, while the attitude of Ugolino was based
on Michelangelo's Sistine prophet, the configuration of the children to the
right of the painting is derived from Annibale Carracci's *Pietà* (plate 62)
– the expiring youth and the supporting figure forming the counterparts of
the Virgin and Mary Salome in Carracci's painting (Postle, 1988b, p. 743;
Prochno, 1990a, pp. 180–1, fig. 171). Carracci was among the most
admired Italian Renaissance artists in eighteenth-century England, not
least because of his perceived position as a seminal figure in the
development of the Academy. In the fourth *Discourse* Reynolds cites

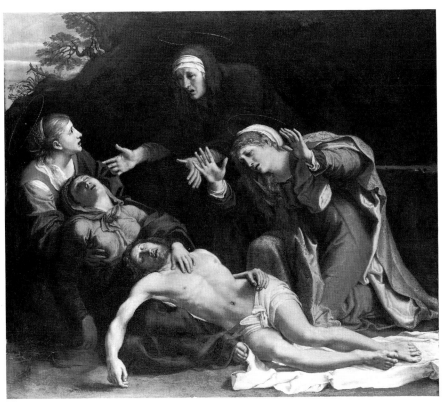

62 Annibale Carracci, *Pietà*.
 Oil on canvas, 92·8 × 103·2 cm. *c*. 1604. The Trustees of the National Gallery,
 London.

Carracci's opinion on composition: 'Annibal Carrache thought twelve
figures sufficient for any story: he conceived that more would contribute
to no end but to fill space; that they would be but cold spectators of the
general action, or, to use his expression, that they would be *figures to be let*'
(in Wark, 1975, p. 65). Even though Reynolds's given narrative prevented
the inclusion of further protagonists, the five figures economically
employed in *Ugolino* correspond to the number of characters in Carracci's
Pietà. Although Carracci's picture did not enter England until 1798, when
it was acquired by Lord Carlisle, Reynolds almost certainly saw it during
a visit to Paris in 1771, when it was in the Duke of Orléans's collection.
(Horace Walpole, who was in Paris at the same time as Reynolds,
observed, upon seeing it, that it had been cleaned and restored – albeit
clumsily.[22]) A noted old-master painting, the *Pietà* was, in any event,
accessible via two separate prints by the French engravers Roullet and (in

reverse) Baudet (see Levey, 1971, cat. 2923, p. 72). Taken together, the adaptation of the figure of one of Christ's ancestors by Michelangelo for Ugolino and a *Pietà* by Carracci for his family underlines Reynolds's dedication to the highest principles of history painting and his determination to present his subject in the form of a secular icon.

Despite the richness and diversity of Reynolds's iconographical sources and the resonances which the picture carries, comparatively little attention has been paid to *Ugolino* in modern critical assessments of late-eighteenth-century history painting. As Robert Rosenblum has recently stated, neither his own *Transformations in Late Eighteenth-Century Art* (1967) nor Michael Levey's *Rococo to Revolution* (1966) gave more than passing notice to Reynolds – let alone his practical contribution to high art (in Penny, 1986, p. 43). And yet, despite its formal shortcomings, *Ugolino* formed a seminal contribution to the evolution of the neo-classical genre of heroic death. Reynolds was not, however, the only British artist to evince an interest in the early 1770s in the broader theme of heroic incarceration and death. Aside from the various illustrations of Sterne's *Captive* mentioned earlier, Zoffany had used George White as the central protagonist in *Caritas Romana*. The theme (the suckling by his daughter of the captive King Evander) had been popular with artists since the Renaissance. Zoffany's treatment of the subject is formally quite different from earlier representations, such as that by Rubens (Hermitage, St Petersburg), its starkness and lack of sensuality bringing it much closer to Reynolds's *Ugolino*. In a similar vein Joseph Wright exhibited a painting (now lost) entitled *The Captive King*, at the Society of Artists in 1773, which was based on the story of the French hero, Guy de Lusignan (Nicolson, 1968b, vol. I, p. 241, cats. 214–15). The same year West showed *The Cave of Despair* from Spenser's *Faerie Queene*, at the Royal Academy, which depicted the emblematic figure of 'Despaire' – an emaciated old man in manacles.[23] The similarity between West's picture and Reynolds's *Ugolino* was not lost upon critics, *The London Chronicle*, noting how *The Cave of Despair* 'is much in the same stile with that of Count Hugolino and her [*sic*] sons, and would, if possible, be still more terrible, were it not that we are convinced it is founded upon a fable, whereas the other is built upon real history'. Neither West's picture, however, nor Wright's, was painted on the physical scale of Ugolino, which formally anticipates the far more ostentatious depictions of heroic death by artists of the French School in the following decade.

As Paul Joannides has demonstrated, evidence of French artists' familiarity with Dixon's engraving of *Ugolino* is to be found in a sketch

made from it by Antoine-Jean Gros of *c.* 1793–6 (1975, p. 783, fig. 16). In addition, I have also recently seen a large, and quite intriguing, oil sketch of *Ugolino* from a private collection in France, evidently taken from Dixon's engraving (the colours employed are quite different from those found in the original painting). In any case, as we have seen, the sculptor Falconet openly expressed his admiration for the work both in his private correspondence and his public writings. Compositionally, *Ugolino* fore-shadows a series of related French neo-classical paintings of the 1790s, most notably Pierre Narcisse Guerin's *The Return of Marcus Sextus* (1797–9; Louvre), where the central protagonist is viewed in monumental isolation, in contrast to swooning subsidiary figures. Indeed, the picture was compared with *Ugolino* by Fuseli and Joseph Farington on a visit to Paris in 1802: 'We talked about Guerin's picture of Sextus which we had seen today. Fuseli thinks it is as much above Sir Joshua Reynolds's Ugolino in Conception and interest as it is inferior in execution' (Farington, 1 October 1802, in Garlick, Macintyre, and Cave, 1978–84, vol. V, p. 1893). (Guerin, however, denied that he had been influenced by Reynolds's painting).[24] It is quite possible, however, that Honoré Dufau's *Death of Ugolino* (Musée des Beaux-Arts, Valence) of 1800 was directly inspired by Reynolds's painting as much as by previous French works along similar lines. As Phillipe Bordes has recently reaffirmed, David – who was prominent in his admiration of British artists – may well have been drawn towards Reynolds's composition in the formulation of his *Lictors Returning to Brutus the Bodies of his Sons*, shown at the Paris Salon of 1789. Reynolds's painting (or rather Dixon's engraving), as Bordes has noted, 'would have...encouraged him to darken to an unprecedented extreme the situation of his classical hero. Just as Ugolino is represented at the precise moment when his sealed fate dawns on him, so David's Brutus is shown acknowledging the full irremediable horror of the sacrifice to which he has consented' (1992, p. 487).

Northcote, whose recollections of the origins of *Ugolino* were imprecise, stated that either Edmund Burke or Oliver Goldsmith had suggested the subject to Reynolds.[25] Richard Cumberland, whose account of the painting Northcote mentions, also referred to Goldsmith as the instigator of the work (Northcote, 1818, vol. I, p. 278). It is worth quoting from Cumberland's account, not least because of the the context in which it appears:

Sir Joshua Reynolds was very good to him [Goldsmith], and would have drilled him into better trim and order for society, if he would have been amenable, for

Reynolds was a perfect gentleman, had good sense, great propriety, with all the social attributes, and all the graces of hospitality, equal to any man. He knew well how to appreciate men of talents, and how near a kin to the muse of poetry was that of art, of which he was so eminent a master. From Goldsmith he caught the subject of his famous Ugolino. What aids he got from others, if he got any, were worthily bestowed and happily applied. (Cumberland, 1806, p. 259)

It has been suggested that as Reynolds would already have known about Ugolino via the writings of Jonathan Richardson, 'he did not need Burke or Goldsmith to remind him' (Penny, 1986, p. 253). Yet, while it is true that the episode was central to an eighteenth-century understanding of Dante, it was also particularly popular among Reynolds's own circle (Yates, 1951, pp. 92–117). During the two decades leading up to Reynolds's own portrayal of *Ugolino* a surprising number of Reynolds's closest associates, including Giuseppe Baretti, Edward Gibbon, Oliver Goldsmith, and Joseph Warton, had all written works which evinced a strong interest in Dante (for a complete list see Toynbee, 1921, p. 27). Baretti and Warton had, in addition, made direct references to the episode of Ugolino in the dungeon, including prose translations of the story in their texts. In 1772 another supporter of Reynolds, Frederick Howard, fifth Earl of Carlisle (1748–1825), produced a new verse translation of the Ugolino episode, which he initially distributed privately and in 1773 published in *The Annual Register* – presumably to coincide with the exhibition of Reynolds's painting.[26] In 1775 Baretti even managed to ingeniously incorporate Reynolds's *Ugolino* into the imaginary dialogue between a dog and a cat at a Royal Academy exhibition, contained in his Italian crammer – *Easy Phraseology, for the Use of Young Ladies* (1775, pp. 133–47). Finally, in 1782 the long-awaited second volume of Joseph Warton's *Essay on the Genius and Writings of Pope*, included, in the course of a discussion of Dante's treatment of the Ugolino episode, a note stating that 'Sir Joshua Reynolds, whose mind is stored with great and exalted ideas, has lately shewn by a picture on this subject, how qualified he is to preside at a Royal Academy, and that he has talents that ought not to be confined to portrait painting' (1782, vol. II, p. 262 n.)

It is clear that Reynolds's preoccupation with Dante both emerged from, and was supported by, the circle of friends he had acquired during the 1750s and 1760s. And it was they whom he wished to impress above all. As he stated in his fifth *Discourse* of 1772: 'Be as select in those whom you endeavour to please, as in those you endeavour to imitate. Without the love of fame you can never do any thing excellent' (in Wark, 1975, p. 89). One individual whom Reynolds would particularly have wished to please

was Edmund Burke, by now a prominent political, as well as literary, figure. Frances Yates first suggested that Whigs could perceive in Ugolino both a 'liberty-loving English lord' and a victim of clerical oppression (1951, p. 99). While this thesis has since been queried (Penny, 1986, p. 253), the acceptance of a political dimension to the painting may, at the very least, help to explain the close association, in Northcote's mind, between Reynolds's painting and Edmund Burke. On 23 April 1770 Burke published *Thoughts on the Causes of the Present Discontents*, in which he asserted the rights of the Rockingham Whigs as the country's natural leaders. In June 1770, at the very time that Reynolds began work on *Ugolino*, he took the argument into the House of Commons (see Magnus, 1939, p. 67). That contemporaries perceived a link between Burke's political activities and Reynolds's painting is suggested by the following notice in *The Morning Herald* in 1783, concerning Burke's decision to reinstate two Treasury officials accused of embezzlement:

Mr Burke appears to take a strange part in regard to Messrs Powell and Bembridge; those gentlemen he relates came to him, requesting with tears, they may resign their situations, but his *humanity* is such (according to his own account) that he will not permit it, although by the refusal, one of the poor supplicants was sent away in a state of *distraction*!

While the above *orator* was decorating the head of one of his *unfortunate* clients with *grey locks*, he was observed to have a *miniature* of Count Ugolino, from Sir Joshua Reynolds in his hand, in order to give *sublimity* to the description together with *Lord Carlisle's* translation of Dante by way of improving it with a touch of the *beautiful*![27]

While Reynolds's own interest in Ugolino was not overtly political, it was surely his intention to ensure that his subject related to the current concerns of sympathetic allies.

As Northcote was the first to point out, it was not Dante but the English artist and theorist Jonathan Richardson the Elder (*c.* 1665–1745) who had provided the immediate source of Reynolds's inspiration. Reynolds's thought owed a great deal to the writings of Richardson, which he had known since his youth (see Hilles, 1936, pp. 5–6). In an essay of 1719 entitled 'An argument on behalf of the science of a connoisseur', Richardson discussed the aforementioned bas-relief of Ugolino and his sons by Pierino da Vinci, which he had seen in Italy (and which he thought to be by Michelangelo).[28] Here he argued that painting provided the best means of translating an historical narrative, examining in turn the way in which the historian (Villani), the poet (Dante), and the sculptor ('Michelangelo', or Pierino da Vinci) had each treated the story of Ugolino.

He concluded: 'Thus History begins, Poetry raises higher, not by Embellishing the Story, but by additions purely Poetical: Sculpture goes yet farther, and Painting Completes and Perfects, and That only can; and here ends. This is the utmost Limits of Humane power in the Communication of Ideas' (Richardson, 1719, p. 35). The gauntlet thrown down by Richardson provided Reynolds with the challenge to translate Ugolino into high art. And, like Richardson, Reynolds believed that practice should involve the direct application of preconceived rules.

Reynolds delivered fifteen *Discourses* to the Royal Academy between 1769 and 1790. By spring 1773, when he exhibited *Ugolino*, Reynolds had already delivered five lectures – a third of his total output. In terms of Reynolds's own burgeoning theories, the most important *Discourses* were the third and fourth, delivered in December 1770 and 1771 respectively. It is significant that many of the ideas to be found in these lectures are reinforced through the visual language employed in *Ugolino and his Children in the Dungeon*. The third *Discourse* introduced Reynolds's audience to the 'great style'. Although the 'great style' is essentially equated with high art, or history painting, Reynolds does not introduce the question of genre, or subject matter, into the third *Discourse*. Rather, he attempts to locate the 'great style' (which he equates with 'taste' and 'genius') in quasi-abstract terms within a particular philosophical methodology. Wary of divine inspiration as the sole vehicle of artistic accomplishment, Reynolds – an innate taxonomist – adopts an empirical stance as he continually sifts data in order to determine the essential characteristics of central forms in nature. 'This idea of the perfect state of nature, which the Artist calls the Ideal Beauty is the great leading principle, by which works of genius are conducted' (in Wark, 1975, pp. 44–5). Artists as diverse as Dürer, Hogarth, Watteau, and Claude Lorrain were excluded by Reynolds from the 'great style' not simply on account of their choice of genre but their inattention to Ideal Beauty.

The fourth *Discourse*, delivered at the Royal Academy on 10 December 1771, is of greater immediate relevance to *Ugolino*. Here Reynolds laid down specific rules governing the practice of the 'great style'. First, he discussed the choice of subject matter, which, he maintained, presented fewest problems for it was generally supplied to the artist by the 'Poet or Historian'. 'With respect to the choice', he added, 'no subject can be proper that is not generally interesting. It ought to be either some eminent instance of heroick action, or heroick suffering. There must be something either in the action, or the object, in which men are universally concerned, and which powerfully strikes upon the publick sympathy' (*ibid.*, p. 57).

Reynolds's generalized frame of reference is not only indicative of his deference towards established tradition, but of his interest in subject matter primarily as a vehicle for painterly concerns. Viewed in this light, it is easier to accept that the decision to paint *Ugolino* arose from the deliberations of a 'committee of taste' who shared common interests rather than from a spontaneous urge to communicate Dante's narrative. The reference to 'publick sympathy' in the above passage also indicates the importance Reynolds attached to the approval of his peers; the 'publick' being more akin to his own circle of acquaintance rather than to more recent democratic definitions.

In the fourth *Discourse* Reynolds gave precise advice which accords with his treatment of the subject in *Ugolino*. Attention, he stated, ought to centre on the principal group in a picture. Subordinate groups could be included but 'they should merely make a part of that whole which would be imperfect without them'. 'The sublime', he went on to say, 'impresses the mind at once with one great idea; it is a single blow' (*ibid*., p. 65). With regard to characterization of both the figure and the face poetic truth was to take precedence over historical truth. As an example he contrasted the heroic figures of the apostles in Raphael's *Cartoons* with similar figures in the paintings of Jacopo Bassano, who 'introduced...the boors of the district of Bassano, and called them patriarchs and prophets' (*ibid*., p. 68). Of facial expression, Reynolds demanded – as we have seen – that one emotion only be displayed, and that emotion should reflect the rank of the particular character. Two quite distinct approaches to the use of colour were permissible: the Roman (where pure colour was applied), or the Bolognese (where colour was reduced to 'little more than *chiaro scuro*'): Reynolds chose the Bolognese method. Finally, drapery was to be simple and bereft of texture or local detail. Of all the *Discourses*, the fourth was the most didactic, and allowed least compromise. Here, the sensuous colouring of the Venetians, which he privately admired, and at times emulated, was characterized almost in terms of contagious disease: 'Rubens carried it to Flanders; Voet to France; and Luca Giordano to Spain and Naples' (*ibid*., p. 67). While *Ugolino* is formally disjointed, its compositional shortcomings were not simply due to lack of imagination but rather to Reynolds's attempt to systematically impose upon himself the same dicta advanced in the *Discourses* as a theoretical platform for British history painting.

Exactly how long it took Reynolds to complete *Ugolino* is uncertain, as in any one year he was severely restricted in his attention to subject painting, owing to ongoing portrait commitments. He could, when necessary, work very quickly, but in the case of his subject paintings he

preferred to take his time, pondering over them like pictorial counterparts to philosophical problems. If Northcote's memory is to be trusted, there was almost a three-year gap between the painting of the central figure of Ugolino and the additional figures, added immediately prior to the painting's exhibition in 1773.

On 18 April, 1773, as the Royal Academy exhibition opened, the British ambassador to the Court of St. Petersburg, Lord Cathcart, wrote to Etienne Falconet, praising *Ugolino*: 'Je ne crois pas qu'il y ait au monde un tableau de la même force d'expression: il n'est pas possible de le regarder un instant, sans être saisi d'une horreur que le Poète même n'a pu exciter, et je vous proteste que ce n'est pas sans émotion que je vous descris' (Falconet, 1781, vol. II, p. 68). Immediately after the exhibition closed, Reynolds, pleased with its critical reception, proceeded to have the picture engraved, as he informed Thomas Robinson, Baron Grantham, British ambassador in Madrid: 'The picture which I begun I believe before your Lordship left England of Count Ugolino was at the last exhibition and got me more credit than any I ever did before. It is at present at the Engravers to make a mezzotinted Print from it, which when finish'd I will do myself the honour of sending to your Lordship.'[29] John Dixon's mezzotint was published by John Boydell on 4 February 1774, and exhibited by him the same year at the Society of Artists. And, as Nicholas Penny has observed, it was 'one of the few mezzotints after Reynolds which was priced as high as the large plates after his full-length portraits of society beauties – that is, at fifteen shillings' (1986, cat. 83, pp. 253–4; Hamilton, 1874, p. 121).

In hindsight *Ugolino* is invariably viewed as Reynolds's token gesture towards the promotion of history painting. To contemporaries, however, it provided tangible proof of Reynolds's genuine commitment to high art. Horace Walpole, who was by no means uncritical of Reynolds, blandly noted that *Ugolino* was 'most admirable', while *The Public Advertiser* (28 April 1773) characteristically bestowed more lavish praise:

Sir. J. Reynolds has this Year exceeded the highest Expectations from him in the number and excellence of his Productions... Count Hugolino and his Children in the Dungeon is, I suppose, the most capital of the History Pieces of this Master. The Expression is very strong, and amazingly fine; the Chiaro' Scuro bold, and the Colours harmonized in a supreme Degree. In short, this is a good picture; and if the same Excellence had been employed on a pleasing Subject, it would have enchanted, as it may now terrify, the Public.

Two days later *The Morning Chronicle* carried two, less flattering,

assessments of *Ugolino*. Both took the form of open letters addressed directly to Reynolds. The shorter of the two castigated the artist for the historical inaccuracies contained in his version of *Ugolino*, although it was in reality a thinly disguised xenophobic rant directed at Giuseppe Baretti, 'that notorious Italian bloody minded sycophant', whom Reynolds had appointed secretary for foreign correspondence at the Royal Academy.[30] Potentially more damaging to Reynolds's own reputation was the following letter from 'Fabius Pector' [*sic*]:

To Sir Joshua Reynolds, President of the Royal Academy

Sir,
if you are as wise in some parts of conduct as you are in others, let me advise you to keep to Portrait Painting; you have often succeeded in it very happily; and although as the arts are rising fast 'tis not over-likely that you will always be able to preserve the first name, yet you will ever be deemed a man of considerable excellence in that way.

It were indeed a pity that any falling off in your business, as a Portrait Painter, should oblige you, at so late a time of your life, to begin wrestling with the difficulties of a new profession; the painting of history is new and strange to you, as appears but too evidently from your unfledged picture last year of Venus and Cupid casting up accounts [actually exhibited in 1771], and the Ugolino and his family now in the present exhibition. Why, Sir, if these pictures were shown even in France or Italy, where you may be ever so little known, every body would, at first glance, judge them to be the rude disorderly abortions of an unstudied man, of a portrait painter, who quitting the confined track where he was calculated to move in safety, had ridiculously bewildered himself in unknown regions, unfurnished with either chart or compass. Be advised, Sir Joshua, keep to your portraits, which will do yourself and your country credit, and leave history painting (as you do watch-making or navigation) for those who have studied it.

If you suspect the sincerity of my advice, ask some history painter (we have four or five of them) or even some travelled man who has knowledge of those matters; and depend upon it, that if he does not flatter you, his opinion and mine will be very little different; he will inform you that your figures are shockingly out of drawing, and finished in a slobbering, herum-skerum, unartist-like way; that from the first concoction of them they smell rankly like the portrait, and are totally wide of all true historical character.

This will mortify you, no doubt, but as you are a very cool man, with your passions always in a proper subordination of your interest, I have great hopes that you will make prudent use of the hints (they are but hints) that, I have given you; and although there may be many men to whom what I have said would rather become poison than medicine yet Sir Joshua is not, I hope of that number; it will

have the most salutory effects upon him; will purge off those gross, humours, deliriums, and eccentricity, that would otherwise contaminate his character.

> I am and shall be,
>> as occasion offers, always
>>> Your humble servant
>
> FABIUS PECTOR [sic].

While the accusation that he lacked the requisite training to tackle high art contained more than a grain of truth, the suggestion that Reynolds was, within a European context, a figure of minor significance was far more wounding. The identity of the writer of the letter has never been satisfactorily established.[31] At the time 'AN ARTIST' writing in *The Morning Chronicle* (15–18 May 1773) informed Reynolds that Fabius Pictor was 'some perturbed spirit amongst the very body over whom you preside'. Earlier this century, William Whitley suggested that artist was James Barry, although more recently William Pressly has cautioned that there is no firm evidence to support such an accusation (Whitley, 1928a, vol. II, pp. 272–9; Pressly, 1981, p. 210, n.). And yet, a comparison between a passage from Fabius Pictor's letter and the following excerpt from Barry's *Inquiry into the Real and Imaginary Obstructions to the Acquisition of the Arts in England*, of 1774, is instructive. Barry (although he does not specifically mention Reynolds), addresses the exact same theme as 'Fabius Pector':

The prime object of study to a history-painter being the entire man, body and mind, he can occasionally confine himself to any part of this subject, and carry a meaning, a dignity, and a propriety into his work, which a mere portrait-painter must be a stranger to, who has generally no ideas of looking further than the likeness and in its moments of still-life. As to the notion that a portrait-painter can also, when called upon, paint history, and that he can, merely from his acquaintance with the map of the face, travel with security over the regions of the body, every part of which has a peculiar and difficult geography of its own; this would be too palpably absurd to need any refutation. He may indeed, by reading and conversation, borrow, collect, or steal opinions, and he may make out general theories; but even in the way of theory what he mixes of his own head will be at best loose and vague, as it cannot be confirmed by the result of his own observations, from repeated and familiar practice. It is easy to collect eulogiums upon Michael Angelo, and the great fathers of historical excellence, but we ought to be careful how we add to them.[32]

Aside from the general argument that portraitists make poor history painters, and the specific ridiculing of Reynolds – who was certainly Barry's target – the two passages are stylistically similar. (Compare, for example, Barry's doubt that the portrait painter can 'merely from his

acquaintance with the map of the face, travel with security over the regions of the body, every part of which has a peculiar and difficult geography of its own', with Fabius Pictor's metaphoric description of the portrait painter 'who quitting the confined track where he was calculated to move in safety, had ridiculously bewildered himself in unknown regions without either chart or compass'.) In the late 1760s and early seventies, Barry had been proud to be considered as Reynolds's protégé, but by 1773 the two individuals were ideologically and artistically increasingly at odds – a fact which Barry was apparently eager to broadcast.

On Monday 3 May 1773 'Fresnoy', writing in *The Morning Chronicle*, quoted Barry as saying: 'Sir Joshua Reynolds! why he knows no more of art than my a----.' The alleged comment appeared in the second of three articles contributed by Fresnoy to the paper, in which the author systematically ridiculed the Royal Academy. 'Fresnoy' was the pseudonym of the Reverend James Wills, who was, among other things, chaplain to the rival Incorporated Society of Artists. While Barry's remarks were intemperate, Reynolds had, it seemed, already offended him, as a piece by 'P. P.', which appeared three days later in the same paper, indicated:

A few days ago, at the hanging of the pictures in the exhibition room, the Committee (appointed for that purpose) had placed his [Barry's] *Jupiter* and *Juno* next to Sir Joshua's picture of *Hugolino* (where No. 86 now stands [a sporting, still-life by Stephen Elmer (*c.* 1714–96)]). Sir Joshua coming there next day, full of a tender concern for Mr. B----'s fate, insisted upon the Jupiter and Juno's being removed out of that, and placed in some less dangerous neighbourhood, which was done accordingly: Mr. B---y's vanity took the alarm when it was told to him, and so he so misconceived everything, as to insinuate to his friends (at least 'tis so reported, for the story has taken wind) that Sir Joshua's only concern was for the effect of his own picture which (as it was painted more in the *portrait* than in the *historical* manner) he was conscious would be seen to more advantage placed near dogs and game, than near a Jupiter and Juno, executed (as Mr. B---- would perhaps insinuate) upon the large elevated plan of the Greek *statuaries* and *Poets*.

Reynolds clearly did not wish to be seen in competition with Barry, even if Barry, as events were to show, very much wanted to demonstrate that his view of history painting differed from that of the president. With respect to Reynolds, William Pressly has observed that mud-slinging of the kind indulged in via the pages of *The Morning Chronicle* 'would have been out of character with his self-image as a courageous champion of truth' (1981, p. 210, n. 40). Even so, Reynolds knew how to manipulate the press in more subtle ways, a fact which may have prompted Barry's more overt, if less scrupulous, commentary.[33] Barry's principal riposte to *Ugolino* was, however, through his art, as he demonstrated by a painting entitled *King*

63 James Barry, *King Lear Weeping over the Body of Cordelia.*
Oil on canvas, 101·6 × 128·3 cm. Exhibited at the Royal Academy, 1774.
Private Collection.

Lear Weeping over the Body of Cordelia (plate 63), exhibited at the Royal
Academy in 1774.

Firstly, *King Lear Weeping over the Body of Cordelia* was as novel a subject
in British art as *Ugolino and his Children in the Dungeon*. Secondly, Barry
followed Hogarth's unorthodox lead in deliberately basing his narrative
directly on Shakespeare's text rather than the popular stage version, in
which the tragic denouement was omitted in favour of a scene of joyful
reconciliation between Lear and his daughters (*ibid.*, p. 55). Barry's
picture, although taken from Shakespeare rather than from Dante, shared
a similar subject – a grieving patriarch with dead (or dying) progeny – and
a common compositional source – Carracci's *Pietà*. In Barry's *Lear* the pose

64 *Lear*.
 Oil on canvas, 75 × 62·5 cm? *c*1763. Private Collection.

of Cordelia was, as William Pressly has pointed out, a conflation of the attitudes of Christ and the Virgin in Carracci's picture, although compared to Reynolds's ostentatious quotation, Barry's adaptation was discreet and in no way intruded into his own composition (*ibid.*, pp. 56–7 and figs. 43 and 44). In addition, whereas Ugolino's features were closely modelled on Reynolds's model, George White, Lear was a composite of Barry's own idea of the patriarchal archetype. Barry's painting openly revealed a highly stylized approach, emphasizing not only his adherence to the mannerism common to artists of his generation, but his celebration of the triumph of the imagination over the individual model. As Reynolds later explained in a note to Du Fresnoy's *Art of Painting*, it was not an approach he could tolerate: 'an individual model, copied with scrupulous exactness, makes a mean style like the Dutch; and the neglect of an actual model, and the method of proceeding solely from an idea, has a tendency to make the painter degenerate into a mannerist' (in Malone, 1819, vol. III, p. 131). If, as Reynolds believed, the essence of true classicism lay mid-way between these two extremes, by the mid-1770s Reynolds and Barry were poles apart.

Reynolds's commentary on Du Fresnoy was published in 1783, 20 years after he had supposedly produced his own painting of *Lear* (plate 64). Reynolds's *Lear* is formally very similar to his studies involving George White. Here, however, the closest comparison is not with an old-master painting, but a print by John Hamilton Mortimer, whose etching of *Lear* (plate 65) was published in 1776 with the legend: 'Here I stand your slave. A poor, infirm, weak and dispis'd old man.'[34] Reynolds's *Lear*, by comparison with Mortimer's highly wrought image, is restrained, a 'correction' which doubtless stemmed from Reynolds's preference for the carefully regulated models of Le Brun and other theorists as well as his reliance on the features of the model (the model for Lear reappears in several other of Reynolds's paintings – most notably his *Old Man Reading a Ballad* (private collection). 'In painting', stated Reynolds, 'it is far better to have a model to depart from, than to have nothing fixed and certain to determine the idea. When there is a model, there is something to proceed on, something to be corrected; so that even supposing no part is adopted, the model has still not been without use' (in Malone, 1819, vol. III, p. 132). Compromising conservatism of this kind highlights the distance between Reynolds's approach to history painting and that of younger artists like Barry and Mortimer in the early 1770s. In works such as *Lear* and *The Captive* Reynolds found a secular equivalent for the swooning

LEAR.

King Lear Act III Scene 3⁴

Here I stand your Slave!
a poor infirm, weak and despis'd old man
but yet I call you servile ministers

that have with two pernicious daughters joind
your high engender'd battles 'gainst a head
so old and white as this, oh! oh! tis foul —

65 John Hamilton Mortimer, *Lear*.
 Etching, 44 × 32·6 cm. 1776. The Trustees of the British Museum.

countenances of penitent Magdalens and enraptured saints which increasingly found their way into his female portraits during the 1770s. His *modus operandi* in these works stemmed primarily from the promptings of his intellect. In an imaginary dialogue between Johnson and Gibbon, written towards the end of his life, Reynolds parodied his own dispassionate stance with reference to *Ugolino*:

JOHNSON:... Ask Reynolds whether he ever felt the distress of Count
 Ugolino when he drew it.

GIBBON: But surely he feels the passion at the moment he is
 representing it.

JOHNSON: About as much as Punch feels. (Hilles, 1952, p. 104)

In comic as well as tragic subject matter Reynolds was invariably guided by reason. Although he expressed the opinion that 'the business of art' was 'rationally to amuse us and not to send us to school', his rarefied brand of humour was geared principally towards an elite who were educated in the visual language of western art (*ibid.*, p. 117) By and large his fancy pictures took the form of clever parodies and occasionally, in a work such as *Pope Pavarius*, he used his old men to the same effect. Reynolds, especially during the early years of the Royal Academy, painted with a specific audience in mind and the inherent conservatism of his approach to subject painting may be explained by his desire to appeal to the conventions which underpinned the taste of his contemporaries. In 1769 Reynolds had advised Barry, then studying in Rome, to treat painting as 'playing a great game' (*ibid.*, p. 17). Such avuncular advice was, however, increasingly ill-suited to Barry's earnest temperament by the mid-1770s, as events were soon to prove.

4 'Fashion's fickle claim': high art 1773–1781

Between 1773 and 1779, when he exhibited *The Nativity*, Reynolds showed no major history paintings at the Royal Academy. Besides his other professional commitments, what were the reasons for this six-year gap? By 1773 Reynolds was the most successful portrait painter in Britain. He was also urbane, and to some extent set in his ways. As his supporters were to do later on his behalf, one could argue that there had been little opportunity for artists of his generation to paint history, and – at the age of fifty – it was too late for him to begin in earnest. Through the *Discourses*, and his presidency of the Royal Academy, Reynolds could adopt the role of catalyst, leading artists of a younger generation by precept rather than by example. At the same time a work such as *Ugolino and his Children in the Dungeon* could stand as an emblem of his commitment to high art as well as a visual realization of his own theories. As events were to show, Reynolds's reasoned compromise was unacceptable to James Barry, who wanted to engage British artists in a crusade to promote high art – at whatever personal cost. And yet, for a short while, after the Royal Academy exhibition of 1773 Reynolds and Barry were united in a common cause – the proposed decoration of St Paul's Cathedral.

On 20 July 1773 Reynolds wrote to Thomas Robinson, second Baron Grantham:

We are upon a scheme at present to adorn St Paul's Church with Pictures, five of us, and I fear there is not more qualified for this purpose, have agreed each to give a large Picture, they are so poor that we must give the Pictures, for they have but the interest of £30,000 to keep that great building in repair which is not near sufficient for the purpose. All those who consent is necessary have freely given it. We think this will be a means of introducing a general fashion off [*sic*] Churches to have Altar Pieces, and that St Paul's will lead the fashion in Pictures as St James's does for dress. It will certainly be in vain to make Historical Painters if there is no means found out for employing them. After we have done this we propose to extend our scheme to have the future Monuments erected there instead of Westminster Abbey, the size of the figures and places, for them, so as to be an ornament to the building, to be under the inspection of the Academy. I have had a long conversation with the Bishop of Bristol who is the Dean of St Pauls and who has the entire direction of the Church, and he favours the scheme entirely. (Black and Penny, 1987, p. 733)

Less than three months later, Reynolds's scheme lay in ruins. On 16 October, Reynolds reported to Philip Yorke, second Earl of Hardwicke (1720–90):

I fear our scheme of ornamenting St Paul's with Pictures is at an end. I have heard that it is disaproved off [sic] by the Archbishop of Canterbury and of London. For the sake of the advantage which would accrue to the Arts by establishing a fashon [sic] of having Pictures in Churches, six Painters agreed to give each of them a Picture to St. Paul's which were to be placed in that part of the Building which supports the Cupola & which was intended by Sir Christoph Wren to be ornamented either with Pictures or Bas reliefs as appears from his drawings. The Dean of St Paul and all the Chapter are very desirous of this scheme being carried into execution but it is uncertain whether they will be able to prevail on those two great Prelates to comply with their wishes. (British Museum, Add. ms. 35 350, fol. 47, quoted by Hilles, 1929, pp. 37–8)

In the light of Reynolds's future attitude towards the promotion of high art, and his rapidly deteriorating relationship with James Barry it is important to follow the sequence of events which led to the above débâcle.

Reynolds was not the first artist to suggest decorating the interior of St Paul's Cathedral with paintings. The decoration of various vacant spaces beneath the dome of St Paul's was a scheme which Wren himself had approved but which had not been executed. In 1715 Sir James Thornhill had decorated the cupola with a series of grisaille paintings based on the ministry of St Paul,[1] while in 1755 the painter Samuel Wale and architect John Gwynn (both of whom were to be active in the foundation of the Royal Academy) made designs which purported to show that Wren had also intended to decorate the area below the dome with history paintings. Also, in 1772 – as William Pressly has noted – an English translation of Pierre Jean Grosley's *A Tour to London* was published, in which the French author suggested that artists should compete to decorate the cathedral in order to promote history painting. He stated:

By adopting this expedient, St Paul's Church will obtain a decoration, that must give it a greater resemblance to St Peter's, which was originally intended: the taste for ornaments of this nature soon extending to other sacred edifices, will open a school of painting in England, which it must want so long as its artists are not excited by so powerful a motive of emulation. (Grosley, 1772, vol. II, p. 61; see also Pressly, 1981, pp. 42 and 210, n. 49)

The present plan stemmed, according to Northcote (who quotes from an anonymous, first-hand, source), from a dinner conversation between Reynolds, Benjamin West, and Thomas Newton (1704–82), Bishop of

Bristol and Dean of St Paul's; although West's biographer, John Galt, claimed that West had proposed the scheme to Newton as early as 1766. (1818, vol. II, p. 307; Galt, 1820, part II, p. 14). West and Reynolds each apparently offered to present a painting, free of charge, as their contribution. Although Newton stated later that he was approached by Reynolds, on behalf of the Royal Academy, it was probably West who introduced Reynolds to Newton and who ultimately initiated the scheme (Newton, 1782, vol. I, pp. 105–6). West had known Newton since 1765, the latter having privately commissioned a number of history paintings from him.[2] Exactly when Reynolds and West first discussed the idea with Newton is not known. Reynolds noted an appointment in his sitter-book with Newton at 4 p.m. on 4 February 1773. Newton also sat to him for his portrait during April and May that year.[3] As Reynolds's letter to Robinson indicates, plans for the decoration of St Paul's were well under way by July, by which time Reynolds and West had recruited three other artists into the scheme.

Newton recalled that Reynolds had approached him on behalf of the Royal Academy. And yet the role of the Academy – in terms of the 'body politic' – was perfunctory throughout. Although the plan was first hatched in early spring, and discussed by Reynolds with Baron Grantham in July, it was not broached at a General Assembly of the Royal Academy until late August. Northcote – then a student at the Royal Academy – left an account of the meeting:

The chapel of Old Somerset-House, which had been given by his Majesty to the Royal Academy, was mentioned one evening at the meeting, as a place which offered a good opportunity of convincing the public at large of the advantages that would arise from ornamenting cathedrals and churches with the productions of the pencil ... The idea was therefore started, that if the members should ornament this chapel, the example might thus afford an opening for the introduction of the art into other places of a similar nature ... All the members were struck with the propriety, and even with the probability of success which attended the scheme; but Sir Joshua Reynolds, in particular immediately took it up on a bolder plan, and offered an amendment, saying, that instead of the chapel, they should fly at once at higher game, and undertake St Paul's Cathedral. (1818, vol. I, pp. 305–6)

Northcote's account conflicts with the one contained in Reynolds's correspondence as it suggests that Reynolds's idea to decorate St Paul's rather than the Royal Chapel was the spontaneous result of democratic discussion. Further on, Northcote stated that the scheme was subsequently discussed formally with the Dean of St Paul's. Only then, he says, were six artists 'chosen' to decorate the cathedral – again at a meeting at the

Academy. This was not strictly true, as Reynolds and West had by then already selected the three other artists who were to carry out the work.

The initial meeting mentioned by Northcote – a General Assembly of the Royal Academy – did take place, although there is some confusion over the date. The minutes of the Royal Academy's General Assembly give the date as 29 August. The date was, however, wrongly transcribed by the secretary in the minute book because 29 August fell on a Sunday in 1773, and no official business was ever conducted on that day. Secondly, while Reynolds noted in his sitter-book for 19 August '7 General meeting', 29 August was left blank. It is important to understand the sequence of events because, contrary to the impression given by Northcote, the operation had been stage-managed by Reynolds in advance. In his sitter-book for 19 August Reynolds noted: 'to receive Mr. Barry / Associates / honorary [?] / St Pauls'. Barry, as the minutes for the meeting show, formally received the Diploma of full Royal Academician from Reynolds that evening.[4] In 1783 Barry wrote:

Immediately upon my connection with the Royal Academy, in conversation at one of our dinners...I made a proposal, that, as his Majesty had given us a palace (Old Somerset House) with a chapel belonging to it, it would become us jointly to undertake the decorating this chapel with pictures...Sir Joshua Reynolds proposed, as an amendment, that, instead of Somerset chapel, we had better undertake St Paul's cathedral. (in Fryer, 1809, vol. II, p. 408)

It was not a coincidence that Barry, whom Reynolds had noted was to be formally admitted into the Academy, should make the above suggestion on the very evening that Reynolds intended to discuss the St Paul's project. Indeed his status as a full Royal Academician was significant if he was to be included in the scheme. Barry's prior interest in the scheme is confirmed by a letter he wrote to the Duke of Richmond on 29 August 1773, where he stated that he had 'proposed this matter to the academicians about a year since' – that is, as early as 1772 (Fryer, 1809, vol. I, p. 241, quoted in Pressly, 1981, p. 42). In his letter to Robinson Reynolds had stated that five artists, including himself, were involved in the St Paul's scheme. In the event six artists – James Barry, Giovanni Battista Cipriani, Nathaniel Dance, Angelica Kauffman, Benjamin West, and Reynolds – were to participate. These are also the six names mentioned by Newton in his account of the scheme. (1782, vol. I, pp. 105–6). (Northcote incorrectly maintained that in addition four members of the Society of Arts were also selected. He was, however, confusing the Royal Academy scheme with a similar one put forward by the Society of Arts the following year (see

Northcote, 1818, vol. I, p. 307).) Whether Barry was the sixth artist, or whether he was one of the original five, is not clear. Nevertheless, Barry's name was almost certainly on Reynolds's and West's short-list well before August 1773.

In order for any scheme to succeed the approval of four individuals – aside from the Dean of St Paul's – was needed. They were the King, the Lord Mayor of London, the Archbishop of Canterbury (Frederick Cornwallis), and the Bishop of London (Richard Terrick).[5] A letter was duly sent under the auspices of the Royal Academy to its patron, George III. Although Reynolds and West had already been given clearance by the Dean and Chapter of St Paul's (in the person of Newton), protocol demanded that they ask the King to 'obtain their consent'. This was given. Approval was also granted by the current Lord Mayor, James Townsend (d. 1787).[6] Unfortunately, both Cornwallis and Terrick were resolutely against the scheme. Terrick in particular held strong views on the matter, believing that a 'Papist' decoration scheme was anathema to the traditions and dogma of the established Church (an objection which, in retrospect, must have been particularly perplexing to the Roman Catholic artist, James Barry) (Northcote, 1818, vol. II, pp. 308–9). Terrick had, in addition, evidently taken umbrage because he had been the last to be informed about the scheme (Newton, vol. I, pp. 105–6, quoted by Northcote, 1818, vol. I, p. 311).

Negotiations between the Academy and the relevant authorities apparently took place during the weeks following the Royal Academy meeting of 19 August. Newton, in his own version of events, stated that the plan was to have Reynolds and West paint 'trial' pictures to hang over the entrances to the high altar from the north and south aisles, the other works to be commenced subject to the approval of these paintings (Newton, 1782). On 4 September Reynolds attended the Royal Academy and on 10 September he recorded an appointment at St Paul's at 2 p.m. The following day Reynolds set out for Devon. He was away for almost a month, and evidently did not return to London until Thursday 7 October. On Monday 11 October he broke the news that the St Paul's scheme had been abandoned. Three days later Barry wrote to the Duke of Richmond: 'Sir Joshua Reynolds who had undertaken the management of this business, informed us last Monday, the day after his return from Plympton, where he was chosen mayor, that the Archbishop of Canterbury and Bishop of London had never given any consent to it, and all thoughts about it must consequently drop' (in Fryer, 1809, vol. I, pp. 243–5).[7] Although Reynolds may have been informed of the decision to reject the

scheme during his sojourn in Devon, he probably did not know until after his return from Devon.

Several observations can be made concerning Reynolds's involvement in the St Paul's scheme. First, although ostensibly set up under the auspices of the Royal Academy, the St Paul's scheme was from the beginning a privately organized venture by West and Reynolds. The principal role of the Royal Academy was to gain the support of the King (which, given George III's personal antipathy towards him, Reynolds would have found difficult in gaining privately). Also, given that the scheme failed through no fault of Reynolds's own, it is curious that Reynolds, as president of the Royal Academy, did not promote an alternative scheme. (The Academy could, for example, have reverted to the original plan and decorated the Royal Chapel at Somerset House.) And yet, to promote a scheme which he had not innovated and over which he had limited control was anathema to Reynolds who, despite his many virtues as president, did not favour the democratic process when dealing with fellow Academicians.

An indication of Reynolds's indifference towards schemes which he did not initiate or control can be gained by his attitude towards the plan formulated in 1774 by the Society of Arts to decorate their new chamber at the Adelphi. This scheme was to have included the six Royal Academicians involved in the St Paul's decorations, as well as John Hamilton Mortimer, Joseph Wright, Edward Penny, and George Romney.[8] Unlike the paintings for St Paul's, which were to be given *gratis*, the Society of Arts proposed to pay the artists out of receipts taken from the exhibition of the paintings. The ultimate decision not to proceed was taken by a meeting of the artists on 5 April 1774 at the Turk's Head. Reynolds was not present (see Pressly, 1981, p. 86). And, since he did not make a note of the meeting in his sitter-book, Reynolds presumably never had any intention of attending.[9] The failure of the St Paul's scheme and the subsequent refusal of the Royal Academy to endorse the venture at the Adelphi were, in hindsight, crucial not only in contributing to the estrangement between Reynolds and Barry but in distancing Reynolds from his fellow professionals. Of more immediate significance, however, was the dashing of any hope that the Academy, under Reynolds's presidency, might provide the platform for the aspirations of British history painters.

Even though the St Paul's scheme came to nothing, at least four of the artists involved evidently produced designs for paintings which they intended to donate to the cathedral (see Newton, 1782, vol. I, p. 106).

West, who was to have depicted *Moses Receiving the Commandments*, exhibited an oil sketch of the subject at the Royal Academy in 1774, and incorporated it later into his designs for the Chapel Royal at Windsor (see von Erffa and Staley, 1986, pp. 299–300). According to James Barry, Dance's painting was to have been *The Raising of Lazarus* – although there is no record of a subsequent painting by the artist of the subject.[10] Barry's original intention, as Pressly has observed, was to paint an *Ecce Homo*, although he subsequently decided upon the *Fall of Satan*.[11] According to Thomas Newton, Reynolds's contribution was to have been 'the infant Jesus lying in the manger, with the shepherds surrounding, and the light flowing all from the child, as in the famous Notte of Corregio [*sic*]' (see Newton, 1782, vol. I, p. 108). Taken together, the four artists' choice of subject suggests that they were free to follow their own inclinations, rather than a prescribed iconographic programme. At least three of the artists – West, Barry, and Reynolds – followed up their designs, Reynolds's *Nativity* forming the focal point of his designs for the west window of New College, Oxford.

Patronage of religious art in mid-eighteenth-century England was not only sporadic, but lay for the most part beyond the auspices of the established Church. Francis Hayman, who had painted a number of works taken from the New Testament (including *St Peter Denying Christ* and *The Resurrection*) relied on the idiosyncratic tastes of Handel's librettist, Charles Jennens. The subject of Mortimer's *St Paul Preaching to the Britons* of 1764 was given to him as a competition piece by the Society of Arts (they subsequently awarded him a prize of £100 for the work). Hogarth too, working alone at St Bartholomew's Hospital, or alongside others at the Foundling Hospital, funded his activities from his own pocket (Allen, 1987, pp. 60–1; see also Croft-Murray, 1962–70, vol. II, pp. 19, 22–3). By the 1760s, however, there were increasing signs that a more enlightened attitude towards the promotion of sacred art was being adopted by the Anglican Church. Benjamin West, who had arrived in England from Italy in 1763, had gained the friendship of a circle of sympathetic clerical patrons including Robert Hay Drummond, Archbishop of York, and Thomas Newton, Bishop of Bristol. By the late 1770s, even prior to his work at St George's Chapel, Windsor, West had produced altarpieces for Rochester Cathedral, St Stephen Walbrook, London and Trinity College Chapel, Cambridge (see von Erffa and Staley, 1986, cats. 304, 388, and 406 respectively). Other artists had also secured the patronage of the clergy. In 1771 All Souls, Oxford had commissioned an altarpiece (*Noli me tangere*) from Anton Raphael Mengs, while in 1776

John Hamilton Mortimer executed designs (*Christ and the Four Evangelists*) for a painted glass window at Brasenose College. Ironically, Richard Terrick, such a vigorous opponent of the St Paul's scheme, commissioned Cipriani to paint an altarpiece for Clare College, Cambridge.[12] At the Royal Academy exhibition religious subject matter gained popularity. In 1777 Copley exhibited a *Nativity* and in 1778 Thomas Stothard showed a *Holy Family* (present whereabouts unknown). Reynolds's fancy pictures too – *The Child Baptist in the Wilderness* (plate 35) and *The Infant Samuel* (plate 36) – reflected a revival of interest in religious subject matter in late-eighteenth-century England.

Opportunities for Reynolds to paint history in the mid-1770s were limited. From 1774 to 1777 Reynolds's portrait commissions rose, following a comparative lull in the early 1770s. He faced stiffer competition as a portraitist than he had for several years. In 1774 Thomas Gainsborough moved from Bath to London, although it was the return of George Romney from Italy the following year that presented a more direct challenge to Reynolds's own brand of 'elevated' portraiture. As a result Reynolds bolstered his reputation not only by the sheer number of works exhibited at the Royal Academy (fifty-one between 1774 and 1777, as opposed to thirty-seven between 1769 and 1773) but with a series of large-scale historical portraits including *Three Ladies Adorning a Term of Hymen* (London, Tate Gallery), and *Lady Cockburn and her Children*, exhibited in 1774 (London, National Gallery), *The Bedford Children* (plate 3) of 1777, and his most ambitious group portrait to date – *The Marlborough Family* (Blenheim Palace), exhibited at the Royal Academy in 1778. Its scale and complexity – it involved a total of eight sitters – must have given Reynolds the confidence to embark on designs for *The Nativity* at New College, which he began towards the end of that year.

Since the mid-1760s the Warden and Fellows of New College, Oxford, had begun to renovate the stained glass in the College Chapel (Woodforde, 1951, pp. 39–40). Initially, they engaged the services of William Peckitt (1731–95). Peckitt, who had carried out work at Lincoln and Exeter Cathedrals in the early 1760s, was also responsible for constructing windows after designs by Cipriani at Trinity College, Cambridge (for Peckitt see Knowles, 1928–9, pp. 45–59; Brighton, 1988, pp. 334–453). In 1777, however, it was decided to dispense with Peckitt in favour of Thomas Jervais (d. 1799) who had gained considerable popularity, owing to a technique of glass-painting which consisted of burning enamel colour into white glass.[13] Having accepted the college's offer to undertake work for them, Jervais wrote to John Oglander (1734–94), Warden of New

College, on 26 June 1777, proposing Benjamin West as the designer of the panels in question. Although Jervais stated that he had 'no Motive in recommending Mr. West more than an opinion of his excellence in this Stile of design', he added that he would 'esteem it a favour my mentioning Mr. West may not be publish'd, as I shall make enemy's [sic] by my seeming partiallity [sic]' (in Woodforde, 1951, p. 40). However, it must already have been decided to approach Reynolds, as the following day Joseph Warton wrote to Oglander telling him that he would be happy to act as go-between on behalf of the college (ibid., p. 41). Warton, headmaster of Winchester School and a friend of Reynolds, acted quickly and on 5 July Reynolds wrote to him, accepting the commission. His acceptance was relayed by Warton in a letter to Oglander on 8 July (ibid., pp. 41–2). Eight days later, on 16 July, a contract setting out Jervais's responsibilities and a proposed schedule was signed between Jervais and New College (ibid., pp. 42–3). Reynolds, however, did not enter into any formal agreement with the college, a fact which was to lead to a subsequent misunderstanding over payment, as well as problems for Jervais – who relied on Reynolds in order to adhere to his own schedule.

According to William Mason, Reynolds had originally been asked by the Master and Fellows of New College to make 'drawings or cartoons' (in Cotton, 1859a, p. 58). Yet, even when Jervais had initially proposed West to the college authorities, he had suggested that the designs should be full-size in order that he would have a complete and detailed design to work upon (Woodforde, 1951, pp. 39–40). Certainly, it was a method preferred by Reynolds. When Mason visited Reynolds's studio he saw the figure of *Faith* (plate 66) – one of the three Christian Virtues – painted on canvas. As Reynolds explained, 'he had been so long in the use of the pallet [sic] and brushes, that he found it easier to him to paint them, to drawing. "Jervas [sic], the painter on glass", says he, "will have a better original to copy; and I suppose persons hereafter may be found to purchase my paintings"' (in Cotton, 1859a, p. 58). In November 1777 Jervais, who was apparently about to visit Oxford, went to Reynolds's studio to discuss the designs for New College. Here he was shown 'a figure of Religion' set against a background of sky. This was evidently *Faith*, the first of the Virtues to be executed by Reynolds. As Jervais reported to Oglander, 'I told him those already painted were in Niches, and the want of uniformity might be an objection' (in Woodforde, 1951, p. 43). It was probably during the same discussion that the possibility of putting the designs together in the west window of the chapel with a Nativity was raised, as Jervais told Oglander some years later:

66 *Faith*.
Oil on canvas, 243 × 83·8 cm.
Exhibited at the Royal
Academy, 1779. Private
Collection.

I call'd on Sʳ. Joshua to inform him I was going to Oxford, & to know if he had any commands, during our chat the plan that was adopted occur'd to me – I asked him (if the Society did not object to it) what was the opinion of putting an Historical Subject in the centre of the Window – he seem'd much pleased with the Idea, and commissioned me to inform the Gentlemen (to promote that plan) he would make the design *gratis* and said he had long wish'd to paint an Historical picture and this commission would give him a good pretence. (*ibid.*, p. 51)

New College evidently agreed to Jervais's suggestion, for on 27 December Reynolds wrote to Oglander telling him that he had already spoken to Jervais about the need to remove existing tracery in the west window in order to accommodate his design (Hilles, 1929, p. 58). On 9 January 1778 Reynolds sent a more detailed account of his intentions to Oglander, together with a drawing indicating exactly which pieces of tracery he wished to remove.[14] In order to strengthen his argument he incorporated the opinion of his own 'committee of taste':

The advantage the window receives from this change is so apparent at first sight that I need not add the authority and approbation of Sir Wm. Chambers to persuade you to adopt it, indeed not only Sir Willm but every person to whom I have shewn it approve[s] of the alteration Mr. T. Warton amongst the rest thinks the beauty of the window will be much improved supposing the Pictures which are occupy[ing] the space out of the question. This change by no means weakens the window, the stone pillars which are removed, suppo[r]ting only the ornament[s] above which are removed with it. (*ibid.*, pp. 59–60)

Reynolds's intended alteration to the exisiting Gothic framework (although subsequently surpassed by Benjamin West's remodelling of the entire east window of St George's Chapel at Windsor in the 1790s to accommodate his *Resurrection*), was a radical proposal.[15] Nevertheless, by demonstrating the approval of an eminent architect (William Chambers), and a prominent Oxford intellectual (Thomas Warton), Reynolds presumably knew that he could overcome any residual prejudice from conservative elements within New College. In the same letter Reynolds set out exactly how he wished to organize the window space:

Supposing this scheme to take place my Idea is to paint in the great space in the centre Christ in the Manger, on the Principle that Corregio has done it in the famous Picture calld the Notte, making all the light proceed from Christ, these tricks of the art, as the[y] may be called, seem to be more properly adapted to Glass painting than any other kind. This middle space will be filled with the Virgin, Christ Joseph, and Angels, the two smaller spaces on each side I shall fill with the shepherds coming to worship, and the seven divisions below fill'd with the figures of Faith Hope and Charity and the four Cardinal Virtues, which will make a proper

67 Richard Earlom (after Thomas Jervais and Sir Joshua Reynolds), *West Window of New College, Oxford.*
of *New College, Oxford.*
Line engraving, 64·8 × 47·5 cm. 1787. The Trustees of the British Museum.

Rustic Base of foundation for the suppport of the Christian Religion upon the whole it appears to me that chance has presented to us materials so well adapted to our purpose, that if we had the whole window of our own invention and contrivance we should not probably have succeeded better. (in Hilles, 1929, p. 60)

A comparison with the finished window (plate 67) indicates that Reynolds adhered closely to this plan.

The first design to have been transferred to glass was probably *Faith*, the window panel bearing the inscription, 'S[r] Joshua Reynolds Delin. Tho[s] Jervais Pinxit 1778'. By the spring of 1779, in addition to the three Christian Virtues – *Faith*, *Hope*, and *Charity* (which were to be placed directly below the main picture) Reynolds had also completed *The Nativity* (plate 68). Throughout January 1779 there were regular appointments with children in his sitter-books which probably relate to *The Nativity*. During February and March a 'Boy & Mother' appeared together on several occasions at the same time. On 12 February 'Child for the Christ' was entered, while, on 9 April – less than two weeks before the exhibition's opening – a sitting for 'the ox' was recorded. Mason, who frequently visited Reynolds's studio in the late 1770s, recalled watching Reynolds at work on *The Nativity*:

Three beautiful young female children, with their hair dishevelled, were placed under a large mirror, which hung angularly over their heads, and from the reflection in this he was painting that charming group as angels which surrounded the Holy Infant. He had nearly finished this part of his design, and I hardly recollect ever to have had greater pleasure than I then had in beholding and comparing beautiful nature, both in its reflection and on the canvas. The effect may be imagined, but it cannot be described. The head of the Virgin in this capital picture was first a profile. I told him it appeared to me so very *Correggiesque*, that I feared it would be throughout thought too close an imitation of that master. What I then said, whether justly or not I will not presume to say, had so much weight with him, that when I saw the picture the next time, the head was altered entirely: part of the retiring cheek was brought forward, and, as he told me, he had got *Mrs. Sheridan* to sit for it to him. (in Cotton, 1859, p. 58)[16]

Reynolds was determined to exhibit *The Nativity* at the Royal Academy in 1779, and rushed to complete it. Indeed, Mason recalled watching him 'at work upon it, even the very day before it was to be sent thither; and it grieved me to see him laying loads of color [sic] and varnish upon it, at the same time prognosticating to myself that it would never stand the test of time' (1859a, p. 59). Mason was correct. As early as 1784 Reynolds wrote to the picture's owner, the Duke of Rutland: 'In regard to the Nativity, the falling off of the colour must be occasioned by the shaking in the carriage,

68 G. S. Facius and J. G. Facius (after Sir Joshua Reynolds), *The Nativity*.
 Stipple engraving, 36·2 × 26·6 cm. 1785. After the painting exhibited at the
 Royal Academy, 1779. The Trustees of the British Museum.

but as it now is in a state of rest, it will remain as it is for ever' (in Hilles, 1929, p. 111). Reynolds offered to visit the Duke's seat, Belvoir Castle, to carry out repairs. The problem, however, had not simply been occasioned by the rigours of transportation, as the diarist Joseph Farington noted in October 1796: 'Marchi…restored the Nativity of Sir Joshua Reynolds at Belvoir Castle by infusing a preparation of paste through the cracks. He thinks it will remain sound 40 years. It was unluckily painted on a *floor Cloth* canvas doubled, which prevented him from lining the picture' (see Garlick, Macintyre, and Cave, 1978–84, vol. III, p. 669, 3 October 1796). Twenty years later, in October 1816, *The Nativity* was destroyed by fire at Belvoir Castle.

Despite the destruction of *The Nativity* its appearance can be determined not only from Jervais's painted window, but from engravings by Richard Earlom and the brothers Facius (plates 67 and 68). In addition there is also a small oil sketch (plate 69), which may represent Reynolds's preliminary ideas for the finished picture. Except in a few minor details (notably the placing of a single angel above the stable instead of the group of three in the sketch) the finished window resembled the oil sketch, which in turn reveals – far more clearly than the existing window – the compositional debt which Reynolds acknowledged to Correggio's famous 'Notte' (Dresden, Gemaldgalerie) of 1522, as well as Domenichino's copy of Carracci's lost *Adoration of the Shepherds* (Edinburgh, National Gallery of Scotland).[17] In the eighteenth century the 'Notte' (sold around 1745 by Francesco III d'Este, and purchased by the Elector of Saxony), was among the most revered old-master paintings in existence, and attracted the praise of Le Brun, Winckelmann, and Reynolds in equal measure. (Although he could not have seen Correggio's original painting, Reynolds had seen several copies of the painting in Italy (see Binyon, 1902, vol. III, p. 207, fol. 9).) Already, in 1754, *The Gray's Inn Journal*, bemoaning the current state of English history painting, had stated that 'The Transfiguration by Raphael, the Nativity by Corregio [*sic*], and the last Judgement by Michael Angelo will perhaps never be matched anywhere else' (no. 20, 9 February 1754, pp. 116–17, quoted in Allen, 1987, p. 58). Reynolds made frequent references to Correggio in his writings. And in the eighth *Discourse*, delivered to the Royal Academy in December 1778 – at the very time he was working on his own *Nativity* – Reynolds paid particular attention to Correggio's handling of light and shade. In praising Correggio's (and Rembrandt's) 'fulness of manner' he noted how the 'effect is produced by melting and losing the shadows in a ground still darker than those shadows; whereas that relief is produced by opposing and separating the

69 *The Nativity*
 Oil sketch, 90·2 × 49·2 cm. *c.* 1778–9. Private collection.

ground from the figure either by light, or shadow, or colour' (in Wark, 1975, p. 160). Reynolds's remarks were made in the context of a discussion about the superiority of 'fullness of effect' over 'relief' in pictorial composition (or the the simple massing of areas of light and shade over the careful delineation of individual objects). Like *Ugolino*, arguments pursued in the *Discourse* reflected his own practice, for as both the oil sketch and the window itself reveal, Reynolds's primary interest lay in the management of light and shade rather than in the narrative.

In addition to the *Nativity*, Reynolds exhibited the three Christian Virtues – *Faith, Hope,* and *Charity* – at the Royal Academy in 1779. And by early September 1779 Jervais's glass panels taken from them were in place in the west window of New College, as the Rev. James Woodforde noted in his diary on the 12th of that month:

In the west window of New Coll. Chapel are three most beautiful emblematical figures of Faith, Hope, and Charity, painted on glass. They were done by Jervase [*sic*] of London, and only put up in the Chapel last week. No painting can exceed them I think on glass. The whole of that great West Window is to be painted by him. The design is of Sir Joshua Reynolds's. (in Beresford, 1924–31, vol. I, pp. 264–5)

In 1780 Reynolds exhibited *Justice* (colour plate 12), the first of the four Cardinal Virtues, at the Academy, although a memorandum in his price ledger from October 1778 referring to his technical methods ('Venetia. Justicia. ma oli panni cera sol') indicates that it was begun two years earlier (Cormack, 1970, p. 168). *Temperance* and *Fortitude* were shown in 1781; and an *Angel* in 1782. The attitudes for the Virtues were derived from a wide variety of pictorial and sculptural sources. *Charity* was based on an engraving of an antique statue of *Niobe, Fortitude* from an engraving of the *Cesi-Juno* (Capitoline Museum), while *Prudence* was adapted from a drawing by Lucas Van Leyden, which Reynolds owned.[18] Technically, and conceptually, the Virtues are the most successful elements of the Oxford scheme, the finest figure possibly being *Justice* – perfectly poised, with the shadow of her arm across the eyes supplanting the customary blindfold. The iconography of the Virtues depended on maxims set out in Cesare Ripa's *Iconologia*. But, as with the 'blindfold' of *Justice*, Reynolds adapted the figures to his own needs as well as to contemporary manners and mores. *Charity* (plate 70) is a case in point. In the finished design by Reynolds, and in the Oxford window, *Charity*, clothed in a plum-coloured gown, supports a baby on her left shoulder and caresses a small girl with her right arm. A third child to her right tugs at her sleeve. According to Ripa, Charity is to be depicted as 'A woman all in red, a Flame on the

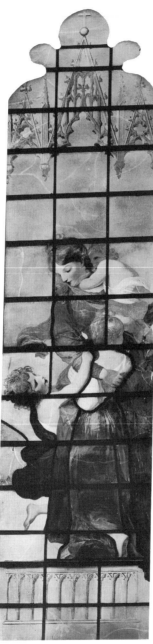

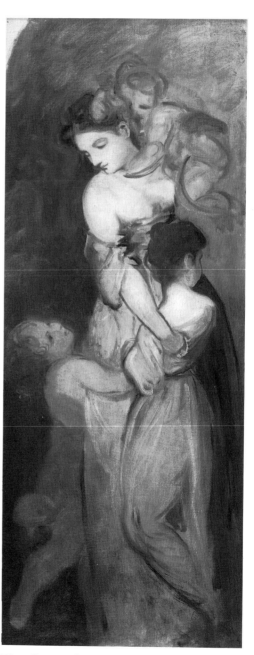

70 Thomas Jervais (after
 Sir Joshua Reynolds) *Charity*.
 Painted glass. 1779.
 New College, Oxford.

71 *Charity* (sketch).
 Oil on canvas, 173×69 cm. *c.*
 1778–9. Ashmolean Museum,
 Oxford.

Crown of her Head, with an Infant sucking, in her left Arm, and the two other standing up, one of which is embrac'd with the right' (1709, fig. 46, p. 12). Reynolds made a number of slight pen-and-ink sketches of a woman with three small children in a variety of attitudes which may relate to his initial ideas for the figure of Charity (Herschel Album, Royal Academy of Arts, London). In addition there are two more substantial studies, both of which indicate that Reynolds originally intended to show the figure breast-feeding an infant. One is a large pen-and-ink drawing (private collection), showing Charity with two naked cherubic infants at her feet, and two babes-in-arms, one of which she suckles. The other is a large oil sketch (plate 71). As in the finished design, there are three children, although again Charity's breasts are exposed. Given that Mrs Sheridan was Reynolds's model for Charity – and would presumably have been recognized as such – iconographical correctness almost certainly gave way to 'political' correctness.

The seven Virtues were self-contained figures. The four panels to either side of the *Nativity*, which were intended to lead the eye out from the central area, were more complex designs. As Reynolds had told Oglander in the aforementioned letter, his intention was to fill these spaces with 'the shepherds coming to worship'. At the extreme right and left he painted two panels showing shepherd boys, which were reminiscent of fancy pictures, such as *The Child Baptist in the Wilderness*. Immediately adjacent to the *Nativity*, on the right, the torchlit peasant woman and two children represented a dramatic demonstration of his concern with 'fullness of effect' through an effective use of *chiaroscuro*. To the left was a portrayal of Reynolds and Jervais as adoring shepherds (colour plate 13). Like St Joseph in his *Nativity* – and Ugolino – Reynolds looks directly at the viewer. Although the attitude can be regarded as a 'visual autograph', within the traditions of western art, *The St James's Chronicle* considered the device to be egotistical, and upbraided Reynolds for placing 'himself and Mr. Jarvois [*sic*] in that inimitable painted Window at New College as Parties in the Adoration, and yet *looking* at those who come to admire two such excellent artists' (M. M., 22–5 October 1785).[19]

Horace Walpole, a sounding-board for fashionable opinion, considered Reynolds's *Nativity* to be 'very great' (in Graves, 1906, vol. VI, p. 273). Others were more sceptical, especially about the characterization of the figures. As it was noted in chapter 1, some critics took exception to the egregious presence of Reynolds's model, George White, as St Joseph – especially as the expression on his face was virtually the same one which he had worn in *Ugolino and his Children in the Dungeon*. In 1783, in a note

in William Mason's English translation of Du Fresnoy's *Art of Painting* Reynolds issued the following advice:

There is another circumstance which, though not improper in single figures, ought never to be practiced in historical pictures: that of representing any figure as looking out of the picture, that is looking at the person who views the picture. This conduct in history gives an appearance to that figure of having no connection with the rest, and ought therefore never to be practiced except in ludicrous subjects'. (in Malone, 1819, vol. III, pp. 133–4)

The contradiction between Reynolds's theory and his own practice was picked up at the time by at least one critic, who stated that Reynolds 'tells us...that, except in ludicrous subjects, none of the personages of the picture ought to be represented as looking out of it – his Nativity, therefore, according to this rule, is a ludicrous subject, as Joseph is looking at the spectator, and pointing to the infant' (in Northcote, 1818, vol. II, p. 109). James Northcote, however, defended Reynolds's practice, stating that the critic had failed to realize that Joseph is not drawing the attention of his fellow protagonists to the infant, but is gesturing to the viewers, 'and directs them to behold their Redeemer' (*ibid.*).

Press reaction to Reynolds's New College designs varied greatly, critics generally being predisposed to base judgements upon their opinion of Reynolds's personal merits rather than an objective assessment of his artistic achievement. The anonymous author of *The Earwig* was ecstatic over the qualities of *Temperance* and *Fortitude*: 'We can do justice to these pictures in no other manner than by comparing them with those on the same subject painted by the immortal Raphael: their character, colouring, etc., are perfectly sublime' (Anon., 1781, p. 16). On the other hand, *The Morning Post* (2 May 1780) suggested that *Justice*, whose unbalanced scales were 'repugnant to the ancients' idea of *justice*' was painted 'in imitation no doubt of the wife of a Clare-Market butcher weighing out a leg of mutton to his dainty customer'. Although similar snide comments abounded, there were few attempts to place Reynolds's subject paintings within the context of his overall achievement. An exception was the author of the following piece in *The Public Advertiser* on 27 April 1779. After a few cavils concerning specific formal shortcomings, he states:

This criticism may be reckoned Heresy by those, who are taught to look up to Sir Joshua as infallible; but though we readily subscribe to this great artist's excellence in portrait painting, we think the rest of his pieces this year, give an additional support to our opinion, yet this, and his other *historical* exhibitions prove, he is not equal to all the parts of his profession.

As this piece of criticism indicates, commentators were aware that Reynolds's claims as a history painter (as well as a portraitist) were actively promoted by the artist and his supporters – to the point that they could admit no shortcomings. *The Morning Post* (8 May 1780), for example, in reviewing Reynolds's portraits of George III and Queen Charlotte which hung in the newly opened Somerset House, stated in a similar vein that 'if it were not likely to be deemed *high treason* against the *Prince of Painters*, we should be apt to criticise pretty freely'.

The ability of Reynolds to generate propaganda for his own work – even at the expense of the true beliefs of his admirers – emerges forcibly in Thomas Warton's *Verses on Sir Joshua Reynolds's Painted Window at New College, Oxford*, published in 1782.[20] Warton's intention was to contrast Reynolds's classically inspired west window with the rest of the Gothic structure and furnishings of the chapel at New College. The first stanza took the form of a 'protest' at the intrusive nature of Reynolds's design, which by its 'bright transparent mass' destroys his 'Gothick' reverie:

> Where elfin sculptors with fantastic clew,
> O'er the long roof their wild embroid'ry drew;
> Where Superstition, with capricious hand,
> In many a maze the wreathed window plann'd.

Warton then appeals to Reynolds not to disturb his romantic vision:

> Chace not the phantoms of my fairy dream,
> Phantoms that shrink at Reason's painful gleam!

The second stanza explains that although Gothic art appeals to the senses, it is a delusion, and can be no match for the more rational truths offered by the classical tradition:

> Sudden, the sombrous imag'ry is fled,
> Which late my visionary rapture fed:
> Thy powerful hand has broke the Gothic chain,
> And brought my bosom back to truth again:
> To truth, whose bold and unresisted aim
> Checks frail caprice, and fashion's fickle claim.

Warton suggests that Reynolds, through his endorsement of classicism, has triumphed over transient fashion in favour of a more permanent and lasting vision. The sentiments expressed in the poem would merit less comment if Thomas Warton had not been among the most prominent advocates of the 'Gothick' style. Already, through verse and criticism, Warton had by the 1780s made significant contributions towards an

increased appreciation of medieval literature and architecture, with such works as *The Crusade* of 1777 and *The Grave of King Arthur*.[21] Moreover, Warton's work, like that of Gray and Collins, contributed towards a more sympathetic appreciation of Gothic architecture which superseded a purely antiquarian interest in the medieval past and fostered the burgeoning aesthetic of the 'Picturesque'.[22] Warton's principal purpose in the *Verses on Sir Joshua Reynolds's Painted Window* was to propagandize on his friend's behalf. For just as Reynolds had used his influence to gain Warton's membership to the 'Club' in 1777 (and was in 1785 to canvass successfully on his behalf for the title of poet-laureate), so Warton in return used his name to lend weight to Reynolds's claims as a history painter.[23] As Mrs Thrale had remarked in 1777 of Reynolds, 'his Thoughts are tending how to propagate Letters written in his Praise, how to make himself respected as a Doctor at Oxford, and how to disseminate his Praise for himself, now Goldsmith is gone who used to do it for him' (in Balderston, 1942, vol. I, p. 80). Given the circumstances, it is not surprising to learn that when Warton initially presented his *Verses* to Reynolds in May 1782, the latter acknowledged that Warton's sentiments did not come straight from the heart:

I owe you great obligations for the Sacrifice which you have made, or pretend to have made, to modern Art, I say pretend, for tho' it is allowed that you have like a true Poet feigned marvellously well, and have opposed the two different stiles with the skill of a Connoisseur, yet I may be allowed to entertain some doubts of the sincerity of your conversion, I have no great confidence in the recantation of such an old offender. (Hilles, 1929, p. 94)[24]

Reynolds, somewhat ironically, characterized himself as a 'modernist', while Warton, the 'old offender', is teased as a fusty antiquarian. (Reynolds's suggestion that one of the most useful attributes of a 'true Poet' was to 'feign' reflected – as Lawrence Lipking has noted – the deliberately shifting ground on which Warton based his own poetic stance (see Lipking, 1970, p. 399).) That Warton's principal aim had been to propagandize was underlined by the fact that Reynolds, upon reading the poem, pointed out that his name had been omitted from the main body of the poem. As he told Warton, 'if the title page should be lost it will appear to be addressed to Mr. Jervais'. Warton made the requisite alteration, and in the second edition of 1783 'Artist, 'tis thine' was replaced by 'Reynolds!, 'tis thine' (Hilles, 1929, p. 95). In the same year that Thomas Warton wrote his *Verses on Sir Joshua Reynolds's Painted Window*, his brother, Joseph, paid his own passing tribute in the course of the long-awaited

second volume of his *Essay on the Genius and Writings of Pope*. Ironically – in view of Reynolds's partial destruction of the existing tracery to accommodate his own design – the context for Warton's remarks was a commentary on Pope's strictures on the removal of medieval church decoration by Puritans. 'The chapel of New College in Oxford', he stated, 'will soon receive a singular and invaluable ornament; A window, the glass of which is stained by Mr. JERVAIS, from that exquisite picture of the Nativity by Sir Joshua Reynolds' (1782, vol. II, p. 197).[25]

In his price ledger of 1780 Reynolds noted that 'Mr. Oglander has paid for all the designs of the window at New College, except the Great picture of the Nativity' (see Cormack, 1970, p. 160). As it turned out, he was to receive no payment for *The Nativity* due, it seems, to the aforementioned verbal communication by Jervais that Reynolds would execute the painting *gratis*. None the less, in 1785, when Jervais's glass-painting of the Nativity was being put in place, Reynolds evidently raised the question of remuneration, informing Oglander that he had no recollection of offering to paint *The Nativity* free of charge. Moreover, he added brusquely, 'I think I am confident that if I had seriously commissioned him [Jervais] to make such a proposal to the College, I should not have forgot it' (in Woodforde, 1951, pp. 51–2). However, since the Duke of Rutland had already paid Reynolds £1,200 for the design – 'a price for an English picture at that time quite unexampled' – he had little cause for complaint (Leslie and Taylor, 1865, vol. II, p. 263). The other designs – paid for by New College (in addition to the fee paid to Jervais) – remained in Reynolds's possession, decorating his gallery during the following decade (see *The Morning Post*, 4 November 1786; *The World*, 9 January 1787).

Jervais's glass-paintings were also displayed in London, before being incorporated into the window at New College. *Justice* and *Prudence* were exhibited in April 1780; *Fortitude* and *Temperance* in 1781; and *The Nativity* in 1783, at Pinchbeck's Rooms, Cockspur Street, Haymarket (Jervais having exhibited his glass panels in this way since at least 1774 – see *The Gazetteer*, 25 April 1780; *The Morning Herald*, 30 April 1781). Displayed in darkened galleries, and set before a strong artificial light source, Jervais's windows drew large crowds, among them the diarist Sylas Neville, who attended the exhibition on 14 June 1783:

The effects of light and shade are beautifully managed, particularly in the Nativity after Sir Joshua, intended for New College, Oxon. The placid countenance of the Virgin, beautifull expression of wonder and joy of the seraphs, who surround the child, from whom the light proceeds – this great idea is borrowed from M. Angelo [sic]. The hand of the child upon one of the angels is not so well, as they are

supposed to be incorporeal beings. Quires of ancient architecture – fluted columns [are] introduced in the stable scene – with what propriety it may be doubted, as the Jews were never celebrated for the arts. (in Cozens-Hardy, 1950, p. 306)

John Byng, Lord Torrington – whose preference for Gothic forms is clear from comments he makes elsewhere – was, however, unimpressed by Jervais's new technique when he saw several of Reynolds's Virtues *in situ* at the college, two years earlier, in 1781:

The new windows of this chapel are at present the admiration of travellers, by being the University boast. Now I am sorry to dissent this run of fine taste, and wou'd hate to think myself peevish or fastidious; yet I must own I prefferr'd the old high-coloured paintings, and their strong, steady shade, to those new and elegant-esteem'd compositions; and to speak my mind, these twisting emblematical figures appear to me half-dress'd languishing harlots; no doubt, but that men of skill have been consulted, who determin'd them to be of the collegiate and Gothic taste, else they had never been introduced into this beautiful old chapel. (in Andrews, 1938, vol. I, p. 55)

Byng expressed a similar disrespect for Reynolds's portraits on a visit to Grimesthorpe Park in 1789, where he spotted 'some faded Pictures by Sir J. Reynolds – of no value to anyone' (*ibid.*, vol. VI, p. 127). Horace Walpole, who harboured no aesthetic grudges against Reynolds's designs for New College or the 'men of skill' who had sanctioned them, expressed qualified admiration for the glass-paintings, although – as he told William Mason in May 1783 – he held out little hope for their long-term success.[26]

In March 1785 the west window was finally fully installed at New College. Among those who inspected it that year was Horace Walpole's correspondent, Henry Seymour Conway. Walpole told him:

I don't wonder you was [*sic*] disappointed with Jarvis's windows at New College; I had foretold their miscarriage. The old and new are as mismatched as an orange and a lemon; nor is there room enough to retire back and see half of the new; and Sir Joshua's washy Virtues make the 'Nativity' a dark spot from the darkness of the shepherds, which happened, as I knew it would, from most of Jarvis's colours being transparent.[27]

Two years earlier Walpole had informed Lady Ossory that Reynolds had, himself, expressed dissatisfaction with the glass-paintings.[28] While – according to Mason – Reynolds, himself, stated: 'I had frequently... pleased myself with reflecting, after I had produced what I thought a brilliant effect of light and shadow on my canvas, how greatly that effect would be heightened by the transparency which the painting on glass would be sure to produce. It turned out quite the reverse.' Mason agreed,

although in his friend's defence, he recalled that he had seen the window on a dull morning; 'whereas, supposing the chapel to stand east and west, a bright evening is the proper time to examine it' (in Cotton, 1859a, p. 59).

In addition to his commitments to portraiture and subject pieces, Reynolds was by 1780 preoccupied with the relocation of the Royal Academy in William Chambers's New Somerset House. (He apparently also continued to rework *The Nativity* (Graves and Cronin, 1899–1901, vol. III, p. 1179).) Yet, despite his existing workload, he took time to contribute to the decoration of the new Royal Academy premises. The work in question (for which he was paid the small sum of 30 – or possibly 60 – guineas) was a ceiling panel for the library, entitled *Theory* (plate 72) (Penny, 1986, p. 284). This emblematic figure was, as contemporaries would have appreciated, fully concomitant with Reynolds's position as the leading British codifier of art theory. As Nicholas Penny has suggested, *Theory* may have been painted as early as 1776 when Chambers's plans for Somerset House were first approved. In any case, it was almost certainly completed during 1779 (*ibid.*). Significantly, there are a number of formal similarities between the figure of Theory and at least two other paintings by Reynolds of the mid-1770s. The head of Theory was a reversal of Barbara Montgomery from the 1774 group portrait of the Montgomery sisters (*Three Ladies Adorning a Term of Hymen*; Tate Gallery), while the lower part of the figure – ultimately adapted from an angel in Raphael's design for a mosaic in the Chigi Chapel in S. Maria del Popolo, Rome – may also have served for the legs of his fancy picture, *St John*, shown at the Royal Academy in 1776.[29] Giuseppe Baretti decoded the iconography of Reynolds's *Theory* in his 1781 guide to the newly opened Academy: 'The Centre-Painting represents the *Theory of the Art* under the form of an elegant and majestick female, seated in the clouds, and looking upwards, as contemplating the Heavens. She holds in one hand the Compass, in the other a Label, on which this sentence is written: THEORY *is the knowledge of what is truly* NATURE' (1781, p. 17). Given Baretti's intimacy with Reynolds – and his familiarity with the painting – it is curious that there is no trace of a compass in Reynolds's design, suggesting that Reynolds erased it or simply decided to omit it. (As Penny notes, Grozer's mezzotint of the painting does include 'twin points radiating from Theory's head', suggestive perhaps of dividers, although the engraving was made in 1785, some five years after the painting had been installed at Somerset House.[30]) The inscription on Theory's scroll served not only to identify the allegorical figure represented but ultimately to draw attention to the intellectual basis of Reynolds's own art.

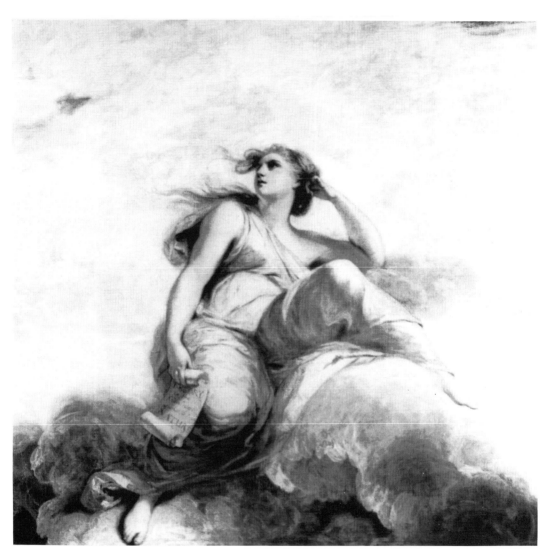

72 *Theory.*
 Oil on canvas, 172·7 × 172·7 cm. *c.* 1779. The Royal Academy of Arts,
 London.

Theory was not exhibited at the Royal Academy, presumably because it was already in place in the library but also because, as a ceiling-painting, it was intended to be viewed from below rather than horizontally. The following year, however, Reynolds exhibited his first major history painting at New Somerset House – *The Death of Dido* (colour plate 13), from Virgil's fourth book of *The Aeneid*. In its treatment of heroic death, and its formal dependence on the Bolognese old-master tradition, *The Death of Dido* was reminiscent of *Ugolino*, to the point that it could be viewed as its female counterpart. The subject, which was well established among the most elevated traditions of western art, also already existed in Britain. In 1777 Angelica Kauffman exhibited *The Death of Dido* at the Royal Academy, as did Cipriani in 1779. Reynolds had also begun his version of *The Death of Dido* by 1779. Indeed, he was clearly far enough advanced with the subject to contemplate employing his pupil William Doughty to make an engraving of it.[31] As the sitter-book for 1779 reveals, even though he was still engaged in painting designs for New College Chapel, Reynolds had the opportunity to work on a painting of Dido that year. From June 1779 until February 1780 he had few portrait commissions, and was absent from the studio only in October 1779 to visit Blenheim Palace – in connection with his recent portrait of the family of the Duke of Marlborough. Evidence of his preoccupation with the painting occurs in his sitter-book for 1780 – opposite the week commencing Monday 7 February – where there is a thumbnail sketch of the head of the goddess Iris, the figure at the extreme left of Dido. By the spring of 1780 Reynolds had probably completed a first version of *The Death of Dido*. He did not, however, have the chance to devote time to it again until the following August owing to the pressure of portrait commissions. When he turned to *The Death of Dido* once more in August 1780, it was not, however, to the original composition, but to a second version – as Henry Fuseli noted.[32]

Fuseli, whom Reynolds had encouraged in his aspirations to be a painter during the late 1760s, returned to London from an eight-year sojourn in Italy in 1780. Rapidly establishing himself among prominent artistic and literary circles in the capital, Fuseli was soon to be taken into Reynolds's confidence. On 27 August Fuseli wrote to Sir Robert Smyth: 'Sir Joshua, whom I spent lately a whole day with, is busy with a Dido again...the same in every respect as the first but less promising in point of execution; he himself begins to think he has failed (in Weinglass, 1982, p. 19).[33] This was not the only occasion on which Fuseli watched Reynolds at work on *The Death of Dido*. As he told Thomas Lawrence in 1813, he had 'seen the progress of the work if not daily, weekly, and knows the throes which it

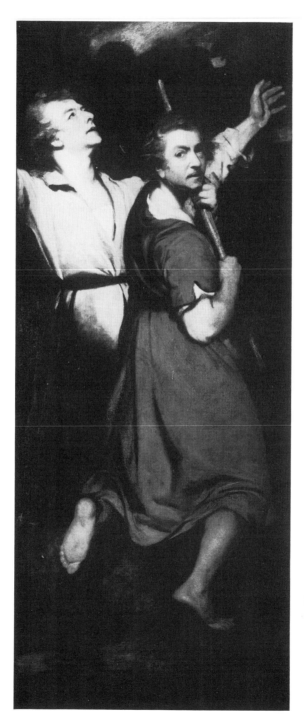

73 *Adoration of the
Shepherds* (Thomas
Jervais and Sir Joshua
Reynolds).
Oil on canvas,
209·2 × 83·2 cm.
c. 1780. Private
collection.

cost the author before it emerged into the beauty, assumed the shape, or was divided into the powerful masses of chiar'oscuro which strike us now' (in Knowles, 1831, vol. I, p. 386). Another, younger, visitor to Reynolds's studio at the time was the twenty-five year old Thomas Stothard, then a student at the Royal Academy. Although it is doubtful whether Reynolds would have disclosed his anxieties about *The Death of Dido* to Stothard, it is significant that the young artist was given complete access to his studio. There, as Stothard observed, Reynolds had assembled a series of props to enable him to realize his conception for *The Death of Dido*, having, as he stated, 'built up the composition with billets of wood, over which the rich drapery under the queen was thrown, and on it a lay-figure in her attitude and dress' (quoted in Leslie and Taylor, 1865, vol. II, pp. 326–7).[34]

The Death of Dido, like *Ugolino and his Children in the Dungeon*, reflected ideas which Reynolds promoted in the *Discourses*. Reynolds's visual terms of reference were wide ranging.[35] As Edgar Wind pointed out in 1938, the figure of Dido appears to be based upon the *Sleeping Psyche* from Giulio Romano's Sala di Psyche in Palazzo del Te, Mantua, although – as Richard Dorment has since observed – Giulio Romano's figure was an adaptation of an antique statue of *Cleopatra* (Vatican Museum, Rome) (Wind, 1938, p. 183; Dorment, 1986, p. 299). In addition, Fuseli observed that the figure of Dido's sister, Anna, was derived from the *Deposition* by Daniele da Volterra (Orsini Chapel, Trinità dei Monte, Rome), a suggestion borne out by the existence of a sketch of this painting in one of Reynolds's Italian sketch-books.[36] Aside from these specific sources, Reynolds was almost certainly inspired by Guercino's *Dido Transfixed with the Sword of Aeneas* (Palazzo Spada, Rome), which he had also commented upon in his note-book, when in Rome.[37] Indeed, the prominent positioning of the pile of wooden billets in that picture may have prompted Reynolds to take the unusual step of constructing his own diorama.

Edgar Wind, in comparing Reynolds's 'borrowings' in *The Death of Dido* from Giulio Romano and Daniele da Volterra, with some of the artist's better-known pictorial sources, suggested that Reynolds 'feeling safe from being discovered in the use of such far-fetched models, thought he could afford to borrow them more literally' (1938, p. 183). And yet the fact that the original identification of these sources came from Fuseli – who had clearly discussed the painting with Reynolds in his studio – indicates that, rather than concealing his sources, Reynolds drew his attention towards them. (Fuseli later maintained that he had been on far more intimate terms with Reynolds than his biographer and pupil, James Northcote. 'I know much more of Sir Joshua than you do', he told him, 'for while I was

admitted always upon familiar terms you were considered as little better than his palette cleaner' (quoted in Weinglass, 1982, p. 507).) The continual rediscovery of a great number of Reynolds's pictorial sources during the present century has tended to reinforce the suspicion that they were originally covert.[38] And yet, while not all of Reynolds's viewers would have recognized some of his more obscure visual references, they would have been spotted by artists, making it less likely that he would have intentionally wished to conceal them.

The issue of imitation, of fundamental importance in any discussion of eighteenth-century art and aesthetics, is clearly relevant to Reynolds's approach to high art. Edgar Wind's view on Reynolds's pictorial borrowings or imitations was outlined in an article entitled '"Borrowed attitudes" in Reynolds and Hogarth', and centred on an investigation of Horace Walpole's assertion that Reynolds's plagiarisms were defensible as a form of 'wit' (Wind, 1938, p. 182). Although Wind agreed with Walpole over intentionally amusing quotations such as *Master Crewe as Henry VIII* (private collection) – which derived from Holbein's famous cartoon fragment (London, National Portrait Gallery) – he believed that the argument was untenable when transferred to more literal adaptations contained in Reynolds's history paintings. Wind made two suggestions: the first was that the higher Reynolds went in addressing the 'Great Style' the more his imagination failed him; his second suggestion was that 'He himself conceived of the grand style as "artificial" and as presupposing an "artificial state of mind" which can be reached only by systematic training, that is, by raising one's self – through imitation – to the level of the old masters' (*ibid.*, p. 183). *Ugolino and his Children in the Dungeon*, *The Nativity*, and *The Death of Dido* all support such a thesis. In his public art, and in his public role as president of the Royal Academy, Reynolds did not want his history paintings simply to convey a moral or tell a story. He wished to communicate in pictorial form those values which he continued to communicate through his own theoretical writings on art. Thus his history paintings represented unashamed exercises in the styles of particular artists, and were intended, like their poetic equivalents – the works of friends such as Johnson, Mason, and the brothers Warton – as objectively conceived imitations. And, like the *Discourses*, they not only borrowed ideas, but adapted and codified them for contemporaries.

Having procrastinated, Reynolds hurried to complete *The Death of Dido* for the 1781 exhibition. A month before the 1781 exhibition was due to open – on 13 March – Fanny Burney visited Reynolds's home, noting: 'Sir Joshua is fat [*sic*] and well. He is preparing for the exhibition a new Death

of Dido' (quoted by Leslie and Taylor, 1865, vol. II, p. 321).[39] (It is unlikely, however, that this was a third version of the subject.) Reynolds had several reasons for wishing to place the picture in the exhibition that year. He must have been aware of Fuseli's intention to show his own version of the subject at the Academy. (Although – as Nicholas Powell has pointed out – it was actually Fuseli's more celebrated *Nightmare*, shown in the same exhibition, which owed the greater debt to Reynolds's composition.[40]) In addition, it was decided at a council meeting at the Royal Academy, on 11 November 1780, that *The Death of Dido* was to be one of the subjects recommended to students for the history-painting prize. Having ratified the choice of the council of the Royal Academy, Reynolds would surely have wished to promote his own painting as a practical endorsement of the subject and a paradigm for students of the Academy to follow.

James Northcote, writing in 1818, stated that when Reynolds's *Death of Dido* was shown at the Royal Academy it 'drew immense crowds, exciting the applause not only of Englishmen, but of most judicious foreigners' (1818, vol. II, p. 121).[41] Foreigners who did not visit the exhibition did not gain the opportunity to view the composition at second hand as Reynolds's efforts to secure an engraving during his lifetime failed. (He attempted to have the painting engraved by William Dickinson, but without success – as *The World* noted (9 January 1787): 'Infelix *Dido* is restored to her Joshua! The Perverseness of her destiny reaches even to the tools of the engraver. Even the *Nulli bene Nupta* – Dickenson [*sic*] himself has tried, but tried it seems, alas! in vain. This fine picture however must not escape us so.') A stipple engraving was published by Joseph Grozer in 1796. The picture itself remained in the possession of Reynolds's family until it was purchased in 1821 by Sir Charles Long, on behalf of George IV (see Penny, 1986, cat. 123).

Most newspapers carried extensive commentaries on the picture at the time of the 1781 exhibition. On a technical level, the consensus of opinion was that although the figure of Dido (evidently painted from a lay-figure) was anatomically incorrect, the beauty of Dido's face and the richness of colour provided compensation. (*The St James's Chronicle* (28 April – 1 May), for example, although it found fault with Dido's figure, thought the face 'expresses the Pain which proceeds as much from the Mind as the Body'.) Horace Walpole told William Mason in 1781: 'Nobody shines there but Sir Joshua and Gainsborough. The head of the former's *Dido* is very fine.'[42] Comparisons were also inevitably made with Fuseli's *Death of Dido* (New York, Richard L. Feigen & Co.), which faced it across the main

exhibition room, *The Morning Chronicle* (5 May) concluding that although Fuseli's picture 'has not a parallel degree of merit, it still does not lose so much as might reasonably be expected, when we consider the great skill and experience of his opponent'. The most extensive survey of Reynolds's *Dido* was provided by 'Ensis' of *The London Courant* (7 May), who used Reynolds's picture as a means to attack Benjamin West:

If Mr. West is equally correct in his drawing, he has not the life and soul of a painter comparable to Sir Joshua; for the latter expresses what the former is not capable of conceiving, and those expressions are visible instantaneously, and without reflection.

But is it really Dido that expires?...Beauty alone expiring, innocent beauty expiring in sufferings, though on a pile, surrounded by shields, and daggers, and images, makes no Dido; and I ask the artist if this is not the feature of his figure? I allow that he who did so much could do more, and ascribe the reason of his giving up the truly grand for the merely graceful, to a deference for the taste of his age; such as it is, call it Dido or Cecilia; it is a face which few works can boast of, though I cannot help observing, that *Guercino*, the vulgar *Guercino*, who in every other part of this subject treated by him, proved himself unworthy of the task, has, strange to tell, preserved this leading feature of the Tyrian Queen.

Similar sentiments were expressed by the author of *The Earwig*, who remarked that the 'face of Dido is the beauty of an expiring saint, and does not convey the poet's idea of the character of Dido' (Anon., 1781, p. 13). As in *Ugolino and his Children in the Dungeon*, it was Reynolds's concern with form at the expense of the specific subject matter in hand which drew the principal criticism. Reynolds's own view, as expressed in the fourth *Discourse*, was that the artist ought to deviate 'from vulgar and strict historical truth, in pursuing the grandeur of his design' (in Wark, 1975, p. 59). And yet, according to Ensis he was simply deferring to 'the taste of his age' by ignoring the intrinsic moral content of the story – heroic self-immolation – in favour of producing beautiful passages of painting.

Reynolds contributed fifteen pictures to the Royal Academy's 1781 exhibition. James Beattie, who was on a visit from Scotland, reported that 'the best pieces, in my opinion, are Thaïs (with a torch in her hand); the Death of Dido; and a Boy, supposed to be listening to a wonderful story; these are by Sir Joshua Reynolds' (in Leslie and Taylor, 1865, vol. II, p. 328).[43] Beattie – a friend of Reynolds – and the subject of Reynolds's 1774 outrageously biased allegorical portrait, known as *The Triumph of Truth* (University of Aberdeen) – was not an impartial observer. In general, many commentators were disappointed with the standard of work on show at the Academy. As 'Guido' observed in *The Whitehall Evening Post*:

Whether this unexpected falling off be really owing to the death of genius, or an unaccommodating temper in the rulers of this royal institution we will not pretend to say; if the former, there is an end to the business; but if the latter, it is encumbent on men of taste to unite their endeavours, in order to prevent a prostitution of power, so fatal to the polite arts. (1–3 May 1781)[44]

Despite Reynolds's contribution, Gainsborough, concluded 'Guido', 'is confessedly the principal support of the present exhibition'. Others felt that the problem was not simply one of quality but a failure by artists to work in the most elevated genres. In a long letter to *The St James's Chronicle* (28 April – 1 May) 'A Friend to the Arts' enquired into the reasons why history painting languished. He wrote:

In England we see a number of artists sprang up in about 20 years, self-instructed, self-animated, and self-encouraged, striving to inspire the Publick with the same Love of their Art as they themselves feel; but fashion is against them. Taste is corrupted – and Fortunes broken. They must now droop their heads, follow the Current of the times, and forsake that great road to excellence, History Painting, without which Art sinks to a mere ornamental Occupation.

The artists themselves were not to blame, 'for I believe all of them would gladly give up twenty portraits for an Opportunity of studying one historical picture'. In this respect Reynolds was presented as a paradigm:

The President of the Royal Academy gives a proper example to the Artists in general by devoting some of his time to the pursuit of the Great Stile by producing some excellent pieces of History almost every year, and shows that whoever turns his mind continually towards the great End of his profession will lose nothing by being employed in some of its inferior branches.

These remarks must have been appreciated (if not expressly commissioned) by Reynolds. To James Barry, who was then embroiled in a financially self-sacrificial scheme to decorate the Great Room of the Society of Arts with a history painting depicting, among other things, *The Progress of Human Civilization*, such platitudes could only have served to strengthen his impression that Reynolds, far from promoting high art, was a deeply compromised figure.

5 *The Labours of Hercules (1782–1789)*

From July to October 1781 Reynolds visited the Continent for the first time since his brief sojourn in Paris in 1771. His destination now was the Low Countries. The journey marked a break with Reynolds's established summer routine of visiting friends in the country and working on his subject pictures. It also heralded a more flexible attitude towards the traditions of high art, as he looked increasingly towards northern artists – notably Rubens – with whom his own art was more instinctively akin. Like Rubens before him, Reynolds may also have been aware that he was the most acclaimed artist not only in his own country, but also in Europe. By the late 1770s, Jean-Baptiste Greuze, once the most popular artist in France, was already in decline (although he did not die until 1805). Fragonard too, was shortly to be reduced to poverty. Many of the artists whom Reynolds would have considered as rivals in terms of international public acclaim had died by the end of the 1770s. Carle van Loo died in 1765; Boucher (whom Reynolds knew personally) died in 1770, as did arguably the greatest painter of the eighteenth century, Giovanni Battista Tiepolo. Finally, in 1779, the continental artist whom Reynolds most resembled, Anton Raphael Mengs, died, at the aged of fifty-one. Despite attempts to bolster the level of state patronage at the accession of Louis XVI in 1774, under the comte d'Angevillier, Parisian history painting, reflected in the work of artists such as Nicholas-Guy Brenet (1728–92), Louis-Jacques Durameau (1733–96), and François-Guillaume Menageot (1744–1816), was lack-lustre.[1] As in England there was a growing interest in scenes taken from the country's own past, as well as in ancient history and mythology, and works such as Brenet's *Death of Guesclin* of 1778 (Musée National du Château de Versailles) form a close counterpart to West's equally drab medieval tableaux of the late 1770s and early 1780s.[2] Of greater significance were recent developments in Rome.

The most influential artist working in Italy in the late 1770s was Joseph-Marie Vien (1716–1809), director of the French Academy in Rome (and mentor there of the young Jacques-Louis David from 1775 to 1781). Aside from Vien, three other artists working in Rome had achieved prominence in fields relating to Reynolds's own practice. One was the recently deceased Mengs. Another was Pompeo Batoni (1708–87), renowned for his portraits of Grand Tourists, but also a more than capable history painter.

A third was the Scots artist Gavin Hamilton (1723–98), whose impact on the dissemination of neo-classical ideals went beyond the realm of painting to the excavation of archeological sites and the export of antiquities. Reynolds discussed his attitude towards the modern 'Roman School' in his fourteenth *Discourse* of 1788:

As Italy has undoubtedly a prescriptive right to an admiration bordering on prejudice, as a soil peculiarly adapted, congenial, and, we may add, destined to the production of men of great genius in our Art, we may not unreasonably suspect that a portion of the great fame of some of their late artists has been owing to the general readiness and disposition of mankind, to acquiesce in their original prepossessions in favour of the Roman School.

On this ground, however unsafe, I will venture to prophesy, that two of the last distinguished Painters of that country, I mean Pompeio Battoni [*sic*] and Raffaelle Mengs, however great their names may at present sound in our ears, will very soon fall into the rank of Imperiale, Sebastiane Concha, Placido Constanza, Massuccio, the rest of their immediate predecessors. (in Wark, 1975, pp. 248–9)

While it is correct to emphasize the debt Reynolds owed to the Italian post-Renaissance tradition – whether Roman, Bolognese, or Venetian – his own assessment of his artistic inheritance was more broadly defined. As the above passage from the fourteenth *Discourse* indicates, Reynolds considered that the modern Romans were living off the past glories of Italian art. British artists on the other hand – as he had affirmed in the first *Discourse* – had one advantage over their continental counterparts, in that they lacked an established tradition of great indigenous artists, and therefore had 'nothing to unlearn'. Reynolds believed that British artists, untrammelled by the success of their forebears, could take a more dispassionate view of the past. By the early 1780s he was able to enunciate this doctrine from a more secure position. Through the medium of the mezzotint his paintings had been disseminated throughout Europe, while the *Discourses* had been translated into German, French, and Italian.[3] By no means a peripheral figure in Europe, Reynolds was confident in shifting his attention away from the south and concentrating on the virtues of the northern European tradition in western art.

Reynolds kept an account of his visit to the Low Countries which was published after his death by Edmond Malone. His itinerary was outlined by Malone in *The Literary Works of Sir Joshua Reynolds*, where Reynolds's notes and observations made on the tour were first published:

Our author [Reynolds], accompanied by Phillip Metalfe, Esq. left London on Tuesday, July 24, 1781, went to Margate, and embarked there for Ostend; proceeded from thence to Ghent, Brussels, Antwerp; Dort, the Hague, Leyden,

Amsterdam, Dusseldorp, Aix-la-Chapelle, Liege; returned to Brussels again, from hence to Ostend; landed at Margate, and arrived in London Sunday, Sept. 16. (1819, vol. II, p. 247)

As one might expect, much of what Reynolds had to say about the artists whose work he looked at during his visit – Rembrandt, Van Eyck, Teniers, Jordaens, Snyders – concerned the formal qualities of their works, as he noted down technical devices or particular passages of painting which pleased him. The greatest technical revelations, however, were afforded to him by Rubens, whose altarpieces he pored over in Antwerp (*ibid.*, pp. 263, 312–13, 413–27). And it was probably a rueful reflection on his own abortive attempt to decorate St Paul's Cathedral that he stated, on leaving Flanders: 'It is a circumstance to be regretted, by painters at least, that the Protestant countries have thought proper to exclude pictures from their churches: how far this circumstance may be the cause that no Protestant country has ever produced a history-painter, may be worthy of consideration' (*ibid.*, pp. 338–9). Rubens exerted a tremendous influence on Reynolds's art during the 1780s. What also needs to be stressed is the increasingly proprietorial manner in which Reynolds regarded him. 'Those who cannot see the extraordinary merit of this great painter', he concluded at the end of his visit to the Low Countries, 'have a narrow conception of the variety of art, or are led away by the affectation of approving nothing but what comes from the Italian School' (*ibid.*, p. 427).

His growing concern with the 'variety of art' he had encountered in Holland and Flanders emerged strongly in his commentary contained in William Mason's English translation of Charles Alfonse Du Fresnoy's Latin poem on painting, *De arte graphica*, published in 1783. Du Fresnoy (1611–68), although French, had spent most of his working life in Italy, where he drew inspiration from a combination of the forms of Poussin with the colouring of Venetian artists. His poem had first been translated into English by John Dryden in 1695 and was familiar to Reynolds, who had introduced Du Fresnoy's arguments into his seventh and eighth *Discourses* of 1776 and 1778 (Wark, 1975, pp. 136, 155–6) In his notes contained in Mason's translation of Du Fresnoy, Reynolds leant heavily on his recent experiences in the Low Countries. Indeed, the trip was probably in part organized to enable him to comment more authoritatively on the text. In Reynolds's notes to *De arte graphica* the attention he gives to non-Roman artists is notable. Colourists such as Rubens and Watteau feature prominently, as do Titian and Veronese, whose names occur more frequently than 'linear' artists such as Raphael and Michelangelo.[4] The

shift in emphasis is also evident in Reynolds's eleventh *Discourse*, delivered to the Royal Academy in December 1782. Here Reynolds stresses the importance in a work of art of perceiving the 'whole' in a composition through a grasp of colour and tone (Wark, 1975, p. 199). The formal qualities of painting, which had always intrigued Reynolds, now increasingly assumed a central role in his theory. So, for example, in his notes on Rubens's *Marriage of Saint Catherine* (Antwerp, church of St Augustine) and Veronese's *Marriage at Cana* (Paris, Louvre) Reynolds emphasized the unimportance of a picture's subject. 'That of Paulo Veronese', he says, 'is only a representation of a great concourse of people at dinner; and the subject of Rubens, if it may be called a subject where nothing is doing, is an assembly of various Saints that lived in different ages' (*ibid.*, p. 201). The subject paintings made by Reynolds during the final decade of his career, depended heavily upon such dogma. According to Reynolds, pictorial icons were not important in their own right but because of the general precepts they taught. 'It is not', he concluded in the eleventh *Discourse*, 'by laying up in the memory the particular details of any of the great works of art, that any man becomes a great arist, if he stops without making himself master of the general principles on which these lines are conducted' (*ibid.*, p. 204).

In *The Political Theory of Painting from Reynolds to Hazlitt* John Barrell has advanced a number of ideas on Reynolds's art theory which relate to shifts in emphasis in Reynolds's attitude towards subject painting in the 1780s (1986, esp. pp. 69–162). He argues that Reynolds, through the *Discourses*, sought to appeal to an elite who could understand his frame of reference ('citizens in the republic of taste'). 'The title to citizenship in Reynolds's republic of taste', states Barrell, 'becomes an ability to see in a certain way, not to act in a certain way' (*ibid.*, p. 99). (As I have stressed in earlier chapters, Reynolds also depended on the intellectual interests of an educated elite to elucidate the theoretical bases of his historical portraits, fancy pictures, and subject pictures.) Having abandoned a rhetorical aesthetic, Barrell notes that Reynolds is enabled in the *Discourses* to adopt a position where 'form' takes precedence over 'fable' (*ibid.*). In rejecting the current structure of civic humanism Reynolds, according to Barrell, sensed the need to adapt it 'in response to an awareness of the disjunction between the "unchanging" social values of the society in which he worked' (*ibid.*, p. 135). Finally, Barrell highlights the emergence in the later *Discourses* of a 'discourse of custom' where emphasis is laid on the importance of the essential characteristics of a particular culture to its art (*ibid.*, pp. 136ff.). While Barrell's professed Marxist conclusion that

Reynolds's theory of art is 'at base a theory of society' is open to debate, the particular points outlined above are supported by the evidence of the artist's practice (*ibid.*, p. 145). Reynolds's decision to distance himself from contemporary Italian art and to evolve a more consciously formal base for his art was not simply the result of an increasing awareness of the richness of the northern tradition but an aspect of his wish to redefine the conditions of membership of this notional 'republic of taste', scorning those artists and connoisseurs who continued to pay lip-service to the existing art-historical hierarchy of Schools – with Rome as the focal point.

During the years immediately following his return from the Low Countries Reynolds's attention to subject painting was limited largely to smaller fancy pictures, which – aside from the limited demands they placed on his other professional activities – were more marketable than large-scale histories. It was, therefore, perhaps by way of a compromise that Reynolds exhibited two works in 1784 and 1785 – *A Nymph and Cupid* (plate 74) and *Venus* (colour plate 14) – which were more ambitious than his usual fancy pictures, yet less intellectually demanding than history paintings. They were, however, pictures which provided ample evidence of his increasing concern with colour, as reflected in the art of Rubens and the Venetian School. The link between *A Nymph and Cupid* and Reynolds's fancy pictures is strengthened by the fact that the attitude of the female figure – as Luke Herrmann has pointed out – is evidently derived from a pen-and-ink sketch of a much younger girl (perhaps one of his neices or a studio model) shielding her arm bashfully from the eye of the artist (Herrmann, 1968, p. 65, fig. 14; Prochno, 1990a, p. 179). Indeed, this conflation of childish coyness and female coquettishness amplifies the point made earlier concerning the ambiguous light in which the child subjects of fancy pictures were held. The subject of the present painting – Cupid loosening the girdle of the semi-reclining nymph – was more overtly sensual than anything previously painted by Reynolds, who in the back of his 1784 sitter-book described the picture as 'The half consenting'. (It is also known as 'The snake in the grass', owing to the presence of a serpent in the foreground of several versions, as well as 'Love untying the zone of Beauty' (Northcote, 1818, vol. II, p. 350).) Horace Walpole – who described the painting as 'bad and gross' – identified Reynolds's model as 'Miss Wilson'. The identity of 'Miss Wilson' is not known. Nor is it known whether other contemporaries were aware of the real-life identity of Reynolds's 'nymph'. In any event, the painting certainly seems to have attracted the attention of a number of patrons. The exhibited version was purchased by Reynolds's friend Lord Carysfort,

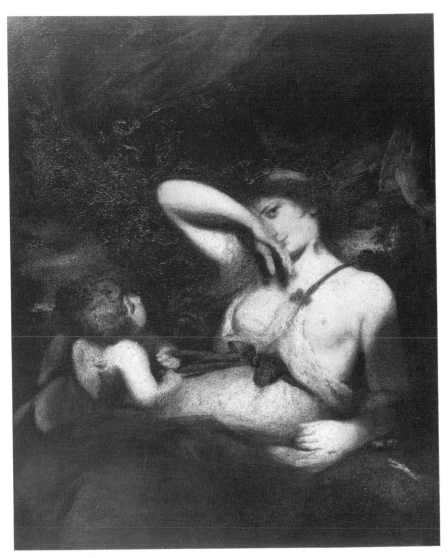

74 *A Nymph and Cupid.*
 Oil on canvas, 124·4 × 99·1 cm. Exhibited at the Royal Academy, 1784.
 The Trustees of the Tate Gallery, London.

British ambassador to the court of St Petersburg, who in turn procured a second version in 1788 for Catherine the Great's sometime lover, Prince Grigori Aleksandrovich Potemkin (1739–91). A third version was retained by Reynolds (and bought in 1821 by Sir John Soane). It was duplicated by a number of his pupils, and reproduced for public consumption in the form of a stipple engraving in 1787 by John Raphael Smith, together with verses by 'R. B. Cooper', whom David Alexander has suggested may have been a young lawyer named Robert Bransby Cooper (born 1762), and who may have been inspired to write them upon seeing Reynolds's picture (see Alexander, 1992, cat. 14, p. 10).

The *Venus* – exhibited at the Royal Academy in 1785 – was not his first exercise in this genre, Reynolds having made a copy of Titian's *Venus and Cupid with a Lute Player* (Fitzwilliam Museum, Cambridge), which then belonged to the duc d'Orléans.[5] Also, in 1759 – as notations in his sitter-book indicate – he had painted his own version of 'Venus'.[6] (Although the painting has never been securely identified it may relate to a half-length painting by the artist depicting a reclining, draped, figure with a winged Cupid hovering at her breast.[7]) The *Venus* of 1785 was the first attempt by Reynolds to paint a nude female figure. And yet, in a letter sent to the Duke of Rutland on 30 May 1785 (at the very time the picture was on exhibition), Reynolds claimed to be indifferent to the picture's iconography:

I don't know how to give a description of my Venus, as it is called; it is no more than a naked woman sitting on the ground leaning her back against a tree, and a boy peeping behind a tree. I have made the landskip as well as I could in the manner of Titian. Though it meets with the approbation of my friends, it is not what it ought to be, nor what I should make it. The next I paint I am more confident will be better. (in Hilles, 1929, p. 124)

Given Reynolds's admission that the painting was heavily influenced by Titian it is worth recalling Titian's own comments on his *Venus of the Pardo* (Louvre), which he had described as 'no more than a naked woman in a landscape with a satyr' (in Hope, 1980, p. 124). While Reynolds may have been consciously emulating Titian's attitude towards his subject, he was more generally reflecting a common attitude among Renaissance artists towards their portrayals of Venus – which were, however, often thinly disguised depictions of their patrons' mistresses. (Palma Vecchio, for example, referred to his Venuses simply as 'donne nude' (Martineau and Hope, 1983, cat. 74, p. 196).) The title of a work of art – as Reynolds had noted in 1780 in his tenth *Discourse* – was not the artist's prime concern,

nor did it necessarily need to precede its production: 'John de Bologna, after he had finished a group of a young man holding up a young woman in his arms, with an old man at his feet, called his friends together to tell him what name he should give it, and it was agreed to call it The Rape of the Sabines' (in Wark, 1975, p. 182). And, as he told Northcote in 1787, when asked whether he approved of the title he had given his Royal Academy Diploma picture, the subject of a painting was ultimately of greater concern to the public than to artists: 'it signifies little what your subject is or how it is treated, for it is intended for the painters, and *they* will look at nothing but execution' (in Fletcher, 1901, p. 59). Reynolds's own execution of *Venus* was closely observed by William Mason: 'Upon this picture he bestowed much time, intending, as I suppose, from the subject, to emulate the Venus of Titian. I have seen it, during its progress, in a variety of different tones of colouring – sometimes rosy beyond nature, and sometimes pallid and blue, and these differences throughout the whole form' (in Cotton, 1859a, p. 55). The figure's anatomy, according to Mason, was 'designed from a plate of some Leda, or like subject of some old master, than from real life', although her face was apparently modelled on the daughter of his servant, Ralph Kirkley.[8]

Several weeks before it went on show at the Royal Academy in 1785, Reynolds's *Venus* was already available for inspection in the artist's own gallery, where it attracted the attention of several newspapers, including *The Morning Herald* (8 April) which reported:

Sir Joshua's *Venus*, is placed at the entrance of the gallery to catch the eye, and invite the foot of *sensibility*, on to the contemplation of his other pictures. Her eye is full of *wanton magic*, the warmth of love is on her cheek and her limbs are disposed so as to possess every *abstraction*. Sir Joshua has done himself great honour in this figure; but the little *genius* of *inquisitive love*, who is peeping out from behind the tree, is a *chaos* of a *cupid*, nothing etherial [*sic*] in him, and even the clay of his composition unformed.

Reynolds's *Venus* was, *The Public Advertiser* concluded (5 April), 'a picture of temptation from her auburn lock to her painted toe'. None the less, to display the naked human form – albeit in classical guise – was not acceptable to some members of the exhibition-going public, as a correspondent of *The General Advertiser* (2 May 1785) stated when *Venus* went on view at the Royal Academy: 'In mentioning our sentiments on this subject, it may not be amiss to remind the artist who has so wantonly displayed the bosom of a woman in the great room, that a little more decency would have had a much better effect.' Yet, according to *The*

Morning Herald (9 May 1785), Reynolds – if he was indeed the target of this accusation – was blameless: 'Sir Joshua will not suffer in his moral character, by charge of having painted his *Bacchante* called by error a *Venus*, from life, as there is traced in every figure shop in London the plaster cast of a model of a French artist, from which Sir Joshua painted his glowing *wanton*.' While I have not come across a sculpted figure in the precise attitude of Reynolds's *Venus*, it is similar enough to a whole range of 'bathers' by French sculptors, including Falconet, Simon-Louis Boizot, and Clodion (1738–1814) to suggest that Reynolds had used such a figurine as the basis for the attitude of his *Venus*. Since 1757 Falconet, as joint director of the Sèvres factory, had duplicated numerous versions of his 'bathers' in *biscuit de Sèvres*. Indeed, as it has been noted, the display of his popular *Baigneuse* at the 1757 Salon 'led to a whole range of figures, now standing, now seated, sometimes accompanied by a Cupid, but which the main purpose always remains a study of the naked female body' (see Kalnein and Levey, 1972, pp. 83–90).[9]

William Mason watched Reynolds at work on the body of 'Venus':

in his sitting chair a very squalid beggar-woman was placed with a child, not above a year old, quite naked on her lap. As may be imagined, I could not help testifying my surprise at seeing him paint the carnation of the Goddess of Beauty from that of a little child, which seemed to have been nourished rather with gin than with milk, and saying that 'I wondered he had not taken some more healthy looking model'; but he answered, with his usual *naiveté*, that, 'whatever I might think, the child's flesh assisted him in giving a certain *morbidezza* to his own colouring, which he thought he should hardly arrive at, had he not such an object, when it was extreme (as it certainly was) before his eyes'. (in Cotton, 1859a, p. 55)

Reynolds's decision to paint the flesh of his 'Venus' from a baby may not entirely have stemmed from personal preference but from propriety. His own sister, Frances, disapproved of working from the naked figure. 'Miss Reynolds', wrote James Northcote to his brother in 1771, 'says it is a great pity that it should be a necessary part in the education of a painter, but she draws all her figures clothed except infants, which she often paints from life, some beggar-woman's child which is laid naked on a pillow in the mother's arms' (in Whitley, 1928a, vol. II, p. 286).

As Reynolds had intimated to the Duke of Rutland in his letter of 30 May 1785, he intended to paint a second version of *Venus*. By the autumn he had begun to work on it, as *The Times* (4 October) noted: 'Sir Joshua, it is suspected, is at work on another *naked figure*. His nymph, from the *plaister* cast, does him honour. He now has a *painted* model before him; mean[ing]

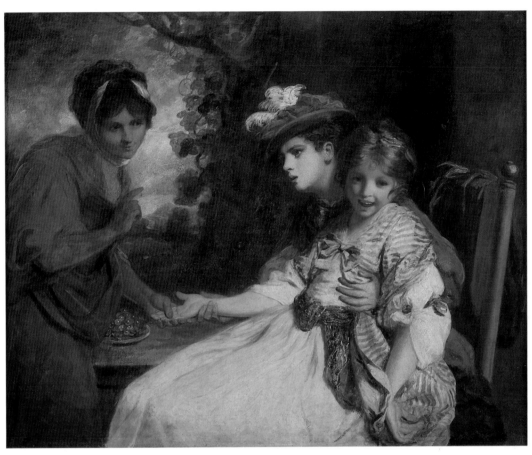

1 *A Fortune-teller*.
Oil on canvas, 145 × 123·2 cm. Exhibited at the Royal Academy, 1777.
National Trust, Waddesdon Manor.

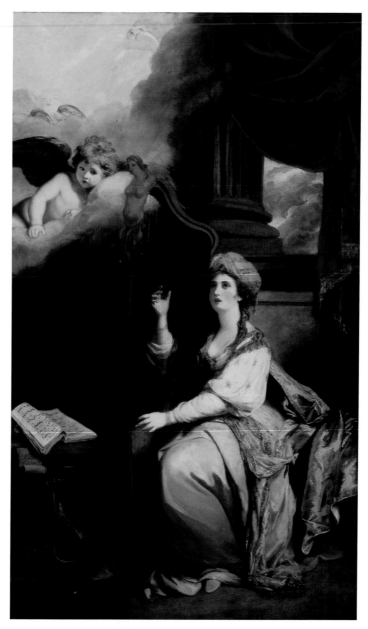

2 *St Cecilia.*
Oil on canvas, 279 × 160 cm. Signed and dated 1775 Los Angeles County
Museum of Art, William Randolph Hearst Collection.

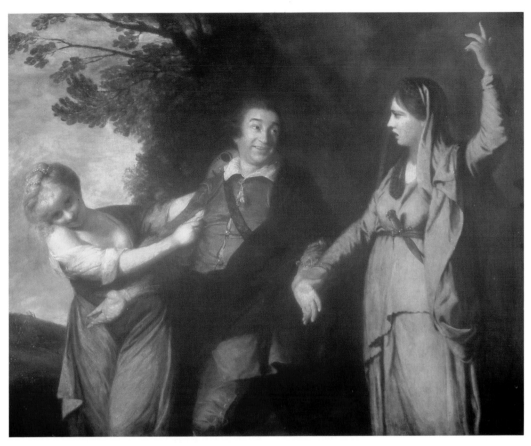

3 *Garrick between Tragedy and Comedy.*
Oil on canvas, 148 × 183 cm. Exhibited at the Society of Artists, 1762, as 'Mr Garrick, between the two muses of tragedy and comedy'. Private Collection.

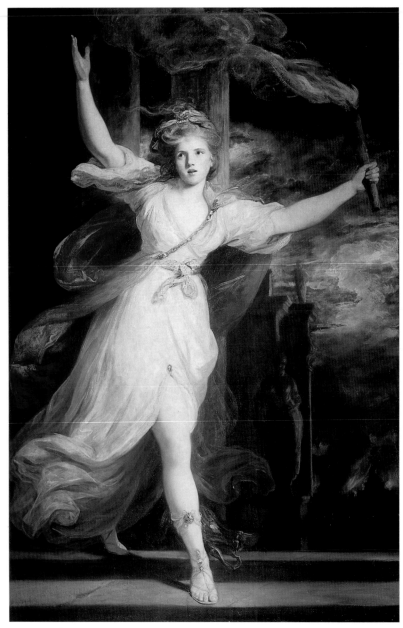

4 *Thaïs.*
 Oil on canvas, 229·2 × 144·2 cm. Exhibited at the Royal Academy, 1781.
 National Trust, Waddesdon Manor.

5 *Cupid as a Link Boy.*
 Oil on canvas, 76 × 63·2 cm. *c.* 1773. Albright-Knox Art Gallery, Buffalo, New
 York. Seymour H. Knox Fund, through special gifts to the fund by Mrs
 Marjorie Knox Campbell, Mrs Dorothy Knox Rogers and Mr Seymour H. Knox
 Jr, 1945.

6 *Venus Chiding Cupid for Learning to Cast Accounts.*
 Oil on canvas, 101·2 × 97·2 cm. Exhibited at the Royal Academy, 1771.
 The Iveagh Bequest, Kenwood House (English Heritage).

7 *The Calling of Samuel.*
Oil on canvas, 90·2 × 69·2 cm. *c.* 1776. Lord Sackville.

8 *The Infant Academy.*
Oil on canvas, 114·2 × 142·2cm. Exhibited at the Royal Academy, 1782, as
'Children'. The Iveagh Bequest, Kenwood House (English Heritage).

9 *Girl Leaning on a Pedestal* (*The Laughing Girl*).
 Oil on canvas, 91·2 × 71·2 cm. *c.* 1775–85. The Iveagh Bequest, Kenwood
 House (English Heritage).

10　*Ugolino and his Children in the Dungeon.*
　　Oil on canvas, 125 × 176 cm. Exhibited at the Royal Academy, 1773, as
　　'Count Hugolino and his children in the Dungeon, as described by Dante...'.
　　Lord Sackville.

11 *Justice*.
Oil on canvas, 223·2 × 83·2 cm. Exhibited at the Royal Academy, 1780.
Private Collection.

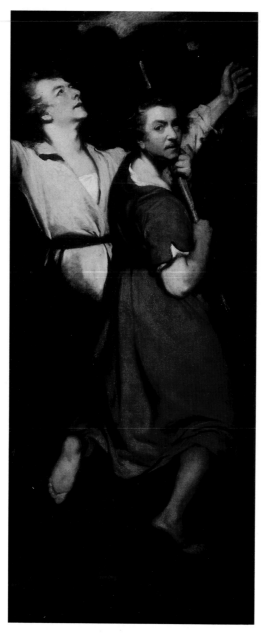

12 *Adoration of the Shepherds* (Thomas Jervais and Sir Joshua Reynolds).
Oil on canvas, 209·2 × 83·2 cm. *c.* 1780. Private Collection.

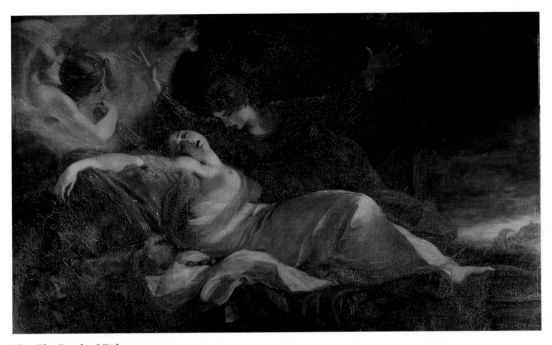

13 *The Death of Dido.*
 Oil on canvas, 142·2 × 251 cm. Exhibited at the Royal Academy, 1781.
 Her Majesty the Queen.

14 *Venus.*
 Oil on canvas, 124·2 × 99 cm. Exhibited at the Royal Academy, 1785.
 Jane and Robert Rosenblum.

15 *The Infant Hercules Strangling the Serpents.*
 Oil on canvas, 303 × 297 cm. Exhibited at the Royal Academy, 1788.
 The Hermitage, St Petersburg.

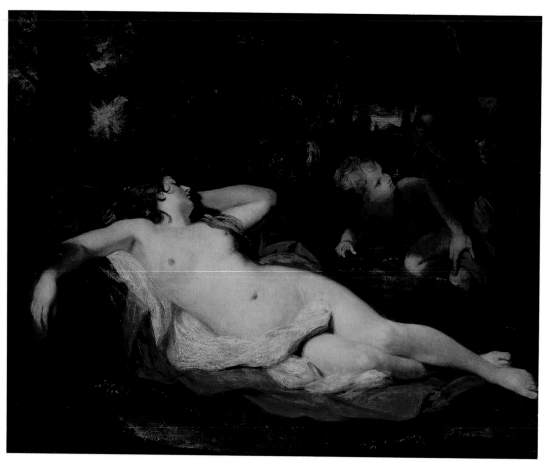

16 *Cimon and Iphigenia.*
Oil on canvas, 139·8 × 167·7 cm. Exhibited at the Royal Academy, 1781.
Her Majesty the Queen.

one of animated nature.' Reynolds's second *Venus* (plate 75) was, in fact, a close replica of the first version, the principal difference lying not in the central figure but in the substitution of Cupid with the figure of a piping boy in a rich crimson jacket. Although we do not know upon what authority the writer in *The Times* stated that Reynolds was working from a living model ('one of animated nature') the existence of two related drawings of a partially clothed woman in the attitude of *Venus* suggests that he did, in part, rely on the living model in designing either one, or both, of his versions of *Venus*.[10] The picture was finished by April 1786, at which time it was available for inspection in the artist's gallery. A correspondent for *The Morning Herald* (19 April) was less impressed with the second version than the first:

The reclining *Bacchante* of last year, has received a sister from Sir Joshua's hand, or rather a half-sister, but it has neither the wanton expression of the original, nor the inviting position. The limbs are also defective in drawing and call Sir Joshua's academical skill in question – one of the thighs appears like a perished limb and one of its feet is much too short. The wreath of flowers round her head has a glaring effect that destroys the brilliancy of the more necessary hues. The piping-boy at her feet wants spirit, and his freely coloured drapery is neither pastoral, nor adequate to Silvan ideas.

Qualms about defective draughtsmanship did not prevent the Duke of Dorset from offering Reynolds £400 for it later in the year, as Reynolds explained in a letter to the Duke of Rutland on 13 July 1786: 'In regard to the Venus, the Duke of Dorset is to have it, not for himself, but for a French marquis, whose name I have forgot; I have since done another with variations, which I think better than the first; but I am not fond of showing it till the other is disposed of' (in Hilles, 1929, p. 124). The following month *The Morning Herald* (31 August) confirmed the Duke of Dorset's position as agent, noting that the painting had been acquired by him 'for a Parisian friend, *Baccelli* being *amorous goddess* enough for him'. The picture was exported to France early in the following year. On 3 February 1787, *The World*, under the headline 'FINE ARTS – Applying to Trade', stated:

Sir Joshua's delicious Venus – is gone the way of all flesh – she is sold – and gone to Paris. *The Duke of Dorset*, the buyer – though the *French women*, some time since seem'd to think, it was *not necessary* to encrease [*sic*] the *female* part of his Grace's collection. None of *Sir Joshua's* women ever made themselves *cheap* – though this was such as to be *cheap at any price*. The *Duke* had her for four hundred – Others he has had, lost him infinitely *more*.

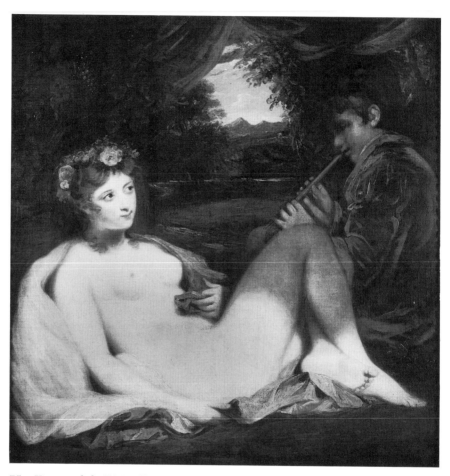

75 *Venus and the Piping Boy.*
 Oil on canvas, $127 \times 104 \cdot 2$ cm. 1786. Private Collection.

What remains uncertain, however, is which version of *Venus* was acquired by the Duke of Dorset especially as, just prior to the aforementioned report in *The World*, *The Morning Herald* (20 January) reported that the 'King of France has purchased Sir *Joshua Reynolds's* original picture of the *Wanton Bacchante* – usually stiled the *Venus*:- The copy, in which the piping shepherd is introduced, is purchased by the Duke of Dorset.'

Reynolds's ledgers do not record the sale of any versions of *Venus*. Contemporary acounts, however, suggest that the Duke of Dorset purchased at least one – and possibly two – versions of the subject from Reynolds on behalf of French patrons. Two versions of Reynolds's second *Venus* (with the piping boy) exist. One entered the collection of the British collector John Julius Angerstein during the 1790s, while the other found its way into an English private collection some time during the nineteenth century (Graves and Cronin, 1899–1901, vol. III, p. 1224). The fact that neither painting was apparently purchased directly from Reynolds suggests that they may be the same works which were acquired by the Duke of Dorset on behalf of Reynolds's French patrons, including Louis XVI. The original painting of *Venus* does not, however, appear to have been sold to Louis XVI (as *The Morning Herald* stated), but remained in Reynolds's possession until his death. According to the terms of Reynolds's will, each of his executors was permitted to choose one picture from those which remained in the artist's studio. John Fitzpatrick (1745–1818), second Earl of Upper Ossory – who had first choice – took *Venus*.[11] Interestingly, Reynolds may have given Lord Ossory the opportunity to purchase a version of *Venus* several years earlier. Indeed, only four days after he had written to the Duke of Rutland about the Duke of Dorset's purchase of *Venus* on behalf of a French marquis (13 July 1786) Reynolds wrote to Lord Ossory:

My Lord,-

My mind at present is entirely occupied in contriving the composition of the Hercules, otherwise I think I should close with your Lordship's proposal, which I acknowledge is very flattering to me. There is another proposal which I beg leave to make, which I can execute immediately, and which I think will be equally valuable to your Lordship, and save me a great deal of time, which is to copy the Nymph and Shepherd, with many improvements which I wish to make, and add to it a landskip, to make it the size of her frame at Ampthill: depend upon it I shall make it the most striking picture I ever did. (Hilles, 1929, p. 156 and n. 1)[12]

Given the circumstances, it is probable that the picture in question was the *Venus and the Piping Boy*. Lord Ossory does not appear to have taken up Reynolds's offer, perhaps because it was not similar enough to his own

'proposal' – whatever that may have been. None the less, the related chain of events outlined here, involving the Duke of Dorset, a French marquis, Louis XVI, as well as Lords Rutland and Ossory, reveals the extent to which Reynolds's 'Venuses' were intended not only to satisfy his own academic interest in Venetian colour, but to accommodate the particular tastes of his aristocratic clientele.

Patrons such as the Duke of Dorset and Lord Carysfort, ambassadors respectively to the French and Imperial Russian courts, were invaluable agents in the promotion of Reynolds's art on the continent – especially given that his relationship with the court of George III was decidedly lukewarm. The Duke of Dorset had been Reynolds's most influential patron of the 1770s, a role increasingly assumed during the following decade by John Joshua Proby, second Baron and first Earl of Carysfort (1752–1828). Lord Carysfort had first sat for his portrait to Reynolds in 1765, with his sister, Elizabeth (Graves and Cronin, 1899–1901, vol. I, pp. 154–5; Waterhouse, 1941, p. 112; Cormack, 1970, p. 114). By the early 1770s they were good friends, Carysfort purchasing a version of the *Strawberry Girl* and a *Nymph with a Young Bacchus*, as well as commissioning further family portraits. Following the death of his first wife in 1783, and his failure to obtain a seat in Parliament the following year Carysfort embarked for the court of St Petersburg (Aston, ms. p. 7). It was Reynolds's friendship with Lord Carysfort which ultimately paved the way for his most prestigious commission of the 1780s – the *Infant Hercules Strangling the Serpents* (colour plate 15) – which he was invited to paint for Catherine the Great in 1785. The seed may, however, have been planted as early as June 1780, when Reynolds had been introduced to the exiled Russian princess, Catherine Dashkova.[13] Although temporarily out of favour at the Russian court, Princess Dashkova had been instrumental in securing the succesion of Catherine the Great (1729–96). A cosmopolitan figure, Dashkova was by 1780 on close terms with a number of Reynolds's friends and acquaintances, including Adam Smith and David Garrick, while Reynolds too recorded engagements with her in June and July of that year.[14] In 1782 Princess Dashkova regained Catherine's favour and returned to Russia, where, on 21 October 1783, she was appointed first president of the Russian Academy, in which capacity she corresponded with Reynolds on at least one occasion, promising to translate the *Discourses* into Russian (see Cotton, 1859a, pp. 71–2; Frederick Hilles in Bond, 1970, p. 269).

While Princess Dashkova no doubt proved a useful intermediary with Catherine the Great, it was Lord Carysfort who took it upon himself to

secure the commission for Reynolds. During the 1770s Catherine had bought paintings by a number of British artists including Joseph Wright and Benjamin West, whose portrait of *George, Prince of Wales, and his brother, Henry Frederick* had been commissioned by Catherine in 1778 (and which was inscribed by West: 'Painted by B. West. Historical Painter to His Majesty London 1778') (see Cross, 1985, pp. 67–82; Dukelskaya, 1979, cats. 130 and 136–7). On 8 December 1785 Lord Carysfort wrote to Reynolds telling him that he had alerted Catherine to the fact that she did not, however, possess anything by Reynolds. Upon listening to Lord Carysfort's argument she granted the commission (Frederick Hilles in Bond, 1970, p. 269). News spread quickly. In January 1786 Reynolds's niece Theophila Palmer wrote to her cousin William Johnson in India telling him of Reynolds's commission from the imperial court, noting that the 'subject is left to his own choice, and at present he is undetermined what to choose' (Cotton, 1859, p. 111; Leslie and Taylor, 1865, vol. II, p. 482). On 17 January *The Times* stated in a similar vein that Reynolds had been asked 'to paint an historical picture, on any subject that may best please his own fancy'. Just over a week later (26–28 January) *The English Chronicle* reported at greater length, under the heading 'Progress of the Arts':

We are glad to find the *Semiramis* of the north attentive to *British* merit: her choice of Sir Joshua Reynolds for an historical picture, confers honour on her taste. *The Empress* hath lately seen some productions of this artist's grand pencil, which gave birth to the commission.

 Sir Joshua we are informed, hath fixed on a subject for the picture to be sent to the Empress of Russia; it is a young Hercules strangling the serpents. We could have wished that a subject from the *Russian* history had employed his genius. The life of Peter certainly abounded with incident; nay the reign of the present Empress is very capable of furnishing immortal material for the display of the President's unrivalled abilities.

Reynolds's first communication of his intention to paint *The Infant Hercules* appeared in a letter written the following month to the Duke of Rutland, on 20 February 1786:

I forgot whether I mentioned in my last letter that I have received a commission from the Empress of Russia to paint an historical picture for her, the size, the subject, and everything else left to me; and another on the same conditions for Prince Potemkin. The subject I have fixed on for the Empress is Hercules strangling the serpents in the cradle, as described by Pindar of which there is a very good translation by Cowley. (in Hilles, 1929, p. 149)

When *The Infant Hercules* was delivered to the court of St Petersburg in 1789, Reynolds wrote an accompanying note to Prince Potemkin, explaining the relevance of his allegory to the Russian empire. He stated, in French (the official language of the Russian court): 'J'ai choisi le trait surprenant de la valeur d'Hercules encore enfant, parce que le sujet fait allusion (au moins une allusion éloignée) à la valeur non enfantine mais si connue de l'empire Russe.'[15] The subject of the Infant Hercules – as Reynolds told Potemkin – was not intended as a specific allegory but as a generalized comment upon the youthful vigour of the empire, which was predestined to become a mighty world power. (Although the Russian imperial engraver, James Walker – who made a print of the painting in 1792 – subsequently observed that Catherine 'perhaps did not quite agree with the painter, that her empire was in its leading strings' (*Paramythia*; *or Mental Pastimes*, 1821, p. 163, quoted in Aston, ms. p. 9).) Catherine's own life could have furnished a number of colourful subjects. Indeed, as Horace Walpole quipped, on learning of Reynolds's choice of subject: 'He told me he had pitched on the Infant Hercules and the Serpents – "Lord!" said I, "people will say she is strangling two Emperors"' (Ivan VI, and her husband, Peter III).[16]

It was not, however, Reynolds's particular choice of allegory that worried most commentators but his preference for allegory over history. Reynolds, it was considered, ought to have chosen a subject which would more obviously relate to the historic past of either England or Russia and which would, at least, evoke a sense of national pride. As Northcote stated, Reynolds having 'debated long with himself on what subject to fix', initially considered portraying the visit of Elizabeth I to the Docks at Tilbury, during the threat of Spanish invasion, his intention presumably being to make a favourable comparison between Elizabeth and Catherine the Great, while at the same time recalling the inspection of the dockyards at Deptford by Peter the Great.[17] Walpole had a similar idea, as Hannah More told her sister in May 1786:

Mr Walpole suggested to Sir Joshua an idea for a picture, which he thought would include something honourable to both nations; the scene Deptford, and the time when Czar Peter was receiving a ship-carpenter's dress, in exchange for his own, to work in the dock. this would be a great idea, and much more worthy of the pencil of the artist than nonsensical Hercules. (Roberts, 1834, vol. II, p. 16; see also Lewis *et al.*, 1937–83, vol. XXXI, p. 243)

Quite aside from her own religious scruples, Hannah More's rejection of 'nonsensical Hercules' reflects the decreasing power of classical mythology

over the eighteenth-century consciousness. By the 1770s, interest in the history of classical civilization and its related mythology was challenged by a surge in interest among artists in subjects closer to Britain's own past. Among the earliest to tackle episodes from British history had been Robert Edge Pine, who in 1763 had won the First Premium offered by the Society of Artists in 1763 for his painting *Canute the Great Reproving his Courtiers*, and John Hamilton Mortimer, whose *Edward the Confessor* had taken the Second Premium the same year, and first prize the following year with *St Paul preaching to the Britons*.[18] From the 1770s similar subjects were to be found in increasing numbers at Royal Academy exhibitions.[19] Among the most prominent exponents of native historical subjects was, ironically, the American artist, Benjamin West, whose works to date had ranged from the early eighth century (*William de Albanac Presents His Three Daughters to Alfred III*, R. A. 1778 (331)) to *The Death of General Wolfe* (R. A. 1771 (210)) which had occurred twelve years earlier in 1759. In 1779 William Cowper suggested, in his poem 'To Sir Joshua Reynolds', that the Muses direct him, also, towards subject matter which celebrated Britain's achievements – at the expense of the French:

> Thus say the Sisterhood – We come –
> Fix well your pallet on your thumb,
> Prepare the pencil and the tints,
> We come to furnish you with hints.
> French Disappointment, British Glory
> Must be the Subject of the Story. (Baird and Ryskamp, 1980, p. 218)[20]

Classical and mythological figures continued to feature in history paintings, although there too the canon was reshaped by the appearance of home-grown heroes such as King Lear and Ossian, as well as heroes from the pages of Spenser and Milton. Even a thoroughgoing classicist like James Beattie, whose portrait Reynolds had painted in the form of an allegory, thought that *Hercules* was an 'unpromising subject'.[21] Significantly, only Edmund Burke – no advocate of British nationalism – voiced his approval (Leslie and Taylor, 1865, vol. II, p. 483).

Previously, Reynolds's friends had offered him suggestions for possible subject paintings. In the 1770s, Daniel Wray had proposed the *Two Lovers of Rimini* as a suitable pendant to *Ugolino* (British Museum, Add. ms. 35402, quoted in Whitley, 1928a, vol. II, p. 266). In 1781, Horace Walpole suggested a religious painting based on the gospel story of Christ blessing the little children, while on another occasion he even encouraged him to compose an entire cycle in the manner of Rubens's life of Marie de

Medici (Lewis *et al.*, 1937–83, vol. XXIX, p. 104). *Ugolino* aside, Reynolds usually preferred to draw upon classical mythology and the Bible for his history paintings. More recent events (as his celebrated rejection in 1770 of West's *Death of Wolfe* indicates) were anathema. His opinion had not altered a decade later. In March 1783 Philip Yorke, second Earl of Hardwicke (1720–90) had suggested to Reynolds the idea of a picture of Monmouth's surrender to James II. Reynolds replied:

the insuperable objection to subjects of that period, is the dress. The first effect of such a picture will be allways mean and vulgar and to depart from Costume is as bad on the other side. It was the late Charles Townsend [*sic*] that recommended to me the interview of The Duke of Bedford and K. James as a subject for a Picture. (in Hilles, 1929, p. 102)

Charles Townshend, Chancellor of the Exchequer under Pitt the Elder, had died in 1767. In an annotation to Mason's translation of *The Art of Painting*, Reynolds referred obliquely – if more scathingly – to Townshend's recommendation:

An instance occurs to me of a subject which was recommended to a Painter by a very distinguished person, but who, as it appears, was but little conversant with the art; it was what passed between James II and the old Earl of Bedford in the Council which was held just before the Revolution. This is a very striking piece of history; but so far from being a proper subject, that it unluckily possesses no one requisite necessary for a picture. (in Malone, 1819, vol. III, p. 105)

Reynolds's opinion, which he subsequently reinforced by his choice of *The Infant Hercules*, was that the history painter's duty was not simply to illustrate the past – as he believed West and Copley were doing. As one of the Liberal Arts, high art did not exist merely to recreate specific historical events but to comment via a pictorial metaphor on an aspect of the human condition.

Reynolds believed that greater truths were revealed by the poet than could be demonstrated by the historian. And greater truths were to be found in ancient history than modern history. Henceforth, in history painting, Reynolds relied on the accounts of the 'ancient' poets, whose stories were timeless and universal. When, on occasion, he made reference to the more recent past – as in *Ugolino and his Children in the Dungeon* – he relied on the version supplied by the poet (Dante), rather than the historian (Villani). Reynolds also believed that modern historical subject matter was by its very nature localized and parochial. Most important, however, he

regarded mythology and ancient history as a *lingua franca*, shared by all artists, irrespective of more transient manners and mores. In William Mason's 1783 translation of Du Fresnoy's *Art of Painting*, it is stated:

> Some lofty theme let judgement first supply,
> Supremely fraught with grace and majesty.

Reynolds's note to the text comments:

> It is a matter of great judgement to know what subjects are or are not fit for painting. It is true that they ought to be such as the verses here direct, full of grace and majesty; but it is not every such subject that will answer to the Painter. The Painter's theme is generally supplied by the Poet or Historian; but as the Painter speaks to the eye, a story in which fine feeling and curious sentiment is predominant, rather than palpable situation, gross interest, and distinct passion, is not suited to his purpose. (*ibid.*, pp. 103–4)

Reynolds's viewpoint, as it is expressed here, is more dogmatic than in the fourth *Discourse*, of 1774, where he had stated that a subject painting 'ought to be either some eminent instance of heroic action, or the object, in which men are universally concerned, and which powerfully strikes upon the public sympathy' (in Wark, 1975, p. 57). By the 1780s Reynolds was increasingly aware, with the diversification of high art, that there was more than one 'public' and the number of people who preferred 'palpable situation, gross interest, and distinct passion' was growing. Interestingly, although the story of the infant Hercules was regarded as arcane in the eyes of Reynolds's compatriots, it had continued to interest a number of his European contemporaries. In 1743 it had been painted by Pompeo Batoni (Florence, Galleria d'Arte Moderna, Palazzo Pitti), while, as Robert Rosenblum has pointed out, Jean-Hugues Taraval had exhibited the subject at the Paris Salon as recently as 1785 (Rosenblum, in Penny, 1986, p. 51).

The existence of a separate painting of the individual figure of the infant Hercules (of which there are several versions), as well as three related pen-and-ink sketches, suggest that – as with *Ugolino and his Children in the Dungeon* – Reynolds did not begin by establishing the general framework of his composition but with the single figure of the picture's main protagonist.[22] Since the mid-1770s, as we have seen, he had depicted a number of superhuman babies including *The Infant Moses*, *The Infant Jupiter*, *The Infant Academy*, as well as as an embryonic Samuel Johnson.[23] However, in order to realize the figure of the infant Hercules, Reynolds

drew on the services of several quite ordinary babies, including the child of his frame-maker, William Cribb, and another belonging to the head bailiff on Edmund Burke's estate at Beaconsfield.[24] While several sculptures of the infant Hercules were available to Reynolds, in the form either of casts or engravings (notably a cast of an antique statue in the possession of the Royal Academy) his main sources were pictorial.[25] A drawing of the infant Hercules by Giulio Romano (Victoria and Albert Museum) was, as Renate Prochno has shown, the basis for a pen-and-ink study of the same figure by Reynolds (British Museum) – although the attitude was not adopted in the finished picture.[26] The attitude eventually adopted for the figure of Hercules was, in part, derived from an etching of Carlo Maratta's *Infant Christ Adored by Angels* upon which Reynolds had previously based his *Infant Jupiter* of 1774.[27]

As Reynolds noted in his letter to the Duke of Rutland, he intended to base his picture upon Pindar's *First Nimean Ode*, using the seventeenth-century translation by Abraham Cowley (although Ozias Humphrey asserted that Reynolds used the version published by Gilbert West in 1747) (Cotton, 1856, p. 170). Reynolds's own interpretation of the text, however, emerges most clearly in the description he subsequently provided for Prince Potemkin:

> Sujet
> du Tableau de S: M. Impériale

L'ouvrage représente lenfant Hercules étranglant les serpens. Sujet tiré de la premiere Ode Néméenne de Pindare, laquelle est dediée à Chromius, qui presqu'au sortir l'enfance, avoit remporté la victoire à la course des chars.

Cette circonstance rappelle au poete, l'héroïsme d'Hercules qui encore au berceau, y avoit ouvert la carrierre de sa gloire. La comparaison faite Pindare comme emporte par un enthousiasme divin, ne peut s'empecher de décrire toutes les particularités de ce grand événement.

D'abord il commence par la jalousie que portoit à Alcémene, la déesse Junon qui dans sa rage implacable, fait descendre deux serpens d'une grosseur enorme pour détruire les enfans de sa rivale, dans leur berceau. Le jeune Hercules empoigne et étrangle les serpents, tandis que le cercle de gens qui lenvironnent, reste dans linaction, saisi de crainte et d'effroi. Cependant sa mere Alcémene s'élance de son lit, résolue de sauver ses enfans ou de périr avec eux.

Aux cris d'Alcémene, Amphitrion qui ignoroit le danger où se trouvoit Hercules, accourit lepée à la main; mais voyant que l'enfant avoit détruit ses ennemis, il s'arrête comme immobile et confondu d'etonnement.

Ensuite Amphitryon fit venir le prophète Tiresias, tant pour expliquer cette merveille inouïe, que pour savoir de lui, quel sort les dieux immortels avoient

marqué à Hercules, au livre des destins, et c'est d'après cette circonstance citée par le poëte, que le Chevalier Reynolds a jugé à propos, d'introduire Tiresias à l'un des coins de son tableau.

Le prophète déclara alors, qu'Hercules après avoir purgé la terre de ses monstres, monteroit au ciel, pour ÿ jouir d'une jeunesse perpétuelle dans un état incorruptible, et pour y être admis au rang des dieux immortels. (Hilles in Bond, 1970, pp. 271–2)

While specific details from the poem were graphically seized on by Reynolds, he did not adhere to the sequence of events set out in Cowley's verses, incorporating successive stages of the narrative – the strangling of the servants by Hercules and the subsequent arrival of Amphitryon – into one image.

Reynolds began to work upon the painting in February 1786, when the sitter-book records two related sittings for the figure of Hercules.[28] Although weekdays were monopolized by portraiture, Reynolds evidently continued to make progress during the spring, *The Morning Herald* noting on 19 April: 'His *Infant Hercules* is at present a *chaos* of colours, but speaking of it as a sketch it certainly has the marks of genius to recommend it.' Clearly determined to use the summer of 1786 to work on the painting, Reynolds declined an invitation from the Duke of Rutland in June 'on account of the picture which I am to paint for the Empress of Russia'.[29] By July, his portrait schedule slackened off (his sitter-books showing two consecutive free days on the week beginning Monday 17 July). On that very day he wrote to Lord Ossory: 'My mind is entirely occupied in contriving the composition of the Hercules' (in Hilles, 1929, p. 155). He was probably not, however, working directly from the model, as only one isolated entry of 'child' occurs over the summer, with further scattered references to models during the autumn.[30]

Reynolds was evidently happy to allow friends to inspect *The Infant Hercules* as he worked upon it. On Sunday 24 September 1786 – as Reynolds's sitter-book reveals – Lord Carysfort paid a visit to Reynolds's studio, presumably so that he could report back to the Empress on Reynolds's progress. (Carysfort visited his studio again on 5 June the following year.) Four days later, on 28 September, Edmond Malone – who had also evidently examined the painting – informed Bishop Thomas Percy (1729–1811) that it was 'yet but sketched out, but it promises great things' (Tillotson, 1944, p. 36). Reynolds also allowed his progress to be monitored by newspaper-correspondents. Indeed the press coverage *The Infant Hercules* received over the next eighteen months was unprecedented for any modern British picture, revealing both Reynolds's own stature,

and the significance of the commission in terms of Britain's burgeoning role in the sphere of the visual arts.

On 21 October 1786 *The Times* reported that '*Hercules* comes forward enriched, and indeed *loaded* with all the treasures of the pallet – the graces of Nature are united with classic knowledge and allegorical taste!', adding, however, on 1 November, that 'the subject is not the most favourable to the art'. Less than a week later (6 November) the same newspaper provided more tangible evidence of the picture's appearance:

Sir *Joshua's* sketch of the Infant *Hercules* strangling the serpents, is universally admired. The drawing indeed deserves equal praise for its *elegance* and *truth*. The remainder of this picture, which is extremely large, is to be filled we understand with *allegorical* figures. This is certainly sacrificing something of propriety; but in such hands it must add considerably to the *effect*.

Although Reynolds was probably already working upon the same large canvas eventually exhibited at the Royal Academy in 1788, his attention was evidently concentrated for the most part on the central figure. At this stage Reynolds was so involved with *The Infant Hercules* that he did not allow even the demands of commissioned portraiture to interrupt him, *The Morning Post* noting on 24 November that the Prince of Wales's commission of a portrait of Mrs. Fitzherbert presented 'a small interuption to Hercules strangling the Serpents'.[31] He was, however, encountering problems – as Horace Walpole told Lady Ossory a week later: 'He would not show me his Russian Hercules – I fancy he has discovered that he was too sanguine about the commission, as you say' (in Lewis *et al.*, 1937–83, vol. XXXIII, p. 539, 1 December 1786). Two months later, on 3 February 1787, *The World* reported: 'A whole length portrait of *Colonel Morgan* has been the work which has lately occupied *Sir Joshua*, and a little checked his progress with the *Prince of Wales*, and *Mrs Fitzherbert*. The great work for the *Empress of Russia* goes on, though but slowly.'[32] Reynolds may originally have hoped to exhibit *The Infant Hercules* at the Royal Academy in 1787. Yet, although it was by then 'an extensive work consisting of thirteen figures', it was – as *The Morning Herald* observed (11 April) – 'so far from completion that we doubt whether it will adorn the Academy in the ensuing Exhibition.'

In fact Reynolds was unable to recommence work on the painting until June, at which point he decided to begin all over again. As *The World* reported on 3 July: 'Sir JOSHUA REYNOLDS is hard at work on his great performance for the Empress of Russia. The subject of the picture is the same, but he treats it differently from what he some time since proposed

– indeed, all that few months since appeared upon the canvas, has been obliterated; and the story is told anew.' The young George Crabbe, a frequent visitor to Reynolds's studio at the time, recalled Reynolds telling him there were four different paintings of *The Infant Hercules* on the same canvas (Crabbe, 1834, p. 122). Indeed, when the painting was finally completed, Reynolds apparently admitted that there were actually 'ten pictures under it, some better, some worse' (in Northcote, 1818, vol. II, p. 219; see also Beechey, 1835, vol. I, p. 206).

During the summer of 1787 Reynolds evidently managed to bring the painting to a high degree of finish, its appearance by the end of August 1787, being recorded in detail by *The World* on 23 August:

Sir JOSHUA, and the CZARINA

To cherish and console this great woman, for her late failure and disappointment at Cherson, *Sir Joshua* has raised, what the Emperor could not, a prodigious work, right in every dimension and point of view – an INFANT HERCULES.

He is, according to the fable, in the act of strangling the serpents. One is in his right hand, the other is in his left. There are two groupes [*sic*] of figures looking on – One on the left hand, of females; the other on the right, of men: The latter are seven, the former are four. There is one woman, a finer figure than the sister in the *Dido*, in all the very act of astonishment and fear – *faemineo ululatu* – with outstretched arms – an open mouth – strained eyes – and her whole visage discomfited and dismayed, for the threatened peril of the child! There is an other female, shrinking at the sense of *her own* danger – for the head of the serpent points to her. The painting about the neck and shoulder of this woman, should be noticed. There is an other infant figure, in close contact with the Hercules, and his serpents – '*nothing loth*'. The six men stand by with varied emotions, as age and profession, the sword or the gown, may make the mode befalling or befitting each. The *dog*, adjoining to this latter groupe, is not the least finished part of the Piece – He is all alive; and ready to snap at any body – who shall say stop thief – and whisper any thing of *M. Angelo*. The background is architecture and sky. This is the Grand Picture – according to the grander order of the *Czarina*, in which the Painter was unlimited in subject and in price – which he has studied so long – which he has finished so well! *Sir Joshua*, as an Artist, yields to none the *World* ever saw! This may not be the most engaging of his works – but unquestionably it ranks among his best. It is nearly finished – and in a week or a fortnight, probably it will be open to common inspection.[33]

A comparison between this description and the finished picture reveals that Reynolds could not have made too many major alterations to the painting's composition between that date and the picture's exhibition the following spring. As *The World* noted, Alcmena was closely modelled on

the figure of Anna in his earlier *Death of Dido* (which was in turn taken from Daniele da Volterra).[34] Of the figure of Tiresias, James Northcote stated: 'I have understood that Sir Joshua told a friend that the attitude and expression of the prophet Tiresias, introduced in the groupe, were taken from those which he had occasionally seen in his deceased friend Johnson' (1818, vol. II, pp. 215–16).[35] Reynolds had, in fact, modelled Tiresias on the portrait of Johnson of 1769 (Lord Sackville), the similarity being evident principally from the idiosyncratic hand gestures common to both figures.[36] Given that Johnson was notoriously shortsighted, Reynolds presumably considered the portrait of his recently deceased friend and mentor an especially suitable model for the blind soothsayer, Tiresias. The female figure at the bottom right-hand corner, who recoils from the serpent, was an adaptation of the Lybian Sibyl from the Sistine Chapel, while the two helmeted soldiers to the right of the composition may have been based on 'Braithwait' or 'Maguire', two models whose names appear regularly in Reynolds's sitter-book at the time.[37] Finally, there is contained in an album of Reynolds's drawings a carefully copied anthemion, the same motif which Reynolds applied to the end of Hercules's crib (Herschel Album, presently on loan to the Royal Academy of Arts).

Despite the existence of a variety of discrete sources, Reynolds's visual quotations in *The Infant Hercules* were less blatant than in earlier works such as *Ugolino* or *The Death of Dido*. One reason may have been that, by the late 1780s, Reynolds was less concerned with the didactic value of such borrowings. In the thirteenth *Discourse*, delivered to the Royal Academy in December 1786, he stated, with regard to artistic 'intuition':

A man endowed with this faculty, feels and acknowledges the truth, though it is not always in his power, perhaps, to give a reason for it; because he cannot recollect and bring before him all the materials that gave birth to his opinion.

This impression is the result of accumulated experience of our whole life, and has been collected, we do not know how, or when. But this mass of collective observation, however acquired, ought to prevail over that reason, which however powerfully exerted on any particular occasion, will probably comprehend but a partial view of the subject. (in Wark, 1975, pp. 230–1)

Reynolds, in other words, suggests that artistic 'intuition' involves a pictorial stream-of-consciousness. Reynolds's attitude towards the composition of the *The Infant Hercules*, which evoked association with a wide range of loosely applied sources, was perhaps the result of such 'intuition'. Thus, devices were no longer didactically transcribed by the artist but found their way into the picture subliminally via Reynolds's 'accumulated experience'. In any event, his contemporaries certainly believed that

Reynolds intended his audience to form comparisons between his theory of art and his practice. On 2 January 1787, shortly after Reynolds had delivered the thirteenth *Discourse* at the Royal Academy, *The World* published an extract from it, concluding: 'Such were the great outlines of Sir Joshua – dilated on in the most admired language, and impressing on the minds of his audience, that HE was the great *example* of what he taught.'

By September 1787 *The Infant Hercules* was open to 'common inspection' in Reynolds's gallery. Among the first to proffer an opinion was Horace Walpole, who visited Reynolds's gallery to look at the picture on 6 September – while Reynolds was in Bedfordshire, at the seat of Lord and Lady Ossory. Walpole, reporting back to Lady Ossory, stated: 'I did not at all admire it: the principal babe put me in mind of what I have read so often, but have not seen, *the monstrous craws*: Master Hercules's knees are as large as, I presume, the late Lady Guildford's. *Blind* Tiresias is *staring* with horror at the spectacle' (in Lewis *et al.*, 1937–83, vol. XXXIII, p. 571).[38] Comparison with the 'monstrous craws' (a current London freak-show 'exhibit') or the unfortunate Lady Guildford, was typical of the type of satirical commentary which Reynolds's allegory was to attract over the forthcoming months. Indeed, only two days earlier, on 4 September, *The Times* had stated:

Sir Joshua cannot please himself in the grouping of his *infant Hercules*. His first design was allegorical and apposite – his *Hercules* was a portrait of Mr. Hastings, with a full-grown serpent in each hand; but some critical connoisseurs having discovered that the *two vipers* were not wholly unlike Messrs Burke and Francis, Sir Joshua felt alarmed for the wandering of his pencil, and, in a fit of ruinous trepidation, dashed in the *varnish-charged brush* across the canvas, and rescued his friend Edmund from the gripe of offended virtue.

The allusion was to Edmund Burke's celebrated prosecution of Warren Hastings, who – under the aegis of Sir Phillip Francis – had been impeached by the House of Commons on 10 May 1787. (It was also, no doubt, inspired by Rowlandson's satirical print of 1784 which had depicted William Pitt as an 'infant Hercules' strangling Charles James Fox and Lord North in the form of serpents (Grego, 1880, vol. I, pp. 115–16).) As with *Ugolino and his Children in the Dungeon*, the press took the opportunity to link Reynolds's history paintings with Burke's political activities, underlining the way in which the two continued to be associated in the public eye. *The Times*'s commentary depended, of course, on its readership's familiarity with Reynolds's penchant for continually altering

the picture's composition. And indeed, even after this date, Reynolds continued to make changes. On 5 October 1787, *The World* reported that 'it now only remains to put the last hand and finishing colours to that wonderful performance', while on 24 October, according to *The Times*, 'Sir Joshua begins to make hasty advances towards the completion of his work, which is designed to extend his fame to the northern world.' A month later, on 21 November 1787, *The World* again reported how the 'grand work which Sir JOSHUA has painted for the EMPRESS of RUSSIA has been much improved by the alteration last made in it. This is putting the female figures on the left hand of the *Hercules*, in shade.' Significantly, rather than being exasperated by Reynolds's inability to put his brush down, commentators delighted in his continued efforts at 'fine-tuning'. Finally, in December 1787, the painting was apparently ready to be dispatched to Catherine the Great, although as *The Times* posited (7 December): 'Is her Imperial Majesty of Russia so impatient for the *Infant Hercules* that she cannot spare it yet a few months for next year's Exhibition?'

The Infant Hercules was exhibited at the Royal Academy in 1788, Reynolds placing it – in the front of his sitter-book – at the top of the list of pictures he intended to exhibit that year. And yet, barely a month before the exhibition (on 26 March 1788), *The World* noted that he was still 'amending and retouching', an observation supported by Ozias Humphry's statement of 31 March that he had 'left Sir Joshua about to give the last finishing to the "Infant Hercules" for the Empress of Russia' (Cotton, 1856, p. 170). John Taylor composed an ode in its honour, demanding rhetorically:

> Ah! Reynolds, why should portrait thee confine,
> Whose stroke can epic force at once impart,
> Whose canvass with Homeric fire can shine
> And blaze with all the true sublime of art. (quoted in Northcote, 1818,
> vol. II, p. 215).

Less reverentially, *The Public Advertiser* (19 May) – by way of reference to an 'extraordinary and curious exhibition of Posture Work, and Exertions of Strength by the Infant Hercules, a child of Ten Years Old' (currently showing at Sadler's Wells) – offered its own idiosyncratic, poetic, tribute:

> The INFANT HERCULES
> of Sadler's Wells, to
> The INFANT HERCULES
> of the ROYAL ACADEMY
> A CHALLENGE

You vye with me, you vulgar brat,
with *dabby cheeks*, all *pursed* and *fat*
For any thing unable!
With *daddles*, *feet*, and *straining stare*
Why z----ds you look, all chased and bare
As if you p---'d the cradle.

Inevitably, there were numerous critical reviews of *The Infant Hercules*, the following extracts being intended to provide a cross-section of the welter of commentary which appeared in the press.

The St James's Chronicle (26–9 April):

The subject was chosen for the pencil of Zeuxis, at a period when the productions of the Arts of Greece were infinitely superior to the tame and laboured Imitations of modern Times ... The Composition is dignified and splendid and the character of the divine infant is finely conceived. As the national honour is in some respect concerned in this Production, we wish the Imagination of the artist had been formed on Greek Literature, and not on the false splendour of Dr Johnson. His colouring might then have been as true and permanent, as it is now clear, beautiful and deceitful.

The Morning Chronicle (30 April):

The artist seems to have mistaken the emotion proper to the situation, and has made his persons more stupified with surprise than alarmed by terror, or disposed to assist the infant hero in his perilous predicament. Alcmena, indeed, appears to be somewhat agitated by the condition of her son, but does not attempt to relieve him, seeming more afraid of the serpents than concerned for his life ... JUNO seems tumbling out of a carpet, rather than riding on a cloud. The light is too scattered, and of course, there is no fine effect produced by masses of light and shadow which impresses the imagination. The chief defect however is the want of interest, the eye gazes with criticism, but the heart is still.

The World (15 May):

SIR JOSHUA – all that this unrivalled Painter has done, and much he has done, may be found in former Papers of the *World* – and therefore need not, for the most part, be found again – The INFANT HERCULES; though much mended of late, by entire new arrangement of the Female Groupe, still is liable to as much blame as praise. With resources such as Sir *Joshua* has, no subject, however poor, can be worthless. That this however is poor, we call to witness Mythology and Enigma. It is bad enough to paint emblematically – A bad emblem is yet worse! – if the Empire of RUSSIA is to be impersonified, the truth is not in Infancy – but in ADVANCED AGE.

As these pieces demonstrate, *The Infant Hercules Strangling the Serpents* did not excite a great deal of admiration among critics. The reasons, however, had less to do with perceived compositional or stylistic flaws than with current expectations concerning the function of history painting. It was even suggested by *The Times* (9 May 1788) that connoisseurs 'considered it as a sarcasm upon themselves, or a species of defiance, in which the artist is personified by *Hercules*, and themselves significantly represented by the serpents, whose poison cannot be exerted without effect'.

Comments directed at *The Infant Hercules* reveal the lack of methodology in the majority of British art critics, who, for the most part, made a random series of observations without any clear programme. There were, however, exceptions. By far the most erudite and informed account of *The Infant Hercules* was written by Henry Fuseli in the first issue of *The Analytical Review*. Before its suppression in 1798, *The Analytical Review* established new standards for art journalism and anticipated the radical stance – as well as the professionalism – of early nineteenth-century critics such as Charles Lamb and William Hazlitt. Fuseli regarded *The Infant Hercules* as a flawed masterpiece, stating that it 'might be called great if it were more correct; it might perhaps have been correct had it not attempted to be great' (May–August, 1788, vol. 1, p. 218). Although Fuseli realized that Reynolds had failed to bring it off, he clearly knew what he was trying to do. As a result he offered two alternative readings of the picture. The first reading employed the conventional language of art criticism, based on an analysis of the form and content of the work. In this respect it was quite similar to other reviews of the painting. It included the customary comparison of the painting and the text on which it was based, noting how Reynolds had, by the introduction of Tiresias, 'thought proper to unite in one instant the successive moments of the poet'. He also commented on the attitudes and actions of various individuals, including 'the clamorous waspishness of Iphicles, the effusions of maternal terror, the mingled fears and horrors of the female attendants' and 'the inanimate astonishment of Amphitryon'. Fuseli did not, however, believe that narrative lay at the heart of the painting's significance because – as he noted – classical mythology no longer had the power to move an audience:

To look for hope or fear among the wilds of mythology, has long been considered the refuge of the cold and tame: to look for them under every aggravation of improbability would be ludicrous. The mighty infant graps his speckled foes in vain, they were sent by Juno, we cannot tremble at the mockery of unreal danger, nor did the artist intend we should: little solicitous about the perplexities of vulgar eyes, he has enchanted the higher connoisseur with the magic of ideal colour, and

an uninterrupted torrent of harmonious hues. Juno, Amphitryon, Alcmena, swept along in a 'flood of glory', mere vehicles of one superior principle they vanish and emerge as it winds or pours its masses of dazzling light or transparent shades. Here may be seen what the steady pursuit of one single principle can do in art: the pathos of the subject is its colour, the colour agitates the eyes, the hearts, that scorn the frigid actors. (*ibid.*)

Fuseli suggested that the 'pathos of the subject' lay not in its narrative but 'its colour'. In that sense, he believed, the painting was revolutionary:

The light and shade of the picture is balanced by two distinct masses. To him, who with a half-shut eye contemplates its effect, an illuminated torrent seems to wind between two darksome rocks from the top, and to lose itself in the lower parts of the picture. Of the colour it would be superfluous to say more. It is all ideal, and beyond all precedent, perhaps beyond all imitation expressive of the subject. Such is the work, which, if we may judge from the impressions it made during its exhibition, we must pronounce it, formed on principles, not sufficiently understood even in this country of arts. (*ibid.*)

One reason for Fuseli's endorsement of *The Infant Hercules* was his shared indifference towards modern-life history painting, which he believed – like Reynolds – to be voguish and localized. Fuseli's urge to argue the case must have been further fuelled by the popularity of Copley's *Death of Chatham*, then drawing large crowds in the Royal Academy's former exhibition rooms in Pall Mall. The direction of high art was not, believed Fuseli, to be conditioned by the approval of the *vox populi*, but on principles held sacred by the artist.[39] If, as it is frequently observed, Copley and West 'anticipated' the work of French modern-life history painters of the early nineteenth century such as Géricault and Gros, Reynolds's own promotion of colour at the expense of fable foreshadowed the stance adopted by Delacroix in the 1820s. Indeed, it was probably no coincidence – given the influence which Reynolds's English followers, Lawrence and Etty, had on Delacroix – that the confusion of Rubensian colour in a work such as *The Death of Sardanapalus* of 1828 (Louvre) was reminiscent of experiments carried out by Reynolds thirty years earlier. *The Infant Hercules* was not dispatched to Russia immediately after its exhibition at the Royal Academy, but stayed in order that a print could be made from it. As *The World* stated on 24 November 1788, 'Sir JOSHUA's great picture of the *Hercules*, for the EMPRESS, goes not to Petersburgh [*sic*] without leaving a copy in this country – from the pencil of the graving tool.' A few days later, on 27 November, *The Morning Herald* confirmed:

Sir Joshua REYNOLDS's Picture of the *Young Hercules* is now at Alderman Boydell's room at Hampstead, for the purpose of being engraved from whence it will go (not to Russia, but) to the Alderman's Exhibition Rooms in Pall Mall; the report of its being bespoke by no means influenced the Northern *Semiramis* to invite its appearance. Falco himself could not blazon the bait sufficiently, and therefore sent word back to the 'Knight of the Pallet' the prudence of disposing of it at home.

In January 1792, a month before Reynolds's death, a print of *The Infant Hercules* was eventually published by James Walker (1748 – c. 1819), engraver to the Imperial Russian Court.[40] It is not certain whether Boydell displayed *The Infant Hercules* in his gallery, although a report in *The World* on 24 December 1788 that 'the Czarina is not to have her Picture of the Infant Hercules till the Spring' suggests that it may have been held back for exhibition purposes there. In any case, as it was shipped to Russia with Prince Potemkin's *Continence of Scipio*, which was shown at the Royal Academy in 1789, it could have remained on view in Boydell's gallery until at least the summer of 1789. The two pictures eventually reached St Petersburg in 1789, under the curatorship of Richard Sutherland, who – as Hilles noted – was described in his obituary as 'Banker to her Imperial Majesty the Empress of Russia' (in Bond, 1970, p. 270). Reynolds – although he had been promised financial remuneration for his labours – received only a gold snuff-box from the Russian Empress in return for *The Infant Hercules*. As the price for the painting had originally been left to Reynolds to decide, the executors of his estate – Edmund Burke, Edmond Malone, and Phillip Metcalfe – wrote to Catherine in 1793 stating that the fee the artist would have demanded from a less important person would have been 1,500 hundred guineas. Catherine (who had evidently forgotten that Reynolds was to be paid at all), stated, in reply, that the snuff-box had been intended to stand in lieu of payment. The following year, however, 1,500 guineas was duly paid to Reynolds's estate (*ibid.*, pp. 276–7).

By the summer of 1788 the 65-year-old Reynolds was in poor health. Yet, over the next two years he exhibited three more large history paintings at the Royal Academy, three works for Boydell's Shakespeare Gallery, plus three paintings for Thomas Macklin's Poets' Gallery and his 'Bible'. In addition, he produced designs for a stained glass window of *The Resurrection* in the Lady Chapel of Salisbury Cathedral – which he had already started by early autumn 1788. The Salisbury *Resurrection* is the least well known of Reynolds's subject pictures, principally because the window was removed from Salisbury as early as 1854.[41] Intended to complement alterations to the cathedral carried out by James Wyatt (1746–1813) the previous year, Reynolds's designs were commissioned

by Bishop Shute Barrington (1734–1826) – an associate of Reynolds and the Wartons. Indeed, around 1794–6 Wyatt apparently incorporated Reynolds's original designs into the gothick reredos of Bishop Barrington's palace chapel at Auckland Castle – although they have since been lost (see Baylis, 1989, p. 93 and n. 142). Reynolds's window was to be placed below one designed by John Hamilton Mortimer, and executed by James Pearson, depicting Moses lifting up the Brazen Serpent, which had been installed above in the east window of the Choir in 1779 (Sunderland, 1986, cat. 153, 153a, 153b, pp. 196–7; Baylis, 1989, pp. 91–2). Although Reynolds's *Resurrection* was evidently destroyed, a stipple engraving by John Jones was published in March 1796 (plate 76). (It is also discernible in J. M. W. Turner's watercolour of the Choir, exhibited at the Royal Academy in 1797 (Salisbury and South Wiltshire Museum, Salisbury) (Wilton, 1979, cat. 197, p. 321; Prochno, 1990a, p. 225, fig. 214). The commission was described in some detail in *The World* on 17 September 1788, shortly after Reynolds had received it:

The subject is the *Resurrection* of *Our Lord*. It is treated in *three compartments* – in the middle is the figure of Jesus – on each side are the Roman soldiery, in corresponding emotions of eager gaze, astonishment and fear. The dimensions of the middle compartment are to fit the window, 12 feet high by 2 feet 2 inches wide – The other compartments are 9 feet high – the Figure of OUR LORD is a few inches above 3 feet high. When finished, they are to be PAINTED UPON GLASS, for the Church – and when so painted, they are to be engraved – Therefore, let BARTOLOZZI, SHARP, and JONES, etc. look about them.

John Jones engraved Reynolds's designs in 1796. Before that, however, they were transferred onto glass by Francis Eginton (the husband of James Wyatt's cousin). As Eginton's window was 23 feet high – while Reynolds's design had apparently only been 12 feet high – he would not have been able to copy the designs directly, but would have needed to enlarge them. A pupil of Matthew Boulton, Eginton was also to execute windows for Wyatt at Fonthill Abbey (after West), and at Lichfield Cathedral where, as Sarah Baylis has suggested, he may also have relied on a design by Reynolds – possibly with the assistance of the young German artist, Johann Heinrich Ramberg.[42] Indeed, one of the reasons why Reynolds may have agreed to carry out the work at Salisbury was a willingness to compete with Benjamin West's *Resurrection*, a tripartite design for the east window of St George's Chapel, Windsor, which had been exhibited at the Royal Academy in 1783, the window itself being installed by Thomas Jervais by 1787 (see Meyer, 1979, pp. 53–65; see also von Erffa and Staley, 1986, cat. 360, pp. 363–5).

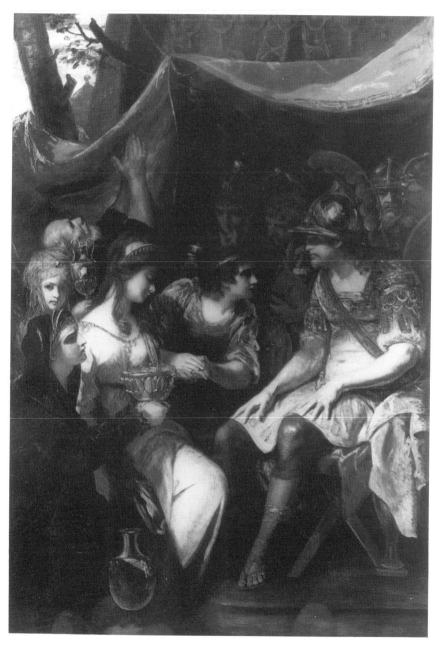

77　*The Continence of Scipio*.
Oil on canvas, 239·5 × 165 cm. Exhibited at the Royal Academy, 1789.
The Hermitage, St Petersburg.

previous paintings of the episode – not least the version by Poussin formerly owned by Sir Robert Walpole, and which had been acquired in 1779 by Catherine the Great.[43] (Reynolds would also have known the version by Van Dyck (Oxford, Christchurch)(Byam Shaw, 1967, cat. 245, pp. 125–6; Larson, 1988, vol. II, cat. 295, p. 122). The episode retained a popularity both in England and on the Continent during the eighteenth century. Benjamin West, for example, had exhibited the subject at the Society of Artists in 1766, while Nicholas-Guy Brenet (1728–92) also exhibited a *Continence of Scipio* at the Paris Salon in 1789.[44] According to Benjamin Robert Haydon, William Young Ottley (1771–1836) 'said the first time he saw Sir Joshua he showed him a picture of the Continence of Scipio, Ottley said it put him in mind of Parmigianino. Sir Joshua seemed angry, for it was stolen from that painter' (quoted in Antal, 1962, p. 250). And yet although Reynolds's painting has strong stylistic affinities with Parmigianino – especially in its mannerist elongation of the figures – there is no known work of this subject by the artist (see Freedburg, 1950, *passim*). (Moreover, Ottley could have been no more than eighteen years old at the time of the encounter.) One painting which Reynolds's work does resemble is Jean François de Troy's 1725 version of *The Continence of Scipio* (Neuchâtel, Musée des Beaux-Arts). One of four large paintings taken from Roman history for Samuel Bernard's gallery in the rue Notre-Dame des Victoires, Paris, the picture's prominent location in the eighteenth century together with the close compositional similarities between the two works suggest that Reynolds may have recollected de Troy's picture in formulating his own work (see Sutton, 1958, cat. 674, fig. 112). More significant, however, is the common debt which both de Troy and Reynolds owed to Rubens – de Troy following the 'Rubeniste' lead provided by the French Academy and Reynolds exploring the lessons he had learnt directly on his visit to Flanders.

On a theoretical level, the work against which Reynolds must have measured his own achievement in the *Continence of Scipio* was Charles Le Brun's *Family of Darius before Alexander* (Louvre), commissioned by Louis XIV in 1661. Known familiarly as *The Tent of Darius* Le Brun's painting had achieved a paradigmatic status through Andre Félibien's treatise *The Tent of Darius Explained*, which had been translated into English in 1703 by William Parsons. Reynolds had discussed both Le Brun's painting – which he deeply admired – and Félibien's *Treatise* in the eighth *Discourse*, as well as making substantial annotations to his own copy of Parsons's translation of Félibien.[45] Moreover, his comments about Le Brun's use of colour have a considerable bearing on his own use of colour in *Scipio*. Having praised

the 'very admirable composition' of the *Tent of Darius*, he criticized the colouring:

The principal light in the Picture of Le Brun, which I just now mentioned, falls on Statira, who is dressed very injudiciously in pale blue drapery; it is true, he has heightened this blue with gold, but that is not enough; the whole picture has a heavy air, and by no means answers the expectation raised by the Print. (in Wark, 1975, p. 158)

Reynolds set out his own views on the subject earlier in the same *Discourse*:

It ought, in my opinion, to be indispensably observed, that the masses of light in a picture be always of a warm mellow colour, yellow, red, or a yellowish-white; and that the blue, the grey, or the green colours be kept almost entirely out of theses masses, and be used only to support and set off these warm colours. (*ibid.*)

Although other pictures by Reynolds can be used to reinforce his own adherence to the above practice, given the context of the remarks – and Fuseli's observations on his preoccupation with colour – few paintings mirror Reynolds's own theories quite so precisely as the *Continence of Scipio*.

Critical reaction to the *Continence of Scipio* was relatively favourable. It was, stated 'Candidus' in *The Public Advertiser* (30 April 1789), 'worthy of the pencil of the President of the Royal Academy; and that, however the invidious and spiteful may rail, it is such as will adorn the cabinet of some future *connoisseur*'. None the less when Reynolds delivered the painting to Potemkin, he candidly admitted that he had originally intended to use a larger canvas for the painting:

J'avois intention que le tableau destiné à Votre Altesse, fut de la même grandeur que celui de Sa Majesté Impériale; mais Je trouvai tant de difficultés et d'embarras à peindre sur une aussi grande toile, que crainte de faire mal, il me fallut renoncer à mon projet, et tâcher de racheter à force de soins et d'efforts, la nécessité où Je me trouvai de peindre en une moindre espace. (quoted by Frederick Hilles, in Bond, 1970, p. 271)

The shortcoming had not been overlooked by critics either. Even the kind-hearted 'Candidus' had criticized the cramped nature of the composition: 'The canvas is perhaps too small for the design, and the figures are, consequently, thrown together too closely.' Less politely, *The Morning Post* (6 May) put forward the amusing – and visually quite plausible – suggestion that the 'man who is supposed to be praying, appears to be putting the tent in proper order' (quoted in Graves and Cronin, 1899–1901, vol. IV, p. 1480YY).[46]

Cimon and Iphigenia (colour plate 16) and *Cupid and Psyche* (plate 78), Reynolds's other two exhibits at the Royal Academy in 1789, if not conceived as pendants, were similar enough in subject matter to be considered as such. In both paintings a sleeping figure is covertly watched by another, although the roles of sexes are reversed – Psyche spying on the dormant Cupid, while Cimon, the male protagonist, gazes upon Iphigenia, asleep in a wooded glade. The story of Cimon and Iphigenia, told in Boccaccio's *Decameron*, was a popular subject in European art. And, as with the *Continence of Scipio*, West had shown the subject at the Society of Artists in the 1760s.[47] More significant, in terms of Reynolds's depiction of the subject, was the fact that it had been recommended by the council of the Royal Academy in 1781 to students competing for the prize for history painting. Also recommended by the council were the *Death of Dido* and the *Continence of Scipio*.[48] Given the didactic nature of Reynolds's subject pictures, and the likelihood that Reynolds would not have had the time to paint the *Continence of Scipio* and *Cimon and Iphigenia* in the months preceding the 1789 exhibition, it is quite possible that both subjects had occupied Reynolds intermittently since the early years of the decade. Those critics concerned with identifying the sources of Reynolds's paintings were divided over which old master had most influenced *Cimon and Iphigenia*, *The St James's Chronicle* (25–8 April) detecting the influence of Giordano, while *The Morning Post* (30 April) maintained more generally that Reynolds could not 'claim the least credit for invention as the figure of Iphigenia is common to RUBENS and his school'. Indeed, the most striking aspect of the painting is the Rubensian sensuality of Iphigenia – a far more mature and naturalistic figure than the naked female figure in the previous paintings of Venus. (Given his penchant for fleshy, Rubensian, women it is not, perhaps, surprising that William Etty made a copy of Reynolds's *Cimon and Iphigenia*.[49]) Unlike *Venus*, there are no known related drawings by Reynolds for *Cimon and Iphigenia*. However, Reynolds evidently did use a living model for the figure of Iphigenia, Northcote subsequently describing her to William Hazlitt as 'a battered courtesan' (in Hazlitt, 1830, p. 103). If Reynolds's visualization of Iphigenia – according to Boccaccio, a young maiden – strayed from the given text, Cimon was even further removed from the character in the story. *The Morning Post* (30 April) observed:

CIMON is so mean and clumsy a rustic, that he seems wholly incapable of being rendered an object of female regard, whatever refinement love might produce in his affections. Sir Joshua might have been expected to have the taste and feeling enough to portray in CIMON sylvan simplicity, but he has drawn a coarse brutal

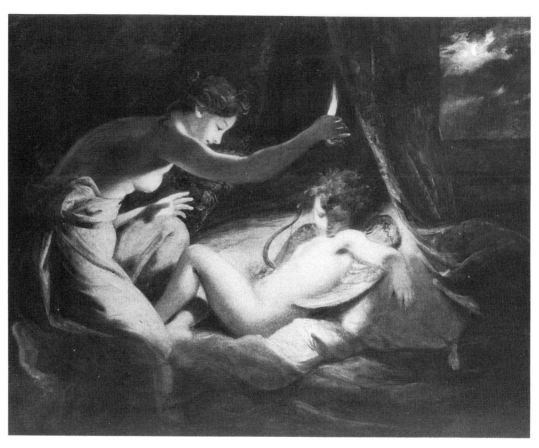

78 *Cupid and Psyche.*
 Oil on canvas, 139·8 × 168·3 cm. Exhibited at the Royal Academy, 1789.
 Miss Jeanne Courtauld.

disgusting boor. It has been said, and not without reason, that poor CIMON's nose seems to have been assailed by FALSTAFF's 'compound of villainous smells'. The idea of introducing the God of Love to lead CIMON to the seat of IPHIGENIA's repose, is miserable, unaffecting, common-place allegory, unworthy of the judicious philosophical pencil of the president.

The critic was correct. Cimon, although boorish and uneducated, was – according to legend – a physically attractive youth of noble birth. The inclusion of Cupid was also a departure from the narrative as no mention of him is made at that point in the text. To Reynolds, a formalist by nature, such liberties were immaterial and were ultimately of secondary importance to the prime concern of colour. Indeed, it is quite possible that Reynolds had originally conceived of the picture as quite another subject – Venus, Artemis and Actaeon, or a 'nymph and shepherd' scene. And yet to the public, increasingly exposed to narrative painting through the exhibitions at the Shakespeare Gallery and the Poets' Gallery, Reynolds's dialogue with the old masters was of less consequence than the story which he purported to illustrate. Of those who commented on *Cimon and Iphigenia* at the time, only Fuseli sympathized with Reynolds's priorities, noting: 'in history, the pictures of the president stand again nearly alone. Iphigenia and Cymon, Cupid and Psyche, are full of every beauty that flesh, colours, and contrast can give. Psyche is, perhaps not Psyche, but the charm of Cupid, and the play of enamoured tints on his body, are divine' (*The Analytical Review*, May–August, 1789, vol. 5, p. 106). None the less, even if Psyche was not, in Fuseli's eye, Psyche, the painting adhered more closely to the text than *Cimon and Iphigenia*.

The story of Cupid and Psyche was told originally in Lucius Apuleius's Latin novel, *The Golden Ass*. Jealous of the beauty of the princess Psyche, the goddess Venus sent Cupid down to earth in order to ensure that she fell in love with an outcast. Having fallen in love with her himself, Cupid married her and took her to his palace, where, in order that she might not discover his identity, he visited her after dark. The episode depicted by Reynolds – the most frequently illustrated episode of the story – shows Psyche leaning over the sleeping body of Cupid, as she illuminates his face with an oil lamp. Of the many pictures based on the episode, Reynolds would have known, among others, versions by Rubens (Rolf Stodter, Hamburg), Giulio Romano (Palazzo del Te, Mantua), Jacopo Zucchi (Galleria Borghese, Rome) and Giuseppe Crespi (Uffizi, Florence). Of these works it is Crespi's picture which his own work most closely resembles. Although it is by no means certain that he was consciously following Crespi, the general similarity suggests, at the very least, that Reynolds

wanted to make *Cupid and Psyche* look like the work of a seventeenth-century Italian, rather than an eighteenth-century British painter.

There is evidence to suggest that *Cupid and Psyche* had been in existence since 1787, 'Cupid' appearing in his sitter-book on 28 September 1787 (Reynolds planned to have it engraved in 1788).[50] However, according to *The St James's Chronicle* (25–8 April 1789) it had only been finished very recently:

When we consider the rapid manner in which this picture was produced, it is wonderful. It has been finished from a mere outline, since the pictures were sent to be exhibited. This furnishes a hint to those who would employ the President. He should be induced always to finish a picture while his imagination is warm, without having the opportunity to alter it. Correggio seems to have been his model in the work before us, the composition of which is graceful and the effect good.

Despite its bituminous surface, a close examination of the painting reveals that it is thinly impasted with little sign of retouching. Indeed, if *The St. James's Chronicle* is to be believed, Reynolds had finished the painting after it was submitted for exhibition. The decision to finish the picture immediately before the opening of the exhibition was almost certainly related to his concern with the need to increase the quota of history paintings on display, rather than to demonstrate his manual dexterity. The exhibition of three large history paintings by Reynolds at the Royal Academy in 1789 was unprecedented. As *The St. James's Chronicle* (25–8 April) reported:

It has been supposed the exhibition of this year would not sustain its usual reputation, as the most eminent artists have been occupied [*sic*] in the undertaking of Mr. Boydell and their production will be exhibited at the opening of his Gallery. The President of the Academy has not been uninfluenced by this opinion, and has made evident efforts to rescue the institution from contempt. We shall direct our observations to the productions of Sir Joshua, in the order of their importance, not of their numbers.

After the Academy exhibition, Fuseli, writing in *The Analytical Review*, stated (in the context of a discourse on Reynolds's subject paintings): 'The historical talents of the artists having been almost exclusively engrossed by the public scheme of Messrs. Boydell, and the private one of Mr. Macklin, the exhibition of this place is become of still less importance than even that of last year to the critic and connoisseur' (May–August 1789, vol. 5, p. 106). Boydell's Shakespeare Gallery and Macklin's Poets' Gallery clearly provided Reynolds with a dilemma. Ostensibly – as we shall see in the next chapter – Reynolds gave his backing to their sponsorship of British history

painting. Nevertheless, in building his own gallery, in which to exhibit the works, Boydell threatened to take the high ground away from the Royal Academy's exhibition: for without history painting the other genres on show would gain a disproportionate importance. Already Copley had effectively seceded from the Academy as a history painter by exhibiting *The Death of Chatham* in the Great Rooms, Pall Mall. Gainsborough, although he had shown an increased interest in subject pictures during the 1780s, did not show his work at the Academy after 1783, preferring to mount annual exhibitions at his home in Pall Mall, Schomberg House. Now, with the expansion of the Shakespeare Gallery and the Poets' Gallery there was a realistic prospect that the Royal Academy would cease to be the principal forum for high art in England.

6 The 'modern Apelles' and 'modern Maecenas': Reynolds, Boydell, and Macklin

During the last months of 1786 British artists had been given an unprecedented opportunity to apply themselves to the production of subject painting via the business acumen of two entrepreneurs, Thomas Macklin (d. 1800) and the so-called 'modern Maecenas', John Boydell (1719–1804). Both men simultaneously engaged in schemes to establish permanent galleries of paintings illustrating scenes from British poetry and literature, through commissioning works by contemporary artists, and both schemes were to be financed by the sale, by subscription, of prints made from the works on show. Macklin's Poets' Gallery was to encompass paintings based on British poetry from Chaucer to the present day, while Boydell's Shakespeare Gallery – as the title indicates – was to concentrate exclusively on the works of Shakespeare (although other subjects were subsequently introduced).[1] John Boydell was by the late 1780s the doyen of the British print market. Trained as an engraver, Boydell's first claim to fame had been the publication, in 1761, of William Woollett's engraving after Wilson's *Niobe*. Since then he had steadily transformed the print market in England, exporting prints after British artists in increasingly large numbers to the Continent, and making his fortune on the way. The Shakespeare Gallery was, as Geoffrey Ashton observed, 'a business venture that was to mark the climax of Alderman John Boydell's outstandingly successful career' – although, in the wake of the French Revolution, it also brought about his downfall.[2]

Comparatively little is known about Thomas Macklin. Unlike Boydell, he seems to have had no artistic training, and little formal education, having been variously a cabin-boy, a gilder of picture frames, a print and picture dealer (see Whitley, 1928b, p. 90). As T. S. R. Boase observed, 'the Poets' Gallery was based on the concept, then much discussed, of "the natural alliance between the Fine Arts"' (1963, p. 148). Macklin's scheme was quite literally a vindication of the topos of *ut pictura poesis* – that true painting should emulate poetry.[3] As Macklin stated in his catalogue, the aim of all the arts was identical: 'it is the awakening of the generous and social affections, the humanizing of the heart, and the imparting of a general taste and relish for beauty and excellence' (*ibid.*).

On 4 January 1787 *The World* carried an advertisement for 'Proposals

by Thomas Macklin, No. 39 Fleet Street, for PUBLISHING a Series of PRINTS, Illustrative of the Most Celebrated BRITISH POETS'. According to this advance publicity, the prints were to be based on paintings by artists including James Barry, Henry Fuseli, Angelica Kauffman, Philippe Jacques de Loutherbourg, John Opie, and Benjamin West. Reynolds's name was absent from the list, although he subsequently contributed one work to Macklin's inaugural exhibition in 1788. The circumstances surrounding the incorporation of this painting – *Tuccia* – into the Poets' Gallery reveals a great deal about the methods of both Macklin and Reynolds, as well as the value which the former placed on having Reynolds represented in his own gallery of art.

In chapter 1 it was discussed, in the context of links between Reynolds's portraiture and subject painting, how critical interest in *Tuccia* (plate 79) had centred on the identity of Reynolds's model – Mrs Seaforth – who was the mistress, and, subsequently, the wife of Richard Barwell. In June 1786 Richard Barwell paid Reynolds 200 guineas for a portrait of 'Mrs Seaforth and Child' (Lady Lever Art Gallery, Port Sunlight).[4] However, as Reynolds's sitter-book shows, Mrs Seaforth sat to Reynolds on at least twenty separate occasions between January and May 1786.[5] As it was exceptional for Reynolds to require so many sittings for a single portrait it is probable that she also acted then as Reynolds's model for *Tuccia* – although she may have sat to him even earlier. On 25 July 1787 – by which time *Tuccia* was on view in Reynolds's gallery – *The Morning Herald* reported that Macklin had purchased the painting. It was still on view in the autumn (19 October), when its presence was commented on by *The World*:

A Drawing Boy – and the Vestal, after her successful trial of holding water in a sieve – are two studies ... the story of the last is told by three more figures :- The size – Bolognese half length – The vestal is a portrait – Mrs SEAFORTH – she was painted long ago – by Sir *Joshua* we mean, as well as by herself – Mr BARWELL has had her some time. And every body may know her.

The inference to be drawn from this sequence of events is that Reynolds had painted *Tuccia* prior to its being selected by Macklin for inclusion in the Poets' Gallery, and that additional figures were then included to increase the narrative element of the painting. Although the painting was eventually shown at the Poets' Gallery in 1788, Reynolds had evidently intended to exhibit it at the Royal Academy – as a memorandum in his sitter-book indicates.[6] In any case, the relation between Reynolds's

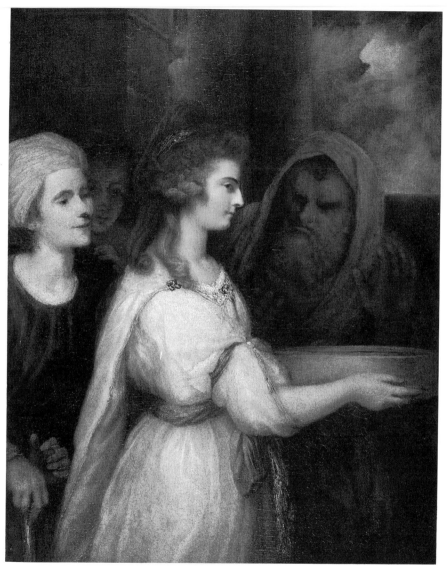

79 *Tuccia.*
 Oil on canvas, 127 × 99·1 cm. Exhibited at the Poets' Gallery, 1788.
 Private Collection.

painting and the poetry which it purported to illustrate, was questioned when it went on show at the Poets' Gallery.

On 16 April 1788, the *Morning Herald* reported that 'The Vestal' – as it was titled in the catalogue – was 'an illustration of Mr. Gregory's ODE TO MEDITATION', and quoted the following lines from the poem:

> Lo, in the injur'd Virgin's cause,
> Nature suspends her rigid laws,
> By power supreme constrain'd,
> The *trembling drops* forget t'obey,
> Old Gravitation's potent sway,
> And rest on air!

'Mrs Seaforth', it concluded, 'is the Lady who sat for the Vestal, and with a great share of conscious security, a considerable degree of beauty is united.' According to Pliny the Elder (*Historia naturalis*, 28:12), Tuccia was a Vestal Virgin who, upon being accused of adultery, had proved her innocence by carrying water in a sieve without spilling a drop. Gregory's 'Ode to meditation' was less well known. As Fuseli indicated in the course of his critique of *Tuccia* in *The Analytical Review*, the Reverend Thomas Gregory was a contemporary British poet: 'Mr. Macklin does not require the sanction of death for his bards – he admits the living, and we are happy he does, we might not else perhaps have had an opportunity of praising the picture here' (May–August 1789, vol. 4, p. 369).[7] None the less, as John Opie had told the Reverend Richard Polwhele – who wanted him to illustrate one of his poems for Macklin: 'I will speak to Mr M[acklin] on the subject; but cannot after all promise to be successful, as I am afraid he will object to having any subject taken from a living poet' (in Earland, 1911, p. 76). Several contemporary poets were, however, introduced by Macklin into the Poets' Gallery, including Anna Barbauld (1743–1825) and Edward Jerningham (1727–1812) (Boase, 1963, p. 149). Unlike Barbauld and Jerningham, the Reverend Gregory was even less of a household name than the Reverend Polwhele. (He is not listed in the author catalogue of the British Library, nor have I been able to trace his work in any compendium of eighteenth-century English verse.) Significantly, the link between Reynolds's painting and Gregory's 'Ode to meditation' was questioned at the time. *The St. James's Chronicle* (17–19 April 1788) stated:

Though the poetry and painting be thus united in the catalogue, we do not imagine that Sir Joshua had any reference to Mr Gregory; and this is a picture not painted for Mr Macklin. It is a production of Sir Joshua in early life and it is evident by the surrounding objects that he was studying Rubens.

Even if Reynolds had read Gregory's 'Ode to meditation' (supposing it consisted of more than the stanza printed in Macklin's catalogue), he would not have needed it to inspire him. Tuccia, like Thaïs, or Hebe, was a standard emblematic figure in west European allegorical portraiture.[8] Macklin, one is forced to conclude, had commissioned, or in some way concocted, Gregory's ode in order to accommodate Reynolds's painting. Moreover, *Tuccia* was not the only example of such an improvisation. Gainsborough's contribution to Macklin's inaugural exhibition was entitled *Lavinia*. Painted in 1786, the picture depicted a child holding a bowl of milk which had been, as Henry Bate Dudley noted, 'oddly perverted by Macklin to the *Lavinia* of Thomson', not least because Gainsborough's model for this fancy picture was a boy (Whitley, 1915, p. 302). Macklin, anxious to ensure that Reynolds and Gainsborough featured in the first exhibition of the Poets' Gallery, had done what print publishers and engravers had been doing to images for decades – altering the meaning to suit their own devices. Macklin's venture, however, aspired to a more elevated sphere and was intended to promote high art by emphasizing the links between painting and poetry, not to undermine it by subverting the creativity of the artists concerned.

The Poets' Gallery opened for the first time on 14 April 1788 at the inauspicious venue of the Mitre Tavern, Fleet Street. The first exhibition contained nineteen pictures.[9] At that year's Royal Academy exhibition, by comparison, a total of 539 paintings were exhibited – of which seventy-one could be classed as 'public art' (religious, allegorical, historical, mythological, or literary).[10] Reynolds alone showed eighteen works – including *The Infant Hercules Strangling the Serpents* and *Lord Heathfield*. In retrospect, there would seem to be have been little competition between the large-scale exhibition at the Royal Academy and Macklin's modest show. And yet on 18 April *The Times* reported that the Poets' Gallery was already drawing artists away from the Royal Academy exhibition, while a week later (26–8 April) *The St James's Chronicle* commented on how Reynolds was artificially propping up the Royal Academy exhibition: 'The President has eighteen Pictures this Year: It being necessary to cover the Room, and [*sic*] many of the principal Artists being engaged with Mr. Boydell or Macklin.' The same day *The Morning Chronicle* (28 April) noted that the absence of five of the country's major artists – Nathaniel Dance, Matthew Peters, John Singleton Copley, Thomas Gainsborough, and George Stubbs – detracted from the Academy's exhibition. The problem, however, was not simply that artists were being induced to exhibit elsewhere but that their efforts in the most elevated genre were being

creamed off from the Academy's exhibition. Moreover, the increasing trend in favour of medieval subjects over classical history and legend at the Royal Academy by the 1780s (as Anthony Smith has shown) meant that schemes such as the Poets' Gallery and the Shakespeare Gallery – which effectively engendered medieval subject matter – were more attractive to leading artists than the non-focussed Royal Academy exhibition. Portraiture (which still dominated the Royal Academy exhibition) – as the critic in *The Morning Chronicle* (29 April) explained – was not an adequate basis on which to mount a public exhibition:

The portraits annually introduced at this place, however they may tend to gratify private vanity, conduce very little to the honor of the arts – and, though, even in the narrow sphere of portrait, a great portion of genius may be distinguished, yet an exhibition chiefly composed of productions of that kind, cannot but be too dull and heavy for the public eye.

Several days later (2 May) *The Morning Chronicle* concluded that 'those who have observed the merit of the Paintings at the Royal Academy, and those at Mr. Macklin's, have preferred this gentleman's exhibition'. The plight of the Royal Academy's exhibition had deepened further the following year, according to Fuseli – in the context of charting the continued success of Macklin's and Boydell's ventures – stating that 'the exhibition of this place is become of still less importance than that of even last year to the critic and connoisseur. The usual farrago of portraits, landscapes, imitations, or rather copies of still life etc. jostle each other, and crowd the room' (*The Analytical Review*, 1789, vol. 5, p. 106). Despite its modest size, the Poets' Gallery not only attracted a large audience, but a wider cross-section of visitors than the Academy.

The public to whom Reynolds had appealed in the 1760s and 1770s was relatively limited, consisting primarily of those who shared his own intellectual interests – his friends, the patrons who commissioned his work, as well as assorted *cognoscenti*. By the 1780s, as the audience for the visual arts became increasingly diversified, the need to satisfy those who could afford to pay the entrance fee to the exhibition but whose collecting habits aspired only to the level of the furniture-print, was increasingly apparent. The emergence of a revised *status quo* presented Reynolds with a number of problems. As president of the Royal Academy Reynolds must have been concerned at the threat to that organization's position as the premier exhibiting body in England, and yet as one who had canvassed for the promotion of subject painting he could not remain aloof without the risk of putting himself on the periphery. And yet, Macklin and Boydell still

needed Reynolds, as acknowledged leader of the British School, at the very least to lend *gravitas* to their venture.

Reynolds – although he had almost certainly painted *Tuccia* prior to Macklin's request for a work to display in the Poets' Gallery – did paint one picture expressly for him – *The Cottagers* (plate 80). Indeed, not only was *The Cottagers* commissioned by Macklin and painted for him from scratch, but the poetry from which it derived – 'Autumn' from James Thomson's *The Seasons* – was decided on before the picture was begun (see Richardson, 1955–6, pp. 1–4). Reynolds began work on *The Cottagers* soon after the first exhibition of the Poets' Gallery in 1788 – presumably after he had had an opportunity to take stock of the public reception of the Poets' Gallery. Reynolds worked on *The Cottagers* between August and October 1788. His models for the picture (as it was observed in chapter 1) were Macklin's wife, his daughter, and Jane Potts, a friend of the family (who, owing to an introduction by Macklin, was later to marry the engraver, John Landseer).[11] The picture was included in the 1789 exhibition of the Poets' Gallery, while the accompanying catalogue contained relevant verses from *The Seasons*. Prints after fancy pictures, and even portraits, had for decades been accompanied by lines of verse in order to generalize the meaning of a work and to make it more saleable. The main consideration of the publisher or engraver was to select verses which matched sentiments apparent in the picture. The Poets' Gallery was supposed to be different. Here, artists were ostensibly commissioned to produce pictures in order to illustrate a specific text. (All twenty-four images were engraved in stipple by Bartolozzi between 1788 and 1799.) There were, as we have seen, at least two notable exceptions to that rubric. Was the Poets' Gallery, therefore, a genuine attempt to raise the status of British subject painting, or was it simply a shrewd way of promoting and selling prints? The answer lies somewhere in between. In a work such as *Tuccia*, which was incorporated into the Poets' Gallery primarily in order to involve Reynolds's name in the scheme, market forces clearly outweighed artistic concerns. *The Cottagers*, painted with Thomson's text in mind, was novel – as far as at least one critic was concerned – in that it revealed a hitherto unknown aspect of Reynolds's art: 'In the *Rural Walk* we have never witnessed anything more charming than this performance – till we saw *The Cottagers* we thought Sir Joshua had been only conversant in the sublimer path of history and the epic' (quoted in Graves and Cronin, 1899–1901, vol. II, p. 604).

James Thomson's *The Seasons*, the first complete edition of which was published in 1730, was among the most influential poetic contributions to

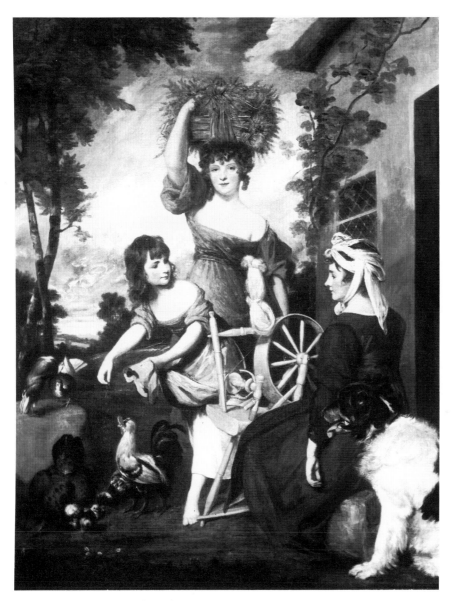

80 *The Cottagers (The Gleaner)*.
Oil on canvas, 240·2 × 180·2 cm. Exhibited at the Poets' Gallery, 1789.
Institute of Arts, Detroit, Michigan.

the eighteenth-century pastoral tradition. And as T. S. R. Boase stated, Thomson's influence on the overall shaping of the Poets' Gallery was immense. 'Macklin's inclusion of Somerville, Shenstone and Jago', he noted, 'indicates the powerful influence of *The Seasons* on taste for "rural charms" and the fashionabled prestige of the "Warwickshire coterie" to which all three belonged' (1963, p. 150). In the four books which made up *The Seasons* Thomson presented a picture of the countryside wherein, through a balance of the pastoral and georgic elements, a harmony of interests between the landed and the labourer, England had succeeded in recapturing in a modern world the vestiges of Arcadia. As it has been observed, Thomson presented two, not entirely compatible, images in *The Seasons*. While on the one hand it charted the passing of a 'golden age' and its replacement by a harsher reality; it also witnessed a modern resurgence of georgic values in England, under the guidance of certain distinterested Whig patricians, to whom Thomson dedicated the poem (Barrell, 1983, pp. 51–79; see also Cohen, 1970, *passim*). Of these dedicatees, John Barrell has stated that they 'could be described as the nearest imaginable equivalent, in verse, of the style of heroic, of "historic" portraiture we associate particularly with Sir Joshua Reynolds; images of men who by their universal, all-embracing interests were able to view society in the wider scope' (Barrell, 1983, p. 69). It is a comparison which serves to emphasize how Reynolds in the late 1780s continued to be indebted to the philosophical outlook of an earlier generation – as well as the close links which bound his portraits and subject pictures.

The central question relating to Reynolds's *Cottagers* – given that it was intended as a visual parallel to Thomson's *Seasons* – is whether the painting was any different to the kind of historical portrait which Reynolds had produced since the 1760s. T. S. R. Boase described the *Cottagers* as 'a stilted piece of mock rusticity' with a 'bold, inappropriately monumental design' (1963, p. 151). And yet, the 'monumentality' of the image depended not simply on the artist's reliance upon a formula which he had used in past historical portraits, but a desire to communicate a particular vision of English peasantry. Superficially, the painting is similar to earlier portraits in character such as *Mrs Sophia Pelham* (Earl of Yarborough) of 1774 and the young *Lady Catherine Pelham-Clinton* (Earl of Radnor) of 1781, who feeds an identical flock of chickens to that found in *The Cottagers* (see Penny, 1986, p. 26, fig. 12 and cat. 156, pp. 331–2; Mannings, *ibid.*, cat. 126, p. 297). And yet, *The Cottagers* was not just another example of 'eighteenth-century pastoral romanticism' intended to mirror the rituals of the masquerade or *fête champêtre*. The characters

are not, I would argue, 'stilted', but deliberately statuesque – particularly the sturdy figure of the gleaner, who is reminiscent of Wheatley's 1771 drawing of a *Young Woman Carrying a Sheaf of Corn* (see Webster, 1970, p. 72, fig. 88). Their clothes, although neat and clean, are simple, and far removed from the more elaborate, and fanciful costume adopted for more recent portrait sitters. The young girl feeding chickens in *The Cottagers* is bare-foot, something which was generally considered infra dig in a society portrait (see Postle, in Strong, 1991, p. 228). Similarly, the woman spinning wears a simple piece of white linen wound loosely around her head, an item far removed from the extravagantly laced bonnet worn by any would-be country maid attending a masquerade. As in the similarly statuesque models for Reynolds's 'Virtues' at New College, Oxford, no overt allegorical comparison was intended between the sitters for *The Cottagers* and the painting's subject. Together, the three figures form a joint personification of autumn, while at the same time demonstrating the benefits of labour and committed husbandry.

In order to demonstrate the point, two distinct hypotheses are relevant to the argument: Jean Hagstrum's reading of the visual imagery of James Thomson, and John Barrell's reading of eighteenth-century landscape painting. In an investigation of the pictorial imagery in Thomson's poetry, Hagstrum stressed the importance of the 'human landscape' to the poet's imagination (1958, pp. 244–67). Hagstrum argued that although pictorial equivalents to Thomson's poetic images are customarily located in the landscapes of Claude and Salvator Rosa, more significant echoes – and ones which Thomson himself had in mind – can be found in the work of seventeenth-century Bolognese artists such as Guido Reni and Guercino. As Hagstrum noted: 'His chief instrument in creating the pictorial image is the personification. His personae must be *seen* if we are ever again to recover the pleasures of reading Thomson' (*ibid.*, p. 86). Both Thomson's and Reynolds's artistic development was formed on the work of seventeenth-century French theorists, and both conceived of 'nature' in terms of the human figures who inhabit a landscape, and where natural forces are alluded to in allegorical terms. Just as Reynolds's portrait of the young *Lady Caroline Scott* (private collection), in a snowy landscape, could be interpreted as 'Winter', so Thomson could personify autumn, 'Crowned with the sickle and the wheaten sheaf...nodding o'er the yellow plain' (quoted in Hagstrum, 1958, p. 262).

More recently, John Barrell has evolved a quite different, but equally pertinent, argument which relates to *The Cottagers* (1980, *passim*). In the context of a commentary on Gainsborough's landscape paintings Barrell

has perceived 'a progressive appropriation of the material of the Pastoral by the Georgic' – both in poetry and the visual arts (*ibid.*, p. 86). He argues that whereas in the work of Thomson (and in the earlier landscapes of Gainsborough), labour and leisure are perceived as admissible (and indeed compatible) facets of the life of the labouring rural poor, in the later landscapes of Gainsborough, and in the poetry of George Crabbe, leisure is excised from the scene. By the late 1780s the quest for 'realism', states Barrell, 'is almost always accompanied and undercut by a compensating desire to re-pastoralise what is then seen as the actual squalor of country life into an image of how that squalor may be avoided by the rural poor, in a life of industry and religion' (*ibid.*, pp. 63–4). Although there are exceptions to Barrell's thesis (Gainsborough's *Haymaker and Sleeping Girl* (Boston Museum of Fine Arts) of *c.* 1785, for example, exemplifies anything but industry and religious virtue), the general argument holds water. In *The Cottagers* Reynolds's peasants are quite clearly intended to represent sober, dutiful labourers whose activities mirror the sentiments contained in the extract from *The Seasons* which accompanied the picture in Macklin's gallery:

> Rich in content, in nature's bounty rich
> In herbs and fruits; whatever greens the Spring,
> When Heaven descends in showers, or bends the bough,
> When Summer reddens, and when Autumn beams;
> Or in the wintry glebe whatever lies
> Conceal'd, and fattens with the richest sap:
> These are not wanting; nor the milky drove,
> Luxurient, spread o'er all the lowing vale;
> Nor bleating mountains; nor the chide of streams,
> And hum of bees, inviting sleep sincere
> Into the guiltless breast, beneath the shade,
> Or thrown at large amid the fragrant hay;
> Nor ought besides of prospect, grove, or song,
> Dim grottos, gleaning lakes, and fountains clear.
> Here too dwells simple truth; plain innocence;
> Unsully'd beauty; sound unbroken youth,
> Patient labor, with a little pleas'd;
> Health even blooming; unambitious toil.

Each figure in the painting personifies an aspect of the 'unambitious toil' of husbandry – gleaning, spinning, and tending poultry.

Reynolds was aware of the ways in which poetic depictions of the rural poor evolved since Thomson. He had, we know, taken more than a passing

interest in Goldsmith's *Deserted Village*, while more recently he had done much to promote the career of George Crabbe, to whom Burke had introduced him in 1781. (Crabbe's son later recalling that 'for Sir Joshua, in particular, he conceived a warm and grateful attachment, which experience only confirmed' (Crabbe, 1834, vol. I, p. 95).) It was Reynolds who recommended Crabbe's newly completed poem, *The Village*, to the attention of Samuel Johnson. Although Crabbe's portrayal of village life differed from Goldsmith's, both poets must have contributed to Reynolds's poetic perception of rural existence – on the one hand exalting the simple joys of Arcadian life, while on the other raising the spectre of a dissolute, shiftless, peasantry. That Reynolds's *Cottagers* was, when exhibited in the Poets' Gallery, intended to be viewed as an embodiment of the 'ideal' peasant, and not merely as the alter egos of Macklin's family, is evident from the following piece of contemporary criticism, from 1790, where the joys of hard work are clearly extolled beyond any bucolic sentiment:

The rustic *Groupe* is pleasingly interesting. The *Spinner*, the *Girl* returned from *Gleaning*, and the *Feeder of Poultry*, each feature and limb has its proper *tone* and attitude, and those the *tones* and attitudes of nature. Such are the employments of the *Peasant Cot*. There is a peculiar beauty in the circumstance of the *Gleaner* standing to survey the employment of the rest of the family on her return, whilst the labour of the wheel is suspended, to enquire of the toil of the *Harvest Field*. Nor should the faithful *dog* be forgotten, who is a most happy introduction, both for figure and propriety of situation. Whilst we contemplated this painting, it was with pleasure we perceived that our favourite Bard had found the verdure of his fields – the foliage of his trees – and his accurate representation of country life, faithfully delineated by so distinguished a pencil as the PRESIDENT's (in Graves and Cronin, 1899–1901, vol. II, p. 604).

Reynolds's 'accurate representation of country life' went on display at the Poets' Gallery in 1789, although, as was now customary with Reynolds's subject pictures, its progress had been monitored by the press since the previous October (see, for example, *The Morning Herald*, 29 October 1788 and 27 December 1788). Fuseli, whose dedication to high art engendered a disdain for such painting, was for once scathing of Reynolds's efforts, calling *The Cottagers* an 'insipid scene, equally destitute of beauty, passion, forms, and chiaroscuro'. He added – as if to forestall any subsequent engraving of the work – that it 'subsists on the canvas by an opposition of tints, but must perish by the monotony of white and black when put to the test of the graver' (*The Analytical Review*, May–August 1789, vol. 4, p. 370).

In 1789, the second year in which paintings were shown at the Poets'

Gallery in Fleet Street, Macklin extended the scope of his exhibition to the Bible, with the inclusion of *The Holy Family* (plate 81) by Reynolds. A down-payment for the painting from Macklin had been recorded in Reynolds's ledger on 16 September 1788, the remaining balance being paid on 30 April 1789, alongside a second payment for *The Cottagers* (Cormack, 1970, p. 158). In total, Reynolds received 500 guineas for the picture. As with *Tuccia*, *The Holy Family* does not appear to have been commissioned by Macklin. On 21 February 1787 – almost eighteenth months before Macklin bought the picture – the correspondent of *The Morning Post* saw it in Reynolds's gallery: 'The Holy Family, by this great artist is most charmingly coloured – the drawing is very so so – the expression tame – yet it is on the whole a delicious *morceau*. The size of the figures displeases us – they should have been much smaller, or as large as life'. The figures in *The Holy Family* are, as *The Morning Post* indicated, smaller than those found in full-length portraits by Reynolds, and in his subject pictures – which are usually life-size. (The canvas itself, while it was the width of a standard full-length portrait (58 inches), was, at 77 inches, 17 inches shorter.) Aside from the designs for New College and Salisbury Cathedral (and several copies of old masters), Reynolds had, over the years, produced several smaller religious paintings of *The Madonna and Child*, including at least one depiction of the Virgin with Christ and John the Baptist, which is stylistically similar to *The Holy Family*.[12] One important compositional source was, however, not a sacred image but Correggio's allegory of Mercury instructing Cupid in front of Venus (National Gallery, London), from which the figure of the infant Baptist in particular is derived.

Macklin's reasons for embarking on the Bible project were financial. Like the Poets' Gallery and Boydell's Shakespeare Gallery the engravings sold to subscribers were ultimately of greater importance to him than the paintings on which they were based. But unlike Boydell, who sponsored artists to produce paintings for the Shakespeare Gallery, Macklin tended to utilize works already in existence, not all of which he owned. Of four works by Benjamin West engraved for the Bible, for example, only two (*St John the Baptist* and *Christ Showing a Little Child as the Emblem of Heaven*) were purchased by Macklin. A third work, *Saul and the Witch of Endor* (Wadsworth Museum, Hartford, Connecticut) dated back to 1777. In 1779 it had been purchased from West by Daniel Daulby, to whom Macklin dedicated the plate of 1797 – presumably in return for being granted permission to produce the engraving (see von Erffa and Staley, 1986, cats. 268, 275, 297, and 325). In total, seventy-one plates were

81 *The Holy Family.*
Oil on canvas, 195·6 × 146 cm. Exhibited at the Poets' Gallery, 1789.
The Trustees of the Tate Gallery, London.

published during the 1790s by Macklin for the Bible, after works by artists
– mostly of a younger generation – including Thomas Stothard (1755–
1834), Angelica Kauffman (1740–1807), William Hamilton (1750/1–
1801), John Opie (1761–1807), Richard Cosway (1742–1821), Henry
Fuseli (1741–1825), and Philippe Jacques de Loutherbourg (1740–1812)
who contributed no fewer than twenty-two paintings (Boase, 1963,
pp. 164–9). As Boase pointed out, there was no attempt to produce an
even spread of subject matter in Macklin's Bible – a factor which suggests
that artists were left to their own devices (*ibid.*, p. 165). Indeed, the lack of
any coherent programme in the formulation of the Bible, together with
the fact that the other paintings in the Bible post-dated Reynolds's con-
tribution, suggests that the scheme may have sprung from Macklin's
decision to purchase Reynolds's *Holy Family* in 1788 rather than any
predetermined plan.

Reynolds's *Holy Family* was engraved by William Sharp in 1792 (an
advertisement designed to attract potential subscribers having appeared in
the Poets' Gallery catalogue in 1789).[13] *The Holy Family* was exhibited at
Macklin's gallery in the spring of 1789. The following spring *The World*
reported that the 'fame of Sir Joshua's *Holy Family* in the Poets' Gallery has
made its way to the Palace – we hear it is in contemplation immediately
after the birthday to gratify the Princess Royal (who is an amateur) with
a view of this *boast* of the English School' (19 April, 1790). Although it
appears to have been exhibited once more in 1791, *The Holy Family* was
not included in Macklin's catalogue of paintings in 1792 or 1793. The
reason, as far as one can tell, was that by 1792 (probably after Reynolds's
death) Macklin had not only made a print from the painting but had sold
it to Sir Peter Burrell for 700 guineas – making a profit of 200 guineas on
the painting, in addition to the revenue which he could expect from sales
of the print. Burrell bequeathed *The Holy Family* to the National Gallery in
1829, although – as a contemporary report indicates – within ten years it
was already a wreck.[14]

On 20 June 1789, *The Morning Post*, in a review of the 'Gallery of the
Poets', had stressed the role played by Macklin in supporting the rise of
subject painting in England. By this time, however, Macklin's venture had
been overshadowed by Boydell's more prestigious Shakespeare Gallery,
which had opened its doors for the first time, two months earlier, on
4 May, at newly constructed premises on Pall Mall. According to William
Hayley the concept of a 'Shakespeare Gallery' was first suggested by
George Romney to John Boydell at the painter's home in Cavendish Square
(see Hayley, 1809, p. 106). The scheme was subsequently discussed at a

dinner held on 4 November 1786 at the home of Boydell. Among those present were the publisher George Nicol, the poet and biographer (and sometime patron of William Blake) William Hayley, as well as the artists George Romney, Paul Sandby, and Benjamin West.[15] The original plan was relatively modest, for, as Winifred Friedman has observed, 'the Boydell scheme may be regarded as a grandiose elaboration on what was basically a project to publish a new illustrated edition of the text' (1976, pp. 23–4). Reynolds, although he knew Boydell, was not a particular friend of any of those who attended the Shakespeare Gallery dinner. (Although there is no firm evidence for the assertion, Allan Cunningham later claimed that Reynolds was so disturbed by the threat Romney presented to his own portrait practice that he referred to him tersely as the 'man in Cavendish Square' (Cunningham, 1879, vol. II, p. 173).[16]) Reynolds's cooperation was, however, considered to be vital for the success of the project, and by the end of November Boydell had evidently persuaded him to join the venture. On 28 November Edmond Malone wrote to Thomas Percy informing him that Reynolds, whom he had dined with the previous evening, had agreed to paint a scene from *Macbeth* (Tillotson, 1944, p. 47; also quoted in Hilles, 1952, p. 160). Early in December Boydell placed an advertisement in the newspapers promoting the Shakespeare Gallery. Here Reynolds was described as 'Portrait-Painter to his Majesty, and President of the Royal Academy'. On 8 December, Reynolds sent Boydell a curt note: 'Sir Joshua Reynolds presents his Compts. to Mr. Alderman Boydell. He finds in his Advertisement that he is styled Portrait Painter to his Majesty, it is a matter of no great consequence, but he does not know why his title is changed, he is styled in his Patent Principal Painter to His Majesty' (in Hilles, 1929, p. 170). The mistitling of the post must have been especially galling to Reynolds given that the Shakespeare Gallery was dependent on the talents of history painters rather than portraitists.

On 5 December, *The Times* reported that plans for the Shakespeare Gallery had been put to George III. 'The President', it stated, 'ever forward in a cause like the present, has chosen the scene of the Incantation for the display of his powers.' Reynolds was not, however, in any sense 'forward' in Boydell's scheme. It was only through the sheer persistence of Boydell and his editor Steevens, backed up by the lure of hard cash, that Reynolds agreed to contribute, as the following letter, sent by Reynolds to Boydell a few months before his death, reveals:

This picture [*Macbeth*] was undertaken in consequence of the most earnest solicitation on his [Boydell's] part, since, after Sir Joshua had twice refused to engage in the business, on the third application Mr. Boydell told him that the success of the whole scheme depended upon his name being seen amongst the list of the performers.

Thus flattered, Sir Joshua said he would give him leave to insert his name as one of the artists who had undertaken to paint for him, and that he would do it if he could; at the same time he told him in confidence that his engagement in portraits was such as to make it very doubtful. He recommended to his consideration whether it would be worth his while to give so great a price as he must demand, that though his demand should not be in any proportion to what he got by portrait painting, yet it would be still more than probably he would think proper to give. To this it was answered that the price was not an object to them, that they would gladly give whatever Sir Joshua should demand, adding that it was necessary that they should be able to declare that Sir Joshua was engaged and had received earnest. Bank bills to the amount of £500 were then laid on the table. To the taking of this Sir Joshua expressed great unwillingness, as it seemed to change his lax and conditional promise into a formal obligation. Sir Joshua, however, took the money, but insisted on giving a receipt that the money should be returned if the picture should never be finished.

A few days after this Mr. Boydell, suspecting Sir Joshua's delay, at his own expense sent to Sir Joshua's a canvas measuring nine feet by twelve, the largest that had ever been in his house. (Hilles, 1952, pp. 162–3)

Reynolds's reluctance to comply fully with Boydell's insistent wishes is revealed also by a notice which appeared on 9 January 1787 in *The Morning Herald* (and which Reynolds no doubt instigated): 'Sir Joshua, we are assured, has made no formal promise of his aid to any of the works now carrying on by subscription. His name is inserted in the list of artists, merely on the score of some scenes from Shakespeare, which he has sketched at the desire of a nobleman a few years since.'[17] That being said, on 13 January John and Josiah Boydell and George Nichol drafted an extensive advertisement for the Shakespeare Gallery, which appeared two days later in *The Public Advertiser*. It announced the first four 'Numbers' – or sets of prints – to be published. Number II contained four plates, the last of which was Act IV, a scene from *Macbeth*: 'A Cavern. A cauldron blazing. Macbeth, Hecate, Witches, Shadows of the Eight Kings, Banquo, &c, &c. Painted by Sir Joshua Reynolds. Engraved by Sharp.' Number III was to include an illustration from Act III, Scene iv of *Hamlet*: 'The Queen's Closet. Hamlet, Queen, and Ghost. Polonius dead. Painted by Sir Joshua Reynolds. Engraved by Caroline Watson.' Aside from Reynolds, the other artists engaged to produce works for the Shakespeare Gallery were

James Barry, Henry Fuseli, Angelica Kauffman, James Northcote, John Opie, John Francis Rigaud, Benjamin West, and Joseph Wright. While the advertisement informed potential subscribers that all these artists were 'decisively agreed with, and have chosen Scenes on which their various Abilities are to be exercised', it added that 'respecting even the first Number of this Undertaking, all the pictures remain to be executed'. Reynolds, as we shall see, never completed *Macbeth and the Witches*. *Hamlet*, according to Northcote, 'was never even begun' (1818, vol. II, p. 233). And yet, it is worth remembering that as early as 1752 Reynolds had noted in his sketch book in the Scuola di S. Rocco in Venice 'The Christ in the White Sheet... will serve extremely well for the apparition that comes to Brutus' (Binyon, 1902, vol. III, p. 217, fol. 53). And, moreover, he had made a drawing in another sketchbook of that very scene from the end of Act IV of Shakespeare's *Julius Caesar* (see sketchbook, Fogg Museum, Harvard ac. no. 1919-560, fol. 31v).

On 7 February at 5 p.m. the word 'Shakespear' appeared in Reynolds's sitter-book, suggesting either a meeting with Boydell, or business connected with his contribution to the Shakespeare Gallery. Less than a week later, on 13 February, Reynolds wrote to the Duke of Rutland, with surprising enthusiasm:

the greatest news relating to virtu is Alderman Boydel's [*sic*] scheme of having pictures and prints taken from those pictures of the most interesting scenes of Shakespear, by which all the painters and engravers find engagements for eight or ten years; he wishes me to do eight pictures, but I have engaged for only one. He has insested [*sic*] on my taking earnest mony [*sic*], and to my great surprise left upon my table five hundred pounds – to have as much more as I shall demand.

I have enclosed Boydel's proposals and my last discourse, which I hope will meet with your Grace's approbation. (in Hilles, 1929, pp. 174–5)

Reynolds had known Boydell since the 1750s, when he had been making a living principally through the import of continental engravings. By the 1780s Boydell had completely transformed the English print market, and was exporting vast quantities of British prints to Europe. His apparent ability to combine his own business interests with the promotion of contemporary British art is underlined by an article which appeared in *The World* on 3 February 1787 – shortly after he had induced Reynolds to participate in the Shakespeare Gallery. The piece – almost certainly sponsored by Boydell – was entitled 'FINE ARTS – Applying to Trade'. While it noted the benefit of Boydell's scheme for a Shakespeare Gallery to British subject painting, it had a more specific aim which related more

directly to Boydell's own business interests. At the time Boydell was lobbying George III (whose government was currently negotiating a trade agreement), to encourage the Portuguese to lift their embargo on the importation of English prints. Boydell's petition, argued *The World*, was in the interests not only of British art but of the British economy:

For valuable prints, the supply of Great Britain was till very lately, from abroad. The *balance* is now turned entirely in our favour; for with our immense exports in the print trade – the *imports* of *last year*, were less than a hundred pounds. If we copy our correspondents figures without a fault, no more than *sixty three pounds* and a fraction of shillings.

There was an inherent disparity between the aims of Boydell and Reynolds. Both men wished to promote the British School, although Boydell's means of achieving it, through the export of British prints to the Continent at the expense of the importation of European prints, undermined Reynolds's commitment to a supranational artistic community, while at the same time emphasizing what had always been anathema to Reynolds – that art was a commodity. Since the early 1770s Boydell had been lending support to works of art with prominent nationalistic themes.[18] In January 1776 he had published William Woollett's engraving of West's *Death of General Wolfe*, while in 1781 he commissioned Copley's *Death of Major Pierson* (Tate Gallery) for £800, subsequently exhibiting it with Copley's *Death of Chatham* at the Great Room, Spring Gardens, daily from 8 a.m. to midnight, at 1 shilling admission. Boydell's principal means of recouping his financial outlay was not admission money, but the sale of prints after the pictures. As Winifred Friedman has noted, Boydell's seminal role in promoting English history painting has consistently been underestimated. None the less, Boydell ensured that his contribution was not lost on contemporaries. On 5 May 1789 *The Morning Post* declared Boydell's Gallery to be:

a treasure of graphic excellence, in the highest degree creditable to BRITISH GENIUS ... The enterprising proprietor of these admirable works has done much for THE ARTS, and they in return will do much for him; for by his spirit and taste, an ENGLISH SCHOOL for HISTORICAL PAINTING will be established and will keep his name in perpetual remembrance and regard.[19]

That Boydell, a mere print publisher, should be promoted as the progenitor of high art within the 'English School' must have perturbed Reynolds. According to Charles Robert Leslie, Reynolds considered it to be 'below the dignity of the Arts thus to enter into the service of speculation', while James Northcote – who had himself contributed to the Shakespeare

Gallery – put it more bluntly, stating that Reynolds 'thought it degrading himself to paint for a print-seller' (Leslie and Taylor, 1865, vol. II, p. 501). Reynolds had always regarded himself as the artistic superior of print-makers and publishers, having been among those founders of the Royal Academy who effectively prevented engravers from attaining the rank of Royal Academician.[20] Moreover, Reynolds – unlike West or Copley – had never considered taking profits from engravings after his works. As David Alexander has noted, although 'thousands of prints had been made of Reynolds's paintings...he had not made any money out of this: it was enough that prints should spread his fame' (David Alexander in Cannon-Brookes, 1991, pp. 31–2). None the less Reynolds was acutely aware that the Shakespeare Gallery was not initiated simply to fuel British artists' aspirations towards high art. He set out his feelings on the subject in his draft of the letter sent to Boydell in December 1791 concerning the dispute over the ownership of *Macbeth*:

Mr Boydell says he should be sorry to see Sir Joshua the only painter that does not co-operate with him, by giving up part of their profit to the greater national object of introducing a taste for historical painting.

One would wish to ask if any profit is like to proceed from this scheme. If there is, it is but reasonable that the co-operators with Mr. Boydell ought to have a share besides that of the honour of being patrons and promoters or co-operators of this public good. It is supposed that Mr. Boydell will acquire a considerable fortune by his patronage of the arts, and as he acknowledged that the living painters have been his co-adjutors, it seems but reasonable that they should share the profit.

As for the co-operation of the artists with Mr. Boydell in this national scheme, if those artists have been persuaded by Mr. Boydell to work for him at an underrate, to act justly Mr. Boydell ought to allow them a share of the profit which it is supposed he will gain by this scheme. It is certainly unreasonable to make the artists themselves be at the expense, whilst Mr. Boydell runs away both with the honour and profit. (in Hilles, 1952, pp. 163–4)

In the event, Reynolds did not send this section of the letter to Boydell (it was only first published by Frederick Hilles in 1952). Nevertheless, the passage underlines emphatically the deep suspicion with which Reynolds viewed the motives of the 'modern Maecenas', and goes a long way towards explaining why *Macbeth and the Witches* remained in Reynolds's studio until his death.

A catalogue accompanying the inaugural exhibition at the Shakespeare Gallery was published in 1789. 'To advance the art towards maturity', it claimed, 'and establish an *English School of Historical Painting*, was the great object of the present design.' Exactly what the 'English School of

Historical Painting' comprised was suggested in an 'unofficial' commentary on the Shakespeare Gallery, entitled *The Bee*. Its author, Humphry Repton (1752–1818), is better known today as a landscape gardener than an art critic. Repton's initial reputation, however, was established as a writer, in which he had been encouraged by both Burke and Reynolds, who expressed admiration for the manuscript of a comedy he had recently written.[21] As Repton stated in the preface to *The Bee*, although his original intention had been to write a commentary on the Royal Academy exhibition, he subsequently decided that the Shakespeare Gallery provided greater scope for constructive criticism. Repton regarded the Shakespeare Gallery as innovative and 'modern', and contrasted its content with more traditional iconography found in subject paintings at the Royal Academy:

Those of the ancient schools, being chiefly taken from the Sacred Writings, have not only a sameness, but often contract a degree of ridicule which weakens their effect, by daring to represent what are not properly objects of sight: these, on the contrary, illustrate scenes with which we are all acquainted – events in which we all participate – and subjects that touch the heart, and 'come home to men's bosoms'.

'Through *Shakespeare*'s soul', he continued, 'the GENIUS of BRITISH POETRY poured forth the most wondrous effects of the Pen; and by the same channel, the GENIUS of BRITISH PAINTING now displays the choicest Production of the Pencil' (1789, p. 5). Just as classical myths like *The Infant Hercules* appeared 'threadbare' to Walpole, their religious equivalents were meaningless to Repton compared to Shakespeare's imagery, which portrayed 'events in which we all participate' (*ibid.*, p. 6).

Repton's essentially Protestant, secular aesthetic did not represent an isolated viewpoint, but was typical of the jingoistic sentiments aroused by the Shakespeare Gallery – as reflected, for example, in John Taylor's verses 'On the magnificent edition of Shakespeare published by the Boydells':

> Where, nobly fir'd with emulative rage,
> PAINTING illumes her tuneful sister's page,
> And gives a vivid omen of the day
> When British Arts shall full lustre display,
> Nor longer humbly yield to ages past,
> But spread a richer radiance that shall last.
> The patriot impulse from the BOYDELL's came,
> Whose fost'ring aid sustain'd the rising flame;
> And hence with SHAKESPEARE shall they proudly stand,
> Protected by the Genius of the Land. (1811, p. 23)

82 *Puck.*
 Oil on panel, 101·6 × 81·3. Exhibited at the Royal Academy, 1789 (and
 subsequently at the Shakespeare Gallery, 1789). Executors of the tenth
 Earl Fitzwilliam.

Repton's prose and Taylor's poetry anticipate the more strident objections made to traditional conventions of high art by Allan Cunningham some forty years later (to be discussed in the final chapter). And yet unlike Cunningham, who turned on Reynolds as a peddler of foreign – and therefore false – ideals, Repton maintained an orthodox respect for the president of the Royal Academy.

Reynolds had initially agreed to produce one painting for Boydell – the aforementioned scene from *Macbeth* (although, as he told the Duke of Rutland, Boydell had wanted him to produce as many as eight). And although it had been commissioned in late 1787, Reynolds appears to have made no effort to finish *Macbeth and the Witches* in time for the 1789 exhibition at the Shakespeare Gallery, even though – as we have seen – he frequently hurried to finish subject paintings in time for exhibition at the Royal Academy. Reynolds did, however, complete two other Shakespearean subjects for Boydell – *Puck* (plate 82) and *The Death of Cardinal Beaufort* (plate 83). The circumstances surrounding their production suggest that Reynolds did not put himself out unduly for Boydell. According to Leslie and Taylor, *Puck* was modelled on the son of William Cribb, Reynolds's frame-maker. As an adult, Cribb junior – then a picture-dealer – repeated his father's claim that 'Sir Joshua, calling at the shop one day on business, was struck by the baby's arch, roguish physiognomy, and begged it might be brought to Leicester Fields to help him in his Puck' (in Leslie and Taylor, 1865, vol. II, p. 504). A more credible account of the painting's genesis was recounted by the grandson of George Nicol:

Alderman Boydell and my grandfather were with Sir Joshua when painting the Death of Cardinal Beaufort, for the Shakespeare Gallery. Boydell was much taken with the portrait of a naked child, and wished it could be brought into the Shakespeare. Sir Joshua said it was painted from a little child he found sitting on his steps in Leicester Fields. My grandfather then said, 'Well, Mr. Alderman, it can very easily come into the Shakespeare, if Sir Joshua will kindly place him on a mushroom, and give him fawn's ears, and make a Puck of him.' The infant son of Cribb, his frame-maker, was one of his models, and is still living. (*ibid.*, p. 536, n. 1)[22]

In his eagerness to gain Reynolds's participation Boydell had evidently cast around Reynolds's studio for anything that might be adapted towards his own scheme, in the same way that Macklin had eagerly incorporated *Tuccia* into the Poets' Gallery. Boydell's interest in obtaining *Puck* for the Shakespeare Gallery may also have been prompted by Reynolds's slowness in completing his more ambitious commissions for the gallery. Boydell

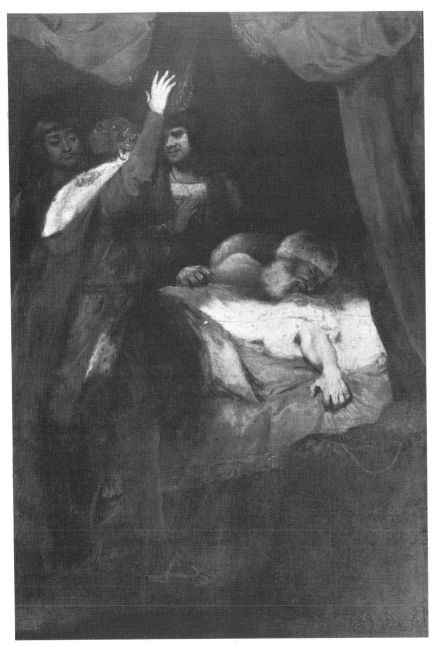

83 *The Death of Cardinal Beaufort.*
 Oil on canvas, 248·5 × 142·3 cm. Exhibited at the Shakespeare Gallery,
 1789. National Trust, Petworth House.

paid Reynolds 100 guineas for *Puck* in June 1789, even though Reynolds had by then put the painting on display at the Royal Academy. In view of the nature of the criticism directed towards *Puck* at the Royal Academy, Boydell may have had cause to regret his decision. *The Morning Post* stated (1 May 1789):

ROBIN GOODFELLOW – Sir J. REYNOLDS R.A. Beyond the merit of fine colouring this picture has no claim to praise, but is rather disgusting, as it seems to be a portrait of a *foetus* taken from some anatomical preparation. It is really offensive, and we wonder the taste and feeling of this admirable artist should ever have been employed on such a subject. The *toad-stool* on which this praeternatural infant is sitting, is one of such disproportionate magnitude, that it seems to have been brought from *Brobdingnab* for the occasion, particularly as the trees are very small.

Fuseli, who was later to produce his own version of the same character (Tabley House Collection), was not convinced either by Reynolds's improvisation. 'This is', he stated, 'a fairy whom fancy may endow with the creation of a midnight mushroom, a snow drop, or a violet; but he surely cannot be mistaken for the Robin of Shakespeare or Milton' (*The Analytical Review*, May–August 1789, vol. 4, p. 106).

As Nicol's grandson noted, the purpose of Boydell's visit to Reynolds's gallery had originally been to inspect the painting which Reynolds was to exhibit at the inaugural exhibition at the Shakespeare Gallery, *The Death of Cardinal Beaufort*.[23] And although it is not known exactly when Reynolds agreed to produce the work for Boydell, as with *Puck*, circumstances suggest that the picture was based on a design which Reynolds had already begun previously. (Northcote maintained that *Puck* was based on a figure taken from Correggio (Gosse, 1879, p. 135).) On 27 December 1788 *The World*, which, as we have seen, made frequent reports on paintings-in-progress in Reynolds's picture gallery, reported: 'Sir Joshua's transcendent work of Cardinal Beaufort was one of his earliest designs. It was resumed entirely at his own impulse. Mr. Boydell has bought it and to fit it for his undertaking, the Canvas is enlarged.' Across the centre of Reynolds's painting – just above the elbow of the figure of the cardinal – a long horizontal line is faintly visible, although it does not appear to be connected with any enlargement Reynolds might have made to a smaller picture. (An examination of the back of the painting may, however, reveal seams invisible to the naked eye.) Even so, the reference by *The World* to *The Death of Cardinal Beaufort* being 'one of his earliest designs' is of considerable interest given the comment in *The Morning Herald* in January 1787 (noted earlier in the chapter) that Reynolds had

agreed to appear on Boydell's advertised list of artists 'merely on the score of some scenes from Shakespeare, which he has sketched at the desire of a nobleman a few years since'. *Cardinal Beaufort* was probably one such design, as the existence of a large unfinished oil sketch of *The Death of Cardinal Beaufort*, bought by Thomas Holcroft in Reynolds's 1796 studio sale (although since destroyed) suggests.[24] (The aforementioned sketch from *Julius Caesar* may have been another.) Of about the same width as the finished painting, although half its height, the sketch of *The Death of Cardinal Beaufort* depicted the cardinal in a similar attitude to that shown in the finished picture (although the subordinate figures are less easy to discern). Shakespeare's *Henry VI* was not, as far as it is known, performed on the London stage during Reynolds's career (see Schiff, 1973, vol. I, cats. 638 and 440, vol. II, p. 105). It had, however, been the subject of at least one British artist (albeit a naturalized one) before Reynolds. A pen-and-ink sketch of the death of Cardinal Beaufort had been sent from Rome by Henry Fuseli to the 1774 Royal Academy exhibition. Fuseli, who repeated the design with variations on several occasions, was evidently influenced by Poussin's *Death of Germanicus* (see Broun, 1987, vol. II, pp. 212–13; Blunt, 1966, p. 114, cat. 23). And, indeed, it was the same work which provided the compositional source – albeit far more literally – for Reynolds's own version of *The Death of Cardinal Beaufort*. Fuseli's drawing, like Poussin's painting – and Reynolds's oil sketch – was horizontal in format. Given the intimacy of Reynolds and Fuseli by the 1780s, it is quite possible that Reynolds had been influenced by Fuseli's earlier drawing, as well as Poussin's original design (an oil sketch of which Reynolds owned).

Reynolds's painting and Fuseli's drawing were based upon lines from the third Act of *Henry VI, Part 2*, towards the end of Scene iii:

> KING HENRY: O thou eternal Mover of the heavens!
> Look with a gentle eye upon this wretch;
> O! beat away the busy meddling fiend
> That lays strong seige unto this wretch's soul,
> And from his bosom purge this black despair.
> WARWICK: See how the pangs of death do make him grin!
> SALISBURY: Disturb him not! let him pass peaceably.
> KING HENRY: Peace be to his soul, if God's good pleasure be!
> Lord Cardinal, if thou think'st on heaven's bliss,
> Hold up thy hand, make signal of thy hope.
> He dies, and makes no sign. O God, forgive him!

William Mason, who watched Reynolds work on the painting, provided among the most memorable accounts of Reynolds's idiosyncratic method:

He had merely scumbled in the positions of the several figures, and was now upon the head of the dying Cardinal. He had now got for his model a porter, or coal heaver, between fifty and sixty years of age, whose black and bushy beard he had paid for letting grow; he was stripped naked to the waist, and with his profile turned to him, sat with a fixed grin, showing his teeth. I could not help laughing at the strange figure, and recollecting why he had ordered the poor fellow so to grin, on account of Shakespeare's line:

> Mark how the pangs of death do make him grin.

I told him, that in my opinion Shakespeare would never have used the word 'grin' in that place, if he could have readily found a better ... He did not agree with me on this point, so the fellow sat grinning on for upwards of one hour, during which he sometimes gave a touch to the face, sometimes scumbled on the bedclothes with white much diluted with spirits of turpentine. After all, he could not catch the expression he wanted, and, I believe, rubbed the face entirely out; for the face and attitude in the present finished picture, which I did not see till above a year after this first fruitless attempt, is certainly different, and on an idea much superior. (in Cotton, 1856, pp. 56–7)[25]

Seventeen years earlier, in his fourth *Discourse*, of 1771, Reynolds had firmly cautioned against the invention of facial expression in history painting, stating that the 'joy, or grief of a character of dignity is not to be expressed in the same manner as a similar passion in a vulgar face'. He went on to censure Bernini's *David* (Rome, Borghese Gallery), where the sculptor, mistaking 'accident for generality' had showed the figure biting his lower lip (Wark, 1975, p. 61). Now, in the grimacing face of Cardinal Beaufort, Reynolds had apparently made a similar transgression. An explanation (if not a vindication) of Reynolds's conduct can be found in a fragmented essay the artist wrote on Shakespeare, and which remained unfinished and unpublished at his death (see Hilles, 1952, appendix I, pp. 107–22).

As Hilles pointed out, Reynolds had first published criticism on Shakespeare as early as 1765, when he had appended five notes to the eighth volume of Samuel Johnson's *Plays of William Shakespeare* (*ibid.*, p. 107). Since then he had also published short notes on *Lear* and *Macbeth* in Edmond Malone's 1780 supplement to the 1778 edition of Johnson's *Shakespeare* (see Hilles, 1936, pp. 27–9, 69, 98–105). His earlier essay was, however, more wide-ranging. And in a defence of Shakespeare's tragi-comedy it emerges that a combination of 'the grandeur of general ideas with the familiar pathetic' – which he had been unable to countenance in Bernini's *David* – was permissible in Shakespeare. Indeed, he argued that it was precisely because Shakespeare had broken rules and

followed his own often unorthodox bent that he had succeeded. In a preliminary note to the essay he called into question art which merely followed set rules:

Art has a wonderful propensity to insipidity. A regular system is not so pleasant as a desultory observation ... *Cato* is cold; Shakespeare the contrary. Art in its most perfect state is when it possesses those accidents which do not belong to the code of laws for that art. Poussin is too artificial in his draperies, perhaps in the whole. Carlo Maratti the same. Raphael's right taste makes him introduce accidental folds etc. (in Hilles, 1952, pp. 108–9)

Reynolds's approach – shaped by ideas which he had imbibed from Burke – reflected contemporary opinion both in England and in Europe on the correlation between genius and the Sublime (Burke, 1757; see also Monk, 1960; Shawe-Taylor, 1987; Murray, 1989). As Diderot had stated in the *Encyclopaedia*: 'To be of genius it must sometimes be careless and have an irregular, rugged, savage air. Sublimity and genius in Shakespeare flash like streaks of lightning in a long night' (quoted in Honour, 1981, p. 146). The image of Cardinal Beaufort, who grins in the throes of death, sets out to exemplify 'those accidents which do not belong to the code of laws for that art', as Reynolds attempted to mirror the non-classical elements of Shakespeare's genius in his own work. Reynolds also superimposed his own unorthodox improvisation to the picture in the physical shape of a 'fiend' on the pillow of the cardinal – of which more will be said presently.

Reynolds was evidently quite well advanced with *The Death of Cardinal Beaufort* by October 1788, as *The World* reported on the 28th of that month:

There are parts of it, as the left arm and head of the *Cardinal*, far beyond any usual excellence in the Art. But these mechanical beauties are subordinate, when there is such transcendent praise of sentiment and tendency. As one of the greatest efforts of Art applied to the greatest objects in nature *The World* eagerly recommends it.

On 22 December *The World* reported again: 'For the display of Manual Art, Philosophic Analysis and Amending Tendency what work is there superior to Sir Joshua's last work of Cardinal Beaufort?' The following year it was shown in public at the Shakespeare Gallery, where it generated more criticism – and controversy – than any other work on display. Attention was not, however, concentrated on the grinning face of Cardinal Beaufort but on Reynolds's insertion of a small 'fiend' on the pillow, behind Cardinal Beaufort's head. Repton, under his *nom de plume*, 'the Bee', expressed his reservations:

London to speak', commented one newspaper, 'we apprehend that he would pronounce it to be an improper mixture of the sacred and profane; as critics we cannot but think that these figures, like the fiend behind Cardinal Beaufort, had been better implied than expressed' (quoted in Graves and Cronin, vol. I, 1899–1901, pp. 82–4 ('a newspaper' of 20 April 1790)).

A contemporary notice suggested that Reynolds, bowing to pressure from contemporaries, was to 'obliterate his little devil so strangely at work behind Cardinal Beaufort'.[26] Albert Roe has suggested that Reynolds did subsequently make substantial alterations to the painting in order to eliminate the fiend (1971, pp. 467–8). A close examination of the picture, however, reveals that although the fiend is all but invisible to the naked eye, except for its general outline and a claw, there are no signs of major *pentimenti*.[27] Indeed, as Thomas Holcroft was told by William Beechey (who, as a young artist, had been present in Reynolds's studio during the discussion), even Edmund Burke – whose opinion Reynolds respected more than any other – was unable to make his friend budge over the matter:

> Burke endeavoured to persuade Sir Joshua Reynolds to alter his picture for the dying cardinal, by taking away the devil, which Burke said was an absurd and ridiculous incident, and a disgrace to the artist. Sir Joshua replied that if Burke thought proper, he could argue as well *per contra*; and Burke asked him if he supposed him so unprincipled as to speak from anything but conviction? No, said Sir Joshua, but had you happened to take the other side, you could have spoken with equal force. Burke again urged him to obliterate this blemish, saying, Sir Joshua had heard his arguments (which B[eechey] did not respect), and desired to know if he could answer them. Sir Joshua replied, it was thought he had conceived and executed to the satisfaction of himself and many others, and having placed the devil there, there he should remain. (in Hazlitt, 1816, vol. II, pp. 276–7)

When the first state of Caroline Watson's engraving of *The Death of Cardinal Beaufort* was published on 25 March 1790 the fiend was included. The second state, published on 1 August 1792 shows that a rather ineffectual attempt had been made to remove it from the plate (Penny, 1986, p. 320, cat. 148). In 1789 *The Times* (7 May) had voiced the hope that 'the obstinate enthusiasm of the genius that formed this Picture, will be corrected by the mature judgement of *Mr. Boydell*, who possesses it, and that the graver may be permitted to redeem the false taste of the pencil'. The removal of the fiend from Watson's engraving was probably at Boydell's instigation, although he evidently thought it best to wait until

after Reynolds's death to make the requisite alteration. Any attempts to remove the fiend from the painting were also almost certainly made after the artist's death, not only because by October 1789 Reynolds's vision was seriously impaired, but because his pride would not have allowed him to do so.

Reynolds's penchant for demonstrating the unorthodox and irregular qualities of Shakespeare's genius surfaced once more in the artist's largest for Boydell – *Macbeth and the Witches* (plate 84) – which, although it was the first painting he had agreed to paint for Boydell, remained, as we have seen, unfinished at his death. Reynolds was not the first British artist to illustrate the more esoteric aspects of Shakespeare. Earlier in the century both Hogarth and Hayman had painted scenes from *The Tempest*, while in 1750 John Wootton (? 1678–1764), best known for his sporting and landscape paintings, had painted *Macbeth and Banquo Meeting the Weird Sisters* (private collection) – a subject also painted by Francesco Zuccarelli in the 1760s (Stratford, Shakespeare Memorial Gallery).[28] In the early 1780s there had been a resurgence of interest in such subject matter, Horace Walpole noting in 1783 in his Royal Academy catalogue that 'of late, Barry, Romney, Fuseli, Mrs Cosway, and others, have attempted to paint deities, visions, witchcrafts, etc., but have only been bombast and extravert, without true dignity'.[29] Of these artists Fuseli's was the most significant contribution to the genre, not only visually, but intellectually, as he demonstrated more comprehensively than any artist since Hogarth an ability not merely to illustrate but to interpret a literary text. Reynolds's interest in *Macbeth and the Witches*, as a potential subject for a painting, may have stemmed from a meeting of the council of the Royal Academy on 28 January 1780 to decide on the subject for the 'Premium of Gold Medal for a Historical Picture'. As the minute book indicates, the original choice, a scene from *Paradise Lost*, was crossed through and replaced by *Macbeth* – 'what ever scene the student pleases'.

The letter concerning *Macbeth and the Witches*, dictated by Reynolds to his niece, and which was quoted earlier in the chapter, indicates that the size of the canvas on which Reynolds's picture was painted – 'nine feet by twelve, the largest that had ever been in his house' – was determined entirely by Boydell. Reynolds's hesitancy in undertaking the commission is borne out by the fact that he did not finish it, nor was it exhibited during his lifetime.[30] Boydell, on the other hand, was anxious from the beginning that Reynolds should proceed quickly with the painting. The first genuine indication that Reynolds seriously contemplated working on *Macbeth* appeared in a report in *The World* on 29 November 1787, where it was

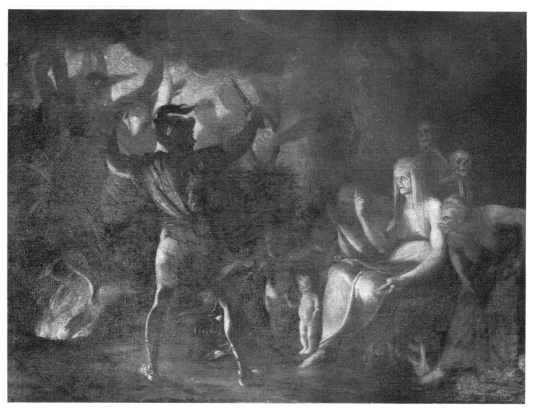

84 *Macbeth and the Witches.*
Oil on canvas, 365·7 × 274·3 cm. 1788–90. National Trust, Petworth House.

stated: 'Sir Joshua is going to begin his *Macbeth* picture for Boydell's Shakespeare. The scene is the Pit of Acheron. The dimensions twenty feet by fourteen.'[31] (A review of Reynolds's sitter-books during the relevant period indicates that he could not actually have given a great deal of attention to *Macbeth and the Witches* before the summer of 1788.) The size of the painting, at least in the memory of the correspondent, had doubled. Nevertheless, the picture was bigger than any Reynolds had ever worked on, including *The Infant Hercules*.

As the survival of a number of related drawings indicates, Reynolds evidently did give some thought to the overall composition of *Macbeth and the Witches* before beginning work on the canvas supplied by Boydell. They include slight pen-and-ink sketches of Macbeth and Hecate.[32] The drawing of Hecate – no more than slight pen-and-ink outline – is close to the figure as she appears in the final painting, although Macbeth differs considerably. Of most interest is a compositional drawing in the collection of Yale University (plate 85). Although it differs from the final composition, the positioning of the main figures is similar, except that the witch dancing around the cauldron is in the centre rather than at the left-hand side. The drawing, unusual in Reynolds's *œuvre*, is more typical of the kind of compositional drawings made by Fuseli and Romney for subject paintings – even though it lacks either Romney's fluidity or Fuseli's vigour. Aside from a sketch for *The Infant Academy* alluded to in an earlier chapter, there are almost no compositional drawings by Reynolds for his more ambitious subject paintings. (An inscription, in a later hand, on the aforementioned drawing of Hecate states that 'Sir Joshua seldom made any sketches with a pencil, or pen, and when he did so, was usually very careful, to destroy them immediately; such sketches therefore and by chance have been preserved on account of their rarity.')

Today *Macbeth and the Witches* is wholly legible only in Robert Thew's engraving of 1802 – the picture itself having darkened considerably over the past 200 years. A number of pictorial sources have been suggested as having provided inspiration for Reynolds. In 1886 William Conway suggested that the composition derived from Jacob Cats's *Book of Emblems*, while more recently Esther Dotson has stated that Reynolds was influenced by Salvator Rosa's *Saul and the Witch of Endor* (Louvre) (Dotson, 1973, p. 161). (Reynolds, as she also noted, owned an *Incantation* by Rosa (*ibid.*, p. 162, n. 156; Brown, 1987, vol. II, p. 57). Individual figures in the painting have also been speculatively linked to various sources. Leslie and Taylor suggested that the attitude of one of the witches was similar to a fiend in Michelangelo's *Last Judgement*, while Nicholas Penny has observed

85 *Study for Macbeth and the Witches*,
Pen, ink, and wash, on paper, 20·1 × 34 cm. *c*. 1788–90. Beinecke Rare Book
and Manuscript Library. Yale University, New Haven, Connecticut.

more generally that 'in physique and physiognomy the witches are derived from Michelangelo's muscle-bound sibyls on the ceiling, and from his devils on the altar wall' (1986, p. 326). The witch on the far right, at any rate, is derived from one of his own earlier creations – the figure of Caliban in his portrait of *Mrs Tollemache as Miranda* (the Iveagh Bequest, Kenwood). The figure of Macbeth, arms outstretched, over the Pit, was – or so Turner interpreted it – reminiscent of Leonardo's *Vitruvian Man* (British Museum, Add. ms. 46151, fol. 109). It may also have itself influenced James Barry's Satan in his 1792 etching *Satan, Sin and Death*, as well as Lawrence's monumental painting, *Satan Summoning up his Legions* (Royal Academy of Arts, London)(see Pressly, 1981, pp. 161–2). Ultimately, as with *The Infant Hercules*, resemblances which *Macbeth and the Witches* bears to other compositions are slight compared to borrowings effected in his portraits, and in earlier subject pictures.

As Esther Dotson has observed, by the late eighteenth century there was a significant change in the attitude towards the role of the witches in *Macbeth*. From about 1720 to 1760 producers and critics had been unwilling to integrate the witches with the 'real' characters in the play. Consequently, they were presented separately from the main drama, as a *divertissement*, performing comic dances with broomsticks and singing songs. Later in the century, however, they were taken more seriously, and were regarded, as they had been in the seventeenth century, as 'sublime' creatures.[33] According to Dotson, artists 'were turning their attention from the merely picturesque aspect of the scene to its function in the revelation of character, from the paraphernalia of the savage landscape and the weirdness of its supernatural inhabitants to the direct analysis of the characteristic reactions of Macbeth and Banquo' (1973, p. 169). Henry Fuseli, she concludes, epitomized the more innovative attitude towards characterization, while Reynolds, by way of contrast, represented the views of an older generation. It is a thesis which deserves further consideration in view of the mutual influence which the two artists exerted on each other during the 1780s.

Dotson accounts for Reynolds's treatment of *Macbeth and the Witches* in terms of his own theory of the 'original or characteristical' style as set out in the *Discourses* of the early 1770s, and as exemplifed in Reynolds's attitude towards the art of Salvator Rosa (see Wark, 1975, pp. 84–5). She contends further that because Reynolds adhered to the conventional view that 'the witch scenes are irregularities in the drama, admirable for their picturesque wildness but distinct from the universal appeal of a heroic or tragic action', he adopted a Salvatoresque style in *Macbeth and the Witches*

(Dotson, 1973, p. 178). Fuseli, on the other hand, eschewed narrative detail in favour of a starker, pared down, image where the hero is captured 'at a moment of revelation', and thus established a new hierarchy of styles which supplanted those upheld by Reynolds. In order to support the theory, Dotson quotes from Fuseli's Royal Academy lecture on 'Invention', which discusses how best to handle such a scene:

It is not by the accumulation of infernal or magic machinery, distinctly seen, by the introduction of Hecate and a chorus of female demons and witches, by surrounding him with successive apparitions at once, and a range of shadows moving above or before him, that Macbeth can be made an object of terror, – to render him so you must place him on a ridge, his down-dashed eye by the murky abyss; surround the horrid vision with darkness, exclude its limits, and sheer its light to glimpses. (Wornum, 1848, p. 456, quoted in Dotson, 1973, pp. 176–7)

'Hardly concealed in this passage', states Dotson, 'is a condemnation of Reynolds's *Macbeth at the Witches Cavern.*'

While it is possible that Fuseli had Reynolds's painting in mind, the fact remains that the passage is immediately preceded by a warm endorsement by Fuseli of Reynolds's skill in combining his portrait figures with appropriate landscape backgrounds (Wornum, 1848, p. 543). Also, *Macbeth and the Witches* is closer to Fuseli's own work than any other painting Reynolds produced. Indeed there are close formal ties between Reynolds's painting and *Titania's Awakening* (Winterthur Museum, Zurich), which Fuseli was then also painting for the Shakespeare Gallery – both works depicting a series of fantastical creatures in various shapes and sizes emerging from a dark void (Schiff, 1975, cat. 28 and p. 21, reproduced). Although Reynolds's *Macbeth and the Witches*, in its simultaneous presentation of successive images, does not match up to Fuseli's ideal, there are aspects of the picture which correspond with them. Macbeth, for example, who stands on a ridge, is certainly enveloped in limitless darkness, nor can (even allowing for the picture's deterioration) the 'magic machinery' be clearly seen. Reynolds's painting does not typify the tradition of Salvator Rosa, whose approach is far more clearly echoed in the work of Wilson, Loutherbourg, or Wright of Derby. Far nearer in spirit, as Northcote observed, was the incandescent gloom of Titian's *Martyrdom of St Lawrence* (Northcote, 1818, vol. II, pp. 227–8). Finally, Reynolds had already, in earlier works such as *Ugolino and his Children in the Dungeon* and *The Death of Dido*, promoted a style where a concentration upon the passions or emotions of the protagonists supplanted the rendering of narrative. Fuseli, as his own painting of *The Death of Dido* reveals, was

highly influenced by Reynolds even though he wished to intensify its epic quality. The difference between Reynolds and Fuseli was therefore one of degree rather than a direct contrast.

Macbeth and the Witches was among the last paintings on which Reynolds was working before his deteriorating eyesight compelled him to stop painting. On 13 July 1789 he noted in his sitter-book 'prevented / By my Eye beginning to be obscured'. Just over two weeks later, on 1 August, *The Morning Post* stated: 'Sir Joshua Reynolds is at present indisposed. His great attention to his art has considerably impaired his eyes.' A month later, on 1 September, it was reported: 'Sir Joshua's unfinished works. The Macbeth for Boydell's Shakespere [*sic*]. This grand picture is almost finished; the material parts, the countenances, figures, are quite complete; a little work wanting in the draperies' (quoted in Graves and Cronin, 1899–1901, vol. III, p. 1171). And on the same day, in the context of Reynolds's loss of sight in one eye *The Morning Post* observed that 'Macbeth will probably remain for ever in its present *visionary* state, the head of Hecate is as fine as possible.'

In the event the painting was not released by Reynolds to Boydell. It remained in his studio and subsequently became the subject of litigation. On 15 December 1791, barely two months before his death, Reynolds, although almost completely blind and in great physical pain, wrote to Boydell – in the letter already referred to earlier in this chapter – with a proposal to settle the matter:

Sir Joshua proposes ... that a select number of artists, or of connoisseurs, with the assistance of some eminent counsellor, shall determine the business by arbitration. The question Sir Joshua apprehends to be whether he can make it appear that he could have got two thousand pounds if he had employed the time in portrait-painting which was employed on that picture (though Sir Joshua demands only fifteen hundred pounds for that picture). (in Hilles, 1952, p. 163)

Reynolds had originally accepted £500 from Boydell to accept the commission for *Macbeth and the Witches*. Clearly he did not regard this as a final fee, but a down-payment. At least one newspaper, which carried a report on Reynolds's health in January 1792, took the president's side in the dispute:

Sir Joshua Reynolds is again recovering; he has regained the use of one eye, enough to see that he is not likely to have fair play in the *Shakespeare Gallery*, without the aid of *John Doe*! A curious pictorial case will soon be brought upon canvas in Westminster Hall, SIR JOSHUA REYNOLDS on the part of Macbeth & Co. Plaintiff, and Mr. Alderman BOYDELL and firm Defendants. The action is to recover

1,500 guineas for a picture, said to be painted per order, for the *Shakespeare Gallery*. (in Graves and Cronin, 1899–1901, vol. III, p. 1171; see also Hilles, 1952, p. 164)

In the event the matter was settled out of court after Reynolds's death, when a price of 1,000 guineas was agreed between Boydell and the artist's executors (Hilles, 1952, p. 164).

7 'That ever living ornament of the English School': Reynolds's subject pictures, 1792–1830

Twelve years before Reynolds's death in February 1792, Mrs Hester Thrale made the following entry in her diary:

Mr. Johnson's criticism of Gray displeases many people: Sir Joshua Reynolds in particular: he professes the Sublime of Painting I think, with the same affectation as Gray does in Poetry, both of them tame quiet Characters by Nature, but forced into Fire by Artifice & Effort: the time will come when some cool Observer will see, or some daring Fellow venture to say of Sir Joshua's Ugolino; all that Johnson has been telling of Gray's Bard. (5 October 1780, in Balderston, 1942, vol. I, pp. 459–60)

Mrs Thrale's comparison of Gray and Reynolds was a valid one, for Gray's characters were often influenced by a variety of pictorial prototypes. His 'Bard' for example was a conflation of Raphael's image of God in the *Vision of Ezekiel* (Florence, Pitti Palace) and Parmigianino's *Moses* from S. Maria della Steccata in Parma (Hagstrum, 1958, pp. 306–14). Reynolds, who referred to Gray as 'our great lyric poet', was aware of the pictorial sources for *The Bard*, noting in his final *Discourse* how Gray had 'warmed his imagination with the remembrance of this noble figure of Parmigianino' (in Wark, 1975, p. 271 and n.). In general the artistic traditions which Gray admired were those which Reynolds later espoused. As John Butt has observed, 'Gray's beings are not fantastic, fairy creatures; instead they have the static composure and appropriateness of figures in the Bologna school of painting' (1979, p. 73). Less positively, Johnson's adverse criticism of Gray was also relevant, because a number of the reservations which he expressed about *The Bard* and his other epic poems, were typical of the kind of comments which Reynolds's own history pictures attracted – particularly after his death. Johnson, having complained in the *Lives of the Poets* that Gray's 'art and struggle' are too visible', stated of his epic work: 'though either vulgar ignorance or common sense at first universally rejected them, many have since been persuaded to think themselves delighted' (Hill, 1905, vol. III, p. 440).

Mrs Thrale's private comments form a useful starting point for a discussion of the nature of Reynolds's posthumous reputation in the years following his death, as it highlights several important issues. Firstly, she

perceived that Reynolds's reasons for making history paintings were guided by specific dogmas and were dictated by circumstance rather than a spontaneous passion for the genre – 'A Rage for Sublimity ill understood', as she described it elsewhere.[1] Secondly, she recognized that although Reynolds's history paintings commanded general respect, it was generated more by the biased enthusiasm of the artist's supporters, than genuine admiration. Finally – and most perspicaciously – she realized that future critics, free from the restraints imposed by current trends, would debunk Reynolds's works in the same way that Johnson sought to debunk Gray.

When Reynolds assumed the presidency of the Royal Academy in 1768 he became *de facto* the leader of what he later termed the 'School of English Artists'.[2] Moreover he was the first British artist to hold such a position. Hogarth had publicly eschewed such a role within the St Martin's Lane Academy, preferring to see the Academy as a democratic organization where subscribers had equal rights and responsibilities – an attitude which had contributed to the rift between himself and the Academy in the early 1750s. Nor was the position of Painter to the King any longer regarded as carrying much kudos. The holder of the position in 1768 was the Scots artist Allan Ramsay who although a portraitist of immense gifts, was employed principally in replicating royal images for foreign courts. And when Reynolds himself was handed the job, following Ramsay's retirement, he referred to it dryly as 'a place of not so much profit, and of near equal dignity with His Majesty's rat catcher'.[3] Reynolds, rather than Hogarth or Gainsborough – or even Ramsay – was regarded at his death as not only the leader of the British School, but its founder. In the years which followed, Reynolds's name became a pawn for factions vying for control of the British art establishment. And just as the *Discourses* continued to play a seminal role in the promotion of art's most elevated genre – history painting – so Reynolds's adherents defended his history paintings as a proof that his own art was worthy of the founder of a national school of art.

Reynolds had all but ceased to paint by the summer of 1789. He retained the presidency of the Royal Academy, however, until his abrupt resignation on 11 February 1790. The issue which sparked off the resignation was ostensibly a disagreement between Reynolds and other members of the council over procedures relating to the election of a Professor of Perspective within the Academy.[4] In the light of the posthumous promotion of Reynolds as the embodiment of British art, it is significant that Reynolds's resignation was also prompted by what he

perceived as a xenophobic faction within the Academy. Reynolds, who wished the post to go to the Italian architect Joseph Bonomi, was accused of circumventing set procedure in order to get his own way. He was, however, more affronted by William Chambers's suggestion that the post should be given to an Englishman as of right. 'The chief argument used for not admitting foreigners' Reynolds confided in a private memorandum, 'was that it would no longer be an English Academy. I combated this opinion likewise with every argument I could suggest. I reminded the Academicians that, if anything was to be inferred from a single instance, our neighbours the French behaved with more liberality and good sense' (in Leslie and Taylor, 1865, vol. II, p. 559). Essentially, Reynolds conceived of the Academy as a microcosm of a larger European artistic community, rather than an expression of nationalism. Patriotism for Reynolds, as for his mentor Samuel Johnson, was the 'last refuge of a scoundrel'. None the less the majority of Academicians had opposed Reynolds's support for Bonomi, including Joseph Farington, who was, ironically, so staunch in his defence of Reynolds's reputation after his death and who did so much to promote the image of Reynolds as an arch-patriot. A handful of artists supported Reynolds: John Opie, Paul Sandby, Reynolds's erstwhile pupil and future biographer James Northcote, the sculptor Joseph Nollekens (whose father had emigrated to England in 1733), John Francis Rigaud (who had come to England from Rome in 1771), the German-born Johan Zoffany, and the Irish enfant terrible, James Barry. The name of the American artist, Benjamin West – who succeeded Reynolds as President of the Royal Academy – is conspicuous by its absence.

Reynolds was reinstated as president of the Royal Academy on 15 May 1790. In increasingly poor health, he died on the evening of 23 February 1792. The next morning *The Morning Herald*, ignorant of the fact, reported: Sir JOSHUA still refuses to see even the most intimate of his friends; to refuse that consolation, which in the decline of life all men prize. He is much depressed in spirits. WEST, like the figure in the Dutch weatherglass, of course proportionally elevated.' On 25 February the same newspaper printed a short obituary by Edmund Burke, apparently written in Reynolds's home just hours after his death – and which can thus lay claim to be the very first piece of posthumous biography. In addition to praising Reynolds's artistic genius he emphasized his personal attributes – not least his stoicism in the face of death. 'His illness', Burke stated, 'was long, but borne with a mild and cheerful fortitude, without the least mixture of any thing irritable or querulous' (quoted in Northcote, 1813, p. 371).

The propaganda over Reynolds's attitude towards death is significant in terms of the shaping of the artist's posthumous reputation as founding father of the British School. Reynolds had been seriously ill during the two years leading up to his death, and lived out his final months in considerable pain owing to an undiagnosed tumour on the liver (which, when removed at the post mortem, weighed an astonishing 12 pounds).[5] None the less, as *The Diary* reported shortly after his death, Reynolds had 'surveyed death with the fortitude of a philosopher and the piety of a christian'.[6] *The Morning Herald*, however, gave a conflicting report, stating that 'this great artist and accomplished character, by no means supported his illness with that composed philosophy that was naturally to be expected from such and enlarged and cultivated mind' (27 February, 1792).[7] The source of the rumour is unknown, but it must have been widespread because both *The St James's Chronicle* and *The Diary* carried pieces condeming it as a falsehood. In a similar vein, while *The General Evening Post* (23–5 February) described Reynolds as a 'firm and faithful friend, and ... benevolent and honourable man', *The General Advertiser* (28 February – 1 March) noted how it had been left to his niece, Mary Palmer, to ensure that Giuseppe Marchi continued to receive his annuity of £100 which Reynolds, himself, had 'neglected to will'. The issue of Reynolds's demeanour just prior to his death, although of minor importance in its own right, highlights the struggle, which intensified over the following decades, between those who wished to apotheosize Reynolds as the moral, as well as the artistic, founder of the British School and those to whom the deification of Reynolds was fundamentally detrimental to the cultivation of an indigenous and yet diverse artistic community.

Reynolds's artistic achievement was summarized at the time in a series of anodyne testaments which appeared in the press – a number of which promoted the issue of nationalism. On 28 February a 'Monody to the memory of Sir Joshua Reynolds' was published by *The Morning Herald*, in which Reynolds was grouped with Garrick and Samuel Johnson as that 'Matchless Trio, BRITAIN's boast and pride!' Three of Reynolds's paintings were alluded to specifically in the piece – *Garrick between Tragedy and Comedy*, *The Infant Hercules*, and *Ugolino and his Children in the Dungeon*. Aside from *Garrick*, which was by then accorded the status of history painting, none of Reynolds's portraits was referred to by name in obituaries. The year 1792 also saw the publication of the first substantial tribute to Reynolds entitled *Testimonies to the Genius and Memory of Sir J. Reynolds* by Samuel Felton, 'the author of Imperfect Hints towards a new edition of Shakespeare'.[8] The volume, a hastily cobbled-together misc-

ellany of news-clippings and anecdotes, nevertheless provides an insight into the nature of Reynolds's reputation at the time. Felton equated Reynolds's portraits with history painting, stating that his 'portraits possess a degree of merit superior to being mere portraits: they imbibe the dignity of history' (Felton, 1792, p. 13). He added that because Reynolds produced so many portraits 'we less regret the few great Historical Paintings which Sir Joshua's pencil has given us' (*ibid.*, pp. 13–14). Felton also included a list of sixty paintings, including a number of portraits, which he considered as forming the core of Reynolds's *œuvre*.[9] Even so, Felton clearly saw the need to explain Reynolds's comparative inattention to high art: 'Had the rage for Historical painting, thirty years ago', he stated, 'been as great as at the present day, there cannot be doubt but that Sir Joshua would have left behind him a treasure indeed' (*ibid.*, p. 20). Similar conclusions had already been drawn by *The Gentleman's Magazine*, and *The General Evening Post*, which stated:

When Sir Joshua taught us how to paint, there were not historic works which called upon the painter's skill – for a true taste was wanting: – vanity, however, was not wanting; and the desire to perpetuate the form of our self-complacency crowded his sitting room with women, who would be transformed like Angels, and men, who would be habited like Heroes … Unhappily, therefore, history-painting has not sufficiently occupied his pencil: – yet he has left us such specimens of what he was competent to, as long will be the boast of the British School – the Ugolino, the Beaufort etc. His very portraits are indeed historic, or rather perhaps epic … (*The General Evening Post*, 25–8 February 1792)[10]

Reynolds's acolytes put forward two arguments with regard to his approach towards history painting: first, that Reynolds's portraits could justifiably assume the mantle of high art; secondly that Reynolds would have produced more history paintings had not his patrons' vanity forced him to concentrate on portraiture.

One way of quantifying the status of Reynolds as a subject painter by the 1790s is to examine how much the public were prepared to pay for these works. On 14–16 April 1796 Reynolds's family and executors auctioned off much of the remaining contents of his studio at Greenwood's Rooms in Savile Row. Among the 218 lots were many unfinished portraits, rejected commissions, and miscellaneous sketches – mainly in oils. The sale was heavily publicized in the press, and a report of the 'private view' was even printed the day before in *The Public Advertiser*:

Those living artists who have done most honour to their great and illustrious leader, attended with fond delay, to behold, for the last time together, his numerous and fascinating progeny. Professor BARRY, OPIE, NORTHCOTE,

SMIRKE, Sir F. BOURGEOIS, and those striving after him in portrait, BEECHEY and SHEE. The magnets of the morning were–

The Death of Dido	Cupid and Psyche
The Infant Moses	The Theory of the Arts
The Duke and Duchess of Hamilton	Mrs Robinson
St. John	C. Greville
Hope nursing Love	And a beginning of Puck
	Ugolino, a head, etc. etc.

Reynolds's most prestigious works were in fact retained by Mary Palmer (and sold after her death in 1821), although there still were some bargains to be had.[11] Significantly, those works which, it was believed, transcended the genre of portraiture were invariably more highly priced – irrespective of size. The highest price paid for a full-length portrait was 100 guineas, for the double portrait of the Duke and Duchess of Hamilton. *Omai* (a native South-Sea Islander who had acquired quasi-mythological status) was almost certainly perceived more as public property than a private portrait, and, as such, also fetched 100 guineas. On the other hand a small fancy picture, *The Infant Moses*, was sold for 125 guineas, while a version of the *Infant St John* went for 150 guineas. And while a full-length portrait of Mrs Carnac was sold for 70 guineas, the smaller portrait of Miss Morris – advertised in the catalogue as 'Hope nursing Love' – was bought for 150 guineas. Although such price differentials reflect the fact that the portrait was by its very nature a customized commodity, of greatest interest to the sitter and their family, it is significant that portraiture was promoted in the sale as a lesser component of Reynolds's *œuvre*. The two most costly works in the sale were a version of *The Death of Dido*, sold for 200 guineas, and *Cupid and Psyche*, which Reynolds had exhibited at the Royal Academy in 1789, and which sold now for 260 guineas. Many of the minor unfinished sketches in the sale were bought by dealers such as Seguier and Cribb (probably with the intention of 'improving' them for resale), while the bigger works were purchased by erstwhile patrons like Sir Francis Bourgeois, Caleb Whitefoord, Sir Charles Long, and the Duke of Leeds. Sir George Beaumont, although he was to prove instrumental in promoting Reynolds's posthumous reputation, bought only two small oil sketches.[12]

The involvement of a commercial dimension in the elevation of Reynolds's subject paintings over his portraiture was not lost on at least one commentator, for as John Williams (alias 'Anthony Pasquin') observed: 'So variably humiliating is common opinion, that in the same year that he received 500 guineas from Messrs. BOYDELL, for his *Death of Cardinal Beaufort* his fine portrait of Nelly O'Brien was sold for 3 guineas,

by public auction, at CHRISTIE's in Pall Mall' (Pasquin, 1796, p. 70).[13] Pasquin also contended that although Reynolds had been a highly competent portraitist, his reputation as a history painter had been improperly strengthened by the sycophancy of his supporters. He stated:

Of this class of persons SIR JOSHUA had more than his share – it was their practice to feed him with the idea, that he was as much qualified to paint History as Portrait; and as men of genius, of all ages, have been more pleased to be lauded for what they could not do, than for what they could, we should not be amazed that he suffered himself into an idea, that his ability was unrestricted. (ibid., p. 67)

Pasquin's comments were contained in a lampoon on the Royal Academy entitled *Memoirs of the Royal Academicians*. None the less between the barbed comments (including the charge that 'Sir JOSHUA REYNOLDS was as injurious to the true principles of painting as a fine prostitute to the establishment of morals' (*ibid.*, p. 72)) Pasquin did actually produce here the first detailed and, on the whole, accurate biographical account of Reynolds. According to Northcote, it had been Reynolds's hope that Edmund Burke would write his biography (Howe, 1930–4, vol. XI, p. 20). And yet despite a brief notice in the press to that effect, nothing was forthcoming either from Burke or from James Boswell, whose preparations for a 'life' of Reynolds were also widely reported.[14] Although Northcote, himself, produced the first extensive biography in 1813, a short account was published in 1797 by Reynolds's friend, Edmond Malone.

While there was general agreement by the mid-1790s that Reynolds's subject pictures were of vital importance in the promotion of high art in England, there were diverging opinions about the way his posthumous reputation ought to be shaped. Political affiliations were instrumental in forming judgements – especially in view of the increasingly hostile attitude towards the French, a race for whom Reynolds had ironically expressed considerable respect. To understand the manner in which Reynolds's reputation was manipulated during this immediate post-revolutionary period one can profitably compare the stance taken by two of Reynolds's supporters: the Protestant, conservative, scholar Edmond Malone, and the Catholic, radical (and increasingly eccentric artist), James Barry.

A prominent writer and literary critic, Malone was typical of the circle who had surrounded Reynolds during his lifetime. As early as 1792, when he had been given access to his private papers, Malone was reported to be engaged on an edition of Reynolds's collected literary works (see *The Gentleman's Magazine*, April 1793, p. 381). Although not an artist, he was ideally placed to write about Reynolds's life as well as his literary works. He

had known him intimately, and had many mutual friends and acquaintances. (He had, moreover, already begun to make notes on Reynolds during the artist's life.) The short essay Malone appended to *The Literary Works* – entitled 'Some account of the life of the author' – contained very little critical commentary on the pictures. His aim, he said, was rather to show 'something of the man, as well as the painter' (1819, vol. I, p. iii). Appreciation of Reynolds's own art was restricted principally to a list of the 'most considerable of his Historical and Miscellaneous pieces' – complete with present owners and prices paid. The inclusion of the owners' names presumably had as much to do with displaying the taste of his peers than identifying the current whereabouts of various pictures. The book was heavily criticized in *The Analytical Review*, which called it 'a meagre performance, heavy without energy, shorn of incident, destitute of character, and ostentatiously trifling' (July 1797, vol. 26, p. 1). 'We cannot but regret', it concluded, 'that in the publication of works consecrated by their author to the public at large, usefulness should have been sacrificed to pomp' (*ibid.*, p. 8).

Malone's comments concerning Reynolds's character and opinions are of even greater significance than his art or writings, not least because he took it upon himself to explain the position Reynolds would have taken had he lived to witness the aftermath of the French Revolution. Malone presented Reynolds as the quintessential patriot, even stating how Reynolds had pre-empted Edmund Burke's *Reflections on the Revolution in France*, of 1790, noting how 'long before that book was written [he] frequently avowed his contempt of those "Adam-wits" who set at nought the accumulated wisdom of ages, and on all occasions are desirous of beginning the world anew' (*ibid.*, p. civ). (In a rare reference to Reynolds's political interests, Northcote had stated that Reynolds – contrary to prevailing opinion – believed that George Washington would prove victorious against the British in America (1813, p. 235).) Reynolds had held conservative views, the contents of his 'Ironical Discourse', for example, anticipating sentiments found later in Burke's *Reflections*.[15] And yet it is intriguing to find, in the context of an account of Reynolds's own life (which had ended before the onset of the Terror), France described as 'that "OPPROBRIOUS DEN OF SHAME", which it is to be hoped no polished Englishman will ever visit' (Malone, 1819, vol. I, p. lxxii). Malone's *Literary Works of Sir Joshua Reynolds* is known today – among other things – as the text on which William Blake appended his infamous marginalia, lambasting Reynolds's *Discourses* (see Wark, 1975, appendix I, pp. 284–319). While it had been Malone's intention to enhance

Reynolds's reputation, his publication of a number of Reynolds's hitherto private notes – including the admission that he had not at first sight fully appreciated Raphael's *Stanze* – fuelled Blake's indignation. Blake's annotations (which date from around 1806–8) were not confined to Reynolds, but extended to 'his Gang of Cunning Hired Knaves'. Blake's quarrel was not simply with Reynolds but with the 'polished' Englishmen who guarded his reputation. 'The Enquiry in England', he stated, 'is not whether a Man has Talents & Genius, But whether he is Passsive & Polite & a Virtuous Ass & obedient to Noblemen's Opinions in Art & Science' (*ibid.*, p. 291) Blake was acutely aware that Malone's text was not simply a vindication of Reynolds's art but an attempt to link his achievement to the current conservative interests. It is not therefore insignificant that Blake's famous annotation, 'This whole Book was Written to Serve Political Purposes', appeared not alongside Reynolds's own writings but in an extended footnote – by Malone – on the current strength of Britain's trade figures (*ibid.*, p. 290).

In the course of his comments in Malone's *Literary Works* the artist with whom Blake most sought to identify was James Barry, who aside from his abiding antagonism towards Reynolds, had been expelled from the Royal Academy in 1799. 'While Sr Joshua was rolling in Riches', noted Blake, 'Barry was Poor & Unemploy'd except by his own Energy' (*ibid.*, p. 284). And yet, although Barry had been a thorn in Reynolds's side from the mid-1770s onwards, he was ironically among Reynolds's staunchest defenders after his death. His reasons, although idiosyncratic, ultimately sprang from his own differences with the art establishment, and in using Reynolds as his ally he was ingeniously attempting to turn the tables on his opponents.

In chapter 3 it was observed how Barry in 1774, in his *Inquiry into the Real and Imaginary Obstructions to the Acquisition of the Arts in England*, had implicitly poured scorn on Reynolds's *Ugolino and his Children in the Dungeon*. In 1783 he had again attacked Reynolds via his *Account of a Series of Pictures in the Great Room of the Society of Arts*, a tirade which he sustained during the decade in his capacity as Professor of Painting at the Royal Academy. As the anonymous writer of a pamphlet of 1790 observed: 'there is one lecture, so expressly calculated to depreciate and ridicule the talents of the late President [Reynolds had then temporarily resigned the post], that he had always thought it prudent to absent himself from the Academy on the evening of its delivery' (quoted in Pressly, 1981, p. 218, n. 7, and Northcote, 1813, p. 302).[16] The first evidence that Barry had altered his opinion was a lecture he delivered at the Royal Academy on 18 February 1793 on the late Sir Joshua Reynolds.[17] Here Barry

excused Reynolds's preoccupation with portraiture, stating that 'for a great part of his life he was continually employed in the painting of portraits, undoubtedly because there was no demand in the country for anything else'. He also, uncharacteristically, elevated certain portraits to the level of history: 'His portrait of Mrs Siddons, is for the ideal and the executive the finest picture of its kind, perhaps in the world, indeed it is something more than a portrait, and may serve to give an excellent idea of what an enthusiastic mind is apt to conceive of those pictures of confined history, for which Apelles was so celebrated by the ancient writers.' And, in order to justify his apparent *volte face* Barry added, 'this picture of Mrs Siddons, or the Tragic Muse, was painted not long since, when much of his attention had been turned to history' (in Fryer, 1809, vol. I, p. 553 n.) Despite the fact that Barry's attacks on Reynolds had been at their most intense during the 1780s, he now praised what he saw as Reynolds's attempt to compensate for earlier shortcomings. 'No student in the academy', he stated, 'could have been more eager for improvement than he was for the last twelve years, and the accumulated vigor and value which characterise what he has done within that period, to the very last, could never have been foreseen or expected from what he had done, even at the outset of the academy and some years after' (*ibid.*, p. 556 n.). Barry had not simply conceived a new-found admiration for Reynolds's paintings. His dislike of the ruling clique within the Royal Academy had, however, intensified. Already in 1790 he had supported Reynolds in his own argument with the Academy, and now he was even willing to embrace Reynolds's history paintings. 'Nothing', he affirmed, 'can exceed the brilliancy of light, the force and vigorous effect of his picture of the Infant Hercules strangling the serpents: it possesses all that we look for, and are accustomed to admire in Rembrandt, united to beautiful forms, and an elevation of mind, to which Rembrandt had no pretentions' (*ibid.*, pp. 553–4 n.).[18]

By promoting Reynolds, and his history paintings, in his lecture of 1793 Barry evidently wished to drive a wedge between the students and the presiding officers of the Academy. (His lectures were apparently very popular with the students.) He also wanted to draw attention to the continuing lack of patronage for history painting. And the praise he lavished on *The Infant Hercules* was a prologue to his main point that such paintings, rather than being commissioned by Catherine the Great, should have been commissioned by British patrons.(*ibid.*, p. 556 n.)

As William Pressly has shown, Barry's art in the immediate aftermath of the French Revolution exhibited strong nationalist tendencies as he

promoted his own views on political and religious emancipation of Catholics in Ireland. Indeed, the week after he delivered his lecture at the Academy reclaiming Reynolds, he published the first of a number of amendments to his etchings of the Adelphi project, in which he placed Cecilius Calvert, second Lord Baltimore, in the central position among the legislators in *Elysium*, in place of William Penn, a substitution which, as Pressly notes, 'enabled the artist to install a Roman Catholic instead of a Quaker as the founder of his ideal political system based on civil and religious equality' (1981, p. 173). Throughout the 1790s, as Barry's rage against the Academy intensified, so ironically his public adherence to the memory of Reynolds grew. In 1798, the year before he was finally expelled from the Royal Academy, Barry published *A Letter to the Dilettanti Society, Respecting the Obtention of certain Matters essentially necessary for the Improvement of Public Taste, and for accomplishing the original Views of the Royal Academy of Great Britain*. By now an avowed Republican, Barry's text was a thinly veiled attack on British artistic and political institutions. Again, Reynolds's name was thrust forward in order to embarrass opponents: 'Alas! Poor Sir Joshua, how many melancholy consequences have taken place since your removal?', he asked rhetorically with reference to the current state of the Royal Academy. And, in relation to his own attempts to secure the Duke of Orléans's collection for Britain, he stated, 'Poor Sir Joshua Reynolds, God be with him: were he living, he could still find a remedy.'[19] By this time Barry was even willing to endorse earlier history paintings by Reynolds such as *Ugolino*, observing how 'shortly after my return from my studies on the continent [1771], I found that Sir Joshua Reynolds ... had thoughts about raising his prices, in order to lessen his business, and thereby obtain more time for the prosecution of historical works, which shortly afterwards took place, to his great honour' (Fryer, 1809, vol. II, pp. 560–1). On 1 October 1798 Barry, who had previously excluded Reynolds from the pantheon of great historical figures in his Adelphi mural *Elysium and Tartarus or the State of Final Retribution*, wrote to the Society of Arts to report that the former president of the Royal Academy had now been added, noting that 'London would have enjoyed more advantage from Sir Joshua's fine talents, had there been remaining in it some of those, exploded, old and happily fashioned convents, where those fine talents might have taken wing' (*ibid.*, p. 643). At the same time Barry improbably characterized Reynolds as a radical who had opposed the united might of the Royal Academy, and in this respect he venerated his memory in the same manner as Jacques-Louis David 'and his noble fellow-labourers in that glorious undertaking' (*ibid.*, p. 518). Both Malone

and Barry manipulated Reynolds's reputation to suit their own ends. And yet there was substance in both viewpoints. Reynolds's concept of a British School, as Barry was quick to seize on, was one which co-existed with, and drew inspiration from, European models. None the less, given Reynolds's penchant for compromise and his deep respect for the views of Burke, there seems little doubt that had he been alive he would have distanced himself from events across the Channel. It was only really in 1799 – by which time Barry had all but burnt his boats – that he finally allowed himself a more candid appraisal of his own relationship with Reynolds. As he said, in the second edition of his *Letter to the Dilettanti Society*:

Sir Joshua ... to say the truth, acted somewhat weakly with respect to me; and, on the other hand, I was myself much to blame with respect to him; my notions of candour and liberality between artists were too juvenile, and romantically strained too high for human frailty in the general occurences of life. Disappointed in not finding more in poor Sir Joshua, I was not then in a humour to make a just estimate of the many excellent qualities I might have really found in him. (*ibid.,* p. 539).

James Barry, by the late 1790s, understood the temperamental, as well as artistic, reasons which had separated him from Reynolds. At the same time, John Opie, another artist who had stood by Reynolds against the Academy in 1790 – and one who also held radical political views – was less sure of the validity of his former position.

In 1798 the second edition of the Reverend Matthew Pilkington's *Gentleman's and Connoisseur's Dictionary of Painters* was published. It contained a supplement on recently deceased British artists including Hogarth, Wilson, Gainsborough, and Reynolds.[20] The eight-page entry on Reynolds was written by John Opie. For the most part it consisted of an enthusiastic appreciation of Reynolds, relying heavily on material in Malone's recently published *Literary Works* (Pilkington, 1798, vol. II, pp. 812–20). The tone of the article changed abruptly, however, towards the end and stands in stark contrast not only to the main body of the piece, but to any previous posthumous critical assessment of Reynolds's achievement. As a history painter, Opie stated that Reynolds lacked imagination, and had failed to give a practical lead in the formation of an indigenous school of history painting. Unlike previous writers, he brusquely dismissed the standard reasons put forward for the predominance of portraiture in Reynolds's *œuvre*:

First, 'that he adopted his style to the taste of his age'. But ought not a great man, placed at the head of his art, to endeavour to lead and improve the taste of the

public, instead of being led and corrupted by it? Secondly 'that a man does not always do what he would, but what he can'. This, whatever truth there may be in it, certainly comes with an ill grace from the mouth of ONE who constantly and confidently maintained in his writings, 'that by exertion alone every excellence of whatever kind, even taste, and genius itself, might be acquired'. (ibid., p. 819)

Opie continued:

The fact is, perhaps, that he never truly felt the excellence of the grand style, of which his disappointment at the first sight of the works of Raffaelle in the Vatican, in addition to his violent opposition to it in his practice, is a strong proof. He wrote from his head, but he painted from his heart; and the world probably loses nothing by his not having had the opportunity of putting his resolution in practice, of adopting the style of Michel Angelo, would he have been permitted to begin the world again; a declaration made evidently without a proper appreciation of his powers, which do not at all appear to have been calculated for excelling in that style.'(ibid., pp. 819–20)

And even with reference to the less controversial *Discourses* Opie opined that 'being frequently undertaken before he had profoundly considered the subject, they are frequently vague and unintelligble, and sometimes contradictory' (ibid., p. 820). In the light of his previous support for Reynolds, and his future statements to students at the Royal Academy (which we will look at later in the chapter) Opie's comments require explanation.

One explanation for Opie's candidness was that the dictionary entry was anonymous. (Indeed, it was only subsequently that he privately confessed to being its author.[21]) Presumably because of its controversial coda, there was speculation at the time concerning the authorship of the entry, some attributing it to Opie's mentor John Wolcot, alias 'Peter Pindar' (see Hazlitt, 1816, vol. III, p. 7, quoted in Earland, 1911, p. 134). And yet, although Wolcot frequently satirized the Royal Academy, Reynolds maintained his almost unqualified respect. On the other hand, Opie (then estranged from Wolcot), who was by the late 1790s experiencing personal and professional difficulties, may have felt particularly disenchanted with Reynolds's confident and urbane approach. Finally, Opie was not by nature or inclination a diplomat and had a reputation for calling a spade a spade.

More typical of the way in which his reputation was being cast at the time were the accounts of Reynolds's art and life which appeared in James Dallaway's *Anecdotes of the Arts in England* (1800) and William Jackson's

The Four Ages of 1798. Jackson, an amateur artist, and organist at Exeter Cathedral, had known Reynolds – although his closest artist-friend had been Thomas Gainsborough. (The two had, however, quarrelled and Gainsborough is treated in a far more cavalier manner in his book than Reynolds.) Jackson's account was among the first to seriously discuss Reynolds's art. Although Jackson was keen to demonstrate his technical knowledge – especially with regard to Reynolds's use of colour – his references to the content of Reynolds's art were uncritical. In contrast to Opie's blunt assessment he noted unequivocally that 'Sir J considered historical painting as the great point of perfection to which artists should aspire, and was himself in the first rank of excellence' (Jackson, 1798, p. 179). Of Reynolds's portraits he said little, although he did state that *Garrick between Tragedy and Comedy* was his 'first historical subject' (*ibid.*, p. 169). (Gainsborough, however, 'either wanted conception or taste, to relish historical painting, which he always considered as out of his way and thought he should make himself ridiculous by it' (*ibid.*, p. 179).) Dallaway was equally enthusiastic about Reynolds's achievement as a history painter. And having praised Reynolds as the founder of the 'English school of painting', Dallaway reeled off a list of his 'most famous paintings', which included *Ugolino* ('Sir Joshua's triumph in the art'), *The Death of Cardinal Beaufort* ('in which are united the local colouring of Titian with the chiaroscuro of Rembrandt'), and his *Holy Family* ('which displays a novel and beautiful manner of treating that very frequent subject'). The three portraits mentioned in the list – *Garrick between Tragedy and Comedy*, *Mrs Siddons as the Tragic Muse*, and *Mrs Billington* – were all 'allegorical' portraits (Dallaway, 1800, pp. 521–2).

Although Malone, and to a lesser extent writers like Jackson and Dallaway, shaped Reynolds's reputation, it was another admirer and former friend, Sir George Beaumont, who was principally responsible for ensuring that Reynolds was accepted unequivocally as the founder of the British School. Despite the recent evaluation of Beaumont as 'one of the most enlightened of British patrons', he remains in many ways an unsatisfying figure (see Owen and Brown, 1988, p. 232). Until the late 1790s he was a tangential character on the British cultural scene. As a Member of Parliament he had been a fellow-traveller; as a traveller he had been little more than a dilettante; and as a patron of the arts he was, despite his enthusiasm, skittish and inconsistent. None the less, by 1800, Beaumont was, with Sir John Fleming Leicester, Sir John Julius Angerstein, and Sir Charles Long, among the most influential figures in the British art establishment. In the early nineteenth century Beaumont combined his

reverence for the memory of Reynolds, with a firmly held belief in the institutional promotion of high art, binding the two together with a staunchly nationalist stance. Such factors help to explain why, during the ensuing decade, Reynolds's subject paintings were used as a vehicle to promote the highest ideals of the British School and why they became such a prominent target for those who resented Beaumont's patrician stance.

In 1801 George Beaumont inspired William Sotheby (1757–1833) to write *A Poetical Epistle to Sir George Beaumont, Bart. on the Encouragement of the British School of Painting*. A leading light in the Dilettante Society since 1792, Sotheby had, in addition to his own poetry, translated Wieland's *Oberon* and Virgil's *Georgics* into English. Now he celebrated, in verse form, Beaumont's plans for a series of retrospective exhibitions of the works of British artists.[22] The tenor of the poem was fiercely jingoistic:

> Ah, woe for Britain! if her youthful train
> Desert their country for the bank of Seine!
> Ah, woe for Britain! if insidious Gaul
> Th'attracted artist to her trophies call. (Sotheby, 1801, p. 24)

And like Malone, four years earlier, he made considerable play of the link between art and commerce:

> Beaumont! (the Arts thus speak), oh urge thy aim:
> Trade, freedom, virtue, vindicate our claim. (*ibid*., p. 28)

Sotheby proceeded to recall the achievements of British artists of the previous century, including Mortimer, Wilson, Hogarth, Gainsborough, and Reynolds – who was accorded the greatest attention: 'Hail! guide and glory of the British School / Whose magic line gave life to every rule' (*ibid*., p. 20). The stanzas accorded to Reynolds concentrated, moreover, solely on his public art with paeans of praise devoted to history pictures such as *Macbeth* and *The Infant Hercules*. Hogarth's achievement was summed up in two lines: 'Satire and sense, on Hogarth's tomb reclin'd / Shall point the ethic painter of mankind' (*ibid*., p. 18).

Hogarth had been dead for nearly forty years. Next to Reynolds, he was regarded as among the most significant British artists of the eighteenth century – as one can see by the space devoted to him in successive editions of Pilkington's *Dictionary of Painters*. Hogarth's entry, at over seven pages, was considerably longer than that of any other artist – except Reynolds's, which ran to eight pages (see Pilkington, 1805, pp. 439–46 (Reynolds) and 248–55 (Hogarth)). The text of Hogarth's entry was

largely lifted from Horace Walpole's earlier *Anecdotes of Painting in England*, there being little attempt to recast the nature of the artist's achievement, which was that of a satirical print-maker (see Walpole, 1780, vol. VI, pp. 68–80). Indeed, more recent writers on Hogarth, such as the Shakespearean scholar George Steevens, John and Samuel Ireland, John Nichols, and Georg Christian Lichtenberg, all confirmed Walpole's assessment of Hogarth as a maker of comic prints. (According to Nichols, even Lichtenberg, 'although a German, looked at him completely through the medium of wit' (1822, p. viii).) Significantly, Hogarth's reputation, unlike that of Reynolds, was shaped by individuals whose primary interest was not in painting but in dealing and print publishing.

As a painter Hogarth was still largely an unknown quantity, beyond the confines of a handful of collectors. And while Reynolds was promoted as a moral as well as an artistic paradigm, any improving influence exerted by Hogarth came through his engravings – principally the 'modern moral subjects'. Unlike Reynolds, Hogarth was not admired for his intellect. (Witness, for example, the Reverend Edmund Ferrers's *Clavis Hogarthiana* of 1817, which consisted of snippets principally from Horace's *Ars Poetica* strung together to illustrate Hogarth's modern moral subjects. The book was subtitled 'illustrations from Hogarth: ie Hogarth illustrated from passages in authors he never read, and could not understand'.) Nor could it have assisted Hogarth's reputation as a serious artist that Reynolds had referred in his fourteenth *Discourse* to 'our late excellent Hogarth, who, with all his extraordinary talents, was not blessed with a knowledge of his own deficiency; or of the bounds which were set to the extent of his powers' (in Wark, 1975, p. 254). Despite the continuing popularity of Hogarth's satirical narratives, his characterization of the power of the mob, his indictment of governmental corruption, his condemnation of moral standards of the gentry and aristocracy, and his graphic depiction of London low-life must have been unsettling for a nation attempting to assert its cultural and moral superiority. None the less, it is a paradox that while Hogarth's importance was anchored firmly in the content of his work, criticism of Reynolds continued, in the first decade of the nineteenth century, to be confined to formal issues, there being little attempt to demonstrate why Reynolds's history paintings should be regarded as vehicles for moral or intellectual improvement. The reasons lay in the hermetic context of artistic debate which continued to be conducted principally by artists and the select group of connoisseurs who felt it incumbent upon them to shape the nation's taste. To such individuals the virtues of high art versus genre or portrait painting were self-evident, as

the following example demonstrates. In 1805 a third edition of *Pilkington's Dictionary of Painters* was published, edited by Henry Fuseli. Reynolds's entry ('JOSHUA REYNOLDS / History, Portraits') remained unchanged at nearly eight pages. Gainsborough's entry ('-------- GAINSBOROUGH / Landscapes, Portraits') had been almost as long in the 1798 edition – principally owing to a lengthy extract from Reynolds's fourteenth *Discourse* on Gainsborough. Now Fuseli pruned it to half a page, and added in a note to the text:

Neither the limits nor the design of this work permitted the insertion of the prolix extract tacked to this life. The discourses of Reynolds are, or ought to be, in the hands of every student or dilettante of this country. Of the account itself not a word has been altered, though it be scarcely 'on this side of idolatry'. Posterity will decide whether the name of Gainsborough deserves to be ranked with those of Vandyck, Rubens, and Claude, in portrait and in landscape. (Pilkington, 1805, pp. 206–7)

Fuseli, although he had a better insight into Reynolds's practice of high art than anyone – including Northcote – was relatively mute on the subject, even in the lectures which he delivered to the Royal Academy. Here he was content to observe (in his second lecture published in 1801) how the 'genius of Reynolds first rescued from the mannered deprivations of foreigners his own branch, and soon extending to higher departments of art, joined that select body of artists who addressed the ever open ear, ever attentive mind of our Royal Founder, with the first idea of this establishment' (Lecture II, 'The art of the moderns', 1801, in Wornum, 1848, p. 406). Of Reynolds's contemporaries – as opposed to his pupils or acolytes – the painter who revealed most about his attitudes to Reynolds's subject pictures was the prolific, if mediocre, Teacher of Perspective at the Royal Academy, Edward Edwards (1738–1806). In 1808, two years after his death, Edwards's *Anecdotes of Painters* was published. While critical of certain aspects of Reynolds's history paintings, Edwards typically sought confirmation of his viewpoint in the current climate of patronage rather than appealing to the sensibilities of those who did not have a vested interest in the economic value of works of art. Some of his criticisms were harsh, although they were not, he stated, 'very different from the opinion generally entertained by connoisseurs'. In order to prove the point he produced a table showing how the value of *Cardinal Beaufort* and *Macbeth* had decreased in real terms since Boydell had purchased them from Reynolds (Edwards, 1808, p. 205). The contents of Boydell's Shakespeare Gallery had been auctioned off in November 1805. Edwards revealed that

although Boydell had originally paid £1,000 for *Macbeth*, it was sold in 1805 for only £500, while the *Death of Cardinal Beaufort* had sold in 1805 for £535, only slightly more than Boydell had orginally paid for it. Both pictures were bought at the sale by the third Earl of Egremont (1751–1837) – who was, significantly, a contemporary of many of those who had purchased Reynolds's subject pictures in the 1770s and 1780s. Edwards had omitted several points in constructing his argument. First, it had only been owing to the exertions of Reynolds's executors that Boydell had eventually paid £1,000 for *Macbeth*. Secondly, even though most of the works included in Boydell's auction in 1805 were sold cheaply, Reynolds's pictures had none the less fetched the highest prices.[23] Ultimately, through his concentration on formal aspects of individual pictures by Reynolds, and their relative value in economic terms, Edwards did little to modify the nature of current debate on Reynolds's reputation.

That criticism of Reynolds remained comparatively mute during the early years of the nineteenth century was in no small measure owing to the strength of patriotic feeling generated by the increasing intensity of the conflict with France. It is against this background that John Opie's Royal Academy lectures of 1807 must be viewed. Opie, who had been appointed to the post of Professor of Painting at the Academy in 1805, delivered the first of a series of lectures on 16 February 1807 (see Opie, 1809, *passim*). Although relations between the Royal Academy and the British Institution were strained, they shared a common interest in proving the superiority of indigenous artists over their French counterparts. Opie was prominent in promoting the patriotic cause, vigorously petitioning for a monument commemorating the Battle of Trafalgar, as well as outlining plans in the *True Briton* for the foundation of a National Gallery (Rogers, 1878, p. 40). He also stressed in his lectures the need for students to remain true to the spirit of high art, and not to be swayed by the populist opinions of the public who attended the annual Academy exhibition. In his second Academy lecture he selected Reynolds's *Death of Cardinal Beaufort* as a valid alternative to works of art which had only transient appeal. 'The varied beauties of this work', he stated, 'might well employ a great part of the lecture' (Lecture II, 'On invention', 23 February 1807, in Opie, 1809, p. 76). As it was he contented himself by defending the most contentious element of the painting – the fiend on the pillow. Reynolds, he conjectured, was correct to include it as it was 'informing us that those are not bodily sufferings, which we behold so forcibly delineated that they are not merely pangs of death which make him grin, but that his agony proceeds from the daggers of the mind' (*ibid*.). Paradoxically, Opie, who, like Reynolds had

made his living as a portraitist, argued that the portrait brought out the worst in the exhibition-going public who – as it was noted in chapter 1 – could only reiterate 'the same *dull* and tasteless question, *who is that?*, and *Is it like?*' Again, it was the formal aspects of a work of art which Opie promoted above those of content. He concluded:

It is no wonder that this work of our great painter has been condemned without mercy, by a set of cold-hearted, fac-simile connoisseurs who are alike ignorant of the true and extensive powers of art; who forget that Pegasus has wings to carry him unobstructed over mountains and seas, or who wish to have him trimmed, adorned with winkers, and reduced to canter prettily and properly on a turnpike road. (*ibid.*, p. 79)[24]

Opie's spirited defence of Reynolds's history paintings against the deprecations of an insensitive public was echoed shortly after his death by J. M. W. Turner (1775–1851) – an Academician of a younger generation. Of those artists who invoked the spirit of Reynolds no one spoke more passionately and sincerely on his behalf than Turner. Beginning in 1811, Turner – in his role as Professor of Perspective – gave a series of lectures at the Royal Academy. His lecture notes bristle with patriotic praise of Reynolds as 'that ever living ornament of the English School', and 'an authority which as Artists we must alway[s] revere'.[25] Frequently Turner revealed, via his determination to demonstrate Reynolds's affiliation to the old-master tradition, an intense respect for Reynolds's history paintings. Thus, for example, he coupled the 'half extinguished light on the Resurrection, by Rembrant [*sic*]' with the 'agonised and Livid tone of Ugolino', and compared the figure of St Paul with his arm upraised in Raphael's *St Paul Preaching* with King Henry VI in the *Death of Cardinal Beaufort*.[26] Similarly, he considered Reynolds's figure of Macbeth to be 'the very Geometric problem mentioned by Vertruvius [*sic*] and stated before "that a figure whose Arms are raised to their utmost Elevation & the legs extended the whole would produce a circle" '.[27]

By the end of the first decade of the nineteenth century, the origins of a British School of art were regarded by artists and laymen alike as centring upon Reynolds and the Royal Academy – a viewpoint summarized in John Gould's *Dictionary of Painters, Sculptors, and Engravers*, of 1810. In his introduction Gould made a comparative analysis of what he termed the 'English School', with the Schools of Rome, Venice, and France. Gould's view was centralist. The English School was, he said, 'connected with the Royal Academy, in London, instituted in 1766 [*sic*]' (1810, pp. xxiv–xxv). As a corollary he affirmed that the 'English School of painting must

at the close of the exhibition that eighteen paintings were to be left on display in the British Institution's galleries for study purposes, thirteen of which were subject pictures.[29] It is significant, also, that by this time the Prince Regent was already forming his own collection of miniatures after Reynolds's subject pictures, including *Cupid and Psyche*, *The Death of Dido*, *Venus*, *Hope Nursing Love*, and *Cimon and Iphigenia* (see Walker, 1992, cats. 789, 790, 792, 795, and 796). And following the exhibition at the British Institution, in recognition of his appreciation for her uncle's subject pictures, Lady Thomond presented the Prince with the original painting of *Cimon and Iphigenia*, which was formally received at Carlton House in 1814 (see Postle, 1993, p. 121).

The same year, a second retrospective exhibition was held by the British Institution of works by Wilson, Gainsborough, Hogarth, and Zoffany. Significantly, doubts were raised by Payne Knight about the inclusion of Zoffany as he was not a 'British Painter'.[30] Hogarth was represented by thirty-four works (twenty-two of which were accounted for by the 'series' paintings – *Marriage à la Mode*, the *Rake's Progress*, *The Election Series*, and *The Four Times of the Day*). There was little constructive criticism of Hogarth as a painter, principally due to the perceptible lack of 'refinement' in his work. Even John Nichols, who continued to publish Hogarth's prints into the nineteenth century, was unwilling to defend Hogarth here: 'To assert ... that his productions possess the poetical beauties, and sublime expressions, that are to be found in the great Italian Masters', he wrote later, 'would be as impudent as to claim that exquisite beauty and truth of execution which characterise the Flemish School' (1822, p. iii). Moreover, Nichols felt that Hogarth's very choice of subject matter militated against him, as did the 'preposterous and tasteless costume of the period, both in dress and furniture, which from our not being accustomed to it in real life, gives to his figures a grotesque and antiquated air' (*ibid.*, p. viii). Wilkie, he stated, was in this respect, more 'natural'. Among those who preferred Wilkie to Hogarth as a painter was William Hazlitt, who noted in *The Champion* in 1815, that 'Mr. Wilkie's pictures are in general much better painted than Hogarth's' (5 March 1815, in Howe, 1930–4, vol. XVIII, p. 99, n. 1). In this context it was ironic that Hazlitt had by 1814 supplanted Lamb as the self-appointed champion of Hogarth and the scourge of Reynolds.

Hazlitt did not write about the Reynolds retrospective. He did, however, review the 1814 exhibition for *The Morning Chronicle*. Although an admirer of Hogarth, he was scrupulously candid in his responses. *The Election Series* of 1754 (which he believed was a comparatively early work)

was 'very little above the standard of common sign painting'; whereas *Marriage à la Mode* of 1743 (which he thought to be later) 'in richness, harmony, and clearness of tone, and in truth, accuracy, and freedom of pencilling, would stand a comparison with the best productions of the Dutch School' (*ibid.*, p. 23). Hazlitt, although he picked up the baton from Lamb, did not hold identical views. Unlike Lamb, for example, he did not seek to elevate the supposed vulgar aspects of Hogarth but attempted via a critique of his favourite work – *Marriage à la Mode* – to demonstrate Hogarth's ability to characterize the upper echelons, as well as the lower orders, of society, and thus present a more rounded picture of the artist than had hitherto emerged. Hazlitt respected the traditions of high art more than Lamb, noting in a separate essay that he would rather 'never have seen the prints of Hogarth than have never have seen those of Raphael' (*ibid.*, vol. VI, p. 148). It was presumably for this reason that he took the opportunity to defend Hogarth's widely ridiculed history painting *Sigismunda*. It was, he asserted, 'delicate in the execution, and refined in the expression, at once beautiful and impassioned, and though not in the first, probably in the second class of pictures of this description' (*ibid.*, vol. XVIII, p. 23).

Hazlitt, as a critic and a man, was an enigmatic blend of radical and conservative. Born in 1778, he was steeped in the traditions and mores of the eighteenth century. In 1796 he proclaimed his three favourite writers to be Burke, Junius, and Rousseau, while on a visit to the Louvre in 1802 he had complained in a letter to his father of being 'condemned to the purgatory of the modern French gallery' while he queued to inspect Napoleon's assemblage of looted old masters (Howe, 1949, p. 84). Hazlitt's background was curiously similar to Reynolds's own. The son of a cleric (albeit a dissenting minister) from a large family, his brother John (a miniaturist) had studied in Reynolds's studio, while Hazlitt himself had briefly entertained a career as a portraitist. Those examples of his work which still exist reveal that he was quite competent although, according to Coleridge, he had no 'imaginative memory'.[31]

As a youth Hazlitt had been on the fringes of Sir George Beaumont's coterie, via his friendship with the Lake poets, and had even hoped to gain Beaumont's patronage. He had, however, offended Beaumont by admitting his admiration for Junius (as well as having had the temerity to contradict Coleridge during a conversation the three men were having). But while Coleridge and Wordsworth increasingly relinquished their radical political stance, Hazlitt's beliefs grew more fervent. By 1808 he had migrated to the company of Charles Lamb and the Hunt brothers, Leigh and Robert. They

regarded their frequent literary gatherings as free-spirited and egalitarian. And, as Hazlitt later recalled, they 'abhorred insipidity, affectation, and fine gentlemen' (in Howe, 1949, p. 131). By 1812 Hazlitt saw his future as lying in journalism rather than painting, and secured a post on the Whig newspaper, *The Morning Chronicle*. From the outset his pieces – including an assault on Thomas Lawrence – were outspoken and controversial, and his contract was soon terminated. And it was as a correspondent of *The Champion* – to which he transferred in the summer of 1814 – that he began to undermine Reynolds's reputation.

Between October 1814 and January 1815 Hazlitt wrote six essays for *The Champion* on Reynolds as an artist and as an art theorist. Of his opinions concerning Reynolds's theory it is sufficient to note here that Hazlitt's principal contention was that Reynolds's claim that the 'Great Style' depended on the belief in the supreme importance of a 'central form' did not hold water (see Howe, 1930–4, vol. XVIII, pp. 62–84; Wark, 1975, appendix II, pp. 320–36). More pertinent to the present discussion are the two introductory essays on the 'Character of Sir Joshua Reynolds' which he published on 30 October and 6 November 1814. 'The authority of Sir Joshua Reynolds both from his example and instructions', began Hazlitt, 'has had, and still continues to have, a considerable influence on the state of the art of this country.' 'From the great and substantial merits of the late president', he continued, 'we have as little the inclination as the power to detract.' Even so, 'we certainly think that they have been sometimes over-rated from the partiality of friends and from the influence of fashion' (in Howe, 1930–4, vol. XVIII, p. 51). Throughout these essays Hazlitt, quite brilliantly, damned Reynolds with faint praise, calling him at one point 'the most original imitator that ever appeared in the world' (*ibid.*, p. 53). Reynolds's best works, affirmed Hazlitt – conscious of the unorthodoxy of his viewpoint – were his male portraits. Fancy pictures, hitherto the object of affectionate praise, were roundly criticized. Of *The Infant Samuel*, for example, Hazlitt stated that Reynolds 'had no idea of a subject in painting them, till some ignorant and officious admirer undertook to supply the deficiency' (*ibid.*, p. 58). His deepest condemnation was, however, reserved for the history paintings. He related how *Ugolino and his Children in the Dungeon* did not begin life as a history painting but as a study of Reynolds's model, George White, which friends had persuaded him to adapt. 'The highest subject which Sir Joshua has attempted', he wrote, 'was the "Count Ugolino", and it was, as might be expected from the circumstances, a total failure' (*ibid.*).

However much Hazlitt may have disapproved of *Ugolino* the real object

of his scorn was not so much Reynolds's painting as those connoisseurs who had uncritically promoted his art in all areas, rather than taking a measured account of his strengths and weaknesses. In this respect his attitude paralleled that of Benjamin Robert Haydon who, although he passionately believed in history painting and admired Reynolds, observed of his acolytes that 'their praise is like the charity of a whore, a sort of compromise with an aching remembrance' (Pope, 1960–3). It was in part because of this feeling of betrayal, and in part because of innate journalistic instincts, that Hazlitt, although he admired Hogarth, devoted far more time and energy to debunking Reynolds than to redeeming the reputation of the former artist. There was a further reason for Hazlitt's attitude which stemmed from his views on the relevance of academies to artistic production. In 1814 in an essay entitled 'Fine arts: whether they are promoted by academies and public institutions', Hazlitt emphasized 'how little the production of such works depend on the most encouraging circumstances' (Howe, 1930–4, vol. XVIII, p. 37). Hogarth, the 'non-academic' artist, was pitted against Reynolds the supreme Academician, in the same way that Hazlitt the lay art critic consciously pitted himself against acknowledged leaders of the *cognoscenti* – even to the point of evolving a whole new mode of art criticism which recognized the right of the layman to express a subjective opinion about art.

Unlike France and Germany, there was no real tradition of interest in the visual arts by literary figures in England. Criticism – as well as art theory – was written by artists, their associates, and collectors. Hazlitt's *modus operandi* was quite new. In the past, even when dissatisfaction with Reynolds's subject pictures surfaced, it had been expressed in formal terms. In composing history paintings, narrative was of secondary importance to Reynolds; it was therefore of little concern to his critics except as the *lingua franca* of high art. Hazlitt maintained, however, that he would not 'attempt to judge them by scientific or technical rules, but make observations on the character and feeling displayed in them' (*ibid.*, p. 53). In other words, he would subject them to the kind of 'reading' that Hogarth was subject to – thus taking them out of the hands of the artists and connoisseurs who had a vested interest in maintaining their exclusive merits. In addition he wished to undermine the nationalist bias which he felt underpinned the promotion of high art by the British Institution. Hazlitt respected the 'Great Style', an art which he considered to reflect 'the universe of thought and sentiment, that surrounds and is raised above the ordinary world of reality' (*ibid.*, vol. VI, p. 146). Paradoxically, in his belief that the British School was a microcosm of a larger European School of art, Hazlitt

was closer to Reynolds's own position than many of those who sought to protect his memory. Hazlitt's writings during, and after, the Napoleonic Wars enraged both artistic and political figures in the establishment who strived to construct a pantheon of national 'heroes'. As the Tory *Quarterly Review* bitterly stated of Hazlitt in 1817: 'If the creature in his endeavours to crawl into the light, must take his way over the tombs of illustrious men, disfiguring the records of their greatness with the slime and filth which marks his track, it is right to point him out that he may be flung back to the situation in which nature designed that he should grovel'.[32]

Among those whom Hazlitt challenged was Richard Payne Knight, who in September 1814 – a month before Hazlitt's views on Reynolds's character had surfaced in *The Champion* – wrote an anonymous panegyric on Reynolds in *The Edinburgh Review*, in the course of a review of James Northcote's recently published *Memoirs of Sir Joshua Reynolds* (*The Edinburgh Review*, 46, September 1814, pp. 263–92).[33] In 1814 – before his controversial rejection of the Elgin Marbles – Knight was still the most influential spokesman on artistic matters in the British establishment. A collector of old-master drawings, Etruscan statuary, and cameos, as well as the work of artists as diverse as Westall, Wilkie, and Rembrandt, Knight was innovative in his championship of art which lay outside accepted canons of taste. An imaginative and pioneering scholar, Knight was in many ways far less of a traditionalist than Hazlitt. Hazlitt was not interested in contemporary British art and – like Reynolds – he revered Michelangelo, whom Knight regarded as a fundamentally corrupting influence, preferring colourists such as Titian and Correggio.[34] None the less Hazlitt and Knight shared a distrust of academies – even though their reasoning differed.

In his *Edinburgh Review* essay Knight contrasted the 'academic' style of artists such as Batoni, Mengs, and David, with Reynolds, arguing that the former had promoted mechanical dexterity at the expense of instinctive ability. Significantly, in view of the promotion of Reynolds as a moral as well as an artistic paradigm, a further comparison was drawn between David and Reynolds – the respective figureheads of the French and British Schools. While David, stated Knight, could 'probably delineate human form and countenance with more accuracy, promptitude and facility, than most of his brethren', he was morally bankrupt, having 'as little feeling for the real beauties of liberal art, as he showed for the sufferings of his fellow-creatures, when a member of Robespierre's committee'. Reynolds, on the other hand, was not only a good artist but a moral one, 'for', as he went on to affirm:

as good taste and good morals spring from the same sources of sound sense and feeling, it is for the general honour and interest of humanity, that the corrupt habits of individuals should never separate them; but that, whatever commands the applause and admiration of mankind, should be inseparably conjoined with that [which] commands their respect and esteem. Such was the happy union which pre-eminently distinguished the subject [Reynolds] of the history under consideration. (*The Edinburgh Review*, September 1814, pp. 268–9)

Knight went on to express his profound admiration for Reynolds's history paintings, based not only on their pictorial merit but – like Shee – on their integrity. Unlike David's work, Reynolds's *Nativity*, *Ugolino*, and *The Infant Hercules* did not display 'any profound knowledge of form or technical expertise'. However, he continued, 'neither do they contain any affected or false display of such knowledge and expertness' (*ibid.*, p. 255) Hogarth's history paintings, however, were condemned as 'those abortive attempts at heroic composition, into which his preposterous vanity led him' (*ibid.*, p. 255). As for the present, Knight believed that public money would be far better spent on history paintings by Richard Westall and Edward Bird than on the provision of ephemeral entertainments such as firework displays which only 'attract the stupid gaze of a dissolute populace' (*ibid.*, p. 288).

James Northcote's biography of Reynolds – the ostensible subject of Knight's attention in *The Edinburgh Review* – was dismissed in a few curt sentences. And yet, despite its makeshift structure, Northcote's book was the first major biography of Reynolds. Indeed, today, Northcote's main claim to fame aside from his being Reynolds's best-known pupil is his role as biographer. Before 1813 – the date of publication of his book – Northcote was better known in his own right as a portrait and subject painter. His literary career took wing around 1810, when he was asked (probably by Sir George Beaumont) to write a short memoir of Reynolds in a book entitled *The Fine Arts of the English School*, edited and partly written by John Britton. Of Northcote's contribution, and Thomas Phillips's memoir of Romney, Britton noted in his preface that they were 'the productions of gentlemen not accustomed to literary composition, but their opinions are sound and authoritative, because both are men of professional talents, and are well qualified to appreciate their respective subjects' (Britton, 1812, Preface (unpaginated)). Northcote had, however, already written several pieces for Prince Hoare's short-lived periodical, *The Artist*;[35] and by 1812 he clearly felt confident enough to embark on a full-scale biography of Reynolds.

As Ronald Lightbown has shown, Northcote's biography was by no means all his own work.[36] Henry Colburn, Northcote's publisher, had

employed a team of researchers to comb old newspapers for Reynolds-related material, much of which was incorporated verbatim (and unacknowledged) into Northcote's text. The book's principal defects were dissected by *The British Critic*: 'it doubtless contains a great variety of anecdotes. But these anecdotes are so artificially strung together, or rather have so little connection, that the performance assimilates much more to a bundle of bon-mots, or witticism, or "felicities in *ana*", than to the character of a regular composition.' More disturbing, argued *The British Critic*, were Northcote's demonstrations of intimacy with Reynolds, made evident by his 'impertinent digressions and quotations'.[37] Northcote had, however, known Reynolds personally (even if Fuseli considered him to be little more than his 'palette-cleaner'). Moreover, at least part of his text was transcribed directly from notes which Northcote had already made for his own projected autobiography.[38] Northcote was, however, not a connoisseur or a scholar, but a practising painter.

Memoirs of Sir Joshua Reynolds is a fascinating, if flawed, fly-on-the-wall biography, not least because it is tinged with the author's own bitterness and personal regrets. Significantly, his assessment of Reynolds's history paintings is fraught with ambiguity. 'We cannot', he stated, 'but lament that he was not frequently called upon to exercise his great genius on subjects more suitable to so enlarged a mind.' And yet he also noted that while Reynolds's portrait compositions were 'unquestionably excellent... his historical pictures are, in this respect, often very defective' (1813, p. 3). Later in the text, he stated that 'it was not his desire to paint any circumstance in history of a complicated nature, his expression to me on that subject was, "That it cost him too dear"' (*ibid.*, p. 342). In 1813 such an opinion was unorthodox as it suggested that subject painting was a pastime rather than a serious component of his art. In the published text Northcote steered clear of any outright criticism of Reynolds. However, the unpublished notes he made for his own autobiography reveal a more deep-seated dissatisfaction.

The first of Northcote's grudges was specific. In 1791 Alderman Boydell, then Lord Mayor of London, had told Northcote of his scheme for promoting the civic patronage of high art by having each newly elected mayor commission a history painting from a British artist. Northcote quite naturally felt he would receive a commission. The plan was, however, squashed by Reynolds who, having told Boydell that 'it was a foolish scheme, because aldermen do not understand history painting', advised him to commission a portrait from Lawrence instead (British Museum, Add. ms. 47792 (Gwynn, 1898, p. 227)). In a letter written to Northcote

at the time, Reynolds denied he had made any such suggestion to Boydell, asking him 'if it was not very extraordinary that he, who had in all his discourses and writings so much insisted on the dignity of history painting, should be accused of acting so much the reverse of all he had said' (*ibid.*). Northcote's second grudge concerned Reynolds's tendency to treat his pupils as scivvies. 'He was not', confided Northcote, 'the master to produce good scholars, as most of his could never get a decent livelihood, but lived in poverty and died in debt, miserable to themselves and a disgrace to the art. I alone escaped this severe fate' (*ibid.* (Gwynn, 1898, pp. 225–6)). Finally, Northcote stated that Reynolds's private face was far less appealing than his public persona, and that his interest in promoting public art only extended as far as it did not threaten his own private ambitions. Moreover – and perhaps with Barry in mind – Northcote felt that Reynolds only encouraged artists who did not threaten his own position. 'The principal drawback on his character', he concluded, 'besides this selfishness, was a want of that firm and manly courage and honour which is so absolutely necessary to the highest degree of rectitude' (*ibid.* (Gwynn, 1898, p. 225)). In the published biography Northcote stated unequivocally that 'with respect to his character as a man, to say that Sir Joshua was without faults, would be to bestow on him that praise to which no human being can have a claim; but when we consider the conspicuous situation in which he stood, it is surprising to find that so few can be discovered in him' (1813, p. 400).

If Northcote, in the role of Royal Academician, felt unable to voice his frank opinions about Reynolds's art and life, William Hazlitt – as a confessed outsider – felt no such compunction. In 1819, another Royal Academician, Joseph Farington, produced a second, somewhat shorter, biography of Reynolds. Like Northcote's earlier biography (which had appeared in an enlarged two-volume edition in 1818), Farington's account was an agglomeration of second-hand facts, interlarded with personal reminiscences. Hazlitt – by now an influential, if controversial, voice – dismissed it in a few sentences in a review in *The Edinburgh Review*, of August 1820 (in Howe, 1930–4, vol. XVI, pp. 181–211). However, like Payne Knight before him, he used it as a hobby-horse to promote his own views on the state of the British School. In the course of his essay Hazlitt not only challenged the notion that a viable school of history painting could be built upon Reynolds's own achievement in that field but the very basis of Reynolds's own ideas – which he had already questioned in *The Champion* some years earlier. 'Sir Joshua did not, after all', he noted, 'found a school of his own in general art, because he had not the strength

of mind for it' (*ibid.*, p. 190). Having allowed some qualified praise of Fuseli and Barry, Hazlitt – with Reynolds clearly in the forefront of his mind – stated that: 'Our greatest and most successful candidates in the epic walk of art, have been those who founded their pretensions to be history painters on their not being portrait painters' (*ibid.*, pp. 207–8). And yet he felt that such divisions between the various genres were artificial. He did not, he avowed, seek to champion the cause of 'high art' against low, but to measure the claims of both these genres against 'true' art. 'We speak and think of Rembrandt as Rembrandt', he noted, 'of Raphael as Raphael, not of one as portrait, of the other as history painter. Portrait may become history or history portrait, as the one gives the soul or the mask of the face' (*ibid.*, pp. 206–7). Paradoxically, he recorded very much the same thing in conversation with Northcote, some years later, where he quoted the artist as stating: 'If a portrait has force, it will do for history; and if history is well painted, it will do for portrait, this is what gave dignity to Sir Joshua' (*ibid.*, p. 194).

Despite Hazlitt's reservations, there was little sign that Reynolds's history paintings were any less popular than they had been in the previous decade. In 1821 the largest existing collection of Reynolds's work, that of the artist's late niece, Mary Palmer, Marchioness of Thomond, was sold at Christie's.[39] The sale generated intense interest among artists and collectors. Haydon, who was present, relished the way in which Reynolds's work not only matched, but surpassed, prices fetched by his collection of old masters, including Teniers, Titian, and Correggio (Pope, 1960–3, vol. II, p. 337). Going on the evidence of purchase prices, the most sought-after picture in the sale was *Charity*, one of Reynolds's designs for the west window of New College, Oxford, which was sold to Lord Normanton for £1,575. Ironically, even Reynolds's sketch-books, which have only recently received any critical attention, were the object of fierce bidding, Sir John Soane, J. M. W. Turner, and William Herschel all competing to purchase a scrapbook of miscellaneous drawings (private collection – on loan to the Royal Academy of Arts).[40]

Two years later, in December 1823, Sir Thomas Lawrence, president of the Royal Academy, addressed students at a prize giving for history painting at the Academy. He began by recalling the past efforts of Barry, Fuseli, Opie, and the lately deceased Benjamin West, whose picture, although the public remained indifferent, 'remains Gentlemen for you, and exists for your instruction' (Lawrence, 1824, pp. 9–10). Lawrence, none the less, contended that West 'would still have yielded the chief honours of the English school to our beloved Sir Joshua!', who was the

main subject of Lawrence's lecture (*ibid.*, p. 12). Aside from rebuffing suggestions he had heard questioning the sincerity of Reynolds's admiration for Michelangelo, Lawrence revived the argument as to why portraits such as *Mrs Siddons as the Tragic Muse* and *Lord Heathfield* could legitimately be regarded as history paintings. And as if to countenance any opposition to the *status quo*, he concluded that 'there can be no new PRINCIPLES in art; and the verdict of ages (unshaken, during the most daring excitement of the human mind), is not now to be disturbed' (*ibid.*, p. 19). One conclusion to be drawn from the 1821 sale and Lawrence's lecture is that Reynolds's subject paintings continued to be not only a 'bankable' part of the artist's *œuvre*, but a paradigm for aspiring young artists. Another which can be drawn is that there was a growing gap between those who looked upon art in terms of investments or practical models and those whose concern went beyond individual painters and pictures and looked instead towards the establishment of a broader, and more democratic, basis for an indigenous school of art.

Sir Thomas Lawrence's lectures were published in 1824. The same year a small octavo volume was published anonymously by Hazlitt as *Sketches of the Principal Picture Galleries in England*. The book's aim was to provide a critical survey of those galleries open to the general public. Among those pictures mentioned were *Lord Heathfield* and *Mrs Siddons as the Tragic Muse*. Of the former work (then in the Angerstein collection) Hazlitt acknowledged that it was 'well composed, richly coloured, with considerable character, and a look of nature'. But, he concluded: 'our artist's pictures, seen among the standard works, have (to speak it plainly) something old-womanish about them. By their obsolete and affected air, they remind one of the antiquated ladies of quality, and are a kind of Duchess-Dowager in the art – somewhere between the living and the dead' (in Howe, 1930–4, vol. X, p. 15). Of the replica of *Mrs Siddons*, made in Reynolds's studio (Dulwich Picture Gallery) Hazlitt remarked that it 'appears to us to resemble neither Mrs Siddons, nor the Tragic Muse. It is in a bastard style of art' (*ibid.*, p. 26). By way of contrast, Hogarth, wherever possible, was praised warmly. Hazlitt's book was a compilation of articles he had been publishing in journals since the early 1820s. At the very time the *Sketches* emerged, a second anonymous guide to Britain's art galleries was published, entitled *British Galleries of Art*. The author was a friend of Hazlitt, the journalist Peter Patmore (1786–1855). Like Hazlitt's guide, Patmore's book was highly critical of Reynolds's contribution to high art. In the course, for example, of a perambulation of Lord Egremont's Gallery at Petworth the author noticed:

an execrable picture of Macbeth in the Witches' cave, by Sir Joshua Reynolds – which seems to me to evince a total want of sentiment, imagination, taste, and even execution. If Sir Joshua had discoursed no better about historical painting than he practised it, his lectures would have enjoyed a somewhat less degree of reputation than they do; and perhaps they enjoy too much as it is. (Patmore, 1824a, p. 88)

In addition to this general volume on British picture galleries open to the public, Patmore also wrote a guide to the Dulwich Picture Gallery. Here he found time to examine *Mrs Siddons as the Tragic Muse* – which had escaped his attention in the earlier work. 'Every one of the great historical painters of the 15th, 16th, and 17th centuries', he stated with regard to *Mrs Siddons*, 'have painted portraits equal to the best of Sir Joshua's; but he has scarcely painted one historical picture to equal the worst of theirs' (Patmore, 1824b, pp. 100–1). Both Patmore and Hazlitt were aware that although an increasing number of private picture galleries had been made open to the public by the early 1820s, opinions about works of art were still expressed only by a minority of artists and connoisseurs, and the public by and large felt intimidated. As one French visitor had noted, on visiting Sir John Fleming Leicester's gallery in Hill Street, London: 'The pleasures of the fine arts are enjoyed here only by the well-to-do. Why are the common people excluded from them? In Paris the poorest Frenchman may visit our magnificent Louvre' (in Whitley, 1930, p. 25). While neither Hazlitt nor Patmore appealed to the poor – or even the 'common people' – they wished to broaden the franchise of those who could enjoy works of art, and to give them the confidence to make their own evaluations of a particular painting's worth. As a result they were keenly aware of the need to entertain, as well as inform, the reader. The hallmark of their gallery guides was moreover a casual, irreverent, approach to art. 'In choosing the subjects for these papers', wrote Patmore in his introduction to his Dulwich Gallery guide, 'I must not forget that they are intended to be popular and amusing, rather than didactic' (1824a, p. 147).

Even among professedly didactic writers there were signs by the mid-1820s that Reynolds was not as secure on his pedestal as he had been in the past. In 1826 William Paulet Carey published *Some Memoirs of the Patronage and Progress of the Fine Arts in England and Ireland*. In it he traced the history of what he termed 'anti-British' prejudice among connoisseurs in the late eighteenth, and early nineteenth, century manifested by their unwillingness to purchase the works of native artists. While Reynolds made a good living from portraiture, his subject pictures, noted Carey, 'were executed for commercial men in this country and for foreigners'. His

conclusion, if ambiguous, was quite candid: 'if Reynolds had been necessitated to struggle for a living by history painting, he must have hazarded starvation' (Carey, 1826, pp. 35–6). Carey genuinely admired Reynolds's art. And yet he could not conceal the damage which he felt the apotheosis of Reynolds had inflicted upon the wider interests of the British School:

It is a memorable satire upon the affected taste of some of his contemporaries, that those chief panegyricists of Reynolds looked with indifference or contempt upon the fine moral and dramatic compositions painted by Hogarth, notwithstanding their great practical excellence ... the grand landscapes of Wilson, and the rural scenery and rustic groups of *Gainsborough*, were equally overlooked and neglected by the arbiters of taste, who were the eulogists of Reynolds. (*ibid.*)

Allied to the tarnishing of Reynolds's laurels as a history painter, the 1820s witnessed new revelations about Reynolds's personal life. The prime mover in this was again Hazlitt, although his stance was modified. While his earlier pieces had been deliberately provocative, his arguments were now presented in more assured terms, designed to encourage popular, but informed, debate. His articles now appeared in mainstream periodicals such as *The London Magazine*, *The New Monthly Magazine*, and the highly respected *Edinburgh Review*. In the summer of 1826 Hazlitt began to publish a series of 'conversations' with James Northcote in *The New Monthly Magazine*.[41] These articles created a whole new context of discussion of Reynolds's personal and professional status. Hazlitt had first met Northcote as early as 1802, probably through his brother, the miniaturist John Hazlitt. Following Fuseli's death in 1825, Northcote, then aged eighty, was almost the only person living who had close first-hand knowledge of Reynolds going back to the foundation of the Royal Academy. Hazlitt probably wrote the bulk of the 'conversations' in 1826, the first six being published between August 1826 and March 1827, under the title 'Boswell Redivivus' – although he had already published several related pieces.[42] 'All you have to do', maintained Hazlitt, 'is to sit and listen; ... it is like hearing one of Titian's faces speak' (in Howe, 1949, p. 384). And yet, although Hazlitt was ostensibly acting as Northcote's amanuensis, he was the puppet-master, adding to or omitting information according to its newsworthiness and applying the time-honoured journalistic maxim of never letting the truth get in the way of a good story. 'I have', he admitted, 'forgotten, mistaken, mis-stated, altered, transposed, a number of things'. And sometimes, 'I have allowed an acute or a severe remark to stand without the accompanying softenings or explanations, for

phobic. Cunningham in turn attempted to discredit Hazlitt and Northcote by highlighting what he perceived to be the unscrupulousness of their literary partnership (Cunningham, 1879, vol. II, pp. 384–419).

Cunningham's support for Hogarth was mirrored by his admiration for the contemporary Scots artist, David Wilkie. James Barry, on the other hand, was regarded as a metaphor for the demise of the traditional iconography of high art, as well as the failure of the oligarchy centred around Sir George Beaumont to shape the canon of the British School according to their own interests (*ibid.*, vol. I, pp. 328–91). 'Fame', as he observed in his life of Hogarth, was not bestowed by committees of taste but was 'the free gift of the people' (*ibid.*, pp. 73–4). Although Reynolds's portraits could be regarded as a form of history painting, Cunningham concluded that 'with the mob of portraits fame and history have nothing to do. The painter who wishes for lasting fame must not lavish his fine colours and his choice postures on the rich and titled alone; he must seek to associate his labours with the genius of his country' (*ibid.*, p. 254).

Such views were regarded by Hazlitt, who managed to keep his own prejudices in better check, with considerable suspicion. Hazlitt believed that it was wrong to adopt Lamb's viewpoint, as Cunningham had done, in looking for an alternative to the essentially Catholic traditions of high art in Hogarth's modern moral subjects. 'We hate', he affirmed, 'all exclusive theories and systems; insomuch as if the Catholic spirit of criticism were banished from the world, it would find refuge in our breast' (in Howe, 1930–4, vol. XI, p. 302). And, he continued, the 'attempt to prove that Hogarth was something more than what he was, shows that his bigotted admirers are not satisfied with what he actually was, and that there was something wanting' (*ibid.*). This was the same argument as he had used earlier against Reynolds's own acolytes. Hazlitt, although he had clearly helped to shape Cunningham's opinions, regarded them as simplistic. And, ironically, he perceived them to be as parochial and as xenophobic as the position adopted by Reynolds's own adherents in the years following his death in 1792. Hazlitt died in 1830. The following year Northcote died, aged eighty-five. Almost all those who had known Reynolds personally in adult life – Henry Fuseli, Joseph Nollekens, Benjamin West, Sir George Beaumont, and Sir Thomas Lawrence – were also now dead. Of those who had known Reynolds in adulthood, only William Beechey, who survived until 1839 (and whose 'Memoir' of the artist was published in 1835), could speak with personal authority about his subject. Subsequent debate on the merits of Reynolds's history paintings – which had since the 1770s been so closely tied to the artistic

and political development of the British School – became increasingly academic. In 1800 the position of Reynolds's history paintings within the canon of British art still seemed secure. A century later, Sir Walter Armstrong – a pillar of Edwardian respectability – could write, without fear of contradiction: 'Let us take them as his tribute to human frailty and give up all attempts to bring them within any reasonable view of art' (1900, p. 278).

Notes

1 *Several types of ambiguity: historical portraiture and history painting*

1 *Thaïs*, for example, is catalogued as a subject picture, although as the model's name was known it was also listed among the portraits. See Graves and Cronin, 1899–1901, vol. II, p. 762, and vol. IV, p. 1217.

2 Balkan also remarks of *Lady Sarah Bunbury Sacrificing to the Graces* (1972, p. 97): 'This classically inspired, grand-manner type of work certainly would have appeared to the viewer as a history painting and not as a portrait.'

3 The exact publication date of Fisher's print is not known. See Smith, 1878–83, Part II, p. 492. On 27 March 1759 *The Juvenile Adventures of Kitty F----r* was published. Two days later, on 29 March, Kitty Fisher published an advertisement in the *Public Advertiser*: 'Miss Fisher is forced to sue to that Jurisdiction to protect from the Business of the little Scribblers, and Scurvey Malevolence; she has been abused in public papers, exposed in Print Shops, and, to wind up the Whole, some Wretches, mean, ignorant, and venal, would impose upon the public, by daring to publish her Memoirs' (quoted in Bleackley, 1909, p. 61; see also pp. 299–302 for a bibliography of contemporary literature on Kitty Fisher).

4 *Kitty Fisher as Cleopatra* was purchased by Charles Bingham Bt, although it is not known exactly when he acquired it. See Penny, 1986, p. 196.

5 Penny suggested that Reynolds, in painting *Kitty Fisher as Cleopatra*, may have been influenced by Hogarth's *Sigismunda*, a work which 'was just enough of a portrait to be acceptable' (Penny, 1986, p. 196).

6 Lewis *et al.*, 1937–83, vol. XX, pp. 311–20 and *passim*. David Mannings has noted: 'Reynolds would have been keen to paint this sensation of London society because he knew it would attract attention at the exhibition' (Penny, 1986, p. 199).

7 See Shawe-Taylor, 1990, pp. 151–3 and Johnson, 1976, cat. 219, p. 86 (reproduced). By October 1760 Elizabeth Gunning was consumptive and had lost her looks. By November Walpole commented that she was 'a skeleton'. See Lewis *et al.*, 1937–83, vol. XXI, pp. 438, 451, and vol. XXII, p. 155.

8 In 1762 Reynolds and James Paine found alternative exhibition space in Spring Gardens for the newly formed Society of Artists of Great Britain. See Hutchison, 1968, pp. 36–7.

9 Florentinus, 'A CARD to Sir Joshua Reynolds, President of the Royal Academy', in the *Morning Chronicle*, 30 April 1773. For a concise account of the classification of art in the eighteenth century see Lee, 1940, pp. 197–249.

10 The person ['you'] referred to by Dilettante is presumably Guido, author of the 'The painter's mirror' in the *Morning Post*. 'Guido', however, only mentioned the *Bedford Children* once (on 25 April), and the notice was brief, but favourable.

11 The quotation is taken from one of a series of five letters, 'From an Italian Artist in London, to his Friend an English Artist at Rome. Transcribed from the Original'.

12 *Le Pour et Le Contre. Being a Poetical Display of the Merit and Demerit of the Capital Paintings Exhibited at Spring Gardens*, 4 May 1767, p. 14.

13 *The Universal Director; or, the Nobleman and Gentleman's True Guide to the Masters and Professors of the Liberal and Polite Arts and Sciences; and of the Mechanic Arts, Manufactures and Trade, Established in London and Westminster, and their Environs*, London, 1763, p. 24.

14 'Histories of the Tete-à-Tete annexed: or, Memoirs of the MODERN APELLES and the AIMIABLE LAURA', *Town and Country Magazine*, August 1779, p. 401.

15 For Alberti, see Grayson, 1972, p. 99; for Michelangelo see Pevsner, 1973, p. 35.

16 For discussion of theories on, and attitudes towards, likeness see Gombrich, 1982, pp. 105–36, and Shawe-Taylor, 1990, pp. 21–32.

17 For the importance of likeness to portrait-sitters see Pointon, 1993, pp. 79–85.

18 See Penny, 1986, p. 247 for notice of this portrait (formerly in the Carrington and Butler collections). Guido in 'the Painter's Mirror for 1774, No. 1', 3 May, *Public Advertiser*, states in a similar vein: 'Mrs Tollemache as Miranda: A whole length of Mrs. Tollemache. We think Sir Joshua has attended rather too minutely to the natural simplicity of Shakespeare's *Miranda* to do justice to the Lady before us.'

19 Mrs Quarrington sat to Reynolds in July 1771 (15 July at 10 a.m.; 18 July at 10 a.m.). The picture was not referred to in connection with this sitter until 1859, when it was put up at Christie's (13 June) as a 'Portrait of Mrs. Quarrington as St. Agnes'. Hitherto it had been referred to in sales and exhibitions as *St Agnes* (see Graves and Cronin, 1899–1901, vol. II, p. 777). Walpole, in his annotated Royal Academy exhibition catalogue, did not identify the sitter, but remarked cryptically: 'More like St. John'. For the unfinished version see Graves and Cronin, 1899–1901, vol. II, p. 778.

20 Reynolds painted Maria, Countess of Waldegrave, on several occasions. For a list of portraits see Graves and Cronin, 1899–1901, vol. 1, p. 184.

21 Gainsborough to the Earl of Dartmouth, 18 April 1771, in Woodall ed., 1963 (2nd edn) p. 53.

22 Quoted in Cunningham, 1879, vol. I, p. 69. For Reynolds and allegorical portraiture see Wind, 1937–8, vol. I, pp. 120–4; Hagstrum, 1958, pp. 144–50; Tinker, 1938, pp. 10–18.

23 Unsigned obituary in the *General Evening Post*, 25–8 February 1792. First

quoted in Felton, 1792, p. 105. The section quoted here was also incorporated by Northcote, with minor alterations, into 'A Biographical Memoir of Sir Joshua Reynolds, Knight', in Britton, 1812, p. 43. It appeared again, in an expanded form, in the *Memoirs of Sir Joshua Reynolds*, published in 1813, and in the two-volume edition of 1818. For an excellent survey of Northcote's use of source material see Lightbown's introduction to the modern facsimile edition of Northcote's 1818 edition (published by Cornmarket Press in one volume, unpaginated, and without a date of publication).

24 Quoted in Northcote, 1818, vol. I, p. 229, and in Penny, 1986, p. 17. Johnson's words are reminiscent of a phrase in Alberti's *De pictura*: 'Painting possesses a truly divine power in that not only does it make the absent present (as they say of friendship), but it also represents the dead to the living many centuries later, so that they are recognised by spectators with pleasure and deep admiration for the artist' (see Grayson, 1972, p. 61).

25 Nathaniel Hone first observed that the attitude was taken from a print after Raphael's *St Margaret* (Louvre). See John Newman, 'Reynolds and Hone. "The Conjuror Unmasked"', in Penny, 1986, p. 231, and pp. 348–9, cat. 62a and figs. 82–3 and 96.

26 For *Mrs Hale* see Mannings in Penny, 1986, pp. 228–9, and Beard, 1978, pp. 13, 60. Mary Chaloner (Mrs Hale) had first sat to Reynolds on 6 July 1762. The last recorded sitting was on 1 August 1764. Mannings (*ibid.*) has argued that *Mrs Hale as 'Euphrosyne'* was painted between 1764 and 1766, and that the earlier sittings may not, in fact, relate to the present picture. The music room at Harewood was not completed until 1769. Adam's coloured drawing shows panels in red, yellow and blue and pale cream walls. (Sir John Soane's Museum, 'Design for furnishing the Musick Room at Ganthrop [i.e. Harewood] House in Yorkshire. The seat of Edwin Lascelles, Esquire', vol. XIV, fol. 118.) Here, the subject painting above the fireplace is not *Mrs Hale* but a woman seated before a red tent, with two men in turbans to the right.

27 Nicholas Penny has pointed out that *Mrs Edward Bouverie* (Lord Radnor) originally took the form of a chimney-piece in the dining room of Delapré Abbey (see Penny, 1986, pp. 243–4).

28 The intended distribution of paintings in Watkin Williams Wynn's music room is clearly shown in Robert Adam's manuscript 'Plan and section of the music room in Sir Watkin Williams Wynn's House St. James Square' dated 24 August 1773 (Sir John Soane's Museum, vol. XL, fol. 71). At the right-hand side of the plan is written in pencil: 'Panells on each side of Chimney are intended for Pictures of St. Cecilia & ----- as mentioned in the Memorandum. Over Doors on each side of Organ was proposed also to have Heads of great Musicians. Over the Door of the End the Muses that honour the Tomb of Orpheus [shown in overmantel facing window]. The other Pannells to have Stucco Ornament with Lyre Girandols introduced.' The walls are washed-in in pea-green, with maroon decorative panels, cornice and

wainscot. To the left of the chimney-piece is a panel on which is written 'St Cecilia' while on the right-hand panel is a pen drawing of St Cecilia seated at a pipe-organ with angels above. See also Penny, 1986, pp. 266–7.

29 William Whitley quotes a letter from Lady Knight concerning the 1775 Royal Academy exhibition: 'Sir Joshua tells me he shall have many in, and there is to be a St Cecilia of his and an Apollo by Dance. I cannot depend either on my own judgement or impartiality but I think I shall like Reynolds best. These pictures are for W. Wynn's Music Room' (Whitley, 1928a, vol. II p. 166).

30 Ellis states that Burney had originally written 'Harpsichord' rather than 'harp' – which might indicate that she had seen the Waddesdon picture. However, given the fact that Burney subsequently crossed out 'Harpsichord' and that, of the two paintings, only the Los Angeles *St Cecilia* has legible sheet music, it seems more likely that it was the latter picture which Fanny Burney saw in Reynolds's studio.

31 Reynolds painted a number of full-length portraits based on the *St Cecilia* format (see, for example, *Lady Eglinton* of 1777 (Graves and Cronin, 1899–1901, vol. I, p. 282). Here too sheet music is shown (but at the sitter's feet).

32 Northcote, 1818, vol. II, p. 35, note. See also Le Fanu, 1960, pp. 118–19, and 168–9.

33 For the most recent critical evaluation of the painting see David Mannings in Penny, 1986, pp. 205–7.

34 Shortly after the picture was completed Elizabeth Montague referred to *Garrick between Tragedy and Comedy* as an 'historical picture' (Blunt, 1925, vol. I, p. 14). In 1798 William Jackson referred to it as Reynolds's 'first historical subject' (Jackson, 1798, p. 188). Edward Edwards, writing in the early nineteenth century, stated that 'it may be considered as his first attempt in historical composition' (Edwards, 1808, p. 188). His statement was repeated, verbatim, by James Northcote in 1812 (in Britton, 1812, p. 44). John Britton, in the same publication, stated with greater circumspection: 'This may be called a poetical portrait or an historical allegory: a living character constitutes the subject of the composition, but this is embellished by the fancy of the artist' (1812, pp. 51–2).

35 See Panofsky, 1930, pp. 37–196; Mannings, 1984, pp. 259–83, and Mannings in Penny, 1986, pp. 205–7; and Busch, 1984, pp. 82–99.

36 Mannings states: 'Shaftesbury says Virtue should carry a sword. Why then does Reynolds replace the sword with a dagger?' (Mannings, 1984, p. 264). The reason must be that the dagger (like the poison chalice) is a standard emblem of Melpomene, the Tragic Muse and, as such, suits Reynolds's parodic intention (just as Comedy holds a mask, the emblem of Thalia, the Comic Muse).

37 As Wind pointed out, although Garrick is depicted between Tragedy and

Comedy, he has in fact already chosen the latter figure. In this sense it could be argued that Reynolds has shifted the action to Shaftesbury's fourth moment – when Hercules has been won over by Virtue. And yet, as Wind states, Garrick's movement may well relate to the actor's own theory of acting where 'the tragedian, in order to be able to present the peaks of emotion truthfully, should first and foremost be schooled in the manifold techniques of comedy' (see Wind, 1986, pp. 36–8).

38 See Addison, 1726, p. 171, fig. 1 and p. 36 for a discussion of this particular medal. See also Addison, 1741, vol. I, pp. 419–525. Also Shawe-Taylor, 1987, pp. 53ff.

39 Bysche: 'She was very decently array'd in white' (1712, p. 53); Lowth: 'A vest, more white than new-fall'n snow she wore' (in Spence, 1747, p. 156); Shenstone: 'Such the chaste Image of the *martial Maid* / In artless Folds of virgin White array'd' (1741, p. 8).

40 *The Theatrical Review; or Annals of the Drama*, February 1763, p. 79. Wind considered 'the suggestion that Garrick in his later years increasingly turned away from tragedy, ceased to be a "mixed" actor, and became a purely comic one' but concluded that 'the facts of theatrical history belie this' (Wind, 1986, p. 36).

41 Horace Walpole stated: 'Reynolds has drawn a large picture of three figures to the knees, the thought taken by Garrick from the judgement of Hercules' (Hilles and Daghlian, 1937, p. 61).

42 For Garrick's library see *A Catalogue of the Library, Splendid Books of Prints, Poetical and Historical tracts of Davide Garrick Esq ... sold by Auction, by Mr. Saunders, at his Great Room, 'The Poets' Gallery, No. 39 Fleet Street*, 23 April–1 May 1823. Lots 14 and 2266 were, respectively, 'Choses (Les) Memorable de Socrate (ib. 1650)' and 'Shaftesbury's (Earl of) Characteristicks of Men, Manners, Opinions, and Times, 3 vols., *with gribelin's plates*'.

43 See Mannings, 1984, pp. 266, 279–80. Reynolds owned a copy of *Polymetis*. See *A catalogue of All the great and Valuable Collection of Ancient Drawings, Scarce Prints, and Books of Prints, which belonged to Sir Joshua Reynolds*, sold by Phillips, 5–26 March 1798, lot. 1437. See Williams, 1939, p. 121, for Shenstone's observation that the poem was by Lowth.

44 Johnson stated of *The Judgement of Hercules*: 'The numbers are smooth, the diction is elegant, and the thought is just' (quoted in Galinsky, 1972, pp. 213–14).

45 For an alternative explanation of Comedy's hairstyle see David Mannings in Penny, 1986, p. 206.

46 See Rogers, 1983, cat. 46, pp. 88–90 and Spencer, 1937, pp. 42–3, and cat. 17. (In 1937 the left-hand figure was believed to be Balthazar Gerbier.)

47 The only other prominent work which might have influenced Reynolds's picture is Lairesse's *Choice of Hercules* (Louvre). Yet it was almost certainly, as Mannings notes, unknown to Reynolds (1984, p. 272, n. 26). The close

similarities between Dobson's Lanier and Reynolds's Garrick are all the more
striking as Mannings notes that there is 'no real parallel' for either Garrick
or the figure of Comedy 'in any of the obvious pictorial prototypes' (1984, p.
275).

48 William Cotton stated: 'Miss Gwatkin has herself told me that her mother sat
to Sir Joshua for the head of Comedy in the celebrated picture of Garrick' (in
Cotton, 1856, p. 70). However, as Leslie and Taylor pointed out, Theophila
Palmer would only have been five at the time (1865, vol. I, p. 265). 'Comedy'
does, however, seem to have been associated with small girls, as Fanny
Burney noted: 'When he [Garrick] went away, he caught Charlotte [Fanny's
sister] in his arms, and ran with her down the steps ... protesting he intended
taking her off as his own *Reynolds's Comedy*, which she looked as if she had
sat for' (in Ellis, 1889, vol. I, p. 197, n. 3).

49 In the mid-nineteenth century it hung above the door of the state dining
room (see Scharf, 1860, p. 7).

50 The Countess of Northumberland sat to Reynolds on 25 and 29 November
and 3, 7, and 14 December 1757. The earl sat on 19, 20, 21, and 22 October
and 1, 2, 6, and 24 November 1762. See also Graves and Cronin,
1899–1901, vol. II, pp. 697–9. Reynolds's portraits hung in the picture
gallery at Northumberland House (Anon., 1766, vol. I, p. 192, and Penny,
1986, pp. 24–5). For notice of entertainments at Northumberland House see
Horace Walpole in Lewis *et al.*, 1937–83, vol. X, pp. 34–5; vol. XXXII, p. 27;
and vol. XXXVIII, pp. 400–1.

51 Walpole, 1762–71, vol. II, p. 60 and p. 109 (Walpole's information derived
largely from the notebooks of George Vertue), and Anon., 1766, vol. I, p.
192.

52 For Reynolds's ownership of this picture see Broun, 1987, vol. II, pp. 95–8,
and Walpole, 1762–71, vol. II, p. 88.

53 The subject for Dobson's picture may have been suggested by Lanier, who not
only had a thorough grounding in European art (having collected works on
behalf of Charles I in Italy), but who also must have been familiar with Ben
Jonson's 1618 masque, 'Pleasure reconciled to Virtue' – a satirical version of
the Choice of Hercules.

54 Rogers suggests the influence of Veronese's *Choice of Hercules* (New York,
Frick) on Dobson (1983, p. 89).

55 Shaftesbury stated: 'in a real *History Painter*, the same Knowledg [*sic*], the
same Study, and Views, are requir'd, as in the real *Poet*' (1714, vol. III,
p. 387). For comparisons between painting and poetry in the *Discourses* see
Wark, 1975, pp. 145–6, and 234–6. For Reynolds's views on the superiority
of poetic truth over historical truth see *ibid.*, pp. 59–60. Reynolds follows
Shaftesbury in his endorsement of the 'Unity of Time'. 'What is done by
Painting', he stated, 'must be done at one blow' (*ibid.*, p. 146).

56 The print, of which there is a state in the print room of the British Museum, is by H. E. Haid. See Britton, 1812, p. 54, and Wind, 1986, p. 36.

57 *A Pindarick Ode on Painting, Addressed to Sir Joshua Reynolds esq.*, London, 1767, quoted in Felton, 1792, p. 11.

58 Richard Cumberland, *The Brothers, A Comedy, As it is Performed at the Theatre-Royal in Covent Garden*, London, 1770. Cumberland's dedication was to Reynolds's friend, the Duke of Grafton. The epilogue has been quoted, in part, by Northcote (1818, vol. I, p. 105); Stone, 1962, pt. IV, p. 1440; Mannings in Penny, 1986, p. 206; and Wind, 1986 p. 36.

59 Wind suggested that Reynolds may have avoided theatrical depictions of actors and actresses, 'because he was fully aware of the opposition between the natural and the heroic and strove to resolve it' (Wind, 1986, p. 41). The difference between Reynolds's depiction of Garrick and those of other artists has also been noted by Kalman A. Burnim (see 'Looking upon his like again: Garrick and the artist', in Kenny, 1984, pp. 208ff.).

60 See Pressly, 1981, p. 55, and Simon, 1979, pp. 213–20. Simon has demonstrated that Hogarth (as Barry was to do later) took his inspiration directly from Shakespeare's text rather than from corrupted versions currently in use. See also Boase, 1947, pp. 83–108, and Merchant, 1959, pp. 35–65.

61 'For the London Evening Post. On Mr. Barry's admirable Picture of King Lear, now exhibiting at the Royal Academy, Pall-Mall' (*London Evening Post*, 3–5 May 1774).

62 'To the Hon. Mrs. T-----, on seeing the Picture of Miranda at the Royal Academy exhibition' (*Public Advertiser*, 10 May 1774).

63 Reynolds recorded sittings with Miss Morris on the following dates: 25 August at 12 p.m.; 29 August at 11 a.m.; 1 September (no time); 5 September at 9 a.m. (and 'Mrs Morris Queen Street'). In 1767 opposite 9 March: 'Mrs Morris picture & the other to be directed to Val. Morris Esq. at Piercefield Monmouthshire to go by James' Bristol Waggon from the 3 cups bread street or white Ros[s]e cellar Picadilly'. See also entries at 9 a.m., 4 September, 1767 ('Mrs. Morris'); 9 a.m., 7 January 1768 ('Miss Morris'); 9 a.m., 25 May 1768 ('Mrs Morris'). Leslie and Taylor stated that Miss Morris was the daughter of Valentine Morris, a Governor in the West Indies, 'on whose death the widow returned to the country in impoverished circumstances, with a son and two daughters' (1865, vol. I, pp. 323–4).

64 In his testimony James Smith stated 'that in Novr 1768 Deft. Colman intending to Engage Miss Morris as an Actress & representations had been made to pltv [plaintiff] by Miss Morris's Friends & Relations to prevent her Appearing upon the Stage & threatening to bring some Action or Actions agt Pltv [against plaintiff] & the proprietors of sd Theatre if she was permitted to appear on the stage' (British Museum, Department of Manuscripts, Add. ms.

33218, Harris vs Colman 1767–8, fol. 27). The case is mentioned in Stone, 1962, Part IV, p. 320.

65 Miss Morris's first performance was on 26 November 1768. Her sixth and last performance was on 2 December 1768. Stone, 1962, Part IV, pp. 1370–1. See also Highfill, Burnim, and Langhans, 1973–, vol. X, p. 320.

66 Reynolds recorded sittings on 14, 17, and 21 January, all at 11 a.m. (An appointment is also recorded for 17 February at 9 a.m., although it is crossed out.)

67 Walpole, in his Royal Academy exhibition catalogue, noted: 'Pretty, her head taken from Correggio's Leda'. See also Graves and Cronin, 1899–1910, vol. II, p. 671. For the version of Michelangelo's *Leda* (National Gallery, London) see Gould, 1962, p. 98, and Broun, 1987, vol. II, pp. 292–5. Broun notes that Reynolds may have owned the painting as early as 1761.

68 *Public Advertiser*, 3 May 1769: 'Monday Night died at Kensington Gravel Pits, where she went for the Recovery of her Health, Miss Morris, the young Lady who appeared this Season with so much Applause at Covent Garden Theatre.'

69 Mrs Hartley's first known stage appearance was as Monimia in *The Orphan* on 4 December 1771. By spring 1772 Garrick had become interested in her. She made her debut at Covent Garden on 5 October 1772 in Rowe's *Jane Shore*, where her looks apparently attracted more attention than her acting ability. See Highfill, Burnim, and Langhans, 1973–, vol. VII, p. 156.

70 In 1771 Mrs Hartley sat to Reynolds at 2 p.m. on 11 July; 11 a.m. on 12 July; 11 a.m. on 16 July; and 1 p.m. on 18 July. Opposite 16 September 1771 Reynolds noted: 'Send to Mrs Hartley.' At the back of the sitter-book (opposite p. 111), is the memorandum: 'Mrs Hartly Little James Street Haymarket at Mr. Kellys'.

71 She sat to Reynolds in 1773 on 23, 26, 30, 31 August and 4 September (each time at 11 a.m.).

72 For *Mrs Hartley as Jane Shore* see Graves and Cronin, 1899–1901, vol. II, p. 448. Mrs Hartley also sat for at least one other painting by Reynolds. See 'Mrs Hartley as a Madonna' in Graves and Cronin, 1899–1901, vol. II, p. 470.

73 Reynolds evidently intended to have the picture engraved: on the back fly-leaf of the sitter-book for 1773, opposite p. 192 is written, 'Jane Shore to Mr Dixon'.

74 Marchi's print was published on 20 February 1773. See also Smith, 1878–83, vol. II, p. 915.

75 See Anthony Griffiths, 'Prints after Reynolds and Gainsborough', in Clifford, Griffiths, and Royalton-Kisch, 1978, pp. 29–42.

76 For the popularity of Milton in eighteenth-century England see Good, 1915, especially chapter 3, 'The publication of Milton's works'. Good's table, showing the number of editions of Milton's works published each year,

reveals that there was a significant increase in interest in Milton between 1740 and 1790 (1915, p. 141).

77 On 3 November 1787 *The World* stated: 'Sir Joshua Reynolds, more than any painter who ever lived, is endebted to engraving'. In 1773 Giuseppe Marchi exhibited 'Mrs Hartley, from Sir Joshua Reynolds, a mezzotinto' (no. 169), at the Society of Artists.

78 David Alexander has observed that although Reynolds was the most engraved of all British artists in the eighteenth century, 'this is not to suggest that Reynolds himself needed to arrange the engraving of pictures once he became successful' (1977, p. 3). C. R. Leslie stated: 'Sir Joshua, with all his popularity, never made money by the publishers. He gave his pictures to the engravers, and was always beset by applicants' (Leslie and Taylor, 1865, vol. II, p. 365). For the role of the mezzotint in Reynolds's art see also Wax, 1990, pp. 73–86.

79 It was not unusual for prints to be published before the painting itself was exhibited. See, for example, Richard Houston's mezzotint of Reynolds's *Maria, Countess of Waldegrave and her Daughter*, published in 1761, a year before the painting was shown by Reynolds at the Society of Artists. See Clifford, Griffiths, and Royalton-Kisch, 1978, cat. 107, p. 43.

80 '"D--n him, how various he is!" exclaimed Gainsborough, as he passed before the pictures of Reynolds, in one of the exhibitions' (Leslie and Taylor, 1865, vol. II, p. 83). Dr Johnson gave four definitions of 'various': (1) 'Different; several; manifold'; (2) 'Changeable; uncertain; unfixed; unlike itself'; (3) 'Unlike each other'; (4) 'Variegated; diversified' (1827, vol. III, p. 19). While it is possible that Gainsborough merely meant that Reynolds was 'diversified', Johnson's second definition, now obsolete, is probably – given the context of the comment and Gainsborough's sardonic turn of phrase – closer to Gainsborough's intention. (I am grateful to Robin Simon for discussing this point with me.)

81 The *General Advertiser*, 27 April 1779, stated: 'The first of these pictures [*The Nativity*] is an historic piece, in which we immediately recollected in the person of Joseph, our old friend the *Captain of Banditti*, and the *Nobleman in Prison, taken from Dante*, exhibited by Sir Joshua some years ago. This plagiarism, however, may be pardonable when a painter *only steals from himself.*'

82 For George White's career as an artist's model see Postle, 1988a, pp. 204–5.

83 Graves and Cronin stated that Elizabeth Johnson was the model for Fortitude (1899–1901, vol. II, p. 527). And yet she also apparently modelled for Reynolds's figure of Design, the face of which is closer to Justice. Tinker states that the model for Fortitude was Lady Dudley and Ward (Tinker, 1939, p. 64). For Prudence and Charity see Graves and Cronin, 1899–1901, vol. III, pp. 1185 and 1187.

84 Robert Rosenblum, 'Reynolds in an International Milieu', in Penny, 1986, p. 44.

85 See Graves and Cronin, 1899–1901, vol. IV, p. 1387. See also the *Gazetteer*, 25 May and 5 June 1781; Romney, 1830, pp. 173–9; Cotton, 1856, p. 155.

86 Aside from *Thaïs* there are no other recorded portraits by Reynolds of Emily Pott, although she was also painted by Nathaniel Dance, George Romney, and the miniaturist Charles Shirreff (or 'Sheriff'). See Spencer, 1913–25, vol. IV, p. 488. William Hickey – the primary source for information on Emily Pott – was a close friend of her lover, Bob Pott, as well as being the son of Reynolds's legal adviser, Joseph Hickey (1712–94).

87 William Whitley stated that the author of *The Earwig* was the failed history painter, Mauritius Lowe (1746–93) – although the claim has never been substantiated (1915, pp. 175–6). For Lowe see Brownell, 1989, pp. 56–68.

88 See 'Histories of the Tete-à-Tete annexed: or, Memoirs of Captain Toper and the Hibernian Thaïs', *Town and Country Magazine*, July 1777, p. 345 and 'Histories of the Tete-à-Tete annexed: or, Memoirs of the Noble Cricketeer, and Miss G-----m' (*ibid.*, October 1776, p. 513). See also the *European Magazine*, November 1783, p. 323.

89 Reynolds noted in his ledger, a second payment, 'Hon. Mr. Greville, for Thais, and his own picture / 157 0 0'. The entry is not dated but appears between entries in June 1786 and 21 June 1787. See Cormack, 1970, pp. 153–4. Nicholas Penny adds: 'That *Thaïs* cost a hundred guineas, as Northcote claimed ... is confirmed by another, cancelled entry on the former page of the ledger (not transcribed by Cormack)' (1986, p. 296). See also Northcote, 1813, p. 281, and Northcote, 1818, vol. II, pp. 120–1.

90 The quotation is taken from Whitley Papers deposited in the print room, British Museum. (There is no copy of the relevant issue of *The Morning Herald* in the British Library.)

91 Macklin paid a total of 1,500 guineas to Reynolds for *The Cottagers*, *Tuccia*, and *The Holy Family*. Although payments for *The Cottagers* and *The Holy Family* are grouped together in Reynolds's sales-ledger, it appears that 400 guineas was paid for *Tuccia* (in two instalments of 200 guineas); 500 guineas for the *Holy Family*, and 600 guineas for *The Cottagers*. See Cormack, 1970, pp. 158–9.

92 Edward Hamilton identified P. W. Tomkins's 1796 stipple engraving of 'The Vestal' or *Tuccia*, as a portrait of the Duchess of Rutland, and consequently lists it in his portrait catalogue, rather than among Reynolds's subject paintings (1874, p. 97).

93 The following year *The Morning Herald* (16 April 1788) reported: 'Macklin's Poets' Gallery, No. III The VESTAL. Mrs Seaforth is the Lady who sat for the Vestal, and, with a great share of conscious security a considerable degree of beauty is united'. (*The Times*, 21 April 1788, also identified the model as Mrs Seaforth.)

94 For a complete list of Fuseli's contributions to *The Analytical Review* see Mason, 1951, pp. 355–9.

95 See, for example, Guido, 'The Painter's Mirror for 1781, No. 1' (*The Morning Herald*, 1 May 1781). In his opening remarks on the 1781 exhibition Guido mentions only Gainsborough. In 'The Painter's Mirror...No. 2' (2 May) Reynolds's work is mentioned, although not entirely unfavourably.

96 The same newspaper had already promoted the picture several days earlier, on 28 April. The 'Nymph and Cupid' referred to in the review is now better known as *The Snake in the Grass*.

97 Early in 1783 William Russell published *The Tragic Muse: A poem Addressed to Mrs Siddons* (cited by Wark, 1971, p. 46). In October 1782 Mrs Siddons had returned, after almost seven years, to the London stage. By December 1782 – almost eighteen months before Reynolds exhibited her portrait at the Royal Academy – her pre-eminence was undisputed. See ffrench, 1954, pp. 60–6. For discussion of the relation of Mrs Siddons to her assumed *persona* of the 'Tragic Muse' see Weinsheimer, 1978, pp. 317–28.

98 *Lord Heathfield* was exhibited at the Shakespeare Gallery in 1790. It was one of nineteen non-Shakespearean 'MISCELLANEOUS Pictures...placed in the middle Compartment of the Gallery' (see *A Catalogue of the Pictures etc. in the Shakespeare Gallery, Pall Mall*, London, 1790, pp. 125–6). Apart from *Lord Heathfield*, there were no other portraits, apart from two civic dignitaries by William Miller. See also John Boydell, 1794, p. 18, no. XI; Davies, 1959, cat. 111, pp. 80–1; Graves and Cronin, 1899–1901, vol. IV, p. 1480; and Bruntjen, 1974, p. 266.

99 The picture by West was the *Death of Chevalier Bayard* (Her Majesty the Queen), exhibited at the Royal Academy in 1773.

2 *The infant academy*

1 When Reynolds exhibited a portrait of Theophila Palmer's daughter at the Royal Academy in 1789 it was entitled 'Portrait of a Young Lady'.

2 Maria Edgeworth to her sister, Mrs Butler, 29 March 1831 in Barry, 1931, p. 380.

3 For Mercier see Ingamells and Raines, 1969, pp. 39–41.

4 See, for example, *A Strawberry Girl*, exhibited at the Royal Academy in 1773 (no. 242), of which there are at last six studio versions (Graves and Cronin, 1899–1901, vol. III, pp. 1213–16, and Ingamells, 1985, pp. 151–3). There is a note in Reynolds's ledger of picture sales (in which he also made a number of notes on his use of colours, glazes, and waxes) dated October 1778: 'Strawberry Girl. cera. Sol' (in Cormack, 1970, p. 168).

5 Northcote stated (1818, vol. II, p. 180): 'Sir Joshua was exceedingly willing at all times to lend pictures, prints or drawings, or any thing in his possession,

particularly to young artists; and he has sometimes been near losing them, by their being seized for rent, or from other circumstances to which the indigence of the borrowers rendered them liable.'

6 Some idea of the popularity of Reynolds's fancy pictures can be gauged from the fact that between 1856 and 1894 no fewer than 323 full-scale copies in oil were made from Reynolds's *Age of Innocence*, which was presented to the National Gallery, London, in 1847. (Information supplied by Elizabeth Einberg.)

7 Reynolds's references to child models in his pocket books were seldom more than 'boy', 'girl', or 'children', while the records he kept in his ledgers of the resulting fancy pictures were often just as curt. See, for example, 'Feb. 1778 Mr. Harding, for a Boy Do., for a Girl', or 'Paid April, 1786 Lord Shelburne, for two half-lengths 147 0 0' (in Cormack, 1970, pp. 154 and 163).

8 An example of how taste altered the meaning of a picture is Reynolds's portrait *Mrs Crewe in the Character of St Genevieve* (private collection), which was exhibited at the Royal Academy in 1772 (no. 206) as 'A lady, whole length'. It was exhibited at the British Institution in 1866 (no. 179) as 'A shepherdess', and in 1867 as an 'Alpine shepherdess' (no. 676). See Graves and Cronin, 1899–1901, vol. I, p. 208.

9 See Mannings in Penny, 1986, pp. 264–5. *Hannibal* was sold at Greenwood's, 16 April 1796, lot 35. A studio replica appeared on the London art market in 1971. There is no evidence to support the suggestion that the sitter was either the son of the auctioneer, Peter Coxe, or Thomas Coke, whose names have both been linked with the painting (see Graves and Cronin, 1899–1901, vol. I, p. 203).

10 Hazlitt, 1873, p. 33, reprinted from *The Champion*, 30 October 1814. For the source of Reynolds's *Infant Jupiter* see Newman in Penny 1986, p. 350, fig. 97.

11 For *Master Herbert* see Graves and Cronin, 1899–1901, vol. I, p. 459.

12 Cormack 1970, p. 156; see also p. 105 for a table of Reynolds's prices for different sizes of canvases over the period 1753–91.

13 See Waterhouse, ms. essay, p. 4 and 1941, p. 64. Reynolds recorded the following sittings for a 'Shepherd Boy' in 1773; 20 and 25 January at 10 a.m., 27 February at 4 p.m., 10 March at 10 a.m., 23 March at 4 p.m., 5 April at 11 a.m. In 1777 the following sittings for a 'Boy Shepherd' are recorded; 14 and 18 January at 9 a.m., 27 and 30 January (no time given), and 4 February at 9 a.m. See also Reynolds's *Study of a Seated Shepherd*, pencil laid on paper (13·4 × 22·2 cm.), Yale Center for British Art.

14 It was almost certainly this picture, and not another later work engraved as, and known as, *The Age of Innocence*, which was sold at Squibb's auction rooms by Greenwood on 15 April, 1796 (lot 59) to Ford for £17 6s 6d. But see Penny 1986, p. 318.

15 Robert Rosenblum, 'Reynolds in an international milieu' in Penny, 1986,

p. 46 and n. 7. For the most recent discussion of Reynolds and French art see Perini, 1992, pp. 205–20. For Reynolds's collection of French paintings see Broun, 1987, vol. II, pp. 187–226.

16 It was sold by Lady Thomond, 19 May 1821 (lot 37). See Leslie and Taylor 1865, vol. II, p. 3, and Graves and Cronin 1899–1901, vol. III, p. 1206 (where the painting is incorrectly catalogued).

17 Leslie and Taylor incorrectly state that Miss Price was the daughter of Uvedale Price. See Leslie and Taylor, 1865, vol. I, p. 357. Walpole identified her as the daughter of Chase Price. See Graves, 1906, vol. VI, p. 270.

18 Reynolds had used this attitude in formal female child portraiture since the 1750s. See, for example, Anne Townshend of 1757 (Graves and Cronin, 1899–1901, vol. I, p. 985 – although their identification of the sitter is incorrect) or Miss Murray of 1765 (Graves and Cronin, 1899–1901, vol. II, p. 680). Reynolds continued to use the same attitude in the 1770s in, for example, Anne Fitzpatrick of 1779 (*ibid.*, 1899–1901, vol. I, p. 314).

19 John Ingamells has stated that the version of *A Strawberry Girl* in the Wallace Collection is probably the painting exhibited by Reynolds at the Royal Academy in 1773. See Ingamells (1985, pp. 151–3). However, while the version purchased by Lord Carysfort – reproduced here – was engraved in mezzotint by Thomas Watson in 1774, the Wallace Collection version was not engraved until 1873. In addition, Northcote's list of Reynolds's subject pictures notes: 'Strawberry Girl / Lord Carysfort / 50 [guineas]' (1818, vol. II, p. 351).

20 There is a note in Reynolds's sales ledger, probably made in 1767; 'Offe's Picture painted with Cera & cap. solo – cinabro' (in Cormack, 1970, p. 141). This may refer to the 1767 portrait of Offy Palmer, sold at the Earl of Rosebery Sale, Christie's, 5 May 1939, lot 112. See Graves and Cronin, 1899–1901, vol. II, pp. 723–4. The attitude of the girl is identical to *A Strawberry Girl* and the face is similar, although her hands and forearms are concealed by a muff. There is a pencil sketch relating to *A Strawberry Girl* in the Herschel Album, on loan to the Royal Academy of Arts (see Herrmann, 1968, pp. 650–8, fig. 10).

21 See also, for example, Christie's, 10 May 1899, lot 5757: 'monochrome, 35 × 29 ins, portrait of a girl called "study for Robinetta"'.

22 For *A Nymph and Bacchus* see Leslie and Taylor, 1865, vol. I, pp. 376–7, n., and p. 399, n. 2; Graves and Cronin, 1899–1901, vol. III, pp. 1165–6, and vol. IV, p. 1456, 1480 AA; Armstrong, 1900, p. 238; Waterhouse, 1941, p. 61; Cormack, 1970, p. 143; Prochno, 1990a, pp. 172–3, figs. 158–9.

23 Perini, 1988, pp. 163–4, pl. 16b. See also Binyon, 1902, vol. III, p. 198, no. 12, fol. 2. See also Penny, 1986, p. 273, and Mitchell, 1942, p. 39. It is possible that *The Child Baptist in the Wilderness* was begun as early as 1770, as a picture with this title is mentioned by Reynolds in his ledgers around this time (see Cormack, 1970, p. 143).

24 For a recent evaluation of Reynolds's Italian sketchbooks see Perini, 1988, pp. 141–68, and 1991, pp. 361–412.

25 A version may have been sold to Augustus Keppel, as among the list of pictures bought by Keppel in September 1779 is 'Do., for Samual [*sic*] 50' (in Cormack, 1970, pp. 156–7). However, a line has been drawn through this entry, suggesting perhaps that the purchase was not completed.

26 For John Opie's painting, the *Calling of Samuel* of *c.* 1803, which depends heavily on Reynolds's *Infant Samuel*, see Cannon-Brookes, 1989, cat. 15, p. 56.

27 Cormack, 1970, p. 149: 'Feb 3 1778 Mr. Chamier, for a Samuel, sent to France 52 10 0.' The picture has been identified with the version of the *Infant Samuel* in the Musée Fabre, Montpellier, which is signed 'J. Reynolds pinxit 1777' and inscribed in the bottom left 'Samuel chap. 3'. See Graves and Cronin, 1899–1901, vol. III, pp. 1200–1; Waterhouse, 1941, pp. 67 and 115; Postle, 1989, catalogue, p. 97.

28 Farington's informant was Charles Long. The picture was probably 'Jul. Romano (49) The Triumph of Venus, an undoubted picture of this scarce master' sold for £9 19s 6d to Mitchell, at Christie's, 13 March 1795, in the sale of Reynolds's old-master collection.

29 The description in the catalogue of Rising's sale (Christie's, 2 May 1818, lot 108) read: '"The Call of Samuel". From the original picture by Sir Joshua, which was consumed at Belvoir Castle. This admirable copy was made in the room and under the eye of Sir Joshua, who applauded Mr. Rising for his ability' (quoted in Graves and Cronin 1899–1901, vol. III, p. 1200).

30 Gainsborough's *Girl with Pigs* was sold by Reynolds to M. de Calonne for 300 guineas, although in Calonne's were published in December 1936. See Burke and Caldwell, 1968, cats. 165–6.

31 See Paulson (1989), 99–100 and plates 141 and 142.

32 Reynolds recorded in his ledger in February 1778, between the sale of self-portraits of Mr and Mrs Hardinge: 'Mr. Harding, for a Boy 42 0 0 / Do. for a Girl 42 0 0' (in Cormack, 1970, p. 154). George Engleheart made miniatures of both works in 1778. See Williamson and Engleheart, 1902, pp. 47–8.

33 Graves and Cronin, 1899–1901, vol. III, pp. 1158–60, vol. IV, p. 1455, 1480 AAA; Waterhouse, 1941, pp. 73 and 125 and pl. 229; Prochno, 1990a, pp. 164–5, figs. 149 and 150, which reproduces Reynolds's pen-and-ink sketch for *The Infant Academy*, in the Beinecke Rare Book and Manuscript Library, Yale University.

34 Graves and Cronin, 1899–1901, vol. III, p. 1164; Waterhouse, 1941, p. 73, pl. 228B; Wind, 1986, p. 25, and n. 69; Carey McIntosh, 'Reynolds's portrait of the Infant Johnson', in Bond, 1970, pp. 279–96; Brownell, 1989, pp. 89–90.

35 Robert Rosenblum, 'Reynolds in an international milieu' in Penny, 1986,

pp. 46–7. It was in a sales catalogue of 1832 (Phillips, 18 May, lot 6) that Reynolds's picture was modelled on a painting by Amigoni, which in the 1770s belonged to the Earl of Wemyss (see annotation by Waterhouse in Graves and Cronin 1899–1901, vol. III, p. 1159, Paul Mellon Centre for Studies in British Art).

36 There is no contemporary evidence to support Reynolds ever having copied Rembrandt's *Girl at a Window* but see Graves and Cronin, 1899–1901, vol. VI, pp. 1448–9, Paul Mellon Centre for Studies in British Art, London; Haak, 1969, p. 190, pl. 310; White *et al.*, 1980, p. 39, cat. 51. See also Brown *et al.*, 1992, pp. 35–6, fig. 10, where the link with the Hermitage copy of the Rembrandt is discounted as being by Reynolds.

37 The identity of 'Mr Campbell' is not known. He may have been John Campbell (first Baron Cawdor). It is also possible that he was a member of the Hume-Campbell family, since both the version of Reynolds's *Laughing Girl* illustrated here and a pastel copy of Rembrandt's *Girl at a Window* made in either 1774 or 1779 (see Brown, 1992, pp. 21 and 35, fig. 9) appear to have been owned at one time by the Hume-Campbells of Berwick.

38 The painting was purchased by Opie at the Polygraphic Society sale, 14 November, 1795. It was sold in Opie's own posthumous sale on 6 June 1807 (see Graves and Cronin, 1899–1901, vol. IV, p. 1456).

39 Engleheart lists the picture in his fee-book, on 5 December 1778. See Williamson and Engleheart, 1902, p. 47. For further discussion of Engleheart's miniatures after Reynolds see pp. 45–56 above.

40 Cormack, 1970, p. 146: 'July 4 1781 Mr. Brommel, for Laughing Praying Boy 50'. Reynolds recorded in his 1781 sitter-book (16–22 April) a 'Laughing Child' among the works he intended to exhibit. Brummell may have purchased the picture as a result of seeing it in the exhibition. Graves and Cronin confuse the painting with *The Infant Samuel* (see 1899–1901, vol. III, p. 1203).

41 See Waterhouse, ms., p. 5, and 1973, p. 15. See also White *et al.*, 1980, p. 34, cat. 32, and Broun 1987, vol. II, p. 72.

42 See sheet of copies after etchings by Rembrandt by Reynolds, Yale Center for British Art (B1982.24.20), discussed and illustrated in White *et al.*, 1980, p. 39, cat. 52, fig. 4. For the *Mathematician* see *ibid*. p. 110, fig. 64.

43 Cormack, 1970, p. 151: 'Oct. 26, 1786 Duke of Dorset for Lesbia 78 15 0'. See also Waagen, 1857, p. 340; Graves and Cronin, 1899–1901, vol. III, p. 1194 and vol. IV, p. 1460; and Sackville-West, 1906, p. 72.

44 For *A Girl Warming her Hands* see, Waagen, 1857, p. 346; Boyle, 1885, p. 264, cat. 14; Graves and Cronin, 1899–1901, vol. III, p. 1124.

45 The picture of Nellie O'Brien with the robin was sold at Sotheby's, 14 March 1984, lot 52. It is not listed in Graves and Cronin's catalogue. For the other paintings of Nellie O'Brien by Reynolds see Graves and Cronin 1899–1901, vol. II, pp. 703–4.

46 Graves and Cronin, 1899–1901, vol. III, p. 1193; Hamilton, 1874, p. 117. Hamilton states that the sitter for *Robinetta* was Anna Lewis, who married Wilbraham Tollemache, fifth Earl of Dysart. She sat to Reynolds as 'Miranda' (exhibited at the Royal Academy in 1774). As she was born in 1746 she was clearly too old to have modelled for *Robinetta*. See also Graves and Cronin, 1899–1901, vol. III, p. 974.

47 For Reynolds's familiarity with Cats's work see Leslie and Taylor, 1865, vol. I, p. 13; Hilles, 1936, p. 6.

48 The notice appeared in the *Morning Chronicle*. It is quoted by Graves and Cronin, although no date is given (1899–1901, vol. III, p. 1173).

49 See Cormack, 1970, p. 150: 'May 2, 1785 Count D'Adhemar the French Ambassador, for a Girl with a Mousetrap 52 10 0'.

3 *'Patriarchs, Prophets and Paviours': Reynolds as a history painter, 1770–1773*

1 Quoted in Paulson, 1991–3, vol. III, p. 223. John Peters (*c.* 1667–1727) was an assistant to Sir Godfrey Kneller. Despite Hogarth's reservations Charlemont kept the picture. 'The Head in question', he told Hogarth, 'is the uppermost Picture over the Fire Place in the Green Drawing Room' (presumably Charlemont House, Dublin) (*ibid.*, fol. 19).

2 Among works Reynolds noted as having copied at the Corsini Palace, Rome in April 1750 are: 'Study of an Old Man's Head, reading' by Rubens and 'Captain Blackquier's P. An Old Beggar Man'. These notes from Reynolds's sketch-book were published (inaccurately) in Cotton, 1859a, p. 1, and also in Leslie and Taylor, 1865, vol. I, pp. 40–1.

3 On 21 February Reynolds bought an 'Old Man' (lot 18) by Jan Lievens, together with a Rembrandt (lot 23), for 5 guineas from Prestage and Hobbs. See Broun, 1987, vol. II, pp. 44 and 66.

4 Reynolds recorded an appointment with a 'Beggar man' in his sitter-book on Wednesday 20 August 1766 at 10 a.m. He also noted inside the back cover of the same sitter-book: 'Old beggarman, yellow oker, lake, and black and blue. Drapery varnish'd with oils. Head etc. with wax Oct. 9.' Nicholas Penny has suggested that the beggar in question may have been George White, and the painting related to *Ugolino* (see, 1986, p. 252). The painting was, however, probably an *Old Man Reading a Ballad* (destroyed 1816), a mezzotint of which was exhibited at the Society of Artists in 1767 by Samuel Okey (no. 257: 'An old man's head, from Mr. Reynolds').

5 *Catalogue of Ralph's Pictures. To be seen at No. 28 Haymarket, April 1791,* reprinted in Graves and Cronin, 1899–1901, vol. IV, p. 1601. The painting, now in the Brera, Milan, then hung over the high altar in S. Antonio Abate, Bologna. It had made a strong impression on Reynolds when he saw it in

1752. See Reynolds's ms. sketch-book, Sir John Soane's Museum, London, fol. 42v, no. 187.

6 Northcote stated: 'Seldom did he take exercise; and so closely was his day spent in his professional employment, that if by any chance he found himself in the street during the middle of the day, he felt ashamed, and thought everybody was looking at him' (in Fletcher, 1901, p. 79).

7 Of Reynolds's *Captain of Banditti*, exhibited in 1772, Walpole noted in his catalogue: 'Taken from a beggar. There were in this exhibition at least six pictures by different painters, from Reynolds's first beggarman' (quoted in Graves, 1906, vol. VI, p. 271). Among the various 'philosophers' and old men's heads exhibited at the Royal Academy in 1772 were works by Charles Catton, Samuel Cotes, John Howes, William Pars, and the miniaturist John Kitchingman. There are also two pastel cameos by Daniel Gardner (who worked in Reynolds's studio *c.* 1773) which clearly depict George White (Witt Library, Courtauld Institute of Art). One of the above pastels may be identified with 'Portrait of an Old Man' exhibited by Gardner at the Royal Academy in 1771.

8 See Ginger, 1977, p. 272. Topham Beauclerk observed that Reynolds and Goldsmith were so fond of each other's company they preferred it to the more gregarious atmosphere of the 'Club'. Mrs Thrale, however, suspected that Reynolds had ulterior motives and wished to use Goldsmith's reputation to further his own. See Hilles, 1952, pp. 27–8.

9 Thomas Warton, 'The Pleasures of Melancholy', 1747. There is no line in the poem which can be related specifically to the imagery in Reynolds's picture, the only personalized verses being:

> O then how fearful is it to reflect,
> That thro' the solitude of the still globe
> No Being wakes but me! 'till stealing sleep
> My drooping temples bathes in opiate views.

10 Laurence Sterne, *A Sentimental Journey through France and Italy, by Mr. Yorick*, 2 vols., 1768. See the chapter entitled 'The Captive'.

11 See Nicolson, 1968a, p. 43, 1968b, vol. I, pp. 241–2; von Erffa and Staley, 1986, pp. 280–2; and Bindman, 1989, pp. 37–8 and 91. West produced a pendant (also from Sterne's *Sentimental Journey*) to *The Captive* entitled *The Dead Ass*. Again White seems to have been the model.

12 Three different works by Reynolds have, at various times, been referred to as 'The banished lord'. They are *Pope Pavarius* (London, Guildhall); *The Captive* (private collection) and a picture still entitled *The Banished Lord* (Tate Gallery).

13 See Williamson and Engleheart, 1902, pp. 53–4. In a later codicil to Engleheart's will, the miniature was incorrectly entitled *Pope Bavarius*.

14 See John Newman, 'Reynolds and Hone. *The Conjuror* unmasked', in Penny, 1986, pp. 344–54. Also Munby, 1947, pp. 82–4; Butlin, 1970, pp. 1–9.

15 There is no record of when White began modelling at the Royal Academy
 Schools. It was probably before spring 1771, as shortly afterwards the first
 depictions of him by students, such as John Sanders, appeared (see Postle,
 1988a, p. 204).

16 An undated inscription in ink on the reverse of Russell's picture reads: 'The
 model Russell employed for this picture was George White a pavior, who was
 employed by Sir J. reynolds for this and other pictures.' Ellis Waterhouse first
 suggested Sanders's *Philosopher* could be George White (see, 1981, p. 331,
 illustrated).

17 For Van Dyck see Larsen, 1988, cat. nos. 15 and 192. For Rubens see
 Sedelmeyer Sale, Paris 1907 (lot 35), of which there is a reproduction in the
 Witt Library.

18 Leslie and Taylor 1865, vol. II, p. 20. Northcote wrote to his brother on 21
 September 1771, 'I have often sat to Sir Joshua for my hands' (quoted in
 Whitley, 1928a, vol. II, p. 284). See also the following anecdote: 'Burke
 came into Sir Joshua's painting room one day, when Northcote, who was
 then a young man, was sitting for one of the children in "Count Ugolino".
 It is the one in profile with the hand to the face. He was introduced as a pupil
 of Sir Joshua's, and, on his looking up, Mr. Burke said, "Then I see that Mr.
 Northcote is not only an artist, but has a head that would do for Titian to
 paint"' (quoted in Graves and Cronin, 1899–1901, vol. III, p. 1219).

19 Reynolds's quotation from Dante appears in the Royal Academy catalogue
 for 1773. The English translation is taken from Musa, 1984, p. 372.

20 See Newman in Penny, 1986, p. 347. See also Munby, 1947, pp. 82–4, and
 Butlin, 1970, pp. 1–9. (Although he identifies the sources of several prints in
 Hone's picture, Munby does not identify 'Aminadab' with 'Ugolino'.)
 Interestingly, William Blake also used Aminadab as the model for his a pen-
 and-wash drawing of the 1770s, entitled the *Reposing Traveller* (British
 Museum, London).

21 Falconet's statue was described in Reynolds's posthumous studio sale
 (Phillips, 5 March *et seq.*) as 'A remarkable beautiful figure representing
 "Winter" by Falconet'. See also Weinshenker, 1966, p. 15.

22 Horace Walpole to the Earl of Strafford, 25 August 1771 in Lewis *et al.*,
 1937–83, vol. XXXV, pp. 344–5. See also Leslie and Taylor, 1865, vol. I,
 p. 415.

23 Von Erffa and Staley, 1986, pp. 278–9, cats. 220–2. See Prochno, 1991,
 pp. 38–42.

24 Joseph Farington, 1 October 1802, in Garlick, Macintyre, and Cave,
 1978–84, vol. V, p. 1893. Farington also stated: 'His figure very much that
 of Ugolino painted by Sir Joshua Reynolds in attitude & in expression; but
 Guerin says He had never seen the print from it when He painted his picture'
 (*ibid.* p. 1891). See also Joannides, 1975, p. 783, n. 43, and Penny, 1986,
 p. 253.

25 Northcote stated that the picture 'was seen, either by Mr. Edmund Burke, or Dr. Goldsmith, I am not certain which' (1818, vol. I, p. 279). Later he referred simply to 'the idea started by Burke' (*ibid.*, p. 283). The only record of Burke's name in Reynolds's sitter book during the time Reynolds was painting *Ugolino* was at 4 p.m. on Wednesday 17 March 1773. However, as Burke paid frequent social calls on Reynolds, too much significance cannot be attached to the date.

26 Frederick Howard, fifth Earl of Carlisle, *Poems consisting of the Following Pieces, viz. I, Ode written upon the death of Mr Gray, II. For the Monument to a favourite Spaniel, III. Another Inscription for the Same, IV. Translation from Dante, Canto xxxiii*, London, 1773. The translation also appeared in the *Annual Register* for 1773 (Part II, pp. 230–2).

27 Burke, then Paymaster General, had defended his action to the House on 19 May, two days before the report appeared in the *Morning Herald*. See Magnus, 1939, pp. 121–3.

28 As Frances Yates noted, in the French edition of 1728 Richardson was more circumspect about attributing the bas-relief to Michelangelo (1951, p. 105 and n. 3).

29 Reynolds to Baron Grantham, 20 July 1773, in Black and Penny, 1987, p. 733. Baron Grantham was appointed ambassador in Madrid in 1771.

30 The critic, 'Florentinus', had attributed Reynolds's historically incorrect rendition of the story (owing to his reliance on Dante rather than Villani) to Baretti's ignorance of Italian history. Baretti responded to the charge indirectly in his *Easy Phraseology*, published two years later, where a dog and a cat discuss Reynolds's *Ugolino*:

> D[og]: The count told him his dreadful story, and in what a cruel manner he had been put to death along with his children by the intrigues of that inhuman archbishop.
>
> C[at]: Did the count forget his grand-children?
>
> D[og]: Nonesense! Dante calls them all his children.
>
> C[at]: But that was not the exact truth; and therefore Mr. Poet told a lie there.
>
> D[og]: Mr. Cat, you are an arrant fool! Don't you know that poets have no business to be punctually exact in their rules.

(Baretti, 1775, p. 146)

31 The original Fabius Pictor was a Roman senator and historian. The name was presumably adopted by the present writer because of the obvious pun on 'pictor'.

32 James Barry, *An Inquiry into the Real and Imaginary Obstructions to the Acquisition of the Arts in England*, London 1774, in Fryer, 1809, vol. II, pp. 248–9.

33 On 22 April 1810 Benjamin Robert Haydon recorded the following entry in his diary: '"talking of Barry", says Sir George [Beaumont], "I recollect

something that Sir Joshua told me of him – that he once published something in the papers which he had entrusted him with in confidence"' (in Pope, 1960–3, vol. IV, p. 152).

34 *Lear* was one of twelve Shakespearean etchings by Mortimer produced between 1775 and 1776. See Nicolson, 1968a, p. 41, no. 79ii and Pressly, 1981, pp. 57–8.

4 'Fashion's fickle claim': high art 1773–1781

1 In *Parentalia* Wren's son noted how his father appproved of the idea of mosaics but disliked Thornhill's scheme for monochromed paintings inside the cupola. See Briggs, 1953, p. 206; see also pp. 247–8 for quotations on the subject from the cathedral minute books for 1709–10.

2 See von Erffa and Staley, 1986, *The Fright of Astyanax* (cat. 163, pp. 248–9), and *Elisha Raising the Shunamite's Son* (cat. 281, pp. 315–16). West had also painted Newton's portrait around 1767 (cat. 657, p. 538).

3 Before sittings began, Reynolds noted in his sitter-book opposite 12 April: '1 Print of the Bishop of Bristol'. Sittings are recorded on 26 April (midday), 30 April (midday), 3 May (1.30 p.m.), 5 May (midday), 7 May (midday), 10 May (midday). The picture, which now hangs in Lambeth Palace, was engraved in 1775 by Thomas Watson.

4 Barry had already been elected as a Royal Academician on 9 February 1773, defeating William Pars by sixteen votes to six. See *General Assembly Minutes, Royal Academy of Arts*, and Pressly, 1981, p. 37.

5 Leslie and Taylor added the Archbishop of York's name to the list (1865, vol. II, p. 37).

6 Leslie and Taylor maintained that Newton gave his 'formal approval' on 21 August 1773 (see Leslie and Taylor, 1865, vol. II, p. 37). The only name recorded in Reynolds's sitter-book that day was the 'Bishop of Chester', William Markham (1719–1807). Tom Taylor, who often provided his own free interpretation of Reynolds's sitter-book entries, assumed (perhaps correctly) that Reynolds had meant to write the Bishop of Bristol's name in his book.

7 Barry was referring to Monday 11 October.

8 See Fryer, 1809, vol. II, pp. 409–12 for an account taken from the minutes of the Society of Arts.

9 See Fryer, *ibid.*, p. 412. Barry states here that Reynolds 'did not attend the meeting at the Turk's Head, to give an answer to the Society of Arts, but commissioned some one of the company (Mr. Cipriani I believe) to signify his refusal'.

10 For Dance's intended contribution see Barry's letter to the Duke of Richmond of 14 October 1773 in Fryer, 1809, vol. I, p. 243.

11 According to Pressly, Barry's *Ecce Homo* probably represented his original

idea, and was supplanted subsequently by the *Fall of Satan* (1981, pp. 43ff.).

12 The following pictures were also exhibited at the Royal Academy during this period: 1778 (no. 35), George Carter, *Adoration of the Shepherds, an Altarpiece for St. James, Colchester*; 1778 (no. 321), Samuel Wale, *Design for an Altarpiece*; 1781 (no. 138), J. F. Rigaud, *Our Saviour taken down from the Cross, a Sketch for an Altarpiece lately put up at the Sardinian Ambassador's Chapel*. See also Green, 1782, pp. 47ff.

13 For a brief account of Jervais's life and studio practice see Williams, 1933, pp. 191 and 194–5.

14 According to Hilles, Reynolds's plan of the window, together with the letter, was in a private collection in America (1929, p. 59, n. 2).

15 See von Erffa and Staley, 1986, pp. 90, 361–2 and 363–4. See also Garlick, Macintyre, and Cave, 1978–84, vol. III, p. 916 (6 November 1797).

16 Mason's manuscript (incomplete) is in the British Museum, Add. ms. 32,564.

17 For Domenichino's copy of Carracci's lost *Adoration of the Shepherds* see Brigstocke, 1978, cat. 2313. The painting, which may have been in the duc d'Orléans's collection, was bequeathed by Sir Francis Bourgeois to Dulwich College in 1811. Northcote maintained that Reynolds's picture was nearer to Carracci's composition ('a Nativity by Hannibal Carrache') than Correggio's *Notte* (1818, vol. II, p. 104). Although Reynolds owned an *Adoration of the Shepherds* by Poussin (London, National Gallery), there is no discernible influence by this work on Reynolds's own picture (Broun, 1987, vol. II, pp. 208–9). Renate Prochno has suggested that Reynolds's *Nativity* may also have been influenced by an *Adoration of the Shepherds* of the Carracci School, presented to New College by the Earl of Radnor in 1773, and which then hung over the altar of the chapel (Prochno, 1990b, p. 462).

18 For Charity see Mitchell, 1942, p. 40; for Fortitude see Penny, 1986, p. 291 (reproduced); for Prudence see Clifford, Griffiths, and Royalton-Kisch, 1978, p. 69, and cat. 269.

19 Henry Crabb Robinson noted in his diary that the figures of Reynolds and Jervais, as shepherds, had been taken from the folio edition of *Pilgrim's Progress* (see Robinson, 1869, vol. II, p. 540). I have been unable to verify this as no folio edition of this book is listed in the British Museum catalogue, nor do any of the woodcuts in other editions contain figures which resemble Reynolds's design.

20 The poem is quoted in part by Northcote 1813, pp. 271–4, and 1818, vol. II, pp. 106–9. For a discussion of Warton's poem and its relation to Reynolds's own art theory see Lipking, 1970, pp. 396–402.

21 Warton wrote an essay on Gothic architecture which was published posthumously. See *Essays on Gothic Architecture by the Rev. T. Warton*, London, 1800.

22 See Hussey, 1927, pp. 191–4. Hussey argues that Reynolds, through his

endorsement of Vanbrugh, was actually instrumental in the formation of a more serious and intellectual consideration of the claims of Gothic architecture.

23 Leslie and Taylor, who refer to Warton's 'pompous verses', note that his poem 'may have been, partly, in return for the compliment thus paid to him that Sir Joshua soon after this proposed Thomas Warton as a member of the Literary Club' (1865, vol. II, pp. 372–3).

24 The letter is dated 13 May 1782. It was first published in Mant, 1802, vol. I, p. lxxx. See also Hilles, 1929, p. 94. Hilles (p. 93, note 3) stated that Reynolds was 'alluding, of course, to Warton's classical tendencies' – although the reverse seems to have been true.

25 Elsewhere in the book Warton also paid tribute to Reynolds's *Death of Dido* and the *Discourses*. See 1782, vol. II, pp. 168, and 394–5.

26 Walpole to William Mason, 7 May 1783, in Lewis *et al*., 1937–83, vol. XXIX, p. 301, quoted in Leslie and Taylor, 1865, vol. II, pp. 411–12.

27 Walpole to Henry Seymour Conway, 6 October 1785, in Lewis *et al*., 1937–83, vol. XXXIX, p. 301, and Cotton, 1859a, pp. 58–9. For the problems inherent in Jervais's glass painting technique see Baylis, 1989, pp. 78ff.

28 Walpole to Lady Ossory, 9 September 1783, in Lewis *et al*., 1937–83, vol. XXXIII, p. 417.

29 See Leslie and Taylor 1865, vol. II p. 288, n. 2, where this source was first cited. Also Mitchell, 1942, p. 39. Mitchell notes that Reynolds had based his design on Dorigny's engraving rather than on the original mosaic. He also suggests (p. 25) that a 'recollection of the general idea of Titian's *Wisdom* in the Library of St. Mark's, and the circumstantial parallel ... were probably in Reynolds's mind'. See also Waterhouse, 1941, p. 125; and Penny, 1986, p. 284, who has suggested that Reynolds may have sketched the figure.

30 Penny, 1986, p. 284. Prochno maintains that the compasses are visible in the right hand of *Theory*, although this may actually be a fold in the drapery (1990a, p. 184).

31 See the note in the back of his 1779 sitter-book, 'Dido Mr Doughty'. Doughty, however, left England the following year. See Ingamells, 1964, pp. 35ff.

32 Only one other full-size version of the *Death of Dido* exists, in the Philadelphia Museum of Art. The painting, which was in Reynolds's studio until its sale in 1796, does not appear to have been the one painted by Reynolds, but a replica – possibly made under his supervision. See Dorment, 1986, pp. 297–301, for full details of this work.

33 Robert Smyth (1744–1802) was MP for Colchester. He had met Fuseli in Italy. A series of technical notes in Reynolds's ledger indicate that he was preoccupied with *Dido* at the time: 'Aug. 1780 (Dido. Blue umbra. senza nero cancelled)'; '1781 Dido. oil./1781 Manner Colouri to be used (?) Indian Red

Light Do. Blue Black finished with Varnish senza olio – poi relocc – con giallo' (in Cormack, 1970, p. 169). For further discussion of Reynolds's colour notes see Eastlake, 1869, vol. II, pp. 538–46, and Talley in Penny, 1986, pp. 55–70.

34 The story could have been told directly by Stothard to Leslie, as Stothard did not die until 1834. Leslie and Taylor note elsewhere: 'Reynolds generally received students in the morning, before he began to paint. He criticised what they had to show him, and freely lent them his pictures to copy ... Stothard and Turner told me they were both often in his rooms when students' (1865, vol. II, pp. 299–300).

35 For the most thorough exploration of Reynolds's sources for the *Death of Dido* see Dorment, 1986, pp. 297–301.

36 Mandowsky, 1940, p. 274; Prochno, 1990a, p. 186, fig. 175; Dorment, 1986, p. 299, who suggests a number of other related compositional sources.

37 Leslie and Taylor, 1865, vol. I, p. 54. They also note (*ibid.*): 'As Reynolds himself afterwards painted the same subject, his remarks on Dido have special interest.' See also Dorment, 1986, p. 299, fig. 83–2.

38 Wind, in discussing Reynolds's use of a figure in a fresco by Trevisani as a model for *Kitty Fisher as Cleopatra*, noted: 'It is practically certain that Reynolds did not wish the spectator to know that he was copying Trevisani' (1938–9, p. 183, n. 4). See also Penny, 1986, p. 196.

39 Opposite the date mentioned by Burney, there is inscribed in Reynolds's sitter-book in a neat hand (not Reynolds's own): 'Miss Eliz. Wateridge/King Street. Covent Garden'. This memorandum, as Tom Taylor was the first to suggest, probably refers to a model whom Reynolds wished to use in the picture. 'Miss Wateridge' appears again at 11 a.m. on Sunday 18 March, 10 a.m. on Friday 23 March, and at 11 a.m. on Tuesday 4 December. Although Graves and Cronin give the surname as 'Wateredge' it is recorded as 'Wateridge' in Reynolds's sitter-book. See 1899–1901, vol. III, p. 1147; also Penny, 1986, p. 294.

40 For Fuseli's version of *The Death of Dido* see Schiff, 1975, cat. 54, and Schiff, 1973, cat. 713. See also Powell, 1973, pp. 67–70.

41 Northcote was almost certainly not relying on his own recollections of the event, as his statement closely follows Felton's earlier comment: 'A picture of great celebrity, which drew crowds to the Exhibition in 1781, and obtained him distinguished applause, not only from his own countrymen, but from foreigners' (in Felton, 1792, p. 24).

42 Walpole to William Mason, 6 May 1781, in Lewis *et al.*, 1937–83, vol. XXIX, pp. 137–8.

43 The comment was probably contained originally in a letter sent by Beattie to Sir William Forbes, 1 June 1781, in which Beattie relates his activities in London. The letter is quoted, in part (but without the relevant section), in Forbes, 1806, vol. I, p. 174.

44 See also *The London Chronicle*, 28 April – 1 May, which noted that the exhibition 'upon the whole is much inferior to that of the last and of several preceding years, there being more indifferent paintings admitted than the Royal Academicians ever before suffered to disgrace their exhibition'.

5 *The Labours of Hercules (1782–1789)*

1 Reynolds kept in touch with several members of the French Royal Academy including Etienne Falconet (1716–91) and Gabriel-François Doyen (1726–1806), whom he had met in Rome in 1750, and with whom he continued to correspond in 1768. (See the note tucked into the back of his 1782 sitter-book: 'a copy of a Paper I gave to Mr. Doyen to bye [*sic*] those Pictures at the Abbe Renoux at St. Sulpice'. See also Leslie and Taylor, 1865, vol. I, p. 288, n. 4; and Perini, 1992, pp. 205–20.

2 See for example, *William de Albanac Presents his Three Daughters to Alfred III, King of Mercia*, exh. R. A. 1778; von Erffa and Staley, 1986, cat. 47.

3 See Hilles, 1936, p. 50–61, 287 and 289. The Florentine edition, translated by Baretti, was published in 1778, while the German edition came out in 1781. Both contained the first seven *Discourses*. A Russian edition was published in 1790. See Hilles, in Bond, 1970, pp. 172ff.; Perini, 1988, pp. 141–3.

4 See for example Malone, 1819, vol. III, pp. 127–8 where Reynolds uses the same comparison, almost verbatim, between Titian's *Assumption* in the Frari, Venice, and Rubens's altarpiece at St Augustine, Antwerp.

5 For Reynolds's copy of Titian's *Venus and Cupid with a Lute Player* see Graves and Cronin, 1899–1901, vol. III, p. 1247, and Goodison and Robertson, 1967, cat. 129, p. 169. A 'Venus and Cupid' which has been thought to be a copy by Reynolds, after Titian's *Venus and Cupid with a Lute Player*, was recently in a private collection in Sweden. Although it omits the lutenist, it does include a small white dog which, although absent from Titian's original picture, is strikingly similar to one which appears in Reynolds's portrait of *Mrs Abington as 'Miss Prue'* (Yale Center for British Art, Paul Mellon Collection).

6 Reynolds records sittings for 'Venus' at midday on 20 and 21 December 1759. It was presumably because William Mason referred to Reynolds's *Venus* of 1785 as his 'first Venus' that both Cotton and Leslie and Taylor mistakenly associated his comments with the 1759 'Venus' (Cotton, 1859a, p. 55; Leslie and Taylor, 1865, vol. I, pp. 173–5).

7 Reproduced in Prochno, 1990a, p. 171, fig. 157. Reynolds's 1759 *Venus* was evidently purchased by Lord Coventry in 1761 (see sitter-book, week beginning 6 July 1761, 'Send the Venus to L Covent'). See also Graves and Cronin, 1899–1901, vol. III, p. 1222.

8 Ralph Kirkley – whose daughter modelled for the head – had entered Reynolds's service in January 1763 (see Cormack, 1970, p. 107).

9 For Falconet's bather see Hildebrandt, 1908, fig. 21

10 One drawing is in a British private collection. For the related drawing in the British Museum see Binyon, 1902, vol. III, p. 197, 'Study for a picture of Nymph and Cupid'. See also Prochno, 1990a, p. 176, fig. 163.

11 'I desire the Earl of Upper Ossory would accept of some one picture of my own painting, that he take his choice of those of my paintings which shall be unsold at my Death' (Probate of the will of Sir Joshua Reynolds Knight deceased, dated 28 February 1792). See also Leslie and Taylor, 1865, vol. II, p. 636.

12 Hilles suggests that the work referred to by Reynolds was perhaps the same one which he acquired by the terms of Reynolds's will.

13 Leslie and Taylor, 1865, vol. II, pp. 303–4 and 482; Frederick Hilles, 'Sir Joshua and the Empress Catherine', in Bond, 1970, p. 268.

14 Evening appointments with Princess Dashkova are recorded in Reynolds's sitter-book on 22 June (as 'Princess Descau'), and on 7 July (as 'Princess Descau' and as 'Princess Daschkaw'). A further appointment is possibly recorded on 15 June, although Reynolds's handwriting is barely legible. See also Frederick Hilles in Bond, 1970, p. 268.

15 Frederick Hilles in Bond, 1970, p. 271. See also Mannings in Penny, 1986, p. 312. Noel Desenfans, who translated Reynolds's subsequent correspondence with Catherine the Great, may also have translated his letter to Potemkin. See Garlick, Macintyre, and Cave, 1978–84, vol. III, p. 1088.

16 Horace Walpole to Thomas Walpole the Younger, 8 April 1786, in Lewis et al., 1937–83, vol. XXXVI, p. 237 n. See also Northcote, 1818, vol. II, p. 216.

17 Northcote, vol. II, 1818, p. 214. Chauncey B. Tinker suggested that Reynolds's decision not to paint this subject may have been linked to Sheridan's burlesquing of the subject in his play *The Critic* of 1779 (Tinker, 1938, p. 65).

18 For a review of British history painting in mid-eighteenth century England see Martin Postle, 'Narrative painting: Hogarth to Reynolds', in Cannon-Brookes, 1991, pp. 9–13.

19 See Smith, 1979, pp. 164–70, and David Alexander, 'Patriotism and Contemporary History, 1770–1830', in Cannon-Brookes, 1991, pp. 31–5.

20 For West see von Erffa and Staley, 1986, pp. 186–7, and 211–13, cats. 47 and 93. See also Wind, 1938, pp. 116–27; Mitchell, 1942, pp. 20–33.

21 See the letter to William Forbes quoted in Northcote, 1818, vol. II, p. 216.

22 For related oil sketches of the single figure of the *Infant Hercules* see Graves and Cronin, 1899–1901, vol. III, pp. 1163–4.

23 See Carey Macintosh, 'Reynolds's portrait of the Infant Johnson', in Bond, 1970, pp. 279–96. See also Graves and Cronin, 1899–1901, vol. I, p. 518 (where the painting is classified as a portrait rather than a subject picture).

24 Leslie and Taylor, 1865, vol. II, p. 483–4; Cotton, 1856, p. 171; Stephens, 1867, p. 27; Graves and Cronin, 1899–1901, vol. III, p. 1162.

25 The Royal Academy's cast of the Capitoline 'Infant Hercules' is visible in Johan Zoffany's *Academicians of the Royal Academy* (Royal Collection). There is also a cast in Sir John Soane's Museum, London. For antique versions of the subject see Woodford, 1983, pp. 121–9.

26 Prochno, 1990a, pp. 189–90, figs. 179–80. Several seventeenth-century Dutch artists painted the 'Infant Hercules strangling the Serpents', including Peter van der Werff (Rijksmuseum, Amsterdam), and Jan de Witt (Holyrood House, Her Majesty the Queen).

27 See Clifford, Griffiths, and Royalton-Kisch, 1978, p. 28 and John Newman, in Penny, 1986, pp. 348–50, and figs. 97–8.

28 Sunday, 12 February 1786 at 10 a.m.: 'Boy for Hercules'; Sunday, 19 February 1786 at 10 a.m.: 'Hercules'.

29 Reynolds to the Duke of Rutland, 23 June, 1786, in Hilles, 1929, p. 151.

30 Entries in Reynolds's sitter-book during the remainder of 1786 which may relate to Hercules are as follows: 'Infant' 11 October (no time); 'Model' 12 October (no time); 'Maguire' (no time, crossed out) 13 October; 'Maguire 5 Bruton St' 15 October (no time); 'Infant' 16 October, 10 a.m.; 'Model' 17 October, 10 a.m.; 'Model' 24 October (no time); 'Boy/Maguire' 25 October, 11 a.m.; 'Maguire' 3 November, 11 a.m.; 'Infant' 4 November, 10 a.m.; 'Maguire' 9 November, 10 a.m.; 'Infant' 10 November, 10 a.m.; 'Infant' 17 November, 10 a.m.; 'Infant' 23 November, 10 a.m.; 'Maguire' 25 November, 10 a.m.; 'Infant Hercules' 6 December, 10 a.m.

31 Reynolds recorded appointments in his sitter-book for Mrs Fitzherbert on 18, 19, 20, 21, 23, and 30 November and 4, 7, 11, and 28 December. See also Graves and Cronin, 1899–1901, vol. I, p. 312.

32 *Colonel Morgan* (National Museum of Wales, Cardiff) was exhibited at the Royal Academy in 1788; *The Prince of Wales* (Duke of Norfolk, Arundel Castle) was exhibited in 1787; *Mrs Fitzherbert* (Lord Portarlington) was not exhibited, but acquired from Reynolds by the Prince of Wales.

33 Catherine the Great's 'failure' at Cherson referred to Prince Potemkin's unsuccessful attempt to establish a fortress at Cherson on the Black Sea.

34 David Mannings has suggested that the figure of Alcmena was adapted by Reynolds from Poussin's *Massacre of the Innocents* (Paris, Petit Palais) – copies of which were on the London art market in the 1770s and 1780s (in Penny, 1986, p. 312). Dukelskaya suggests also that 'the face of the woman standing behind Amphitryon recalls the actress Sarah Siddons' (Dukelskaya, 1979, cat. 125). There is, however, no woman behind Amphitryon, nor does any woman in the picture resemble Mrs Siddons.

35 See also Simmons, 1965, pp. 208–14.

36 For Johnson's portrait see Penny, 1986, cat. 73, pp. 240–1.

37 Entries during June in Reynolds's 1787 sitter-book which may relate to

Hercules are as follows: 'Maguire' 18 June, 9 a.m.; 'Hercules' 19 June, 10 a.m.; 'Maguire' 20 June (no time); 'girl' 22 June, 10 a.m.; 'Braithwait at Mr. Young's Tobacconists / Drury lane' 23 June, 10 a.m.; 'Braithwait' 29 June, 10 a.m.; 'Hercules' 30 June, 10 a.m.

38 For the 'monstrous Craws' see *The Times*, 29 August, 3 September, 12 September, 1787.

39 Fuseli's writings bristle with distaste for popular conceptions of art. See Mason, 1951, pp. 187–97 ('Great art and the depravity of all culture') and pp. 194–7 ('Culture and the masses').

40 Northcote stated: 'An engraving in mezzotinto was taken from it before it left England; and another print from it was done in Russia, by an English artist, patronised by that court' (1818, vol. II, p. 218). Engravings were published by James Walker, 1 January 1792, and Charles Hodges, 1793.

41 See Graves and Cronin, 1899–1901, vol. III, p. 1193. They state: 'The picture should be in the Barrington family.' However, none of the panels have ever been located. For the removal of the window from Salisbury Cathedral see *The Art Journal*, 1854, p. 191, and Baylis, 1989, p. 78.

42 For Eginton see W. C. Aitken, 'Francis Eginton', *Transactions of the Birmingham and Midland Institute Archeological Society*, 1872, 1873, pp. 27–43, and Baylis, 1989, *passim*. For Reynolds's and Ramberg's involvement in Eginton's window at Lichfield Cathedral see Baylis, 1989, pp. 93–5.

43 For Poussin, see Wright, 1985, cat. 135, p. 203. For the *Continence of Scipio* see Livy, *The History of Rome from its Foundation*, Book XXXVI, 50.

44 For West see von Erffa and Staley, 1986, cat. no. 18, pp. 171–2. For Brenet see Kalnein and Levey, Penguin 1972, p. 152.

45 See Wark, 1975, p. 156. Reynolds owned, and annotated, William Parsons's 1703 English translation of Félibien. See Hilles, 1936, pp. 121–2, 124 and 232.

46 See also the *St. James's Chronicle*, 25–28 April: 'The composition has considerable merit, but appears rather crowded on the canvas...', and the *Morning Post* 30 April 1789: 'The figures are huddled together without method or effect'.

47 von Erffa and Staley, 1986, cat. 196, pp. 264–5. For Francis Hayman's version of the subject see Allen, 1987, cat. 51, pp. 125–6.

48 Royal Academy council minutes, 11 November 1780. The minutes specified that *Cimon and Iphigenia* was to be based on Dryden's *Fables* of 1700.

49 Farr, 1958, cat. 296, pp. 181–2. For a copy of Reynolds's *Cimon and Iphigenia* by Richard Westall (1765–1836) see Ingamells, 1985, pp. 191–2.

50 Reynolds recorded 'Cupid' on 28 September 1787 at 10 a.m. in his sitter-book. In the back of his 1788 sitter-book is the note 'Cupid/Miss Watson' – a reference to a putative engraving by Caroline Watson.

6 *The 'modern Apelles' and the 'modern Maecenas': Reynolds, Boydell,*
and Macklin

1 See Merchant, 1959 (the appendix includes a full list of known pictures made
for Boydell's Shakespeare Gallery); Boase, 1963, pp. 148–77; Dotson, 1973;
Friedman, 1974.

2 Bruntjen, 1974, pp. 241ff. Geoffrey Ashton, 'The Boydell Shakespeare
Gallery: before and after', in Cannon-Brookes, 1991, p. 38; also Wax, 1990,
pp. 64–5.

3 For the theory of *ut pictura poesis* see Lee, 1940, pp. 197–269.

4 'Feb. 1787. Mr. Barwell, for Mrs Seaforth. See Mrs. Seaforth', and 'June,
1786. Mrs Seaforth and Child 21 0 0' (in Cormack 1970, pp. 147 and 164).

5 Reynolds's sitter-book for 1785 is missing. The dates of sittings for Mrs
Seaforth in 1786 are as follows: 3, 6, 10, 16, 18, 21, 23, and 28 January;
2, 6, 11, 15, 17, and 22 February; 8 March; 18 and 24 April; 1, 8, and 23
May.

6 *Tuccia* is listed (although crossed through) in the front of the sitter-book,
among the works which he intended to show at the Royal Academy. He also
noted in the back of his 1787 sitter-book 'Tuccia to Miss Watson', indicating
that he intended to have the painting engraved by Caroline Watson. It was
not, however, engraved until 1796 by P. W. Tomkins.

7 For a more anodyne critique of *Tuccia* see *The Morning Post*, 4 June 1788:
'No. 3. The Vestal from Gregory's Ode to Meditation – by Sir Joshua Reynolds.
The Knight has seldom been *more at home* than in this performance; –
whether the Vestal suffered the *Sacred Fire* to go out, we know not, but of this
we are certain, that in the subject has kindled the *sacred fire* of genius – the
look of conscious innocence is given with magic charm; the secondary
figures are well conceived, particularly the one which looks with fearful
curiosity over the shoulder of the Vestal.'

8 See for example Giusto Sustermans's portrait of Vittoria della Rovere as
'Tuccia', Palatine Gallery, Florence.

9 Bruntjen states that the Poets' Gallery was established in 1788 in the former
premises of the Royal Academy in Pall Mall, although this did not happen
until 1790 (1974, p. 118). In spring 1788 the 'Great Rooms' in Pall Mall
housed a temporary exhibition of the Bishop of Bristol's old-master picture
collection, as well as Copley's *Death of Chatham*. See *The Times*, 14 April 1788
for an advertisement giving the location of the Poets' Gallery.

10 For a table of the exhibition of works at the Royal Academy, according to
genre, see Smith, 1979, p. 177.

11 The following entries in Reynolds's 1788 sitter-book relate to the picture: 20
August (12 p.m.) 'Mrs Macklin; 21 August (11 a.m.) 'Miss Macklin'; 25
August (11 a.m.) 'Miss Macklin'; 1 September (2 p.m.) 'Miss Pott'; 4
September (2 p.m.) 'Miss Macklin'; 6 September (2 p.m.) 'Miss Macklin'; 10

September (2 p.m.) 'Miss Macklin'; 11 September (2 p.m.) 'Mr(s) Macklin'; 19 September (2 p.m.) 'Mrs Macklin'; 22 September (2 p.m.) 'Mrs Macklin' [crossed through]; 23 September (2 p.m.) 'Mrs Macklin'; 24 September (10 a.m.) 'Miss Macklin'; 25 September (2 p.m.) 'Mr. (?) Bruin the Dog'; 29 September (2 p.m.) 'Dog'; 2 October (2 p.m.) 'Dog of Mr. Macklin'.

12 For Reynolds's paintings of the Virgin and Child see Graves and Cronin, 1899–1901, vol. III, pp. 1172–3 and 1226–7. Graves and Cronin also list a 'Virgin giving suck, after Guido', and a 'Holy Family, after Poussin', both copied at the Palazzo Falconiere, Rome, in 1750. See also Cotton, 1859a, pp. 1–46. Reynolds's notebook, containing the list of paintings copied in Italy is in a private collection. The pages containing the relevant notes on copies made by Reynolds in Rome have, however, been removed since they were published by Cotton. There is also a copy, apparently made by Reynolds, of a Madonna and Child, after Seghers (private collection). See also Prochno, 1991, pp. 228–31.

13 Edward Hamilton stated that *The Holy Family* was engraved in 1782, although this appears to be a typographical error (1874, p. 113).

14 In 1839 John Landseer, ARA, stated: 'When it hung in Macklin's Gallery and subsequently in that of Sir Peter Burrell, it was then a fine picture with a solemn tone suited to the sacredness of the subject … the St Joseph was not then "a weak old man" but might vie with any St Joseph from the hand of Titian himself. The old man's head has suffered dreadfully from both the bad chemistry of Sir Joshua's experiments and from a recent cleaning, or operation, by a member of "The Skinners" Company', by which the glazings and something more have been partially and incautiously removed. And little St John has suffered in like manner, and looks as if he had been beated black and blue … The picture was even better two years ago than it is now' (*The Probe*, 1839–40, p. 182).

15 See Friedman 1974, pp. 63ff. See also Garlick, Macintyre, and Cave, 1978–84, vol. III, p. 1057 (for Josiah Boydell's version of the origins of the Shakespeare Gallery).

16 Haydon was told in 1833 that Barry, in turn, had referred to Reynolds as 'that man in Leicester Fields' (in Pope, 1960–3, vol. IV, p. 62).

17 See also the *Public Adverstiser*, 11 January, 1787: 'In a late paper, we observed that Sir Joshua Reynolds had fixed upon Hamlet: He also thought of a scene from Macbeth – the pit of Acheron! But Sir Joshua will not pledge himself to complete either.'

18 See Bruntjen, 1974, pp. 35ff. See also David Alexander, 'Patriotism and contemporary history, 1770–1830', in Cannon-Brookes, 1991, pp. 31–5.

19 On 7 May *The Times* noted; 'Historical painting and engraving are almost exclusively endebted to Mr. Boydell for their present advancement.'

20 For a contemporary account of the exclusion of engravers from the Royal Academy see Strange, 1775, pp. 112ff.

21 Repton's play was entitled, *Odd Whims, or Two at a Time*, Stroud, 1962, p. 25.

22 Leslie and Taylor also state elsewhere: 'One of his models for the Puck was, a few years ago, a drayman, in the employment of Barclay and Perkins. Mr. Cribb, the picture dealer, late of King Street, Covent Garden, son of Sir Joshua's frame maker, sat for the same figure; and other children were, no doubt, laid under contribution' (1865, vol. II, p. 484). In 1856 the *London News* (7 June) reported that the model for Puck was a porter at Elliott's brewery, Pimlico, who had been present when the painting was sold (Christie's, 16 February, 1856, lot. 28) by Samuel Rogers (Graves and Cronin, 1899–1901, vol. III, p. 1189). Also Penny, 1986, p. 322.

23 '22 June, 1789. Mr. Alderman Boydell, for the "Death of Cardinal Beaufort" 500 gs. paid' (in Cormack, 1970, p. 147).

24 The picture measured 123·8 × 165·7 cm. It was purchased at Greenwood's by Holcroft on 16 April 1796 (lot 69) for two guineas. It had entered the Dulwich Picture Gallery by 1850. See also Graves and Cronin, 1899–1901, vol. III, p. 1146.

25 Several appointments with old male models are recorded in Reynolds's sitter-books at this time: 18 January and 22 September 1787; 19 August, 11 October, 18 December 1788; 14 May, 26 June, 7 July 1789. Some of these appointments could be associated with *Cardinal Beaufort* but also with the *Holy Family* or the *Continence of Scipio*.

26 Taken from the Whitley Papers, Department of Prints and Drawings, British Museum. Whitley's source was an album of newspaper cuttings in the Victoria and Albert Museum.

27 I am grateful to Alastair Laing and the staff of the National Trust at Petworth House for making special provision for me to make a detailed examination of the picture surface of *The Death of Cardinal Beaufort* and *Macbeth and the Witches*.

28 For Wootton's painting see Cannon-Brookes, 1991, cat. 1, p. 46. For other pictorial treatments of *Macbeth* see Dotson, 1973, pp. 134–220, and Merchant, 1959, pp. 35–76.

29 Annotation to Horace Walpole's 1783 Royal Academy catalogue, quoted in Leslie and Taylor, 1865, vol. II, p. 409.

30 Esther Dotson has stated that the picture was exhibited at Boydell's Shakespeare Gallery in 1789, although I have been unable to find specific evidence to support this observation. See Dotson, 1973, p. 161.

31 In the front of his 1787 sitter-book Reynolds noted: 'Mr. Alderman Boydel's / cloth 8f. 6 High / 12 f. – long / Sight measure'. The picture measures 144 × 108 inches.

32 For Reynolds's sketches relating to *Macbeth* see Graves and Cronin, vol. III, pp. 1172; Tinker, 1938, p. 166; Prochno, 1990a, pp. 195–7, figs. 185–7.

33 See Dotson, 1973, pp. 158ff. for discussion of depictions of the witches in late eighteenth- and early nineteenth-century British art.

7 *'That ever living ornament of the English School': Reynolds's subject pictures, 1792–1830*

1 On 10 January 1781 Mrs Thrale wrote:
 Of Reynolds what Good shall be said? – or what harm?
 His Temper too frigid, his Pencil too warm;
 A Rage for Sublimity ill understood,
 To seek still for the Great, by forsaking the Good. (Balderston, 1942, p. 473)

2 Reynolds stated in 1780 in the ninth *Discourse*: 'It will be no small addition to the glory which this nation has already acquired from having given birth to eminent men in every part of science, if it should be enabled to produce, in consequence of this institution, a School of English Artists' (in Wark, 1975, p. 169).

3 Reynolds to the Duke of Rutland, 24 September 1784 (Hilles, 1929, p. 112).

4 For contemporary accounts of the affair see Farington in Malone, 1819 (5th edn), pp. ccxvii–ccxxx, and Northcote, 1813, pp. 351–9. The most complete account is to be found in Leslie and Taylor, 1865, vol. II, pp. 553–87.

5 *General Advertiser*, 28 February–1 March 1792: 'The body of Sir Joshua Reynolds has been opened, and it appears that a complaint of the liver occasioned his death; it being also inflamed to such a degree as to have weighed twelve pounds.' This century Ernest Irons concluded: 'That the last illness of Sir Joshua Reynolds was caused by a malignant tumor of the liver, primarily in the left eye, seems the best explanation of the known facts' (1939, p. 18). Irons's general aim was to defend Reynolds's physicians against Malone's assertion that he would have lived longer had they tended him better. See also Prior, 1860, pp. 432–3.

6 Quoted (unacknowledged) in Northcote, 1813, p. 370 and, in an expanded form in Northcote, 1818, vol. II, p. 286.

7 It had also appeared in *The Diary* on 25 February.

8 Samuel Felton, who had also written on landscape gardening, does not seem to have been connected with Reynolds's circle.

9 Felton, 1792, pp. 20–30. In addition to the subject pictures Felton included the following portraits: *Master Crewe as Henry VIII, Master Herbert in the Character of Bacchus, Mary Meyer as Hebe, Cleopatra* (Kitty Fisher); *Garrick as Kitely, Mrs Abingdon as Comedy, The Duchess of Manchester as Diana, Lady Blake as Juno, Cornelia and her Children* (Lady Cockburn and her three children), *Mrs Siddons as the Tragic Muse*, and *Mrs Tollemache as Miranda*.

10 Quoted by Felton, 1792, p. 105, and by Farington, 1819, p. 135. See also *The Gentleman's Magazine*, February 1792, p. 190, and April 1792, p. 381 for similar comments.

11 Reynolds's unfinished portrait of Kitty Fisher (see Penny, 1986, cat. 46) was,

for example, bought on the first day of the sale (lot 67) by Lord Carysfort for £4 18s.

12 Beaumont bought two small studies of heads: 'Study of a black man's head', 15 April, lot 53 (Menil Foundation, Houston); 'Profile of an old man's head', 16 April, lot 37 (Tate Gallery).

13 It was quoted almost verbatim, and without acknowledgement, in *The New Monthly Magazine and Universal Register*, November 1816, p. 327.

14 *The Morning Herald* reported, 2 March 1792: 'Mr BURKE is to write the Epitaph on Sir JOSHUA REYNOLDS. It cannot be in better hands.' It was not referring simply to Burke's obituary of Reynolds, which had already appeared. John Wolcot noted in the early 1790s: 'Is it not astonishing that the life of so great a man as Sir Joshua Reynolds should not have been written?...But Fame proclaimeth Mr. James Boswell to be big with the biography of this celebrated artist, and ready to sink into the straw!' (Wolcot, 1809, vol. III, pp. 330–1). See also Balderston, 1942, vol. II, p. 835, and n. 4. Ronald Lightbown has stated that Boswell refused to write Reynolds's biography 'because he thought Reynolds at fault in his quarrel with the Academy'. See Lightbown (no date, unpaginated).

15 See Hilles, 1952, pp. 123–46 for the complete text of the 'Ironical Discourse'.

16 For Barry's wrangles with the Royal Academy during the 1790s see Pressly, 1981, pp. 133ff.

17 The original text of Barry's lecture is in the National Library of Ireland, Dublin (ms. 18,580).

18 For Barry's changing attitude towards Reynolds see also Pressly, 1981, p. 136.

19 Fryer, 1809, vol. II, p. 607 and p. 617, in 'An Appendix to the Letter to the Diletantti Society', 17 March 1798.

20 See 'Supplement containing Lives of Painters Not mentioned in the Dictionary' (Pilkington, 1798, vol. II, pp. 781–840). The first edition of 1770 had included two deceased British artists, Sir James Thornhill and Sir Godfrey Kneller. Hogarth, who had died in 1764, was not included.

21 See Earland, 1911, p. 214, who quotes an entry of 2 July 1806 from Thomas Green's *Diary of a Lover of Literature*: 'Walked to Opie's and viewed his pictures. Opie said he wrote Sir J. Reynolds' Life in Pilkington's account of Painters.' Earland incorrectly cites the date of the second edition of Pilkington's *Dictionary* as 1792 (*ibid.*, p. 121).

22 In his preface Sotheby stated: 'The following poem arose from a perusal of a plan, originally suggested by Sir George Beaumont, for the improvement of the School of Painting in this country, by an exhibition of those pictures of English Masters, on which the test of time, and the decision of the public, had conferred distinguished approbation' (Sotheby, 1801, p. v).

23 The sale took place at Christie's, 5 November 1805.

24 In the light of material discussed later in the chapter, it is interesting to

compare this passage with the following sentence by Hazlitt in *The Edinburgh Review* of 1820: 'The progress of the Fine Arts has hitherto been slow, and wavering and unpromising in this country, like the forced pace of a shuffling nag, not like the flight of Pegasus' (in Howe, 1930–4, vol. XVI, p. 195). Hazlitt had read Opie's lectures, as he mentioned in a letter to Henry Crabb Robinson in 1809 (see Howe, 1949, pp. 138–9).

25 Turner. ms. lecture notes, Department of Manuscripts, British Museum, Add. ms. 46151 BB, fol. 50 A, and Add. ms. 46151 S, fol. 3. I am grateful to Richard Spencer for allowing me to consult his transcription of Turner's ms. lecture notes. For discussion of these notes, and the questions involving their dating, see Ziff, 1963, pp. 124–47.

26 Turner, ms. lecture notes, Department of Manuscripts, British Museum, Add. ms. 46151 N, fol. 7.

27 *Ibid.*, fol. 10a.

28 Joseph Farington, 24 May 1813, in Garlick, Macintyre, and Cave, 1978–84, vol. XII, p. 4355.

29 For a full list of the works retained for study purposes see Farington, 1819, p. 256.

30 Farington noted in his diary on 23 April 1814: 'He [Sir George Beaumont] told me that Sir Thos. Bernard & Mr. P. Knight had objected to the pictures by Zoffany being admitted, as He was not a *British Painter*' (see Garlick, Macintyre, and Cave, 1978–84, vol. XIII, pp. 4495–6).

31 Coleridge to Thomas Wedgwood, 16 September, 1803, quoted in Howe, 1949, p. 96.

32 The remarks were made in the context of a review of Hazlitt's *Round Table*. See *The Quarterly Review*, April–July, vol. 17, p. 159.

33 For Knight's authorship of this article see Clarke and Penny, 1982, p. 119.

34 See Peter Funnell, 'Visible Appearances', in Clarke and Penny, 1982, pp. 82–92.

35 For Northcote's articles in *The Artist* see Northcote, 1813, pp. iii–clxxvii.

36 See R. W. Lightbown's extensive introduction (unpaginated) to the facsimile edition of Northcote's 1818 *Life of Sir Joshua Reynolds*.

37 See *The British Critic*, February 1814, p. 150, and *The Critical Review*, vol. 4, October 1813, pp. 352–69.

38 See Department of Prints and Drawings, British Museum, Add. mss. 47790–3. Northcote's notes were partly transcribed and published in Gwynn, 1898. As Gwynn's transcription is not entirely accurate, quotations cited here are taken from Northcote's original manuscript, with Gwynn's page numbers given in parentheses.

39 Sales of Reynolds's remaining old-master drawings, sketch-books, oil sketches, unfinished portraits, and other paintings took place at Christie's on 16–21 May 1821.

40 The Herschel Album of drawings (private collection) is currently on loan to
 the Royal Academy of Arts.

41 All references to Hazlitt's *Conversations of James Northcote* are taken from
 Howe, 1930–4, vol. XI, pp. 185–320 and 350–76.

42 'On patronage and puffing', in *Table Talk*, 1821–2 (Howe, 1930–4, vol. VIII,
 pp. 289–302); and 'On the old age of artists' in the *Plain Speaker* (*ibid.*, vol.
 XII, pp. 88–96).

43 First published in 1830 in *Conversations of James Northcote* (see Howe,
 1930–4, vol. XI, p. 257).

44 Hartley Coleridge's ms. annotations to Allan Cunningham's *Lives of the Most
 Eminent British Painters*, 1829, vol. I, pp. 318–19. Coleridge's annotated
 copy of the above text is in the British Library.

References

Abbott, Claude Colleer (1928), *The Life and Letters of George Darley, Poet and Critic*, Oxford.

Addison, Joseph (1726), *Dialogues upon the Usefulness of Ancient Medals*, London.

(1741), *The Works of the Late Right Honourable Joseph Addison*, 4 vols., London.

Alexander, David (1973), 'The Dublin group: Irish mezzotint engravers in London, 1750–1775', *Quarterly Bulletin of the Irish Georgian Society*, July–Sept., pp. 73–93.

(1977), 'Mezzotints after Sir Joshua Reynolds (1723–92)', in *A Selection from the Cooper Abbs Collection on Exhibition at the Treasurer's House, York*.

(1992), *Affecting Moments: Prints of English Literature made in the Age of Sensibility, 1775–18*, exhibition catalogue, City Art Gallery, York; revised edition.

Alexander, David and Richard T. Godfrey (1980), *Painters and Engraving. The Reproductive Print from Hogarth to Wilkie*, exhibition catalogue, Yale Center for British Art, New Haven.

Allen, Brian (1987), *Francis Hayman*, New Haven and London.

Allentuck, M. (1972), 'David Hume and Allan Ramsay', *Studies in Scottish Literature*, 9, pp. 265ff

Andrews, A. A. (1859), *History of British Journalism*, London.

Andrews, C. B. (ed.) (1938), *The Torrington Diaries Containing the Tours through England and Wales of the Hon. John Byng (later Fifth Viscount Torrington) between the Years 1781 and 1794*, 4 vols., London.

Anon. (1766), *The English Connoisseur: Containing an Account of whatever is curious in Painting, Sculpture, etc. In the Palaces and Seats of the Nobility and Principal Gentry of England, both in Town and Country*, 2 vols., London.

(1774), *Observations on the Discourses delivered at the Royal Academy*, London.

(1780), *A Candid Review of the Exhibition*.

(1781), *The Ear-wig; or An Old Woman's Remarks on the Present Exhibition of Pictures at the Royal Academy*, London.

(1790), *Observations on the Present State of the Royal Academy, with the Characters of Living Painters*, London.

Antal, Frederick (1962), *Hogarth and his Place in European Art*, London.

Armstrong, Sir Walter (1900), *Sir Joshua Reynolds*, London.

Aston, Nigel, 'Lord Carysfort and Sir Joshua Reynolds: the patron as friend', unpublished ms. essay.

Baird, John D. and Charles Ryskamp (1980), *The Poems of William Cowper: 1748–1782*, vol. I, Oxford.

Baker, C. H. Collins (1936), *A Catalogue of British Paintings in the Henry E. Huntington Library and Art Gallery*, San Marino.

Baker, R. (1771), *Observations on the present exhibition at the Royal Academy*, London.

Balderston, K. C. (ed.) (1942), *Thraliana. The Diary of Mrs. Hester Lynch Thrale (later Mrs. Piozzi) 1776–1809*, 2 vols., Oxford.

Balkan, Katherine Shelley (1972), 'Sir Joshua Reynolds' theory and practice of portraiture: a re-evaluation', unpublished Ph.D thesis, University of California, Los Angeles.

Barbin, M. (1969), '"Je prie Dieu pour mon père et pour la France": Histoire d'une image', *Gazette des Beaux Arts*, 74, pp. 97–104.

Baretti, Joseph [Giuseppe] (1775), *Easy Phraseology, for the Use of Young Ladies, who intend to learn the colloquial part of the Italian Language*, London.

 (1781), *A Guide through the Royal Academy*, London.

Barrell, John (1980), *The Dark Side of the Landscape: the Rural Poor in English Painting, 1730–1840*, Cambridge.

 (1983), *English Literature in History 1730–80: an Equal, Wide Survey*, London.

 (1986), *The Political Theory of Painting from Reynolds to Hazlitt*, New Haven and London.

Barrett, C. F. (ed.) (1842–46), *The Diary and Letters of Madame d'Arblay*, 7 vols., London.

Barry, F. V. (1931), *Maria Edgeworth: Chosen Letters*, London.

Bate, Walter Jackson (1946), *From Classic to Romantic*, Cambridge, Mass.

Baylis, Sarah (1989), 'Glass-Painting in Britain *c*. 1760 – *c*. 1840. A revolution in taste', unpublished Ph.D thesis, University of Cambridge.

Beard, Geoffrey (1978), *The Work of Robert Adam*, Edinburgh.

Beechey, H. W. (1835), 'Memoir' attached to *The Literary Works of Sir Joshua Reynolds*, revised edn, 2 vols., London.

Beresford, John (1924–31), *James Woodforde, Rector of Weston Longville. The Diary of a Country Parson*, London.

Bickley, F. (ed.) (1928), *The Diaries of Sylvester Douglas, Lord Glenbervie*, 2 vols., London, Boston, New York.

Bicknell, Alexander (1790), *Painting Personified*, London.

Bindman, David (1989), *The Shadow of the Guillotine. Britain and the French Revolution*, exhibition catalogue, British Museum, London.

Binyon, Laurence (1902), *Catalogue of Drawings by British Artists and Artists of Foreign Origin Working in Great Britain, Preserved in the Department of Prints and Drawings in the British Museum*, vol. III, London.

Black, Jeremy and Nicholas Penny (1987), 'Letters from Reynolds to Lord Grantham', *Burlington Magazine*, Nov., vol. 129, pp. 731–2.

Bleackley, H. (1907), *The Story of a Beautiful Duchess. Being an Account of the Life and Times of Elizabeth Gunning, Duchess of Hamilton and Argyll*, London.
 (1909), *Ladies, Frail and Fair*, London.

Blunden, Edmund (1930), *Leigh Hunt. A Biography*, London.

Blunt, A. (1966), *The Paintings of Nicholas Poussin, a Critical Catalogue*, London.

Blunt, R. (1925), *Mrs. Montague, 'Queen of the Blues'. Her Letters and Friendships from 1762 to 1800*, 2 vols., London.

Boase, T. S. R. (1947), 'Illustrations of Shakespeare's plays in the seventeenth and eighteenth centuries', *Journal of the Courtauld and Warburg Institutes*, vol. 10, pp. 83–108.
 (1963), 'Macklin and Bowyer', *Journal of the Courtauld and Warburg Institutes*, vol. 26, pp. 148–77.

Bodmer, H. (1939), *Lodovico Carracci*, Burg.

Bond, W. H. (ed.) (1970), *Eighteenth-Century Studies in Honour of Donald F. Hyde*, New York.

Bordes, Phillipe (1992), 'Jacques-Louis David's anglophilia on the eve of the French Revolution', *Burlington Magazine*, vol. 134, August, pp. 482–90.

Boydell, J (1790), *A Catalogue of Pictures in the Shakespeare Gallery*, Pall Mall, London.
 (1794), *A Description of Several Pictures Presented to the Corporation of the City of London*, London.

Boyle, M. L. (1885), *Biographical Catalogue of the Portraits at Panshanger, the Seat of Earl Cowper*, London.

Brett, R. L. (1951), *The Third Earl of Shaftesbury. A Study in Eighteenth-Century Literary Theory*, London.

Briggs, Martin (1953), *Wren the Incomparable*, London.

Brighton, Trevor (1988), 'William Peckitt's commission book, 1751–95', *Walpole Society*, vol. 54, pp. 334–453.

Brigstocke, Hugh (1978), *Italian and Spanish Paintings in the National Gallery of Scotland*, Edinburgh.

Britton, J. (1812), *The Fine Arts of the English School*, London.

Brookner, Anita (1972), *Greuze. The Rise and Fall of an Eighteenth-century Phenomenon*, London.

Broun, Francis (1987), 'Sir Joshua Reynolds's collection of paintings', unpublished Ph.D thesis, Princeton University, New Jersey.

Brown, Christopher (ed.), (1992) *Rembrandt Van Rijn. Girl at a Window*, exhibition catalogue, Dulwich Picture Gallery, London.

Brownell, Morris (1989), *Dr. Johnson and the Visual Arts*, Oxford.

Bruntjen, H. A. (1974), 'John Boydell (1719–1804): a study of art patronage and publishing in Georgian London', unpublished Ph.D thesis, Stanford University, California.

Burke, Edmund (1757), *A Philosophical Enquiry into the Origin of our Ideas of the Sublime and Beautiful*, London.

Burke, Joseph and Colin Caldwell (1968), *Hogarth. The Complete Engravings*, London.

Bury, Adrian (1949) (ed.), *Rowlandson's Drawings*, London.

Busch, Werner (1984), 'Hogarth und Reynolds. Porträts des Schauspielers Garrick', *Zeitschrift für Kunstgeschichte*, vol. 42, pp. 82–99.

Butlin, Martin (1970), 'An eighteenth-century art scandal: Nathaniel Hone's "The Conjuror"', *Connoisseur*, vol. 174, May, pp. 1–9.

Butt, John (ed.), (1963), *The Poems of Alexander Pope*, London.

(1979), *The Oxford History of English Literature: the Mid-Eighteenth Century*, Oxford.

Byam Shaw, J. (1967), *Paintings by Old Masters at Christ Church, Oxford*, London.

Bysche, E. (1712), *The Memorable Things of Socrates. Written by Xenophon in Five Books. Translated into English*, London.

Carey, William Paulet (1826), *Some Memoirs of the Patronage and Progress of the Fine Arts in England and Ireland*, London.

Cannon-Brookes, P. (ed.), (1989) *Paintings from Tabley: an Exhibition of Paintings from Tabley House*, exhibition catalogue, Heim Gallery, London.

(ed.), (1991) *The Painted Word. British History Painting, 1750–1830*, exhibition catalogue, Heim Gallery, London.

Clarke, Michael and Nicholas Penny (eds.) (1982), *The Arrogant Connoisseur: Richard Payne Knight, 1751–1824*, Manchester.

Clifford, Timothy, Anthony Griffiths, and Martin Royalton-Kisch (1978), *Gainsborough and Reynolds in the British Museum*, London.

Cohen, R. (1970), *The Unfolding of 'The Seasons'. A Study of James Thomson's Poem*, London.

Coleridge, Hartley (1851), *Essays and Marginalia by Hartley Coleridge, Edited by his Brother*, 2 vols., London.

Conway, W. S. (1886), *The Artistic Development of Reynolds and Gainsborough*, London.

Cormack, Malcolm (1970), 'The ledgers of Sir Joshua Reynolds', *Walpole Society*, vol. 42, pp. 105–69.

Cotton, William (1856), *Sir Joshua Reynolds and his Works. Gleanings from his Diary, unpublished Manuscripts, and from other Sources*, ed. J. Burnet, London.

(1859a), *Sir Joshua Reynolds's Notes and Observations on pictures ... extracts from his Italian sketchbooks, also the Rev. W. Mason's Observations of Sir Joshua's method of colouring*, London.

(1859b), *Some Account of the Ancient borough town of Plympton St Maurice, or Plympton Earl; with Memoirs of the Reynolds family*, London.

Cozens-Hardy, B. (1950), *The Diary of Sylas Neville 1767–1788*, Oxford.

Crabbe, George (1834), *The Poetical Works of the Rev. George Crabbe: with His Letters and Journals, and his Life, by his Son*, 8 vols., London.

Croft-Murray, Edward (1962–70), *Decorative Painting in England, 1537–1837*, 2 vols., London.

Cross, A. G. (1985), '"The great patroness of the north": Catherine II's role in fostering Anglo-Russian cultural contacts', *Oxford Slavonic Papers*, NS 18, pp. 67–82.

Crown, Patricia (1984), 'Portraits and fancy pictures by Gainsborough and Reynolds: contrasting images of childhood', *British Journal for Eighteenth-Century Studies*, VII, Autumn 1984, pp. 159–67.

Cumberland, Richard (1806), *Memoirs of Richard Cumberland, Written by Himself*, London.

Cunningham, Allan (1829), *Lives of the Most Eminent British Painters*, vol. I, London.

(1879), *Lives of the most Eminent British Painters*, 2 vols., London.

Dallaway, James (1800), *Anecdotes of the Arts in England; or, Comparative Remarks on Architecture, Sculpture, and Painting*, London.

Davies, Martin (1959), *The British School. National Gallery, Catalogue*, 2nd edn (revised), London.

Dodsworth, William (1792), *A Guide to the Cathedral Church of Salisbury. With a particular account of the late great improvements made therein, under the direction of James Wyatt, Esq.*, Salisbury.

Dorment, Richard (1986), *British Painting in the Philadelphia Museum of Art. From the Seventeenth Century through the Nineteenth Century*, Philadelphia and London.

Dotson, E. G. (1973), 'Shakespeare illustrated, 1770–1820', unpublished Ph.D thesis, New York University.

Dukelskaya, L. (1979), *The Hermitage: English Art, Sixteenth to Nineteenth Century*, Leningrad.

Earland, Ada (1911), *John Opie and his Circle*, London.

Eastlake, Sir Charles (1869), *Materials for a History of Oil Painting*, 2 vols., London.

Edgeworth, Maria (1971), *Letters from England, 1813–1844*, Oxford.

Edwards, Edward (1808), *Anecdotes of Painters*, London.

Einberg, Elizabeth (1976), *Gainsborough's 'Giovanna Baccelli'*, London.

Ellis, A. R. (ed.)(1889), *The Early Diary of Frances Burney, 1768–1778*, 2 vols., London.

Falconet, Etienne (1781), *Œuvres d'Etienne Falconet, statuaire*, 6 vols.

Farington, Joseph (1819), *Memoirs of the life of Sir Joshua Reynolds; with Some Observations on his Talents and Character*, London.

Farr, Dennis (1958), *William Etty*, London.

Felton, Samuel (1792), *Testimonies to the Genius and Memory of Sir J. Reynolds by the author of Imperfect Hints towards a new edition of Shakespeare*, London.

ffrench, Y. (1954), *Mrs. Siddons. Tragic Actress*, 2nd edn, London.

Fletcher, Ernest (ed.) (1901), *Conversations of James Northcote R. A. with James Ward on Art and Artists*, London.

Forbes, Sir William (1806), *Life of Beattie*, 2 vols., London.

Freedberg, S. J. (1950), *Parmigianino and his Works in Painting*, Cambridge, Mass.

Friedman, Winifred H. (1974), 'Boydell's Shakespeare Gallery', unpublished Ph.D thesis, Harvard University.

Frith, William Powell (1889), *My Autobiography and Reminiscences*, 3 vols., London.

Fryer, E. (ed.) (1809), *The Works of James Barry*, 2 vols., London.

Galinsky, G. K. (1972), *The Herakles Theme. Adaptations of the Hero in Literature from Homer to the Twentieth Century*, Oxford.

Galt, John (1820), *The Life, Studies and Works of Benjamin West*, 2 parts, London.

Garlick, Kenneth, Angus Macintyre and Kathryn Cave (1978–84) (eds.) *The Diary of Joseph Farington*, 16 vols. London and New Haven.

Germer, Stefan and Hubertus Kohle (1986), 'From the theatrical to the aesthetic hero: on the privatisation of the idea of Virtue in David's *Brutus* and *Sabines*', *Art History*, vol. 9, no. 2, June 1986, pp. 168–84.

Ginger, John (1977), *The Notable Man, the Life and Times of Oliver Goldsmith*, London.

Godfrey, Richard T. (1978), *Printmaking in Britain. A General History from its Beginnings to the Present Day*, Oxford.

Gombrich, E. H. (1942), 'Reynolds's theory and practice of imitation', *Burlington Magazine*, vol. 80, February, pp. 40–50.

 (1982), *The Image and the Eye*, Oxford.

Good, J. W. (1915), *Studies in the Milton Tradition*, Carbondale, Illinois.

Goodison, J. W., and G. H. Robertson (1967), *Catalogue of Paintings. Fitzwilliam Museum, Cambridge*, 2 vols., Cambridge.

Gosse, Edmund (ed.)(1879), *Conversations of James Northcote*, London.

Gould, Cecil (1962), *National Gallery Catalogue. The Sixteenth-Century Italian Schools (Excluding the Venetian)*, London.

Gould, John (1810), *A Dictionary of Painters, Sculptors, Architects, and Engravers, containing biographical Sketches of the most celebrated Artists, from the Earliest Ages to the Present Time; to which is added an Appendix, Comprising the Substance of Walpole's Anecdotes of Painting in England from Vertue, Forming a complete English School*, London.

Graves, Algernon (1906), *The Royal Academy of Arts. A Complete Dictionary of Contributors and their Works from its foundation in 1769 to 1904*, 8 vols., London.

Graves, Algernon, and William Vine Cronin (1899–1901), *A History of the Works of Sir Joshua Reynolds, P.R.A.*, 4 vols., London. (Annotated copy, bequeathed by Sir Ellis Waterhouse to the Paul Mellon Centre for Studies in British Art, London)

Grayson, C. (ed.) (1972), *Leon Battista Alberti, On Painting and on Sculpture*, London.

Green, Valentine (1782), *A Review of the Polite Arts in France, at the time of their Establishment under Louis XIV, compared with their Present State in England ...*

in a Letter to Sir Joshua Reynolds, President of the Royal Academy, and F.R.S., London.

Grego, Joseph (1880), *Rowlandson the Caricaturist*, 2 vols., London.

Grosley, P. J. (1772) *A Tour to London*, trans. T. Nugent, 2 vols., London.

Guttuso, R. (1981), *L'Opera completa del Caravaggio*, Milan.

Gwynn, Stephen (1898), *Memorials of an Eighteenth-century Painter (James Northcote)*, London.

Haak, B. (1969), *Rembrandt: His Life, Work and Times*, London.

Hagstrum, Jean. H (1958), *The Sister Arts: The Tradition of Literary Pictorialism and English Poetry from Dryden to Gray*, Chicago.

Hamilton, Edward (1874), *A Catalogue Raisonné of the Engraved Works of Sir Joshua Reynolds, P.R.A. from 1755–1820*, London.

Hayes, John (1975), *Gainsborough*, Oxford.

Hazlitt, William (ed.) (1816), *The Memoirs of the late Thomas Holcroft*, 3 vols., London.

 (1824), *Sketches of the Principal Picture Galleries of England*, London.

 (1830), *Conversations of James Northcote Esq., R.A.*, London.

 (1873), *Essays on the Fine Arts*, London.

Hemlow, Joyce (ed.) (1972–82), *The Diary and Letters of Fanny Burney*, 12 vols., London.

Hendy, P. (1926), 'Rembrandt's Girl with a Medal', *Burlington Magazine*, vol. 18, February, p. 83.

Herrmann, Luke (1968), 'The drawings by Sir Joshua Reynolds in the Herschel Album', *Burlington Magazine*, vol. 110, December, pp. 650–8.

Highfill Jr, P. H., K. A. Burnim, and E. A. Langhans (1973), *A Biographical Dictionary of Actors, Managers & other Stage Personnel in London, 1660–1800*, 12 vols., Carbondale, Ill. (ongoing).

Hildebrandt, Edmund (1908), *Leben, Werke unde Schriften des Bildhauers E-M Falconet*, Strasburg.

Hill, G. B. (ed.) (1897), *Johnsonian Miscellanies*, 2 vols., London.

 (1905) (ed.), *Samuel Johnson. The Lives of the English Poets*, 3 vols., Oxford.

Hill, G. B., and L. F. Powell (eds.) (1934–50), *Boswell's Life of Johnson*, 6 vols., Oxford.

Hilles, F. W. (1929), *Letters of Sir Joshua Reynolds*, Cambridge.

 (1936), *The Literary Career of Sir Joshua Reynolds*, Cambridge.

 (1952), *Portraits. Character Sketches of Oliver Goldsmith, Samuel Johnson, and David Garrick, together with other MSS of Reynolds Recently Discovered among the Private Papers of James Boswell*, New York, Toronto and London.

 (1969), 'Sir Joshua at the Hotel de Thiers', *Gazette des Beaux-Arts*, vol. 74, pp. 201–10.

Hilles, F. W., and P. B. Daghlian (1937), *Horace Walpole. Anecdotes of Painting in England*, Vol. V, London and New Haven.

Hoare, Prince (1813), *Epochs of the Arts*, London.

Honour, Hugh (1981), *Neo Classicism*, Harmondsworth.

Hope, Charles (1980), *Titian*, London.

Howe, P. P. (ed.) (1930–4), *The Complete Works of William Hazlitt*, 21 vols., London and Toronto.

(1949), *Life of William Hazlitt*, London.

Hudson, Derek (1958) *Sir Joshua Reynolds, a Personal Study*, London.

Hussey, Christopher (1927), *The Picturesque, Studies in a Point of View*, London.

Hutchison, Sydney (1968), *The History of the Royal Academy, 1768–1968*, London.

Ingamells, John (1964), 'William Doughty, a little known York painter', *Apollo*, vol. 80, July, pp. 33–7.

(1985), *The Wallace Collection. Catalogue of Pictures I: British, German, Italian and Spanish*, London.

(1989), *The Wallace Collection. Catalogue of Pictures III: French before 1815*, London.

Ingamells, John, and Robert Raines (1969), *Philip Mercier, 1689–1760, an exhibition of Paintings and Engravings*, exhibition catalogue, City Art Gallery, York, and Iveagh Bequest, Kenwood, London.

Irons, Ernest E. (1939), *The Last Illness of Sir Joshua Reynolds*, Chicago.

Jackson, William (1798), *The Four Ages*, London.

Jesse, J. H. (1843–4), *George Selwyn and his Contemporaries*, London.

Joannides, Paul (1975), 'Some English themes in the early work of Gros', *Burlington Magazine*, Dec., vol. 117, pp. 774–85.

Johnson, Edward Mead (1976), *Francis Cotes*, London.

Johnson, Samuel (1827), *A Dictionary of the English Language*, 2nd edn, 3 vols., London.

Kalnein, W. G., and M. Levey (1972), *Art and Architecture of the Eighteenth Century in France*, Harmondsworth.

Kemp, Martin (1975), *Dr. William Hunter at the Royal Academy of Arts*, Glasgow.

Kenney, E. J. (1991), Letter to the Editor, *Apollo Magazine*, vol. 133, January, p. 66.

Kenny, S. S. (ed.) (1984), *British Theatre and the Other Arts, 1660–1800*, London and Toronto.

Kitson, Michael (1990), 'British artists and the Bolognese ideal', in *Il luogo ed il ruolo della città di Bologna tra Europa continentale e mediterranea*, Atti del colloquio CIHA, Pinacoteca Nazionale, Accademia Clementina, Fondazione Cesare Gnudi, pp. 431–47.

Knight, Richard Payne (1824), introd., *An Account of all the Pictures Exhibited in the Room of the British Institution, from 1813 to 1823, belonging to the Nobility and Gentry of England*, London.

Knowles, John (1831), *Life and Writings of Henry Fuseli*, 3 vols., London.

Knowles, J. A. (1928–9), 'William Peckitt, glass painter', *Walpole Society*, vol. 18, pp. 45–59.

Köller, Alexander (1992), 'Das Westfenster von New College Chapel: Aspekte

eines "Picture Window" des Spaten 18.JH.', Diplomarbeit zur Erlangung des Magistergrades an der Geisteswissenschaftlichen Fakultät der Universität Salzburg.

Larson, Erik (1988), *The Paintings of Anthony Van Dyck*, 2 vols., Düsseldorf.

Latham, H. M. (ed.) (1927), *Catalogue Raisonné of Engraved British Portraits from Altered Plates, from the notes of George Somes Layard arranged by H. M. Latham*, London.

Lawrence, Sir Thomas (1824), *Address to the Students of the Royal Academy, Delivered before the General Assembly at the Annual Distribution of Prizes, 10 December 1823*, London.

Le Brun, Charles (1734), translated by John Williams, *A Method to learn the Passions. Proposed in a Conference on their General and Particular Expression. Written in French, and illustrated with a great many Figures excellently Designed, by Mr. Le Brun, chief Painter to the French King, Chancellor and Director of the Royal Academy of Painting and Sculpture*, London.

Lee, W. R. (1940), 'Ut pictura poesis: the humanistic theory of painting', *Art Bulletin*, vol. 22, pp. 197–269.

Le Fanu, William (ed.) (1960), *Betsey Sheridan's Journal. Letters from Sheridan's Sister 1784–1786 and 1788–1790*, London.

Leslie, Charles Robert, and Tom Taylor (1865), *The Life and Times of Sir Joshua Reynolds with Notices of his Contemporaries*, 2 vols., London.

Levey, Michael (1971), *National Gallery Catalogues, the Seventeenth and Eighteenth-Century Italian Schools*, London.

Lewis, W. S., (ed.) (1937–83), *Horace Walpole's Correspondence*, 48 vols., London and New Haven.

Lightbown, R. L. (no date), introduction to modern facsimile edition of James Northcote, *The Life of Sir Joshua Reynolds*, 2 vols., London, 1818. [This one-volume edition is undated and Lightbown's introduction is unpaginated.]

Lipking, Lawrence (1970), *The Ordering of the Arts in Eighteenth-Century England*, Princeton.

Lonsdale, Roger (1988), 'The strange case of John Bampfylde', *London Review of Books*, vol. 10, no. 5, 3 March, pp. 18–19.

Lynd, R., and W. McDonald (1929), *The Collected Essays of Charles Lamb*, 2 vols., London and Toronto.

Magnus, P. (1939), *Edmund Burke. A Life*, London.

Malone, Edmond (1780), *Supplement to the Edition of Shakespeare's Plays by Samuel Johnson and George Steevens*, 2 vols., London.

 (ed.) (1819), *The Literary Works of Sir Joshua Reynolds*, 3 vols., London, 1798. 5th edn.

Mandowsky, E. (1940), 'Reynolds's conceptions of truth', *Burlington Magazine*, vol. 76, Dec., pp. 195–201.

Mannings, David (1984), 'Reynolds, Garrick and the choice of Hercules', *Eighteenth-Century Studies*, spring, pp. 259–83.

Mant, Richard (1802), *Poetical Works of Thomas Warton*, Oxford.

Martin, W. (1913), *Gerard Dou, Klassiker der Kunst*, Stuttgart.

Martineau, Jane, and Charles Hope (eds.) (1983), *The Genius of Venice, 1500–1600*, exhibition catalogue, Royal Academy of Arts, London.

Mason, Eudo. C. (1951), *The Mind of Henry Fuseli; Selections from his Writings with an Introductory Study*, London.

Merchant, W. M. (1959), *Shakespeare and the Artist*, London.

Meyer, Jerry D. (1979), 'Benjamin West's window designs for St George's Chapel, Windsor', *American Art Journal*, vol. 11, pp. 53–65.

Millar, Oliver (1969a), *The Later Georgian Pictures in the Collection of Her Majesty the Queen*, 2 vols., London.

(1969b), 'Notes on three pictures by Van Dyck', *Burlington Magazine*, vol. 111, July, pp. 414–17.

Mitchell, Charles (1938), 'Benjamin West's "Death of General Wolfe" and the popular history piece', *Journal of the Warburg and Courtauld Institutes*, vol. 7, pp. 20–33.

(1942), 'Three phases of Reynolds's pictorial method', *Burlington Magazine*, vol. 80, February, pp. 35–42.

Monk, Samuel H. (1960), *The Sublime: a Study of Critical Theories in Seventeenth-Century England*, Ann Arbor, Michigan.

Montagu, Jennifer (1959), 'Charles Le Brun's conférence sur l'expression générale et particulière', unpublished Ph.D thesis, University of London.

Montagu, Jennifer, Helen Glanville, Richard Wrigley (1990), *Courage and Cruelty. Le Brun's Horatius Cocles and the Massacre of the Innocents*, exhibition catalogue, Dulwich Picture Gallery, London.

Morley, E. J. (ed.) (1938), *Henry Crabb Robinson on Books and their Writers*, 3 vols., London.

Moser, Joseph (1803), 'Vestiges, collected and recollected, by Joseph Moser, Esq.', *The European Magazine*, No. 13, July–Dec. 1803.

Munby, A. N. L. (1947), 'Nathaniel Hone's "Conjuror"', *Connoisseur*, vol. 120, Dec., pp. 82–84.

Murray, Penelope (1989), *Genius: the History of an Idea*, Oxford.

Murray, Peter (1972), *The Iveagh Bequest, Kenwood. Catalogue of Paintings*, London.

Musa, Mark (transl.) (1984), *Dante, The Divine Comedy*, vol. I: *Inferno*, Harmondsworth.

National Gallery of Scotland (1957), *National Gallery of Scotland. Catalogue of Paintings and Sculpture*, Edinburgh.

Neilson, Nancy Ward (1971), 'A rediscovered work by Sir Joshua Reynolds', *Apollo Magazine*, vol. 93, Feb., pp. 128–9.

Newton, Thomas (1782), *The Works of the Right Reverend Thomas Newton*, 2 vols., London.

Nichols, John (1822), *The Works of William Hogarth from the original Plates restored*

by James Heath, to which are prefixed a biographical essay on the Genius and Productions of Hogarth, London.

Nicolson, Benedict (1968a), *John Hamilton Mortimer, A.R.A., 1740–1779*, exhibition catalogue, Eastbourne and London.

(1968b), *Joseph Wright of Derby*, 2 vols., New Haven and London.

Northcote, James (1813), *Memoirs of Sir Joshua Reynolds*, London.

(1818), *The Life of Sir Joshua Reynolds*, 2 vols., London.

Opie, John (1809), *Lectures on Painting. Delivered at the Royal Academy of Arts*, London.

Orgel, Stephen, and Roy Strong (1973), *Inigo Jones. The Theatre of the Stuart Court*, 2 vols., London, Berkeley and Los Angeles.

Owen, Felicity, and David Blayney Brown (1988), *Collector of Genius. A Life of Sir George Beaumont*, London and New Haven.

Panofsky, Erwin (1930), '"Hercules Prodicus". Die Wiedergeburt einer Griechischen Moralerzahlung im Deutschen und Italienschen Humanismus'. Hercules am Scheidewege und andere Antike bildstoffe in der Neuren Kunst, *Studien der Bibliothek Warburg Herausgegeben Von Fritz Saxl*, 18, Leipzig and Berlin.

Pasquin, Anthony (1796), *Memoirs of the Royal Academicians; being an Attempt to Improve the National Taste*, London.

Patmore, P. G. (1824a), *British Galleries of Art*, London.

(1824b), *Beauties of the Dulwich Picture Gallery*, London.

Paulson, Ronald (1989) *Hogarth's Graphic Works*, 3rd edn, revised, London.

(1991–3), *Hogarth*, 3 vols., Cambridge.

Penny, Nicholas (ed.) (1986), *Reynolds*, exhibition catalogue, Royal Academy of Arts, London.

Perini, Giovanna (1988), 'Sir Joshua Reynolds and Italian art and literature. A study of the sketchbooks in the British Museum and Sir John Soane's Museum', *Journal of the Warburg and Courtauld Institutes*, vol. 51, pp. 141–68.

(1991), 'Considerazioni preliminari ad un'edizione critica dei taccuini di viaggio basate sul taccuino conservato al Sir John Soane's Museum di Londra', *Storia dell'Arte*, no. 73, 1991, pp. 361–412.

(1992), '(R)evolution in art across the Channel: Reynolds and the continental tradition', *L'Art et les révolutions. L'Art au temps de la Révolution française* (Section 1), Congrès international d'histoire de l'art. Société Alsacienne pour le Développement de l'Histoire de l'Art, Strasbourg, pp. 205–20.

Pilkington, Rev. Matthew (1798), *The Gentleman's and Connoisseur's Dictionary of Painters. A New edition to which is added A Supplement; Anecdotes of the latest and most celebrated artists, including several by Lord Orford; also Remarks on the Present State of the Art of Painting by James Barry R.A.*, 2 vols., London.

(1805), *Pilkington's Dictionary of Painters*, ed. Henry Fuseli, with further ms. additions and corrections by Fuseli dated 10 January 1810. British Library.

Pointon, Marcia (1970), *Milton and English Art*, Manchester.

(1993), *Hanging the Head. Portraiture and Social Formation in Eighteenth-Century England*, New Haven and London.

Pope, W. B. (1960–3), *The Diary of Benjamin Robert Haydon*, 5 vols., Cambridge, Mass.

Postle, Martin (1988a), 'Pathos personified', *Country Life*, June, pp. 204–5.

(1988b), 'Patriarchs, prophets, and paviours: Reynolds's images of old age', *Burlington Magazine*, vol. 130, Oct., pp. 735–44.

(1989), 'The subject pictures of Sir Joshua Reynolds', unpublished Ph.D thesis, University of London.

(1990), 'Reynolds, Shaftesbury, Van Dyck and Dobson: Sources for "Garrick between Tragedy and Comedy"', *Apollo Magazine*, vol. 132, Nov., pp. 306–11.

(1993), 'A taste for history: Reynolds, West, George III, and George IV, *Apollo Magazine*, vol. 138, Sept., pp. 186–91.

Powell, Nicholas (1973), *Fuseli: The Nightmare*, London.

Pressly, William. L. (1981), *The Life and Art of James Barry*, New Haven and London.

(1983), *James Barry, the Artist as Hero*, exhibition catalogue, Tate Gallery, London.

Prior, Sir James (1860), *Life of Edmond Malone, Editor of Shakespeare with Selections from his Manuscript Anecdotes*, London.

Prochno, Renate (1990a), *Joshua Reynolds*, Weinheim.

(1990b), 'Sir Joshua Reynolds' use of Bolognese art', *Il luogo ed il ruolo della città di Bologna tra Europa continentale e mediterranea*, Atti del colloquio CIHA, 1990, Pinacoteca Nazionale, Accademia Clementina, Fondazione Cesare Gnudi.

(1991), 'Nationalism in British eighteenth-century painting: Sir Joshua Reynolds and Benjamin West', in Richard Etlin (ed.), *Nationalism and the Visual Arts* (Studies in the History of Art, 29, Center for Advanced Study in the Visual Arts, National Gallery of Art, Washington), Washington.

Radcliffe, S. M. (ed.) (1930), *Sir Joshua's Nephew, being Letters Written 1769–1778, by a Young Man to his Sisters*, London.

Ramsay, Allan (1788), *The Gentle Shepherd, A Pastoral Comedy*, Glasgow.

Repton, Humphry (1789), *The Bee: or a Companion to the Shakespeare Gallery: Containing a Catalogue Raisonné of all the Pictures; with Comments, Illustrations, and Remarks*, London.

Ribiero, Aileen (1983), 'The dress worn at masquerades in England, 1730–1790, and its relation to fancy dress in portraiture', unpublished Ph.D thesis, Courtauld Institute, University of London.

Richardson, E. (1955–6), 'A fancy picture by Reynolds', *Detroit Institute of Arts Bulletin*, vol. 35, No. 1, pp. 1–4.

Richardson, Jonathan (1719), *Two Discourses*, London.

Ripa, Cesare (1709), *Iconologia or Moral Emblems. Newly Design'd, and Engraved on Copper by I. Fuller*, London.

Roberts, W. (1834), *Memoirs of the Life and Correspondence of Hannah More*, 4 vols., London.

Robinson, H. C. (1869), *Diary*, London.

Roe, Albert (1971), 'The demon behind the pillow: a note on Erasmus Darwin and Reynolds', *Burlington Magazine*, vol. 113, Aug., pp. 460–70.

Rogers, John Jope (1878), *Opie and his Works. Being a Catalogue of 760 Pictures by John Opie, RA Preceded by a Biographical Sketch*, London.

Rogers, Malcolm (1983), *William Dobson, 1611–46*, exhibition catalogue, National Portrait Gallery, London.

Rogerson, Brewster (1953), 'The art of painting the passions', *Journal of the History of Ideas*, vol. 14, no. 1, pp. 68–94.

Romney, Rev. John (1830), *Memoirs of the Life and Works of George Romney*, London.

Rosenblum, Robert (1967), *Transformations in Late Eighteenth-Century Art*, Princeton, N. J.

Sackville-West, Lionel (1906), *Knole house: its State Rooms, Pictures, and Antiquities*, Sevenoaks.

Scharf, G. (1860), *Catalogue of Pictures and Works of Art in the Public Rooms at Blenheim Palace*, London.

Schiff, Gert (1973), *Johann Heinrich Fuseli, 1741–1825*, 2 vols., Zurich.

(1975), *Henry Fuseli, 1741–1825*, exhibition catalogue, Tate Gallery, London.

Shaftesbury, Earl of, Anthony Ashley (1714), *Characteristicks of Men, Manners, Opinions, Times*, 2nd edn, corrected, 3 vols., London.

Shawe-Taylor, Desmond (1987), *Genial Company: the Theme of Genius in Eighteenth-Century British Portraiture*, exhibition catalogue, Nottingham University Gallery and Scottish National Portrait Gallery.

(1990), *The Georgians. Eighteenth-Century Portraiture and Society*, London.

Shee, Martin Archer (1814), *The Commemoration of Reynolds, in Two Parts*, London.

Shenstone, William (1741), *The Judgement of Hercules*, London.

Sherburn, George (ed.) (1956), *Correspondence of Alexander Pope*, Oxford.

Simmons, J. S. G. (1965), 'Samuel Johnson "on the Banks of the Neva": A note on a picture by Reynolds in the Hermitage', in *Johnson, Boswell, and their Circle. Essays Presented to Lawrence Fitzroy Powell*, Oxford.

Simon, Robin (1979), 'Hogarth's Shakespeare', *Apollo Magazine*, vol. 109, March, pp. 213–20.

Simon, Robin, and Alastair Smart (1983), *The Art of Cricket*, London.

Smart, Alastair (1965), 'Dramatic gesture and expression in the age of Hogarth and Reynolds', *Apollo Magazine*, vol. 82, no. 42, Aug., pp. 90–7.

Smith, Anthony D. (1979), 'The "Historical Revival" in late eighteenth-century England and France', *Art History*, vol. 2, no. 2., pp. 156–78.

Smith, J. C. (1833), *British Mezzotint Portraits*, 4 vols., London.

(1878–83), *British Mezzotinto portraits; being a descriptive Catalogue*, 4 parts, London.

Smith, J. T. (1817), *Vagabondia*, London.

Sotheby, William (1801), *A Poetical Epistle to Sir George Beaumont, Bart.*, London.

Spence, Joseph (1747), *Polymetis*, London.

Spencer, A. (ed.) (1913–25), *Memoirs of William Hickey*, 4 vols., London.

Spencer, B. M. (1937), 'William Dobson', unpublished MA thesis, University of London.

Steinberg, Ronald M. (1977), *Fra Girolamo Savonarola, Florentine Art, and Renaissance Historiography*, Athens, Ohio.

Stephens, Frederic G. (1867), *English Children as Painted by Sir Joshua Reynolds*, London.

Stone Jr, G. W. (1962), *The London Stage 1660–1800. A Calendar of Plays, Entertainments and After Pieces together with Casts, Box Receipts and Contemporary Comment*, part 5, 1747–76, Carbondale, Ill.

Strachey, Lionel (transl.) (1904), *Memoirs of Madame Vigee Le Brun*, London.

Strange, Robert (1775), *An Inquiry into the Establishment of the Royal Academy of Arts. To which is Prefixed a Letter to the Earl of Bute*, London.

Strong, Roy (introd. and ed.) (1991), *The British Portrait, 1660–1960*, London.

Stroud, Dorothy (1962), *Humphry Repton*, London.

Sunderland, John (1988), 'John Hamilton Mortimer. His life and works', *The Walpole Society*, vol. 52.

Sutton, Denys (1958), *France in the Eighteenth Century*, exhibition catalogue, Royal Academy of Arts, London.

Sutton, Peter (1984), *Masters of Seventeenth-Century Dutch Genre Painting*, exhibition catalogue, Philadelphia Museum of Art and Royal Academy of Arts, London.

Taylor, John (1811), *Poems on Several Occasions*, Edinburgh.

Tillotson, A. (ed.) (1944), *The Percy Letters: the Correspondence of Thomas Percy and Edmond Malone*, Baton Rouge, La.

Tinker, Chauncey B. (1938), *Painter and Poet: Studies in the Literary Relations of English Painting*, Cambridge, Mass.

Thomson, William (1771), *The Conduct of the Royal Academicians, while Members of the Incorporated Society of Great Britain*, London.

Toynbee, Paget (1921), *Britain's Tribute to Dante in Literature and Art*, London.

Tuer, Andrew B. (1881), *Bartolozzi and his Works*, 2 vols., London.

Vaughan, William (1983), 'When was the English School?', *Probleme und Methoden der Klassifizierung*, International Conference in the History of Art, Vienna, 4–10 Sept., pp. 105–11.

Vertue, George (1930, 1932, 1934, 1936, 1938), 'Notebooks', *Walpole Society*, vols. 18, 20, 22, 24, and 26.

von Erffa, Helmut, and Allen Staley (1986), *The Paintings of Benjamin West*, New Haven and London.

Waagen, G. (1857), *Galleries of Art in Great Britain*, London.

Walker, Richard (1992), *The Eighteenth and Early Nineteenth Century Miniatures in the Collection of Her Majesty the Queen*, Cambridge.

Walker, R. S. (ed.) (1946), 'James Beattie's London Diary, 1773', *Aberdeen University Studies*, no. 122, Aberdeen.

Walpole, Horace (1762–71), *Anecdotes of Painting in England*, 4 vols., London.

Wark, Robert R. (1971), *Ten British Pictures, 1740–1840*, San Marino, Calif.

 (ed.) (1975), *Sir Joshua Reynolds. Discourses on Art*, New Haven and London.

Warton, Joseph (1782), *An Essay on the Genius and Writings of Pope*, vol. II, 3rd edn, London.

Waterhouse, E. K., 'Reynolds's fancy pictures', unpublished manuscript essay, Paul Mellon Centre for Studies in British Art, London.

 ms. notebooks, Getty Museum, Malibu, Calif.

 (1941), *Reynolds*, London.

 (1946), 'Gainsborough's fancy pictures', *Burlington Magazine*, vol. 88, June, pp. 134–40.

 (1953), *Painting in Britain 1530 to 1790*, Harmondsworth.

 (1967), *The James A. Rothschild Collection at Waddesdon Manor, Paintings*, London.

 (1968), 'A child baptist by Sir Joshua Reynolds', *Minneapolis Institute of Arts Bulletin*, vol. 57, pp. 51–3.

 (1973), *Reynolds*, London.

 (1981), *The Dictionary of British 18th Century Painters in Oils and Crayons*, Woodbridge.

Wax, Carol (1990), *The Mezzotint. History and Technique*, London.

Webster, Mary (1970), *Francis Wheatley*, London.

 (1976), *Johan Zoffany, 1733–1810*, exhibition catalogue, National Portrait Gallery, London.

Weinglass, D. H. (1982), *Collected Letters of Henry Fuseli*, New York.

Weinsheimer, J. (1978), 'Mrs Siddons, the Tragic Muse, and the problem of *As*', *Journal of Aesthetics and Art Criticism*, vol. 36, Spring, pp. 317–28

Weinshenker, A. B. (1966), *Falconet: his Writings, and his Friend Diderot*, Geneva, 1966

White, Christopher, David Alexander, and Ellen D'Oench (1980), *Rembrandt in Eighteenth-Century England*, exhibition catalogue, Yale Center for British Art, New Haven and London.

Whitley, William T. (1915), *Thomas Gainsborough*, London.

 (1928a), *Artists and their Friends in England, 1700–1799*, 2 vols., London.

 (1928b), *Art in England, 1800–1820*, London.

 (1930), *Art in England, 1821–1837*, London.

Williams, C. (ed.) (1933), *Sophie in London, 1786; being the Diary of Sophie Von La Roche*, London.

Williams, J. (pseud., 'A. Pasquin') (1796), *Memoirs of the Royal Academicians*, London.

Williams, M. (ed.) (1939), *The Letters of William Shenstone*, Oxford.

Williamson, G. C. (1903), *John Russell, R.A.*, London.

Williamson, G. C, and H. L. D. Engleheart (1902), *George Engleheart, 1750–1829, Miniature Painter to George III*, London.

Wilton, Andrew (1979), *The Life and Work of J. M. W. Turner*, London.

Wind, Edgar (1937), 'Studies in allegorical portraiture, I: In defence of composite portraits', *Journal of the Warburg and Courtauld Institutes*, vol. 1, pp. 138–42.

— (1938–9), 'The revolution in history painting' and 'Borrowed Attitudes in Reynolds and Hogarth, *Journal of the Warburg and Courtauld Institutes*, vol. 2, pp. 116–27 and 182–5.

— (1986), *Hume and the Heroic Portrait. Studies in Eighteenth-Century Imagery*, trans. into English, and ed. Jaynie Anderson, Oxford.

Wolcot, J. (pseud. 'Peter Pindar') (1785), *More Lyric Odes to the Royal Academicians, by a Distant Relation to the Poet of Thebes, and Laureate to the Academy*, London.

— (1809), *The Works of Peter Pindar*, 4 vols., London.

Woodall, Mary (1963), *The Letters of Thomas Gainsborough*, 2nd edn, London.

Woodford, Susan (1983), 'The iconography of the Infant Herakles strangling snakes', in F. Lissarrague and F. Thelamon (eds.), *Image et céramique Grecque* (Publications de l'Université de Rouen, no. 96), Rouen, pp. 121–9.

Woodforde, Christopher (1951), *The Stained Glass of New College*, Oxford.

Woodward, J., and M. Cormack (1961), *Exhibition of Works by Sir Joshua Reynolds*, Birmingham.

Wornum, R. N. (ed.) (1848), *Lectures on Painting by the Royal Academicians, Barry, Opie and Fuseli*, London.

Wright, Christopher (1985), *Poussin's Paintings, a Catalogue Raisonné*, London.

Yates, Frances (1951), 'Transformations of Dante's Ugolino', *Journal of the Warburg and Courtauld Institutes*, Jan.–June, pp. 92–117.

Ziff, J. (1963), '"Backgrounds, introduction of Architecture and Landscape", a lecture by J. M. W. Turner', *Journal of the Warburg and Courtauld Institutes*, vol. 26, pp. 124–47.

Index